TIME EXPOSURE

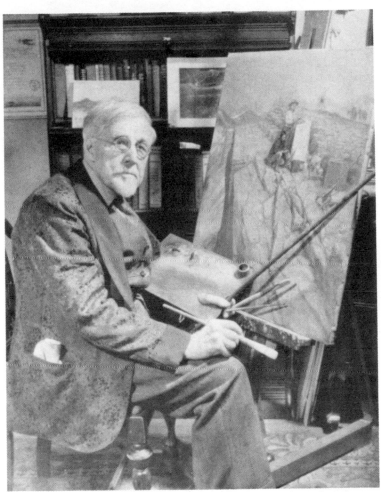

Courtesy of *Look Magazine*

TIME EXPOSURE

The Autobiography of

WILLIAM HENRY JACKSON

*Profusely illustrated
with photographs, paintings, and drawings
by the author*

NEW YORK
COOPER SQUARE PUBLISHERS, INC.
1970

Originally Published 1940
Copyright © 1940 by William Henry Jackson
Reprinted by Permission of G. P. Putnam's Sons
Published 1970 by Cooper Square Publishers, Inc.
59 Fourth Avenue, New York, N. Y. 10003
International Standard Book No. 0-8154-0362-3
Library of Congress Catalog Card No. 77-133914

Printed in the United States of America

FOREWORD

IT WAS NEARLY EIGHTY YEARS AGO that I started writing this book. And now that it is finished, quite a number of sentences still stand just as I put them down in the notebook I carried with me to the War.

As time went on, I continued to write a journal; and, in spite of many periods of interruption, I suppose I have accumulated a million words of longhand notes. Selecting from this mass of material, bridging the many gaps (from a memory at times reluctant), and turning the whole into what I hope may be a readable narrative, all this has been no easy task. I could not have done it alone.

Among my helpers, I am first of all indebted to Karl Brown, who has worked closely with me at all stages in the preparation of the final manuscript. In addition, he has often argued with me—and I am grateful for that as well.

Without the help of my children, this book would be much less complete. I thank my son Clarence S. Jackson and my daughters Louise Jackson McLeod and Harriet Jackson Pattison for invaluable family items.

In the tedious labor of checking names, dates, and the like, and in correcting manuscript and proofs, I have been ably assisted by Theodora Hill, and I thank her for her part.

I also gratefully acknowledge my debt to my loyal associates of the Geological Survey (through whose courtesy I am here able to reproduce many photographs), the National Park Service, and the Oregon Trail Memorial Association; and to all my other friends who, through the years, have contributed to this book.

W. H. JACKSON

New York City
July, 1940

CONTENTS

CONTENTS

ILLUSTRATIONS

TIME EXPOSURE

TIME KATOGINS

UNCLE SAM'S NEPHEW

O NE day early in 1848 a lean and sunburned soldier arrived at my father's house in Columbus, Georgia. The soldier was my mother's brother, Edward Allen, on his way home from the Mexican War. Of his visit and the tales he told I have no very distinct memories. Yet, though not quite five, I understood that Uncle Edward had been away fighting against a wicked man. To me General Santa Anna—whose name I did not know—was the same scoundrel King George III must have been to a small boy seventy years before, the identical villain other young Americans found in the German Kaiser seventy years later. How I hated Santa Anna! And now my anger against that patriotic gentleman, although cooled somewhat by the intervening ninety-two years, still stands out as the earliest recollection of my life.

The family Bible has the date of my birth as April 4, 1843, the place as Keeseville, New York, a little town about two miles below the famous Ausable Chasm. I was the first of seven children born to George Hallock Jackson and Harriet Maria Allen. My father's family, members of the Society of Friends, had come from Ireland about 1700 and settled in New Hampshire. Before the turn of the nineteenth century my great-grandfather had moved his wife and children to New York and gone to farming near Keeseville. There my father was born in 1820; he lived to the age of eighty-four. The Allens, English, also out of New Hampshire, settled in Troy about 1795. My mother

was born there in 1821. She was a graduate of the Troy Female Academy, later the Emma Willard School, and lived to enjoy the distinction of being its oldest alumna. She died in 1912 in her ninety-second year.

Quite the most distinguished member of my family was a great-uncle of my mother's. He enjoyed during his later years a singular fame that is hardly diminished today—a fame that no other American has quite equaled. That is an extravagant claim, but I believe no one will refuse the honor to the man who has personified his country for a century and a quarter. Chinese who have never heard of George Washington know the long face and lanky figure of "Uncle Sam." Hindus who have never known about Abraham Lincoln are familiar with "Uncle Sam's" scraggly chin whiskers and striped pantaloons. Even in this country children who are too young to know their country's heroes can identify my Uncle Sam. His real name was Samuel Wilson. His birthplace, like Homer's, is disputed by several towns. He was probably born either in Arlington, Massachusetts, or Mason, New Hampshire, in 1766. With an older brother he moved to Troy in 1789, the year that city was incorporated, and established a brick yard. By 1805 they must have been very prosperous, for in that year, with their brick works flourishing, the brothers advertised a new enterprise: their slaughterhouse was prepared to "kill, cut and pack 150 head of cattle per day."

Enduring fame began to settle upon Samuel Wilson during the War of 1812. While troops were encamped near Albany a man named Elbert Anderson got the contract for supplying them with barreled pork and beef, and on every barrel were stamped the letters "U.S.—E.A."—for the United States and Elbert Anderson. Many of these barrels came straight from the Wilson packing house; and when anyone asked what the initials stood for, the common, if facetious, answer was: "What! Don't you know

Uncle Sam Wilson? Uncle Sam's a great patriot, and he's feeding up the army to lick the British." By the end of the war "Uncle Sam" was permanently established. Although newspaper cartooning was then all but unknown, the rest of the country became familiar with his conventionalized appearance through the medium of the stage; by 1825 he was a stock character. The earliest known published drawing labeled "Uncle Sam" came out in the *New York Lantern* in 1852, and from then on, lean and fat, with and without whiskers, he was the property of all cartoonists. Thomas Nast, the greatest of them, used him freely in *Harper's Weekly* during the War of the Secession. In the '80's when I met Nast in Colorado he learned for the first time that "Uncle Sam" had a flesh-and-blood prototype in my great-great-uncle. Uncle Sam had to pay quite a price for his distinction: for forty years simple people, as well as many not so simple, pestered him to set them up in business or, at the very least, to supply them with farms. But Samuel Wilson came of tough stock. He lived until 1854, when I was eleven. A few years ago a fine monument was erected to his memory in Mt. Ida Cemetery in Troy.

While my mother grew up as a "city girl," my father had his boyhood on the farm. After completing the usual country grade-school course, plus a year or two in a private academy in Plattsburg, he worked on the farm for a few years. Then, before he was twenty, he started off to find a career of his own. I know little about his next few years, except that he traveled around the country considerably; he went as far west as the Mississippi, then the frontier, and I believe he sailed down it to New Orleans. Apparently Father came back with more money than he had started with; for upon his return he opened a blacksmith and carriage-building shop in Keeseville. He was competent and industrious, and soon after meeting my

mother, when he was only twenty-one, he was in a posi-
tion to ask her to marry him. Their wedding took place
on June 15, 1842.

Father always had his eyes open for new things. Soon
after the daguerreotype process was discovered in 1839 he
began experimenting with a camera of his own. But that
was only a passing phase, a hobby. Perhaps Father was too
busy building wagons; but, whatever the reason, parts of
the first camera ever owned by a Jackson came into my
hands as a toy when I was a very small boy. I hadn't any
real idea what the lens-box was intended for; but I got the
feel of a camera almost before I could walk. It may sound
foolish, yet I can't help believing that this childhood ex-
perience helped to direct my life. An undoubted influence
was my mother's gift with pencil and water-color. I can
hardly remember the time when I didn't draw pictures.
It was something without beginning—and is still without
an end.

When I was about a year old I acquired another habit
that I have never lost—traveling. In 1844 my father's busi-
ness caused us to move south to Georgia, where we lived
for some three years. By the time my Uncle Edward arrived
there from Mexico we were beginning to pull stakes to go
back to New York State—perhaps the presence of a husky
young soldier to help us move had something to do with
our departure at that precise time. At any rate, we started
north in the middle of winter, 1848. I retain two impres-
sions of our journey. One is of the little stern-wheeler that
took us down the Chattahoochie River; Uncle Ed carried
me out on deck to show me the palmettos and the shining
waters under the light of a great full moon. The other has
to do with the last two or three days of that trip, when we
traveled by sleigh from Whitehall up the gleaming surface
of Lake Champlain to Plattsburg; I can still hear the
horse's shoes biting into the ice.

For a year or so we lived in Plattsburg, and then Father

bought a two-hundred-acre farm about halfway between there and Keeseville, my birthplace. The house in Peru Township, from what I can remember of its architecture, was of the Dutch-Colonial type, standing well off the road, up a lane of poplars.

My sharpest picture is of the kitchen, with my mother and the hired girl always stirring about with the cooking and baking, or putting up jelly, or filling a tub with hot water to do the washing. There I played with my brother Edward, eighteen months younger than I, and there my tiny sister Mary Elizabeth (born in 1849) was rocked in her cradle.

It was the center of life, that kitchen, a room of ample size. Extending nearly the full width of the building, it must have been close to forty feet long; its low ceiling made that dimension seem even greater, and a tall person had to stoop a little in order to avoid the sagging strings of dried apples and shucked corn hung from the beams. At one end of the room was a stove (which my father bought after we moved in), cupboards and shelves, and a sturdy, wide-planked table, of pine or maple, at which we took our meals. At the other end of the kitchen stood a smaller table, a tall "secretary" that all but scraped the ceiling, three or four rocking chairs topped with anti-macassars, and an old horsehair sofa demoted from the parlor. This was really the family sitting room. Here my

father checked his accounts and figured his seasonal needs. Here, also, my mother would read to us after she had finished her evening's work. I can remember the reading lamp, with its steady, white flame. Elsewhere we used candles; but the lamp was always lighted after supper. The fuel was camphine, a distillate of turpentine; kerosene was still unknown, and coal oil was just coming in.

In the middle of the kitchen rose the fireplace built of fieldstone. I am not sure how much we used the open fire for cooking after the stove was bought; but my impression is that it always had at least one huge pot simmering over the coals. I do know that all the baking was done in the oven that was part of it, and no bread ever quite equaled the big round loaves that came straight from the hot brick floor to the table. No day passed that failed to yield a pastry of some sort. When bread was not being baked there might be molasses cookies in the oven, or ginger-bread, or, at the very least, a thick apple pie.

My mother was an excellent cook, and our food, if lacking great variety, was plentiful and nourishing. We always had an abundance of milk and butter, and, except during the moulting season, all the eggs we could use. Salt pork was the great staple everywhere in those days; but we had plenty of fresh beef, and sometimes lamb. Chicken was a common dish on our table, and often, when Father could take time to do a little hunting, we would have broiled partridge or rabbit stew or—when some friend had been gunning in the near-by Adirondacks— venison steak. Vegetables were abundant and delicious in summer; during the winter they were still plentiful, but not nearly so succulent. Potatoes, turnips, onions, and cabbages we had with us always; but there were no fast trains rushing Southern peas and asparagus, no refrigerator cars bringing California greens. Such "greens" as we ate between September and June we had dried ourselves in the sun during the summer, or put up in jars and stone

crocks. You couldn't get them in a can from the grocer, either. To begin with, there wasn't any grocer, but a very independent gentleman who ran a general store where you could buy horse liniment, tenpenny nails, brown sugar, black thread, and coffee; that upright citizen had decided views about folks who bothered him with frivolous demands. But even more to the point was the circumstance that the canning industry hadn't yet been thought of. The fruit you ate was the fruit you raised yourself or found growing wild in the meadows and along the hillsides —apples, pears, plums, cherries, quinces, and the common berries. Peaches were almost unknown that far north. Oranges were Christmas wonders found at the bottom of your stocking, while pineapples and bananas and other true tropical fruits were as far removed from us small children as the kangaroo and the elephant.

It was while we lived on the farm that the marvel of the ages arrived—white sugar, in loaves. No doubt they had been using it in New York and other large centers long before 1850; but Keeseville had never experienced "loaf" sugar until it suddenly appeared on display at the general store. Up to that time coarse brown cane sugar had been used on the table as well as for cooking; maple sugar was also in general use in up-state New York and Vermont, where most people had their own sugar orchards. Men debated the new invention, women discussed it in practical terms, and the children stared in silence or boasted that they had been given a taste. It was a great day when my father came home with a snowy five-pound loaf.

Our farm was as busy as any, I am sure. Yet when asked to describe the details a few years ago, I was unable to give much information about the work I performed as a small boy. For a moment I wondered whether my memory hadn't begun to slip. Then it struck me that I hadn't forgotten—I just hadn't done any work to speak

of, and the reason was that I was too young to be of any real use. Apart from fetching firewood, gathering eggs from the barn, bringing in the cows at milking time, carrying water for the haying hands, and running odd errands, there wasn't much I was big enough to do.

One job I do remember. Leading to the highway, some three hundred yards from the door, was a lane or avenue of ancient poplars. They must have been unsafe, for soon after we came to live there all of them had to be cut down. And then the lane seemed nearer three thousand than three hundred yards long: it was my task to stack the fire-lengths sawed from the poplar logs. Probably I did only a small part of the work, and I am sure I was paid in proportion to my labor. My father rewarded me with a silver three-cent piece, bright and fresh from the mint.

For some reason I can't very logically explain, another item of that period sticks in my mind. There was a barn-raising at a near-by farm, and while the real work was going on half a dozen boys, myself included, played the game of follow-the-leader. After we had clambered over beams and rafters for a time the leader dipped up a cup of cider and polished it off. We all followed—a feat that was repeated a number of times. Just how hard the cider was is a matter I couldn't testify to now; but I know that my brother Ed had to be carried out to the family conveyance. I wasn't much better off myself. Since then I have sometimes wondered how it happened that we ever got the chance to work up such a jag. I suppose the grown-ups were too busy to notice what we boys were doing.

It was during our residence in Peru Township that I started my formal education, in a little one-room schoolhouse half a mile from home. There were no more than a dozen or fifteen pupils, and the teacher was a girl of perhaps nineteen—who seemed very old indeed to us children. I recall no details of instruction in that first school; but I remember that the teacher "boarded around"

during the term. When it was our turn to have her she was installed in the "minister's room"—that tiny cubicle common to all early New England and upper New York farmhouses—and I remember how important I felt to have the fountainhead of all knowledge under the same roof with me. One other thing has stayed fixed in my mind: the school supply of firewood was furnished by the children's parents, and a pupil's social standing was likely to be influenced by the quality of fuel his father contributed. One load of green logs marked you and your family forever.

When I was about eight my father received a commission to set up a factory of some kind in Petersburg, Virginia, and we moved south again. There were then four children in the family, my brother Fred having been born in 1851.

Our stay in Petersburg was comparatively short; I know there was little time for school—a deprivation I survived with no pain. My clearest memory of the South is of the little pickaninnies, who were my constant playmates. I remember, too, the great tobacco plantations, with hundreds of Negroes at work in the fields. I was too young to understand that they were slaves; but when the War of the Secession began to brew I thought of those black men and women again.

From Petersburg we moved to Philadelphia. Since we lived there for a year or more, I undoubtedly went to school; yet Philadelphia's contribution to my formal learning was so slight as to be forgotten now. One extracurricular lesson was more vivid. In company with another little boy, I smoked my first cigar, a ferocious black stogie we had purloined from the little tobacco-and-candy shop which my father conducted on the side. That first cigar convinced me that I had no taste for tobacco; and, al-

though I have tried everything from hookahs to cigarettes, I still don't care for smoking.

The fact that we ran a little shop in the front room of our house makes me think that this was a period of hard times for my father. There were now five children in the family (my brother Frank was born in January, 1853), and I am sure there was need for more money than father was then earning at his regular work of carriage-building. But before we left Philadelphia things must have picked up, for one day the entire family, all in our Sunday best, went downtown to be daguerreotyped. You couldn't be hard up and afford to have your picture taken in those days.

It was soon after our visit to the photographer's that I started out alone on the most wonderful journey of my life.

SCHOOL AND MY FIRST JOB

I HAVE marched off to fight in a war, bullwhacked over the plains while the Sioux and the Cheyennes were still busy taking scalps, climbed unmapped peaks in the Rockies, and frozen my back teeth crossing Siberia in the dead of winter; but no adventure of mine has ever provided excitement to equal that of my trip from Philadelphia to Troy in 1853. My parents, who were then preparing to move to my mother's home town, decided that my schooling was in a sorry state (as it undoubtedly was), and it was arranged that I should precede them and get a good start at the beginning of the new term. My home, until the rest of the family should arrive, was to be with my mother's older brother, George Wilson Allen.

Several weeks before leaving Philadelphia I was taken to a tailor and measured for a suit of clothes—a scandalous extravagance that cost my father eight dollars. But, if my pride in ownership is a valid consideration, it was well worth it. There was also a fine new traveling cap to go with the outfit. Even more dazzling than my clothes was the little trunk they bought for me. It was really no more than a box, about thirty inches long and fifteen inches deep, but it was bound in brass and it had a padlock— the key didn't leave my pocket for months.

On the day of my departure I was up at dawn and saw to it that everybody else was ready to start for the depot at least three hours before train time. By "everybody" I

13

mean the entire family: Father of course had to go to see that I had my ticket and got on the right cars; my brother Edward, because he would not be denied; Mother, because she was my mother; and the three youngest, Mary Elizabeth, Fred, and my baby brother Frank, because Mother couldn't leave them at home. A hired carriage came for us at the appointed hour, and seven Jacksons, one brassbound trunk, and one brown-paper package of sandwiches departed for the railway station.

I don't know what time the train left Philadelphia; but I do remember that it was well before noon. And almost as soon as we puffed out of the sheds I opened my lunch; it was the first time that I had ever not had anyone to tell me what to do—or when not to do it. After eating as much as I could I began to enjoy the scenery. The countryside between Philadelphia and New York isn't particularly stimulating even today; but to me, aged ten and on my first independent expedition, all of it was entrancing. Even the car I rode in was a thing to excite me. What did I care if the seats were hard and straight-backed, or if the trucks rattled and jolted my kidneys at every joint of the rails? It was adventure. The only thing like it today is a trip from the Battery to the Bronx on the Third Avenue El in New York.

Of course, at that time the Philadelphia trains didn't go right into New York City. That didn't happen until almost sixty years later, when the Pennsylvania Railroad finished its tunnel under the North River. In 1853 the tracks ended on the Jersey shore, and all the passengers for New York took a long ferry ride across the harbor. At the time of my first arrival in Manhattan there wasn't quite as much to see as there is today—no great liners coming up through the Narrows, no Statue of Liberty on Bedloe's Island, and not a single skyscraper. Castle Garden (now the Aquarium), where Jenny Lind had sung only a year or two before, was the most striking object on the shore's edge,

and the tallest structure was the steeple of Trinity Church, then newly rebuilt. A quarter-mile farther up Broadway the spire of St. Paul's could be seen.

I was provided with a letter of instructions, and, tiny trunk on shoulder, I found my way without difficulty from the ferry slip to the Albany boat. The trip up the Hudson began well before dark, and for several hours I stood out on deck and took in the scenery—the departing shore of Manhattan, low beyond the wake of the steamboat as it plowed upstream; the nearing shore of New Jersey sheer and high, as we swung out into mid-channel. As we proceeded, the shore on both sides grew higher and more wooded, while the stream grew wider and wider. These many-currented, broadening waters were no river—we were sailing out into a new, unexplored sea!

People have asked me about the river boats of that era. Now, I have gone down Long Island Sound on an army transport, seen many more on the Potomac during the War of the Secession, crossed and recrossed the Mississippi, and sailed up and down the Missouri—always on some sort of "river boat." Some of them I remember well, others I have forgotten, and that Hudson River boat, while far from forgotten, just doesn't stand out sharply. I wouldn't trust my own description of it today, except for two or three things: it was, of course, a side-wheeler; it made a great deal of noise; it shook all over; it had a pair of perilously tall smokestacks (braced by wires fastened to cleats on the deck); and it threw out immense clouds of black smoke. I can't remember much about the accommodations. When it had grown too dark to see the shore I went into what was probably called the Grand Saloon Cabin and ate the rest of the food I had carried with me from Philadelphia. Immediately afterward I curled up on my bunk and slept soundly until daylight.

When the boat docked in Albany next morning I realized for the first time that I was quite alone in the world—

the day before I had been an explorer, but now I wanted breakfast and my mother to give it to me. I followed the other disembarking passengers onto the boat landing, where a kind gentleman, observing that no one was present to meet me, offered his assistance. I told him I wanted the stage to Troy. He told me where to go, and soon I was on my way, with the trunk fastened on top.

Today you hardly know where Albany ends and Troy begins, but then it was a six-mile drive through open country. I reached my uncle's house in time for dinner, which in 1853 came at high noon. Before that first meal ended I suspect that Uncle George and Aunt Ellen had begun to repent their bargain in taking me to live with them; having eaten no breakfast, I piled into my victuals like a woodchopper.

The months I lived at my uncle's were, on the whole, pleasant months for me. George Allen was kind and just, but he was a stricter man than my father. He was a more settled man, too, and the business of conducting a retail market had taught him to be methodical—and to expect others to be governed by his own desire for order. Every evening Uncle George returned home with the day's receipts tied up in a canvas bag. And every evening after supper, regular as the grandfather clock in the hall, he would go to work on his books. That is something I remember very well, for it was my double duty to count the cash and give Uncle George the exact amount in dollars and cents—no mean mathematical feat, since at that time specie was still rare, and a large proportion of the coinage in circulation was foreign. Spanish pesetas, French francs, English shillings, and Mexican dollars were as familiar as American silver and equally acceptable as currency. Sometimes, when I wanted to do something else, I found this clerking tedious. But usually I found it quite stimulating. At that time it was customary for the boys in school to make up their own problems, instead of

having examples assigned from a book by the teacher. Most pupils came in with practical situations, like the area of a wheatfield, or the cubic capacity of a barn. Some of the more unpleasant boys even arrived at school wanting to know how many days it would take three and a half men to build a house and a half, if six and a half men could finish one in a week and a half—or something of the sort. I proudly presented problems in foreign exchange, and the answers were always right. My uncle saw to that.

Schooling began in earnest almost as soon as I reached Troy. It was the old Fourth Ward School that I entered—a three-story brick building, furnished with all the latest equipment. We had the new "assembly" desks, similar, at least in structural principle, to the kind still used; that is, they consisted of a desk screwed to the floor, with the seat hinged to the desk behind, and so on, row upon row. Apart from undoubted slight departures in detail, there was one major difference: the desks of today are individual, while the ones of my time were two-seaters. The teacher's desk was on a platform up front, of course—but the teacher I remember best was usually around in the back of the room somewhere. Mr. Brooks, a tall, lank man with black hair that flowed to his collar, prowled the aisles with a catlike tread, ready to pounce on one of us poor little chickens. Best of all he liked to catch a boy chewing gum; when he did he got a headlock with one arm, while the forefinger of his free hand expertly probed the culprit's mouth and never failed to dislodge the hated wad. But Mr. Brooks, for all his zeal, couldn't wipe out the practice he so detested. Spruce gum was less a vice than a cult. All the boys chewed it—you needed only a spruce tree and a jackknife to keep yourself supplied—and there was an endless rivalry among us to see who could most quickly convert the sap from hard, grayish flakes into the smoothest purple gum. It took half a day's per-

sistent chewing to gain the desired consistency, so it would have been clearly impossible to finish the job entirely out of school hours.

Around the schoolroom walls hung steel engravings and lithographs. George Washington was the most frequent subject, and in one classroom or another he could always be found—crossing the Delaware, wintering at Valley Forge, or delivering his Farewell Address (which, by the way, was often used by prize speakers in contests). I remember, too, the stern countenance of Daniel Webster, who was still a very live hero in New England and along the Hudson although he had been dead for a full twelve months. There was also a shining new portrait of President Franklin Pierce, handsome and young, who had been inaugurated only that year. If anyone should wonder about room for all those pictures, one answer is that wall blackboards did not exist. Easel blackboards were the very latest thing when I started school in Troy.

There was no globe in that schoolroom, and I am not sure that we studied geography. Of history lessons I can't be sure either; but writers of textbooks on the American theme flourished in that day (I have since learned, while digging up information in various libraries), and it is a reasonable guess that we were given at least a sketch of our country's progress. Arithmetic I have already mentioned; it was my best subject. The worst in every way was public speaking—"declamations," I think we called it. In after life I have made a few speeches and I never particularly minded getting up before my audience when I had something I wanted to say; but as a boy my most dreadful experience was that long, solitary walk down the aisle on Speech Day to deliver the words some great man had spoken or written down before me. Yet I recited them: Daniel Webster and William Cullen Bryant, Whittier and Longfellow, even that long-forgotten poet Joel

Barlow. There is still another whose name I cannot re-call—but who will ever forget *Casabianca?*

We had intensive lessons in writing. Good penmanship was indispensable if a young man wished to get along in the world, and no subject was taught with greater care. We practiced on slates; but our "exhibition pieces" were written with pen and ink on fine paper. My own hand was never exceptional, but it was passable. Today there is nothing for which I am more grateful, for I have a col-lection of notebooks, journals, and diaries that would fill twenty printed volumes, and I would now be much handi-capped if they were not readily legible. The art of reading —the first and presumably the most important of the tra-ditional three R's—was never a difficult one for me. I always had enough curiosity about things in general to dig for myself, which, since I never attended school after I was fourteen or fifteen, has been a very lucky thing for me. Although I read few books of any consequence as a boy, I found that I did read with pleasure when inter-ested.

In recent years many people have asked me whether my school used the famous McGuffey's readers. The an-swer is: No, I was not taught to read in the McGuffey manner. Today McGuffey seems to be something of a god; but when I was a boy he was an upstart educator from Ohio. At least, the more conservative sections of the East still viewed his innovations with profound suspicion, if not with horror.

Playgrounds in the modern sense did not exist when I went to school, but that didn't mean we lacked space for our games and squabbles. There was a vacant lot almost next to the school, and after the final bell we dashed over. The game I best remember was the still-popular one-o'-cat, two-o'-cat, a kind of scrub baseball, with each batter staying in until put out, then retiring to right field and working his way back to the plate, as other batters go

down. Ducks-and-drakes was also a favorite, and so was our simpler version of the game which now seems to be known as gangsters-and-G-men.

In the winter, of course, we had coasting, skating, and shinny. And if we never saw the kind of hockey that is played now in Madison Square Garden, we never saw headguards and shin protectors either. One point on which I can fully trust my memory is that our home-made shinny sticks laid open a scalp just as effectively as the best professional hockey stick in use today.

"There's snow on Jacob Street Hill!" That cry, and not the calendar, heralded the real coming of winter. Within an hour of the first flurry of the year scores of boys and girls would come trooping, bright-eyed and pink-nosed, and before the ground was fully white the first sleds were scraping over the dirt and striking sparks against the stones. Soon, if the snow continued, the whole hill would be dotted with coasters, big boys and girls in their 'teens among them, and even a few grown-ups. One day, after a long cold spell, with the snow crunching under foot and lightning fast beneath the runners, a sled carrying three or four big boys started down just as a freight train pulled in over the tracks that crossed Jacob Street well past the end of the grade. When the sled hit the bottom it was going too fast to stop. It flashed on, and over the tracks— under one of the cars, and then out onto the ice-bound river, with the boys miraculously unscathed!

Some time during my first year in Troy Mother and Father and the younger children arrived, and I naturally left my Uncle George's to live with them. I was already spending most of my spare time drawing, and Mother, a talented water-colorist, gave me a copy of J. G. Chapman's *American Drawing Book*. No single thing in my life, before or since that day, has ever been so important to me. Up to that time I had drawn pictures with a burning zeal, but with very little else to recommend them—even to my-

self. My houses were flat, my horses stood on stilts (or were hidden up to their bellies in tall grass), my rivers ran up hill, and my men and women all had water on the knee and on the brain. From Chapman I first learned the mysteries of perspective, the rules of composition and design, the laws of color values, and how to model. I discovered the technique of delineating man's features—by copying and recopying the heads of Apollo and George Washington. I learned how to draw the human body in bone and muscle, and I found the way to give roots to my trees and how to bend them in the wind. And I learned

how to economize, to eliminate, and to suggest, as well as to emphasize. Years later I read the praises of another Chapman; but young John Keats owed no more to his Chapman than I do to mine.

Our house on North Fourth Street had a good-sized back yard. Down at the end of the plot was a small two-story building, the ground floor of which was more than ample for our needs as storeroom, woodshed, and toolhouse. Upstairs was a fine big room. As soon as my parents saw the extent of my interest in drawing and painting they turned it over to me for a studio. Perhaps "studio" is a little pretentious; but if it means a place of study, then it

is a good word to describe that room at the end of the yard. There I worked and experimented. I had no teacher but myself and Chapman. But I had a sound critic in my mother, and her judgment of my work was the detached appraisal of an artist, not the foolish praise of an admiring parent. I have often wished that she might have given me more time—but time was something she could not squander on one child, with five to care for and a home to run.

I drew or painted every day, and for a while I did almost nothing but landscapes, either real or imaginary. In time I turned from water-colors to oils, and a year or so later I began to copy old portraits. I completed a family gallery, including a likeness of Samuel Wilson. If that one should ever turn up again, I am sure no one could recognize "Uncle Sam," for my portrait showed him without the characteristic whiskers. Uncle Sam never wore them while I knew him, nor in the earliest cartoons; they were added by later artists, either because beards were again in fashion or because chin whiskers were taken to be the trade-mark of any solid, homespun citizen.

My biggest problem in the early days was not so much artistic as economic—to keep myself supplied with materials. I started to cast about for a job, and since I was willing to work for very little, I found one.

That was in the summer of 1855, when I was twelve. My father had developed a considerable activity in local politics—a little later he was elected Supervisor of the Fourth Ward—and among his influential friends was a junior partner in the law firm headed by the venerable Judge Gould, who was persuaded to hire me as a vacation-time office boy. My day began at eight o'clock, and I worked until five or later, running errands, carrying mail to and from the post office, finding reports, and copying outgoing correspondence with a letter press. It was hard

work for a boy; but I was earning money—two dollars a week—to buy paints and brushes with.

The following summer I found a job that paid me even better. One of my numerous Wilson cousins was a printer, and he needed a boy to help him. I learned to fold and straighten paper, to turn a hand-press, and even to do a little typesetting. It was all a valuable experience, and I earned three dollars a week besides. The only trouble was that I had no time at all for my painting.

I don't know exactly how old I was when I made the most important discovery of my life—that it was possible to do the thing I most wanted to do and get paid for it as well. My great enlightener was a druggist named Johnson (whose son Ira later came to work for *me,* when I opened my photographic studio in Omaha). But I don't want to give the impression that Mr. Johnson was a mellow philosopher and an unselfish molder of thought—that wouldn't be fair to Mr. Johnson. On the contrary, he was a hard-headed chemist in need of some display cards, neatly hand-lettered and enriched with tasteful curlicues in blue, red, and gold. He also wanted them cheap, and that is why he and I were able to strike a bargain.

If Druggist Johnson had been the proprietor of a modern establishment, he might have kept me on doing piece-work for years. But in the '50's a drug store wasn't a place where you could buy everything from hamburgers to lawn mowers. You went there for your dyspepsia pills or your lung tonic, or to get a prescription compounded. With such a limited field of merchandise Mr. Johnson didn't need me very long. Yet I left with a knowledge worth far more than the few dollars I earned. All I had to do was find more customers for my wares, and then I could go on painting forever.

At that time (and for many years afterward) window screens were more than mere utilitarian barriers to house-flies and mosquitoes. They were the medium for display-

ing some of the most astonishing pictorial art ever known
to man. As you walked along Fourth Street on a summer's
day every open window cried aloud for admiration. Here
were Mr. Jones's parlor windows parading the virtues of
home life among the Romans; there were Mrs. Smith's
testifying to her travels through the Black Forest and an
idyllic honeymoon on Lake Lucerne; just beyond, Dr.
Robinson's eloquently bespoke his love of grazing cows,
old mills, and waterfalls. It was a wonderful world—and
a live market for a boy who could create it.

I got all of the window-screen business I could take
care of—by underselling my professional competitors. My
usual fee, which had to cover the cost of paint and wear-
and-tear on brushes, was fifteen cents a screen; however,
once in a while I screwed up my nerve to the point of
charging a quarter if the screen turned out to be excep-
tionally large. If I made a profit I don't remember it; I
feel safer in saying that I plowed every cent right back
into the business.

I must have pleased my patrons, for word-of-mouth ad-
vertising brought orders in other fields: window cards for
merchants, placards announcing church sociables, posters
for political rallies. (In 1856 the Republican Party, spir-
itual successor to the exhausted Whigs, first appeared in
national politics. At thirteen I took part in the campaign
to elect that brave soldier and renowned explorer John C.
Frémont. But although I marched in several processions,
attended a great mass meeting, and saw to it that a few
pumpkins were made into jack-o'-lanterns for window
decorations, Colonel Frémont and his running mate, Day-
ton, went down to defeat. The man who rescued the Re-
publican Party four years later was still practicing law
out in Illinois.)

My first "big" commission came from the local theater,
where we were occasionally regaled with a minstrel show,
a reading from *Hamlet* or *King Lear,* or perhaps a real

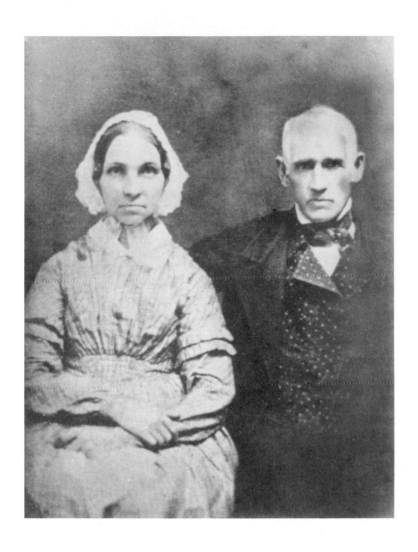

My maternal grandparents, Amos and Betsey Wilson Allen,
from a daguerreotype made not later than 1845.

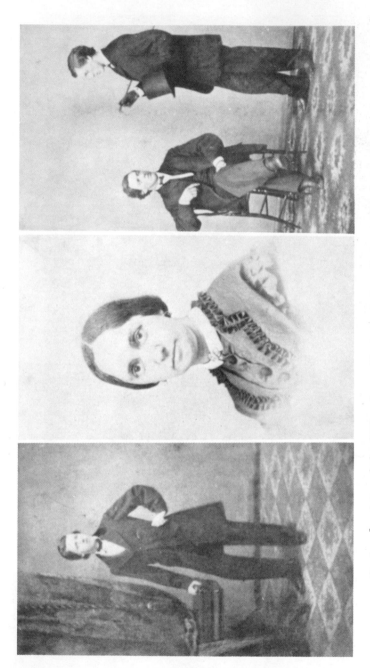

Cartes-de-visite of the '60's: the earliest surviving photograph of myself, aged 17; my mother, 1860; myself, 1865 (showing that we could make double exposures seventy-five years ago).

thriller like Mrs. Stowe's new play *Uncle Tom's Cabin*. My opportunity came with the production of an "oriental phantasy" called *Ali Baba and the Forty Thieves*. I was charged with the major duty of painting a row of man-sized oil jars on the back-drop—for which I was paid a whole dollar, as I recall. In addition, I received a hearty slap on the back from the stage manager. The approval of this great man was reward beyond rubies.

In the early months of 1858, either just before or just after my fifteenth birthday, I really became launched on my career. But I certainly had no realization of it at the time. All I knew was that C. C. Schoonmaker, Troy's leading photographer, was busy enough to employ my services as a piecework retoucher and that my handiness with pen and pencil could earn me three or four dollars a week.

Before telling about my work in Mr. Schoonmaker's River Street studio I think I should first put in a few words about the processes and technics of photography in those prewar days. Daguerreotypy, first commercially practiced in the United States in 1840, was the art of sensitizing a silver-surfaced copper plate with sublimated iodine; exposing the plate through a lens; developing the latent image with mercury fumes; fixing the image in a bath of hyposulphite of soda; washing the plate in distilled water; delivering the finished plate, properly encased, to the customer—and collecting your money. This "negative" was, of itself, the positive; and there was no way to make extra prints except by additional exposures. When, during the early '50's, the new collodion wet-plate process began to supersede the daguerreotype method it became possible not only to make multiple prints from any given negative but to duplicate the many daguerreotypes already in existence. As soon as people found that they could buy more and better pictures for less money they flocked to

the studios, and a competent photographer was always up to his neck in work.

My part in Schoonmaker's work was sharpening and improving certain details of his prints with India ink and "warming them up" with water colors; the paper then used almost always produced photographs of rough appearance, and retouching was indispensable. I was never an "operator" (that is, a camera man) during those first years. Nevertheless, I was in a position to learn a lot about photography—knowledge which served me later.

For portrait work we used a single large box camera built to accommodate plate holders of various dimensions. Lenses were excellent. There were no shutters. Exposures were made by uncapping the lens, while the subject, head firmly clamped to a supporting rod, literally stopped breathing for ten to thirty seconds. Contact prints (prints the same size as the negatives) were the usual thing; but enlargements, though not always satisfactory, could be made with a "solar camera." Equipped with a condensing lens, this enlarging machine was housed on the roof, where natural light was strongest.

Those were good pictures that Schoonmaker made in Troy. One thing that helped was the patience of the sitters. Possibly a generation of men and women previously accustomed to being painted for posterity and their own pleasure could sit more composedly than most of us are able today. Besides, the camera was still a novelty. Remember that photography, as distinguished from daguerreotypy, was less than ten years old.

During these years I took no more notice of the contemporary world outside than any other average boy of fifteen or sixteen. Perhaps I was even less aware than most, for I had what very few boys of that age possessed:

an absorbing profession that left me little time for extraneous matters. Yet certain things were bound to take my attention and rivet themselves fast to my mind. From the summer of 1858, for example, two things stand out.

In July the famous Lincoln-Douglas debates began. I followed them closely, and it was a real personal blow when, some months later, the Illinois legislature re-elected the Little Giant to the United States Senate. I must add that I had only slight knowledge of the merits of the case. But Lincoln was already something of a hero to me. He had been a "favorite son" at the 1856 Republican Convention. And hadn't I "worked" for Frémont, the choice of that same convention? It is interesting now to look back on those debates. Today Lincoln's speech about "a house divided against itself" is treasured as a jewel of persuasive eloquence. But at the time many people regarded it as cheap political oratory, designed (as it surely must have been) to serve an immediate need. Douglas made mincemeat of it.

The other epochal event of that summer was the successful laying of the Atlantic cable. Just twelve months before, after years of preparation, the cable had parted almost as soon as it was down. But in August of 1858 actual telegraphic communication tied England to the United States. Queen Victoria exchanged greetings with President Buchanan, and everybody rejoiced. We could hardly realize that New York and London were as close to each other as Troy was to Albany.

In some ways we were even more impressed by the first overland mail from California. In October came the unbelievable news that letters from San Francisco had been received in St. Louis only twenty-four days after posting. A bare half-dozen years before, three or four months, by way of the Isthmus of Panama, was the best anyone could

hope for; and now, proved beyond doubt, the Eastern seaboard was scarcely a single month removed from the West Coast. The early dreamers had not been wrong: a nation spanning the continent was no longer an impractical speculation—it was accomplished. As if to prove it, Oregon Territory in the remote Northwest achieved its population quota at that precise moment, and early in the next year it was admitted to the dignity and responsibility of statehood.

Surely the most dramatic occurrence of 1859 was the insurrection at Harpers Ferry. Since that autumn day when John Brown armed a group of Negroes and made his abortive and pathetic gesture, books have been written about him, poems have been recited, songs have been sung, and many men have died in battle. I don't know whether John Brown was an evangelist or a mere agitator. I don't know whether he deserved the hangman's noose he got so quickly, and I don't know whether he speeded up the great conflict to which he played a violent prologue or just got in its way. All I know about John Brown is that every sensible man I listened to at the time shook his head and set him down as an unfortunate crank.

But the great event of 1859 had nothing to do with wars, communication lines, or the destiny of nations. It had to do with something far more appealing—a hero. All during the late spring every newspaper had carried long accounts of preparations by one Monsieur Blondin to cross the Niagara River through the air. This madman, so the papers said, would stretch a wire above the torrent and then, God willing, walk over it with his own two feet. Some of the journals were cynical enough to suspect a hoax, but millions of men, women, and children, along with at least one photographer's assistant, awaited the scheduled crossing with faith, hope, and anxiety. Supporting the great majority was the *New-York Daily Tribune*.

On Tuesday, June 28, 1859, it carried the following headline:

THE GREAT TIGHT-ROPE FEAT

CROSSING NIAGARA RIVER ON A CORD

The story described the preliminaries: how Blondin had sent the heavy tight-rope over the river with a light wire, how he had trotted about high in the air to test it, how he had demonstrated his ability by rehearsing his walk on a cable that hung above the suspension bridge which spanned the gorge, how thousands of tense watchers had taken a holiday to watch all this. The crossing over the raging waters of the Niagara would take place two days later.

On Thursday, June 30, the country stopped breathing, and on Friday, July 1, many thousands routed themselves out of bed at dawn to read of death or victory. It was of victory that they read. The *Tribune* gave the story two columns—"from our own correspondent"—and did M. Blondin the additional honor of eulogizing him in an editorial. For a number of reasons that editorial has always interested me:

M. Blondin yesterday performed the daring feat of walking across the Niagara River, a short distance below the cataract, on a tight-rope. During the trip, he indulged in various hair-rising antics, and when at the middle dropped a line 150 feet to the steamer *Maid of the Mist,* drew up a bottle of wine, drank it, tossed the bottle into the river, and went on his way rejoicing. Twelve thousand people were there with the fond anticipation of seeing him tumble into the river, but were disappointed. . . .

Even then we were not without our Byrds, our Lindberghs, and our American public.

FORT SUMTER FALLS

A S the fateful year 1860 dawned I was still a photographer's "artist" and odd-job decorator in Troy, and nothing was to happen to change my own private career for nearly twelve months to come. But the air was filled with change. Local business and political associates of my father's, visitors to the studio, farmers and merchants in little knots at the bank, loafers along the streets, all breathed change. And I, not quite seventeen, listened eagerly and indiscriminately.

When Abraham Lincoln, who had continued to grow as a national figure after his lost contest with Douglas, delivered his Cooper Union speech late in February the effect was almost physical. The Republican Party, the sad and puny baby born in 1856, had suddenly whooped lustily and kicked out with both feet.

I want to make it clear that I *felt* far more than I *thought*. I was the perfect partisan. I picked my side, and I stuck to it. When the Democrats broke into two factions, one nominating Senator Douglas for President, and the other Senator Breckinridge, I knew—because I was a Republican—that they couldn't win. The fact that the Republican Convention had a split of its own, an offshoot called the Constitutional Unionists, didn't worry me at all. The election was (even though the phrase was at the time hardly common) in the bag for Lincoln. There could be no remote doubt of that—I was a Lincoln man.

I did experience a brief moment of misgiving when I

heard about the Chicago convention. Many people feared
that the Republican nominee might be ruined by the
crackpot element in his camp. The convention hall had
swarmed with assorted fanatics: temperance zealots, who
insisted upon a dry plank in the platform; prison reform-
ers, who saw a connection between their movement and
slavery; spiritualists, who carried a direct mandate from
the ghost of John Brown; representatives of the new So-
ciety for the Prevention of Cruelty to Animals; survivors
of the Know-Nothing Party, demanding a declaration
against the Pope of Rome and all other foreigners;
phrenologists, mesmerists, snake-oil doctors, Y.M.C.A.
secretaries, Bloomer girls, and Workers for the Ameliora-
tion of the Condition of the Insane. On top of all this,
the convention had to deal soothingly with Susan B. An-
thony and Mrs. Elizabeth Cady Stanton, who were in
Chicago militantly crusading, as always, for Women's
Rights—("You talk about taxation without representation.
What about us? You're going to free the slaves, and then
the lowly black man will have a vote. What about us?")—
to say nothing of the usual complement of politicians, each
of whom wanted something for his particular state, county,
or township.

But my discouragement quickly evaporated in the ex-
citement of the campaign, which was by far the most
intensely waged political battle that has been fought
within my lifetime. Everybody seemed to take part—I
wonder now how there could ever have been enough
people left over to listen to all the speeches or to watch
all the parades and torchlight processions. Of course, I
can speak only for Troy; but such enthusiastic partisanship
could not have been merely local.

Elsewhere men must have fought fiercely for Breckin-
ridge or Douglas. In places like New York and Baltimore
sentiment may have been evenly divided between one or

the other and Lincoln. But Troy, as nearly as I could tell, was heavily for the Railsplitter.

I remember the night before election eighty years ago as well as I know my name. There was a tremendous procession, led by a band playing "Yankee Doodle," "John Brown's Body," "The Star Spangled Banner," and many nameless marches of the day. Immediately following the musicians marched a large company of men dressed in black capes and shiny black caps; these were the "Black Republicans," part of an informal organization that had spread all over the North after the opposition had sneer-

ingly coined the epithet to describe their foes. The parade grew as it proceeded through town, and by the time it had climbed University Hill, site of Rensselaer Polytechnic Institute, there must have been three or four thousand men and boys in line. Almost every marcher carried a torchlight and a bundle of Roman candles, while flags and banners fluttered all along the line.

When we reached the campus, on the crest of the hill, the Roman candles were set off, and the city below was lighted in a blaze of glory that I have never seen equaled. When I started home some time after midnight the torches

were still flaming beneath the trees, and from a little distance the whole scene had that artificial quality which bright lights always create when thrown against shrubbery at night. But it was all very real then and still is today.

Election Day was then, as now, a general holiday. But Schoonmaker's portrait studio was open as usual—a lot of people would be in from the country, and it was sure to be a good day for business. I was still four years away from my first vote, and since I had a lot of work to do I never saw any of the polling places in action. Late that night, however, when telegraphic returns began coming in, I was downtown in the thick of the excitement. A man with a megaphone reported the bulletins as they arrived. With each announcement of votes for Lincoln the crowd yelled and stamped in wild approval. With every tally for Breckinridge or Douglas, or, occasionally, for Bell, the Unionist, groans went up. Or so it seemed to me. Surely there were many people out in the street who had voted against Lincoln—but I was a Lincoln man, and I could hear no applause for the opposition.

When two o'clock came it seemed likely that Abraham Lincoln of Illinois and Hannibal Hamlin of Maine were elected. I went home exhausted, but happy in the belief that my candidates had won. Next morning when I woke up I had a severe sinking spell. What if Lincoln hadn't made it? Life under the tyranny of a slaveholder, or any other Democrat, would be unendurable. I could eat no breakfast, but must hurry down to the newspaper office to learn the truth. There I found, to my intense relief, that Lincoln was safely in.

In December President Buchanan, that unhappy man who still strove wretchedly to maintain peace until his term of office should expire on the fourth of March following, issued his message on secession. The South, stated the President, had no legal right to withdraw from the Union; but, on the other hand, the Federal Government

possessed no power to prevent secession. While the nation pondered this confusing doctrine South Carolina seceded.

This crisis hardly attracted my attention. Something much more important was happening to me: I was beginning a new job in a new town.

One day a month or so after election Frank Mowrey, a photographer of Rutland, Vermont, called at the studio to visit his friend Mr. Schoonmaker. After an exchange of amenities Mowrey stated the reason for his visit. He was looking for a capable "artist" and hoped that Schoonmaker, since he lived in a much larger town and knew everybody, could recommend a likely candidate. Mr. Schoonmaker said he had a young man who did quite a lot of brush-and-pencil work for him and offered to arrange a meeting. The upshot of it was that Mowrey engaged me, at $6 a week, to go to work for him. I raced home with the exciting news, and a short while later I moved to Rutland.

I was still not a photographer. But while busy with my retouching I learned more and more about the camera and the art of processing plates and making prints. I also began to pick up a store of knowledge concerning the economics of photography, and with it some very practical hints on pleasing the customers. "Whole-plate" portraits (those made with the standard camera using plates six and one-half by eight and one-half inches) normally ran from $2.50 to $5, depending upon the finish, style of mounting, etc. With my assistance, for a small extra sum, those whole-plates could now be had in full color. Many persons ordered them. When occasional customers demanded more exotic backgrounds than the portable columns and tasseled draperies of the studio, we had the means for transporting them to Niagara Falls, the pyramids of Egypt, or the ruins of Athens. I furnished the transportation.

But such specialties would never have supported the

studio. For every whole-plate photograph, tinted or un-tinted, with or without the pyramids or the Parthenon, we sold a dozen quarter and half sizes. Ambrotypes (images on glass, rendered positive by a black backing) and tin-types (pictures made on black japanned sheet iron) brought in a substantial revenue. But most important of all were the immensely popular *cartes-de-visite.*

According to Robert Taft, author of *Photography and the American Scene,* the best history of the art I have read, the *carte-de-visite* was introduced in 1857 by the Duke of Parma, when he caused his portrait to be printed on his visiting cards. I am sure that Mr. Taft is correct; but in my part of the world I never knew those pictures to be so used. They were simply small photographs mounted on thin, round-cornered cards measuring about two and one-half by four inches. They were the sort of picture you had made by the dozen—because they were so inexpensive—to be given to your friends. You also mailed them to people; they were the only pictures small enough to be contained in a letter, and anything larger had to be sent by express.

It would be natural to assume that our big rush of business came on Saturdays. But such was not the case. The general half-holiday to which all of us are now ac-customed was unknown in my youth. Stores stayed open until ten o'clock (or eleven, or twelve); office workers, who normally shut their books at five-thirty or six, were lucky to get out no more than an hour later than usual. So Saturday afternoon and evening, instead of being a time for amusement and light occupation, found nearly everybody except the photographers working a little harder and a little longer. But what the Mowrey studio lost one day it gained the next—we caught them on Sun-day after church. It was all a touch *sub rosa;* but every-body knew where Mr. Mowrey could be found after the

recessional. And what could have been more convenient than a photographer who was ready to uncap his lens while you were still arrayed in your silk-lapeled frock coat and best stove-pipe hat? The ladies liked it too: at the close of the morning service their finest ruffles were still freshly starched, their side-curls still precisely set, and their back hair still smoothly netted. And so everybody was satisfied—except, possibly, the local ministers. But that is something I would hardly have known about, for I was never an active churchgoer.

Such time as I had away from my work I preferred to spend sketching and painting. Yet I was no hermit. I liked to be with boys and girls of my own age, and not very long after my arrival in Rutland I began to find myself welcomed into the homes of the town. I lived on Center Street with a family named Fisher, an elderly couple with a middle-aged daughter who taught school. Miss Fisher saw to it that I met young people, and my life, even on a tiny salary, was thoroughly happy.

During all of my first year in Rutland I worked for six dollars a week, and it was enough to live on decently. The Fishers' total income could not have been large, and these kind people were pleased to have a sober, steady boarder who paid them $3.50 a week. That sum covered everything—room, food, and laundry—and if my manner of living was not lavish, it was always exactly as good as the Fishers themselves enjoyed. I had no expensive tastes (if only for the reason that I could not afford to acquire any). Before the War the finest coat in Rutland—made to measure, of course—could be purchased for $25. Hand-made boots of best quality calf cost no more than $10, while ordinary cow-hide working footgear was available at two or three dollars a pair. (I sometimes wish that those close-fitting, comfortable high boots were worn today; but then I remember the hooks and jacks that had to go with them and forget the whole thing.) Good shirts cost

seventy-five cents, or were made for you, along with your underwear, by your mother.

Smoking cost me nothing, because I didn't like it. Liquor, except on rare occasions, was another extravagance that left my purse intact. Plays were rare. The most costly dissipation was hiring a livery-stable rig and taking your girl for a Sunday drive and supper at some roadhouse. And I was spared the drain of such Babylonish luxury for the simple reason that I had no girl—yet. My pleasures, apart from painting, were found almost entirely in the homes of friends. Little suppers were the usual thing, or, under the sternest chaperonage, hay-rides with picnic lunches. The usual hour for breaking up a party (unless it was a Thanksgiving dance) was a quarter of ten. All the girls had to be in by ten, and if the nine-forty-five departures were not made on the dot, the father of our hostess of the evening would be likely to come in and wind the clock. No one could stand around chattering after that.

The problems of my own development overshadowed everything else during the turbulent days of '61; but I would have been an uncommonly stupid boy had I succeeded in missing entirely the great tragedy then unfolding. It was one of those times that may come once or twice in a man's life—when events are so positive that every living soul knows he is involved in the universal drama.

Rutland was far removed from the center of the stage. But up in the hills of Vermont we missed no implication when Senator Jefferson Davis of Mississippi solemnly resigned his office late in January. And when, on March 4, Lincoln became President the part of his inaugural address we noted was not "We are not enemies but friends." What struck us was the sentence "No state upon its own mere motion can lawfully get out of the Union."

Yet we were not prepared for a war—nor able to recognize one after it started. When, upon that Sunday in mid-April, we learned that Major Anderson had saluted his flag and, drums beating, marched his battle-singed, hungry troops out of Fort Sumter our first feeling was one of indignation. Noisy anger followed. The rascals would have to be punished, well punished. A couple of weeks and a brigade or two would fix them. President Lincoln was calling for 75,000 men. Probably the mere call would be enough. But we wouldn't let them off with just a scare. Not this time.

And so on Monday everybody in Rutland went back to work as usual. If our fine army wasn't big enough, those 75,000 new soldiers could handle the situation in South Carolina—and any other places where the flag was not respected. But it still wasn't war to us. We had all grown used to thinking of the struggle between North and South as a clash of ideas instead of men.

By the end of April, after troops had been fired on by a mob in Baltimore, it was no longer a matter of sending a punitive expedition to Charleston. The Confederacy was more than a theory. It was an existing condition that must be wiped out. And so the cry became "On to Richmond!" But people—at least in upper rural New England—still saw no need to be upset.

The grim understanding that we were truly waging war did not strike until midsummer. Then the impact was tremendous. In the first direct engagement of troops General McDowell's forces were repulsed, then routed. That was Bull Run. Soon the cry changed to "Down with Lincoln!"

In the weeks that followed Bull Run I began to weigh the thought of enlistment. I exchanged numerous letters with my parents. They hoped I would wait—there were enough soldiers, and Mother and Father thought it would be a pity for me to give up a promising career unless the need should become more urgent. Mowrey offered me the

same advice. But perhaps I should have gone ahead and enlisted if another circumstance had not unexpectedly deterred me.

In October the famous Orson Squire Fowler arrived in Rutland to give "readings." Professor Fowler was the great phrenologist of the day, and for a week nobody thought of photographs, nor, indeed, of anything else. Everybody sat at the feet of Fowler, and I was one of his most devoted sitters. Here is a portion of what that great man wrote down after feeling the bumps on my eighteen-year-old skull:

You, Sir, have a noble head throughout . . . One side of your ancestors are nature's noblemen . . .

[You] are beginning to be a little impaired in your digestion and nervous system, as well as circulation, yet if you take the proper care, you can have the best health in the world . . . Should knock about outdoors, skate, slide down hill, tear around, anything for exercise, and remember, unless you do take care of your bodily powers, they will not be adequate to the development of your head. So that your splendid talents will wane.

Your largest organ is Benevolence. I beg that you would cultivate monetary grip, and learn the value of a dollar, even if you had to go to college to do it . . .

You ought to be pitched right in head-long into the river of business life, and told to sink or swim, as you choose, and made to do your own work, will hang on to father too long . . .

Your mother lacked expectation so that you were born with too little spirit of adventure, please cultivate it and also marry a hopeful light-hearted wife . . .

Your love of the beautiful and perfect is large, have really a fine imagination, are stylish and elevated in sentiment and conduct. You are noted for the classical throughout your character in manners, in sentiment, in expression, in everything . . .

You have great powers of thought, as well as original cast of mind. You both plan on a large scale, and argue ably. Your talents run towards the purely literary and philosophical rather than practical . . .

Your mechanical genius is far above mediocrity, and will enable you to draw, make, copy, anything you like, and give

you excellence as a painter, perhaps even sculpture, for you are really a genius, and no mistake.

My country's need may have been great. But the career, perhaps the life, of an unmistakable genius was at stake. I must make my decision, even though the choice pain me. I renounced war and rushed out to buy a pair of forty-pound Indian clubs (the heaviest on the market): when the time came for genius to burgeon I would be ready!

The War of the Secession droned on. In February, 1862, (when I was pretty well recovered from the lameness brought on through using those miserable clubs) came the cheering news that Fort Donelson had fallen. General Grant won his picturesque nickname of "Unconditional Surrender." He was the man of the hour. People even stopped damning Lincoln—for a few weeks.

Then in March we read the black intelligence of the sinking of the frigate *Congress* and the sloop-of-war *Cumberland* by the terrible *Merrimac,* the first of the ironclads. The prompt arrival and success of John Ericsson's *Monitor* in Hampton Roads only partly allayed the consternation of the previous day. This was *guerre à outrance.* When General McClellan was relieved as commander-in-chief it hardly increased public confidence in the armies of the Union.

Late in April sentiment improved again. Admiral Farragut had just occupied New Orleans. But a few weeks later this success brought forth a severe repercussion. General Butler, military governor of the district, not only hanged a civilian but issued his famous Order Number 28. The ladies of New Orleans had been studiously insulting Northern soldiers and officers, and to discourage their troublesome behavior Ben Butler decreed that thereafter any woman so apprehended should be "held liable to be treated as a woman of the town plying her avocation." The entire South instantly shrieked that Order Number 28 (which was

never intended or used as license to molest the ladies of New Orleans) perfectly expressed the character of all its enemies. Not only did Butler become the involuntary model for Southern art work on certain intimate forms of chamber crockery then in universal use, but the deep effect was to unify still further all the rebel states. (Even in Rutland, so far from any line of battle, we learned the importance of a sound morale. Although we had no army, we had a provost marshal, whose principal duty was to ferret out such subversive influences as might come to light in a remote country town. That officer found no spies and no plots; but he did find some dangerous music. Upon his recommendation such "depressing" songs as "Tenting To-night" and "When This Cruel War Is Over" were no longer sung.)

In June Robert E. Lee was assigned to command the Confederate forces near Richmond, and toward the end of the month the Army of the Potomac, under McClellan, advanced against the Southern capital. The fighting that followed—the bloody Seven Days' Battle—was another blow to the North: McClellan was driven back down the Peninsula to Harrison's Landing on the James River. On July 1, President Lincoln called for 300,000 additional troops to serve three years. If there had been any lingering doubt that the country was at war, or that I was needed to fight for it, all uncertainty was now dispelled. I began to wind up my affairs in Rutland.

Response to the President's call was so lagging that he issued another early in August. This time the term of service was designated as only nine months. But there were teeth: in such States as should not fill their quotas of men by August 15 a draft would be instituted.

There was in Rutland an organization known as the Light Guard; but up to this time, although part of the State Militia, it had been a social club rather than a strictly military body. Now, in response to the appeal for

more soldiers, its members voted to offer their services to the Government as a unit. On Monday, August 18, 1862, I presented myself to Captain Levi G. Kingsley and applied for membership in the Rutland Light Guard. An extract from my notebook, dated the same day, will show how I felt—or, at least, how I thought I felt—at the time:

I had previously made up my mind to enlist. God knows that the country needs men, and I regard it as the duty of every able bodied man, who can possibly do so to enlist at once, the sooner the better and it is better by far to enlist voluntarily than to be dragged into the army a conscript. Nothing to me would appear more degrading; but I am glad the draft has been decided upon. It was plain to see that if we did not bring men forward, and rapidly too, we should lose all we had won and more besides. An order for a draft will stimulate enlistment and it may be a draft can be avoided in some parts of the country though in other and less patriotic portions they will wait until they are forced to go—and then sullenly and unwillingly—a pest to their friends and a drawback upon the Government.

On Tuesday, August 19, I was elected a member of the Light Guard and signed the by-laws, "thus," as my notebook records it, "involving myself effectually." Two days later I went off to spend a week in Troy with my family. It was always a pretty leisurely sort of war.

WASHINGTON, 1862

We are coming, Father Abraham,
Three hundred thousand more,
From Mississippi's winding stream
And from New England's shore;
We leave our plows and workshops,
Our wives and children dear,
With hearts too full for utterance,
With but a silent tear;
We dare not look behind us,
But steadfastly before—
We are coming, Father Abraham,
Three hundred thousand more.

THERE was more—about "Richmond's bloody tide," "Treason's savage grasp," and "Our brothers' bones beside"—but so much as I have quoted was known and sung throughout the North. For a time it was even more popular than "The Battle Hymn of the Republic." As my regiment proceeded to Washington, and thereafter in various encampments, we marched to, or just sang, "John Brown's Body," "Tramp, Tramp, Tramp, the Boys Are Marching," "Rally Round the Flag, Boys," "Just Before the Battle, Mother" and "Johnny Comes Marching Home." We also sang (once we were out of Rutland) those two songs that the provost marshal had banned, "Tenting Tonight" and "When This Cruel War Is Over." But more than any other we marched to and heard other bands play "We Are Coming, Father Abraham."

Before going to meet Father Abraham in Washington, however, I first had to get myself into the United States

43

Army. The Rutland Light Guard was only a preliminary, and all of us had some six weeks of hard drilling before we were mustered into the service as Company K of the Twelfth Vermont Volunteers.

A leatherbound pocket notebook which I carried during my whole enlistment now serves as my most helpful guide in recalling those days. Its first entry was the one of August 18, which I have previously quoted on page 42. Since I like to read other men's diaries and journals, I have decided to indulge that amiable weakness in reverse. If nothing more, these jottings of my twentieth year may stand as a warning against the vice:

NOTEBOOK 1862

Thursday, 21 [*Aug.*] Left Rutland for Troy at 3. o'clock this afternoon and arrived at home at 8. Folks were rather surprised at my enlistment having heard nothing of it . . . I had previously written home on the subject and I was told to act on my own judgement but counseld delay—I might get some office—or not drafted at all. But I am determined to go, and go I shall.

Monday 25 Have been purchasing some little knick-knacks and conveniencies to take with me—1st a little rubber ink stand—price 37 cts. 2nd Portfolio 45 cts. 3d 5 quires paper—.75. 4th One stick of India Ink—.18.

Thursday 28 Arrived in Rutland at 11½ this P.M.

Monday, Sep 1 Commenced drilling this morning at 9 o'clock until 11 . . . We were instructed in the facings and some in marching

Wednesday Sep 3 The Co. was inspected to-day by Dr. Adams. Was found all right, and passed

Friday Sep 5th This evening just after supper I was surprised to see Ed [*my brother, then*

not quite eighteen] walk into the house, as he was entirely unexpected. Said he had come up to enlist. Had written him several days before about his chance in entering the ranks of the Sharp Shooters, as we thought he could not enter the L.G. with me the Co. being full, but he now being here, thought it could do no harm to step around to the Captain's office and see if there might not be a chance, which there was as we found out, in consequence of the dismissal of several from the ranks . . .

Saturday 6th went around to Dr. Adams' office and had him [*Ed*] examined—all right—Commenced drilling this morning—

Friday Sept 19th . . . Uncle Sam seems to be getting a little run out in the line of blankets—in an order from the Adj. Gen. office it is said that owing to the great demand the Government is unable at present to furnish volunteers with their blankets and recommends them to purchase some for themselves if they wish to render themselves comfortable while in camp.
Don't know what I shall do for one—haven't got any money, or friends that have got blankets, here—Have wrote home to see what they can do for us . . .
Have been doing some work for Moury during my enlistment—to day I have painted two pictures, a cabinet and a whole size—made some very good things of them.

Friday Sep 26th We are at last in camp [*in Brattleboro*], and as I am now writing the confusion of a hundred tongues and the noisy clamor of the hammers of the carpenters who are finishing up our quarters makes a very bedlam . . . Marched into our quarters and picked out our bunks—

pitched into some straw piled up out back and covered the boards with it. then laid our rubber blankets on it and our woollen ones to cover us, (we rec^d our blankets here contrary to expectation also a rubber blanket, so the one we bought ourself will have to be sent home) . . .

Saturday. 27.

Yesterday afternoon we rec^d our muskets, the capt. said before giving them out, that he had never before seen better rifled muskets. And they really were fine pieces, very smoothly and finely polished, and N° 1 guns in every respect.

After supper we were drawn up on dress parade and I must say that we made a fine appearance . . .

Sunday.

Reveille beat this morning at six, breakfast at 7. directly after breakfast we packed up our duds and proceeded to move our quarters further down the line, in accordance with orders. Last-night at dress parade, the Adj. gave the several companies position in line in accordance with the rank of Capt. We came Co K. as our Capt was the newest captain in the line—

On assembling on our company parade ground the Captain took us to do for our appearance, said their appearance was somewhat irregular—wished them always to have their eyes square to the front and remain immovable. We need the correction.

Monday Sep 29

This afternoon was set to work with five others from our company, on barracks work hard all the afternoon in

boarding up roofs and sides of the building. found it hard work: blistering my hands in the morning in using the shovel —were clearing up our parade ground in front of our quarters

Saturday Oct. 4 During the past few days we have received about everything in the way of equipment—Knapsacks, haversacks, cartridge and cap boxes, shirts and drawers —everything that a soldier needs. On Friday, the 3d, at 2 o'clock in the afternoon we were brought out on dress parade, and fully equipped—knapsack, canteen &c—this was the first time we had shouldered our knapsacks and when we first slung them on they were pronounced light—and very easy to carry—we were brought out and drilled for about an hour, and at the end of that time the knapsack was pronounced as decidedly heavy, and two or three left the ranks in consequence of the fatigue—It was very severe. Our muskets were carried constantly at shoulder, and that alone was enough to tire us pretty well—we were very glad indeed to sling them off once more.

This morning at 10 were again under our bindings with the addition of knife fork plate and cup in a haversack for inspection . . .

At 2 in the afternoon were mustered into the service of the U.S. by Major Austin of the regular army.

Monday 6 Were paid our bounty $100.00 and back States pay amounting to $10.70—Makes some of us feel pretty rich, to have so much in our pockets at once—Sent $40.00 to Mrs. Fisher—due for board. Sent $70.00 home.

Tuesday 7th Started today for Dixie. . . .

I was in the army now and, within seven weeks after my decision, on my way to the front. We were green troops, but we were fit. Most of us were country boys, ranging in age from seventeen to twenty-three or twenty-four, and the preliminary training in camp had made us as tough as our native pines. I had put nearly ten extra pounds onto my five-foot-nine frame and left Vermont weighing 160.

At half-past eleven on Tuesday, October 7, the Twelfth Regiment, Second Vermont Brigade, formed in parade and marched to the Brattleboro depot. Most of the townspeople were gathered along the route or congregated at the station to see us off. Flags were fluttering all along the way, bunting was draped on many buildings, the cheering was continuous, and altogether it was a great occasion.

I am sure that never before or since have so many passengers awaited a train in Brattleboro. I am also sure that the railway company has never been so ill prepared to handle the traffic—but, of course, there were several trainfuls of us. We waited all afternoon, lounging on the platform or stretched out in the surrounding fields, and it was not until eight o'clock, more than six hours after we had assembled beside the tracks, that Company K rattled south. Rattling was the least of our discomforts: we traveled in box cars.

About six the following morning we reached New Haven, Conn., where much of the day was passed—it was a substantial labor to detrain so many men, feed them, and march them to the docks for the next leg of our journey. We left sometime that afternoon on the steamer *Continental*.

At noon on Thursday we arrived at Perth Amboy. Very efficient preparations had been made for us there, and a great open-air dinner was served the instant we disembarked. A single trifling incident brings it back vividly: one of the boys complained that his portion of stew contained no meat, whereupon the cook serving us as we filed

by plunged his bare arm into the kettle, brought up a great hunk of beef and splashed it square into the disgruntled soldier's tin plate. At two o'clock we entrained for Philadelphia, once more riding in box cars.

That trip required five or six hours, and it was long after dark when we stepped out into the orderly city which I hadn't seen since I was ten years old. For the second time that day we experienced an efficient and enthusiastic hospitality. After a fine dinner we boarded some more box cars and set out for Baltimore.

Apparently soldiers were the least perishable commodity on the rails that night. For every mile we moved ahead we seemed to spend an hour on a siding. Enough milk, hogs, flour, and coal passed us that night to supply all the armies of the Republic for twenty years. Actually we were nearly eight hours on the way—and, remember, we had only the floor of our box car to sleep on.

Fortunately we had a good breakfast shortly after our arrival, for it took us as long to get out of Baltimore as it had to reach the city. At the time an ordinance prohibited the passage of trains under their own power, and our cars were pulled through the streets by teams of horses. It was after two o'clock before we started on our way once more. We reached Washington about 8 P.M.

Suddenly, now that I had set foot in the capital, the war that I had heard so much about became real. So far it had been a war of distant armies identified by the names of their generals. Now it was a war of soldiers—who ate and drank and smoked and swore and slept on floors, like me.

For the next three weeks we were encamped on East Capitol Hill, about one mile east of the Capitol—the unfinished and scaffolded dome of which commanded the landscape—and I took every opportunity to visit the Halls of Congress and to study (with immense respect) the rather primitive art then on display there. The same com-

ment holds true for the Smithsonian Institution; but it was a wonderful chance for a boy from the country to see something of the great world outside, and I reveled in the good fortunes that had come to me with the war.

On October 29, "we rec^d intelligence that we were to move off somewhere tomorrow," and at 8.30 next morning we struck tents, formed into line, and were soon under way.

All we in the ranks knew was that we were on our way. Marching under full equipment, we trudged down Pennsylvania Avenue, then across the Long Bridge (a brick causeway more than a mile in length) into Virginia. Some eight miles beyond Washington we pitched camp. It was a peaceful-seeming country. All was quiet. Yet we stood now on the soil of the Confederacy.

GUARDING THE POTOMAC

FROM November 2 until December 12 the Second Brigade was assigned to picket duty in the wooded country beyond the Potomac. Our headquarters lay a dozen miles or so from Washington.

The winter of '62-'63 came early, beginning with a four-inch snow on November 7, and all of us had full reason to be thankful for the trees among which our tents were pitched. They shielded us from the winds, supplied us with firewood, and provided us with building material. As soon as the commanding officers learned that a relatively long stay seemed assured, axes were handed out and we were instructed to build shelters.

These shelters consisted of mud-calked log walls, about three feet high, with tents as roofs. We built ourselves little stoves of brick (taken from near-by houses that the rules of war had condemned), and we lived a warm life and a dry one for the first time in many weeks.

With some measure of comfort and order in this new existence, I found it possible to get back to my sketching again; and no letter of mine went out that didn't contain at least one drawing. I did most of them on little cards, about 3 by 5 inches, and that practice has brought me a small fame—which is, I regret to say, quite undeserved. Somehow or other the legend has grown up that I am the "inventor" of the picture postal card. I don't know who really devised the first picture postal (a German or an Austrian, I think), but I am not the man.

Among the boys I was in pretty constant demand as a "portrait artist." While we were in the capital the tintype photographers had done a whacking good business with the members of the Twelfth; but down here in the woods there were no cameras. (I never saw the great Mathew Brady, or any of his assistants, while I was in the army.) Many of my companions-in-arms were lads whose beards were just beginning to be visible across a campfire, and they wanted to be sure that the straw-colored stubble on their chins would be recorded for their families. Possibly I found a vicarious pleasure in depicting their facial foliage, for I was at the time unable to sprout so much as a set of burnsides (General Ambrose Burnside was already beginning to achieve immortality by becoming a common noun).

Life in camp was busy and serious—we were one of the outposts, the first line of defense—but there was time enough for a varied individual life too. I explored the country round about, often in company with my brother Ed and Abe Burnett, or with one or another of my tent-mates, Charley Ripley, Ned Birdsall, and Lewis Hemenway. Ruel Rounds, with whom I was to make my first trip west in 1866, and John Mead, who later became Governor of Vermont, were other close companions. None of us had much money (our army pay was $13 a month), nor was there any place where we could have spent much. Now and then the camp sutler would manage to get a few kegs of beer, and then we might buy a round or two. During bad weather, and especially after a tour of guard, there would be a regular issue of rum, one gill to a man. That was the extent of our alcoholic sprees. Once in a while, usually on rainy days, we played cards: poker and seven-up are the only ones I recall by name. The stakes were tiny, if any—we were country boys, unaccustomed to gambling with anybody, and least of all with our friends.

Just two days after arriving in camp, I had an experience that might well have had grave consequences for myself: "On Guard, stationed to guard the property of a man, said to be a secesh. I came very near being caught asleep on my beat by the Grand Rounds [*sergeant of the guard, and squad*] as it was, were very near asleep—dozing pretty soundly and had to challenge at short distance ..."

When I was not on sentry detail, there was company drill, two to four hours every day. Or we might be given a "hardening" march of a dozen miles, under full equipment. Or we would be ordered out with picks and shovels to work on our fort, a pentagonal earth-and-timber redoubt commanding a knoll. There were no soft men in the part of the Army of the Potomac to which I belonged.

But although I had plenty to do every day, there was seldom a stretch of more than twenty-four hours without a period of freedom. Along with roaming and sketching the countryside, there were two more occupations to fill my days completely. I liked to sleep. And I liked to eat.

It was a great luxury to crawl into some hay-mow and instantly drop off for an hour or more. Another satisfactory experience was to find a persimmon tree and clean it of its tangy frost-bitten fruit. And it was rewarding as well as mildly exciting to go foraging. After one of our successful expeditions, I recorded these Lucullan details: "...we

brought in corn, turnips, and sweet potatoes, and with our tea, pork and crackers made out a first rate meal."

The weather, after that first, early snowfall, continued to be severe. On December 6 I made the following entry in my notebook: "Some what windy at night—froze hard. Seven soldiers in the Convalescent camp died this night— ice froze inch and a half thick."

On December 11 news came through that we would break camp before dawn the following day. At the moment we were, of course, not told where we should be heading the next morning. As it happened, the coming five weeks or so would find us stationed just outside Fairfax Court House, living under the same general conditions that had shaped our lives in the place we were now ordered to evacuate. So far it had been a quiet war for the Second Vermont Brigade; but soon we were to have our first brush with the enemy.

Next afternoon, "after a long and weary march," we came to Fairfax Court House. Continuing about a mile beyond town, we encamped in a piece of pine woods. And on the next morning began the old routine of stockading our tents.

I was not very favorably disposed toward the new place. But perhaps the rigors of the march had something to do with my notebook comment dated December 12: "The country through which we traveled is the most desolate God forsaken place I've seen yet. There were but very few houses all old rotten buildings and all that were not half torn down or burnt up, were used as hospitals. Fairfax Court House is a dirty nasty hole, the houses are all old dilapitated rickety and dirty concerns . . ."

Nothing of note happened during our first two weeks. Christmas came, with nothing to mark it save suspension of company drill. As it was, half the company worked

somewhat harder than usual—some fifty of the boys were ordered to near-by Chantilly Battlefield to help rebury the hurriedly interred soldiers who had fallen there nearly three months earlier.

Then on Sunday, December 28, after dress parade, we received orders to be in readiness to march at a moment's notice. Our first scrap was at hand:

NOTEBOOK 1862

December 28 . . . Catridge boxes were inspected and filled with 40 rounds. About six we fell in and marched by the flank out through the C.H. towards Washington. about half a mile beyond we filed to the right and occupied a line of breast works facing W——. Companies G and B were sent forward as skirmishers. A battery of four brass canon commanded the road, two of them protected by earthworks, and the other two in the road . . . Stood on the line until about 9 when the Gen. [*Brig. Gen. Edwin H. Stoughton, a Vermonter*] ordered pieces to be loaded and the two exposed companies to lie flat on the ground, the Gen. gave us particular instructions as how to fire and repel cavalry —Soon after while watching the road, we heard galloping, a hurrah! two or three shots then a volley—silence following. It was about a hundred rods from us and the flash of the guns of the skirmishers was plainly seen. We lay in breathless silence expecting the very next moment to see the enemy come dashing over the hill, we were ready for them, our pieces all aimed at the spot they would appear. The moments passed away and nothing more heard. The Gen. rode up and said the skirmishers had repelled the charge of two companies of cavalry, and used them up badly. After that, although we expected them to appear at

any moment, nothing more was seen of them. Towards eleven a large fire was observed ahead. Soon after the Gen. ordered the battery to fire in that direction and try to see what was up. Four shells were sent screaming over the hills at intervals of four or five minutes, but no response was elicited —but the fire disappeared instantly. The night was cold intensely and hard work it was to keep warm. All laying together in a pile, stamping, and walking around.

About one or two, fell into line and marched through the village on a double quick and formed a line of battle just out of it, our Co. flanking the road, and the rest of the regt stretching off to the right. A cavalry charge was expected and were all ready for them. The position was admirably chosen for defense and we could have held our own against any odds. Remained in line until daylight when we were marched back

Monday the 29th to quarters, arriving just at sunrise without further adventure . . .

Between my enlistment and the end of 1862 the South had continued to win individual successes in the field. Late in summer, just a little more than a year after the Union disaster at Bull Run, the Rebels had won another battle at the same place. That was quickly followed by Stonewall Jackson's capture of Harpers Ferry, an important strategic point. In October Jeb Stuart had crossed the Potomac and driven as far north as Chambersburg, Pennsylvania. And in December the Confederates had gained another positive decision at Fredericksburg in what was perhaps the bloodiest engagement of the entire four years; Burnside was thrown back beyond the Rappahannock, and the blow to the North was most severe.

Meanwhile the Federal Government had been weakened internally by heavy mid-term losses at the polls to

Democratic candidates for Congress: the electorate was clearly dissatisfied with the conduct of the war to date. The Federal Treasury was empty, and the bankers had cotton in their ears. It was a black outlook.

Yet there was one thing that was to nullify all the gains so far scored by the Confederacy. Back in September McClellan had repulsed Lee at Antietam. It wasn't much of a victory, as measured by losses inflicted; it wasn't even a complete victory, for Lee was allowed to retire unpursued. But it was a wound from which the South would never quite be able to recover. Antietam gave Lincoln the victory he needed to announce his most profound war measure—that in all states still in rebellion on Jan. 1, 1863, the slaves would be declared free. Antietam also proved that the North had a backbone, and thus served to block British recognition of the Confederate States of America as one of the nations of the world.

When, on New Year's Day, the promised Emancipation Proclamation issued from the White House, England and all the wavering countries of Europe knew that the war would go on to a finish. Emancipation guaranteed that the Union would never yield. It further guaranteed a war of attrition until the document should become a reality. In addition, there was the moral issue; foreign sentiment was strongly against slavery.

But we in camp at Fairfax Court House had no knowledge of such weighty matters. We were young men obeying orders. My notebook entry for Jan. 1, 1863, consists of two words—"Company drill."

For nearly three weeks more that entry might have been made every day as the chief event. There were no attacks anywhere near the tents of Company K, not even the rumble of a distant gun.

I picked this quiet period—rather considerately, it seems to me now—to have an attack of grippe. "Went over to the surgeon's," I noted on Sunday, January 11, "and got a

bottle of medicine—Don't seem to do much good—took a dose of Cayenne pepper and molasses—Attended Services—" But not even spiritual medicine could help me, and I went through a whole week of sore throat, headache, and shivers before I felt fit again. It is all so clear in mind, perhaps, because I have never since that January of my twentieth year had a real illness.

On Monday, January 19, orders were issued to break camp, and at 7 A.M. on the twentieth the regiment struck tents, slung knapsacks, and set off southward through Fairfax Station to Wolf Run Shoals. There we settled in as comfortably as we could—by now we were old soldiers and used to the routine of changing camp—and during the next few days we were busy cutting logs and building stockades. On the twenty-ninth I was paid off, only three months late, up to the first of November. I got $31.60, and used part of it the next day on a boot-buying excursion to Alexandria.

At this time we were engaged in no particular military activities, and I found myself with a good deal of leisure—which I used, of course, in the way that I had been accustomed since the age of ten and earlier. I sketched. As I have said, I was already in some demand for portraits. But now I began to do more and more landscapes. I drew many pictures of our fortifications, and a fairly comprehensive sketch of the Shoals. Several of the officers had already shown an interest in my work, and there had been rumors that I might get a chance to do some military drawings.

The chance came on February 20, in the form of a summons from Colonel Blunt. When I reported to him, I was ordered simply "to sketch or draw." The assignment gave me almost *carte blanche*. The colonel wanted, as much as anything, a record of camp life; consequently I was free to draw anything I pleased, as I pleased. It is hardly neces-

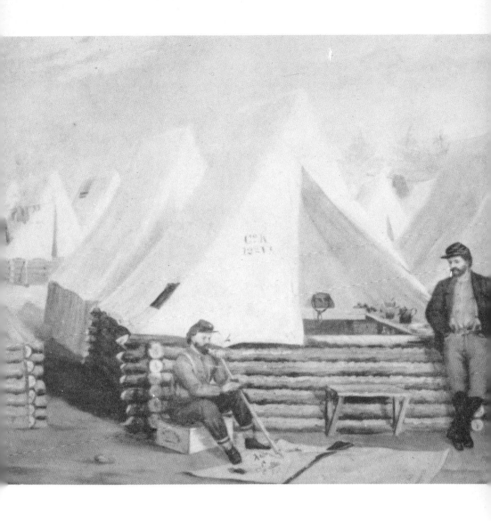

Two of my tentmates, Charley Huntoon and Ned Birdsall, as I painted them in camp along the Potomac in the spring of 1863. This canvas, about 12 x 15 inches, is now in the possession of Mr. W. C. Landon, of Rutland, Vermont, the son of Captain Landon of Company K.

Killington Peak, near Rutland, Vermont, a favorite picnic ground for swains and their sweethearts. I made this sketch at the summit shortly after returning from the War.

sary to add that I applied myself diligently. But I did more than make pictures of the camp and its occupants. I mapped the surrounding countryside, and the finished work was of substantial aid to the commanding officers in planning breastworks and trenches. Few things are so helpful, either strategically or tactically, as a dependable ground-plan, and I am able to say that the drawings I prepared met the test.

During my period as "staff artist" I was relieved of ordinary fatigue duty. I roamed at will—and I am afraid there was a little swagger in my movements. Nominally my quarters were still with my company, but I took nearly all of my meals at the orderlies' mess and spent many nights in a tent close to the Colonel's headquarters.

On the evening of February 26 the Colonel sent for me and looked over the pictures I had made. He was pleased with them, and he told me to go to Washington the next day and buy more supplies of paper. I set off at half past three in the afternoon and had two hours of sloshing through deep mud to the railway station, where I was invited by my old friend Burnett to take supper at his mess. The cook made a great fuss about feeding outsiders, and three of us went off to the sutler's, where we supped independently, if indigestibly, on sweet cakes and cheese.

Next morning I took the cars to Alexandria, and from there a ferry across to Washington. I wandered around for some time, hoping to run into an acquaintance, but I didn't see anyone I knew. When my shopping was done I crossed back over the Potomac to Alexandria and put up at the Marshall House.

As a hotel, it was no great shakes. But the Marshall House had quite an appeal for me, because it was almost a national shrine. Here, on May 24, 1861, Colonel Elmer Ephraim Ellsworth, organizer of the renowned New York Zouaves, had lost his life and become the North's first martyr with any real publicity value. Ellsworth, a New York

Stater, had gone to Chicago as a very young man and there studied law. In 1860 he went to work in Lincoln's Springfield office; the young lawyer had a genuine flair for getting attention, and he proved most helpful in the Presidential campaign. Ellsworth's eye for color and action had previously been tested, when, to gratify a thwarted military ambition, he had formed the spectacular "U. S. Zouave Cadets," a group of youths whom he uniformed and drilled in imitation of Algerian troops under the French flag. The gaiters, baggy trousers, and fezzes of these cadets, along with their rapid maneuvers, brought them engagements to drill in a number of large cities. When the war broke out Ellsworth was in New York City, and at once he offered his services to President Lincoln. Then he recruited the regiment known as the New York Zouaves, which was closely modeled on his cadet corps. (Again Colonel Ellsworth demonstrated his sensitive knowledge of public response: his recruits came from the ranks of New York's volunteer firemen, and if there was ever a uniform to persuade a volunteer fireman to give up his helmet and red shirt, it was the Zouave rig.) The Zouaves were one of the first "three-year regiments" to take the field, and their earliest active service came during the occupation of Alexandria, hardly six weeks after the war began. While leading his troops through that town Colonel Ellsworth saw a Confederate flag flying outrageously from a staff on top of the Marshall House. He halted his forces and, in person, tore down the Rebel standard—for which self-imposed duty he was promptly shot dead by the proprietor of the hotel. Ellsworth's body lay in state in the White House, and the public mourning provided a very useful emotional stimulus throughout the North. The dead leader was handsome, romantic, and only twenty-four.

For the best part of a month I was so busy with my happy task of sketching that my notebook was almost ig-

nored. Apart from listing my subject matter, I hardly troubled to make an entry. And at this precise time, when I was scribbling "not very busy," or making trite observations about the weather, the most exciting single event of my whole army career took place—the kidnaping of General Stoughton. I never put down a single word about it; but the whole affair was so vivid that a written reminder seemed unnecessary.

Stoughton, a native Vermonter, was our brigadier; and, West Pointer though he was, one of the many untried soldiers whose civil influence, rather than skill or experience, had gained them high commissions. While Colonel Blunt lived in camp and worked harder than any of his men, his superior galloped about on his fine horse, occupied a handsome house, and lived the life of Riley. Stoughton gave splendid dinner and supper parties at his quarters in Fairfax Court House, and an invitation to be his guest was considered a great distinction. One night in the middle of March, a little while after the General had bidden his guests good night, a dozen cavalrymen in gray entered his bedroom. General Stoughton was led out and forced to accompany the raiders. It all happened in the flash of an eye—and the daring Confederate raider, Colonel John Mosby, had delivered another telling blow.

Stoughton was exchanged some time later; but his military days were over. He was, in the polite phrase which is still, I believe, affected by the military, "relieved of his command."

March ran on, and as spring appeared I was satisfactorily occupied with map-making. Early in April my zeal led me into one of the few dangerous situations I encountered during my service. I was eager to finish a map of the Bull Run, and the left bank was so marshy that I couldn't follow its exact line on foot. Then I found a raft

(half a dozen logs roped together), which was just what I needed to help me plot the course of the sluggish stream.

I had drifted slowly for a mile or more, noting the curves and marking the clumps of willow and oak along the banks, when, out of sight, I heard the cock of muskets and a sharp "Who goes there?" I stammered "Friend" and hastily poled my clumsy craft in from the middle of the forty-foot run. Three or four Union pickets were waiting for me when I scrambled up the bank, and they took me to their squad sergeant. Satisfied with my pass, he nevertheless called me down for my careless behavior in openly riding down a stream that had already been the scene of two fierce battles.

Otherwise, April was an uneventful month. On the fourth I celebrated my twentieth birthday. On the fifth we had a twelve-inch snowfall. On the ninth there was a nocturnal commotion, when some cavalrymen—Union, I regret to say—roused a near-by female resident to cries and imprecations by assaulting her hen roost. On the twenty-second General Stannard quietly succeeded the "deposed" Stoughton. And on the following day at least half the camp seemed to be out greeting the balmy weather by playing baseball.

We moved camp again on May 2, going to Catlett's Station. I remember this particular move poignantly; for during the confusion of packing I lost my sketchbook and never recovered it.

We had scarcely settled into our new quarters when a cavalry attack surprised us. Mosby's "Partisan Rangers" were raiding again. The yelling and firing could be plainly heard—but, as usual, I did not get into the fight. There was continuing activity all around us during this time. We must have been on the fringe of a major engagement.

A few days later a man named Barrett died. I knew him only slightly; but I mention his passing for the reason that we took up a collection to embalm his body and ship it

home for burial. That was very unusual. Most soldiers were buried where they fell.

At about this time an unfortunate gentleman named Quisenberry began to feel the horrors of war. He had a red-brick house and a prosperous farm, and we raided him on May 13 (proceeds, two bags of bacon and a pig); May 15 (a calf); May 26 (another calf). On the twenty-sixth we had veal for breakfast, and Mr. Quisenberry and his daughter moved out of their house. I don't blame them.

A day later several companies of us were transferred to Union Mills, and three days after that there was some real excitement. A small troop of Confederates attacked and burned a train between our new encampment and Catlett's Station. "The 22 [*train*] guards skadadded into the woods," I entered on May 30. "Cavalry pursued them. [*The enemy*] posted their cannon in a narrow defile in the road and twice repulsed the 5th N.Y. Co. H of the Vt Cavalry charged and took the piece. We lost in all four killed..."

The early part of June was a period of utter repose—no raids, no fires, and very little work to do. In addition to sketching for my own pleasure, I had time to swim in the heat of the day and to go calling in the cool of early evening. Yes, there were a number of vivacious young ladies living in the vicinity of Union Mills.

On June 7 a letter from home informed me that my family "was presented with a new male member." At the towering age of twenty, I had a baby brother! He was named Allen.

This time of quiet along the Potomac was not long to endure:

NOTEBOOK 1863

Tuesday 9th [*June*] ... Rumors of big cavalry fight at Culpeper Court House ...

Wednesday 10th ...Firing heard off in the direction of Rappahannock Station. Large detail at work felling trees into the Bull Run

Sunday 14th ...Advance guard of 11th corps came in...

Monday 15th ...Early in the morning the 11th corps came in and pitched tents and about noon the 1st corps...we came across detachments of the 2d 6th and 12th corps All morning this way. The whole army seems to be in motion...

Tuesday 16th The army still moves on. Hear rumors of the rebs being in Penn. at Chambersburgh, nearly took Milroy [*Union commander*] at Winchester—this evening the 6th corps baggage train is bivouacked here. Woods all afire on the opposite side of the Bull Run...

Wednesday 17th The army baggage still continues to pass through this place, bound northward ...Canonading heard in the distance...

The War was approaching its crisis. Quite possibly the President and a few of his leaders knew it. Very probably a number of other men—here and there a general, a senator, a banker, an editor—suspected it. But the people had no intimation: by mid-June of 1863 the rank-and-file of the North had resigned themselves to an endless conflict, a grinding struggle that promised neither military nor diplomatic decision. And certainly the soldiers had no inkling of what lay so short a distance before.

Yet those of us with the Army of the Potomac knew that something tremendous was stirring—we were in one of the places where we could see the stir. All the movements of troops during these warm June days and nights, all this centering of brigades, divisions, and corps, must signify something. That something was to be Gettysburg.

GETTYSBURG, AND AFTER

L IKE so many other momentous happenings, in peace as well as in war, the Battle of Gettysburg was an accident. The positions of the main armies of the North and the South made a great battle inevitable; but that meeting came when and where it did because a little town in southern Pennsylvania was the center of a network of roads.

The South believed that a smashing victory on Union soil would win the war. Southern leaders were also convinced that the North had lost its enthusiasm and was ready, almost eager, to fold up—an attitude that Horace Greeley and his *Tribune* did everything to confirm. And so General Lee was again invading. This time his forces had penetrated almost as far as Harrisburg: one corps was above Carlisle; two more were in the vicinity of Chambersburg; Stuart's cavalry was roaming and raiding somewhere west of Washington. The natural point for consolidating the eighty thousand troops was Gettysburg.

Meanwhile the Army of the Potomac was working up across Maryland from Virginia. It was my fortune to be one of those 115,000 footsore, dirt-encrusted soldiers who were converging upon this same innocent town.

On June 30, General George G. Meade, the "damned old goggle-eyed snapping-turtle" who had relieved General Hooker only two days before, sent his cavalry ahead to cover the army's occupation. At the same time General Heth, in command of one of Lee's corps, was recon-

noitering. The whole Southern army was in desperate need
of footgear, and Heth had learned that he might find a
supply in Gettysburg.

Thus the two armies met, Lee's, strangely, from the
north, Meade's from the south. The real battle began on
July 1, with Heth's attack on General Buford's position
along Seminary Ridge. That afternoon Lee arrived with
his main army and late that night Meade came up with his.
The second day saw the heaviest continuous fighting and
the third day, so far as results are concerned, the end of
the battle. Shortly after one o'clock in the afternoon of
Friday, July 3, the gallant fifteen thousand under Petti-
grew and Pickett crossed the mile of open ground that lay
before Cemetery Ridge—and only a handful came back.
Every schoolboy knows that the momentary planting of
Virginia's blue flag beyond the stone wall was the "high-
water mark of the Confederacy."

General Abner Doubleday, one of Meade's corps com-
manders (but far better known today as the "Father of
Baseball"), has written a complete history of this decisive
engagement, and I can recommend it as the full account.
The general gives liberal credit to the Second Vermont
Brigade, known at Gettysburg as the "paper-collar bri-
gade" because some of the boys at times were seen wear-
ing those unwarlike neckpieces beneath their uniform
coats. He even mentions that section of the Second which
was assigned to the baggage trains behind the lines. I was
one of those guards; and, since General Doubleday was
more usefully occupied at the front, I venture to supple-
ment his history with an account of *my* Battle of Gettys-
burg:

NOTEBOOK 1863

Tuesday 30th [*June*] Reveille at 4.30 marched at 6, start-
ing in the rain. Passed through Adams-
ville, Lewistown, Kitoctin [*Catoctin*]
Furnace. First rate traveling, all day on

a McAdamized Pike—Feet very sore indeed. Encamped at Emmittsburgh 20 miles from Fredrick City—

Wednesday July 1st Left in a rain storm about 11 A.M. Passed over Mason & Dixon's under a drenching rain storm and more than ankle deep in water When within three or four miles of Gettysburgh the baggage halted and we filed into the woods & loaded our pieces. The 15th went on towards the field and we acted as guard to the baggage, going back some 3 or 4 miles in the dark. Early next morning the baggage went.

Thursday 2d Started at six– our Co. acted as advance guard. The train went so fast [*Stuart's raiders were thought to be near by*] that it gave us a very hard march indeed. Just out of Taneytown we filed one side and let the baggage go ahead and near night rejoined the regt. Got into Camp about 11 P.M. pretty well tired out.

Friday 3d Lay still most all day. Rip & I went down town in the afternoon and looked around—

Saturday 4th Cleaned up guns; hard rain and thunder storm, wetting everything. The whole regt detailed to guard 2300 prisoners to Baltimore . . .

Res ipsa loquitur

Next day just after noon we left by train for Baltimore and before dark had delivered our 2,300 prisoners to Fort McHenry as ordered. The Twelfth Regiment pitched its tents on the outskirts of the city and most of us had leave for some thirty-six hours. The high spots for me were a performance at the Holliday Street Theater—"the Webb

Sisters as Stars, playing very indifferent"—and a real bed, my first in many weeks, at the Calvert House.

On July 7 the regiment started north. Our enlistment time was up, and we were being returned to Brattleboro, where we had mustered in. We rode from Baltimore to the Jersey shore on box cars, as before; they were so crowded that some of us had to ride on top—but it was a pleasure to be outside. All of us had a gay time along the way. The good news of Gettysburg, along with Grant's capture of Vicksburg, brought enthusiastic crowds to the stations to look at part of the army that had at last won a real victory. I considered with some amusement the fact that many of us had spent the best part of a year at the front without once firing our guns at the enemy.

We reached Amboy about 2 A.M. on July 8 and at once took a boat for New York. Arriving at the Battery between five and six, we spread out our blankets as unceremoniously as if we had still been in the woods of Virginia and slept through the morning; neither the sun nor a gaping public could interrupt the rest of weary soldiers. The steamer *Traveller* took us to New Haven that afternoon, and we entrained there for Brattleboro sometime before midnight.

Our arrival was singularly quiet. Perhaps we came in too early in the morning, or perhaps the townspeople felt they had done their full duty by the Twelfth when we left there the previous October. As we marched from the depot to our old barracks, some of the boys expressed themselves rather pointedly on the lack of an organized reception. So far as I was concerned, it made no difference. I had spent nearly a year in the service, and the applause of crowds, or its lack, could add nothing to the value of that experience. Besides, I was too busy with plans for the future to pay much attention to what people might think of something that was past.

Two days later there was a review by the Governor of

Vermont, and then I went off for a quick visit to Rutland. I called on Frank Mowrey and found that my old job was waiting for me. Then I hurried back to Brattleboro to get my discharge and such money as was due me.

Just before mustering us out Colonel Blunt asked the regiment whether we wished to volunteer, as a unit, to go to New York City to serve in maintaining civil order. The violent draft riots were at their height and further disorders were anticipated. My notebook covers that: "Companies C & K voted mostly to go, but the rest of the regt were backwards. So we don't go. Recd States pay amts to $65.33."

Perhaps my quitting the Army before the War ended will seem strange today. But the Northern attitude, based on fact, was this: we have ample man power, therefore, when a volunteer has served his enlistment time, he can retire with honor and let his place be taken by a fresh soldier. I had been a volunteer, and I was one who felt no impulsion to serve longer.

My brother had a different cast of mind. A few weeks later Ed enlisted with the 125th New York and served through to Appomattox. In his further career he combined genuine military talent with great good luck. The 125th saw some of the hardest fighting of the whole war. When Lee surrendered, Ed was not only an officer but the senior officer of his regiment: all of his one-time superiors had been killed or disabled. In 1865, at the age of twenty, Ed retired a brevet major, with permanent rank of captain.

But before Ed signed up with his new regiment both of us went home for a visit. I come of an undemonstrative family; but I confess that there was a real demonstration in our house in Troy when we walked in two days after our discharge. It was good to sit down and be waited on and receive the admiration of our parents and the younger children. To them at least I am sure we were great heroes.

A week or so of solid loafing was enough for me. Mow-

rey had great plans for me in Rutland, and I had even greater plans of my own. There was the money side, too. The remains of my bounty payment (which I had sent home in October) and the few dollars still in pocket from my final Army pay were a trifling capital. I had filled out too much to get into my old clothes, and by the time new garments had been tailored and paid for my cash balance was practically invisible. And so, before the end of July, I was back again in Rutland.

Many of the families in town and on the surrounding countryside had sons and husbands in the Army, or recently retired, and they all seemed to want imposing military portraits. That opened two fields to me: hand-tinting the enlargements of existing photographs and doing straight oil portraits. The fact that I had served in the Army, plus the publicity from the many drawings I had mailed back to friends, gave my work a considerable vogue. And Mowrey, always a sound business man, wanted me to be satisfied in my association with him. When I suggested that he pay me by the piece instead of by the week he willingly agreed. He also gave me, at a nominal rental, a large room in the building which housed his studio.

The new plan was an improvement in all respects save one—I quickly found, now that I was substantially my own boss, that I spent many nights as well as all my days on the job. Even when there was a lull in orders for family portraits I had plenty of work to do. General Grant had been a popular hero from the outset, and, now that the tide had turned, Lincoln was coming in for his share of adulation. We did a profitable business supplying hand-finished portraits of these two. I doubt, though, whether both of them combined ever won more enthusiastic devotion than George A. Custer. Promoted a brigadier of cavalry at the age of twenty-three, just before Gettysburg, he rose to be a major general and never knew anything

but brilliant success throughout the war. The children loved him, the ladies adored him, and all men envied him. All men, that is, except photographers. They loved him too, and never was there a subject who offered more to a retoucher handy with colors. Even then this hero had long mustaches and his famous flowing golden hair. He scorned the blue service uniform and wore instead a green-gray suit of velveteen richly trimmed with gold braid. He likewise spurned regulation headgear and chose a wide-brimmed cavalier hat. All those adornments still did not suffice: a long scarlet tie streamed invariably from his collar. General Custer was the artist's dream beyond compare.

My earnings were very comfortable. I kept no precise books; but, as I recall it, my income averaged between $10 and $12 a week. It was a respectable living in that day and in a small community, enabling me to dine in good restaurants, to wear good clothes, and to afford the modest amusements at hand. A little later my income was augmented slightly by the painting lessons which I gave to young ladies; but the principal reward was the recognition that I was a sufficiently competent craftsman to be an art instructor.

During the next year, in spite of my heavy working schedule, I found time for as busy a social career as I have ever known. As before my enlistment, the most important entertainments were our "Sunday amusements," the dashing rides into the country (with a race assured every time another buggy was met up with) and the picnics, suppers, and informal dances. I was now very much a part of all those affairs—and I had a sweetheart. She was the belle of the town, and by the time I had arrived at my twenty-first birthday there already existed what was known as an "understanding" between Miss Caroline Eastman and myself. I was the envy of all my friends, for not only was Caddie Eastman pretty and vivacious but her stepfather,

Mr. McDaniel, was one of the substantial citizens of Rutland. I was, in the words of a song that had not yet been written, sitting on top of the world.

At this time, also, I was one of a little group which was identified only by the letters S.S.C. We were very decidedly the young bloods of town, dining together periodically, having our photographs taken with all of us in plug hats, and thoroughly enjoying the hush-hush that our unexplained label provided. If I now disclose that S.S.C. stood for Social Sardine Club, I am no longer betraying a secret belonging to anyone else. A more serious affiliation was the Masonic Order; but that didn't come for another year.

In 1864, I took part in my third Republican campaign. For the first time in the eight-year-old history of that party its candidate went before the electorate an overwhelming favorite—Abraham Lincoln was at last the people's choice. For the first time, too, I was to have an active voice at the polls, and in November I proudly helped to keep my old Commander-in-Chief in the White House.

Shortly before election complacent New England experienced its first and only war scare. On October 20 the entire North was rocked by the sensational news of a Rebel attack on St. Albans, Vermont, the previous day. A handful of Southern raiders had come in across the border from Canada, looted three banks of some $200,000 and attempted to burn the town. "Vengeance for Sherman's vandalism!" they had cried as they galloped away. Most of the twenty-odd men were captured by pursuers, while the remaining three or four escaped into Canada, where Quebec police picked them up. The attack was over almost as soon as it began—but its memory endured for months to plague the inhabitants of upper New England. Housewives buried their silver, home-defense councils were called, and old men got down their flintlocks and filled their powder-horns. Governor Smith requisitioned a detachment of in-

valid veterans from the hospital in Montpelier, and two companies of volunteers were recruited to guard their native heath. It was Hannibal at the gates of Rome. (One reason for the widespread and instantaneous dread was the recently acquired habit of taking daily newspapers. Before the war most people contented themselves with local weeklies; but by the summer of 1861 the big dailies were increasing their circulations at a rate never since equaled —the citizens of the North couldn't wait from Thursday to Thursday to find out what was going on at the front.)

Just before Christmas a certain Mr. Styles, the leading photographer of Burlington, Vermont, invited me to enter his employ. "You don't have to worry about Mr. Mowrey," he assured me. "I've already had quite a talk with him, and he told me he wouldn't stand in your way. Now I need a man who can do the kind of work you handle here. What's more, I'll make it worth your while. I'm ready to pay as much as $25, with a chance to work into the business if you suit. There's few places outside the big cities where an artist could make as much."

Twenty-five dollars a week! I could hardly believe it. Anyone whose salary was a thousand a year was a man to be looked up to as a potential capitalist; and here I was, at twenty-one, actually being offered $300 in excess of that magic sum.

With great self-control I thanked Mr. Styles for his offer and told him I would "think it over." That was not entirely a gesture. Frank Mowrey had been generous in his treatment of me. I was becoming an accepted member of a pleasant community. And I was engaged—still informally —to be married to a charming young lady. Rutland gave every promise of being the place where I should make my permanent home.

I had a long talk with Mowrey. He told me that Styles was an enterprising man and that Burlington was a good

town. He added that the salary promised me was more than I could expect to earn in Rutland for some time. Most important, in Mowrey's mind, was the opportunity the new job offered to work in a less exploited field. In short, he advised me to make the change.

And so, a little while before Lee's surrender, I finished my last portrait for Frank Mowrey and allied my fortune with that of F. Styles and his "Vermont Gallery of Art." (That "F" is a minor comment on the manners of a day in which many wives commonly addressed their husbands as "mister." I worked for Styles for more than a year, and in all that time I never learned his first name!)

Burlington, as both Styles and Mowrey had painted it, turned out to be a live, attractive town. Agreeably situated on a crest above Lake Champlain and profusely wooded, it was not only the metropolis of northern Vermont but the seat of the State university. Fine residences and trim business blocks bespoke the town's prosperity, while the Van Ness and American Houses further reflected the flourishing state of the community.

The studio occupied commodious ground-floor quarters at 150 Church Street. In front was a spacious reception room where patrons awaited their turn seated upon stiff-backed plush chairs and curly sofas, or beguiling the time at a heavily carved square grand piano with music of their own fashioning. On all four walls hung photographs, oil paintings, and lithographed landscapes. An ornate chandelier in the dead center of the ceiling shed an ample light.

At the rear of the main salon a sort of Moorish arch opened on to a smaller hall. Here were many more pictures, an immense cylindrical "base burner," so placed as to furnish heat for both rooms, and several mirrors. Beyond this "primping room," up half a dozen carpeted steps, was the studio itself. That part of the building was a single-

F. Styles's "Vermont Gallery of Art," in Burlington, as I
sketched it in 1865, while employed as photographer's "artist."
Above: the waiting room. Below: the studio itself, showing
two cameras and sundry background props.

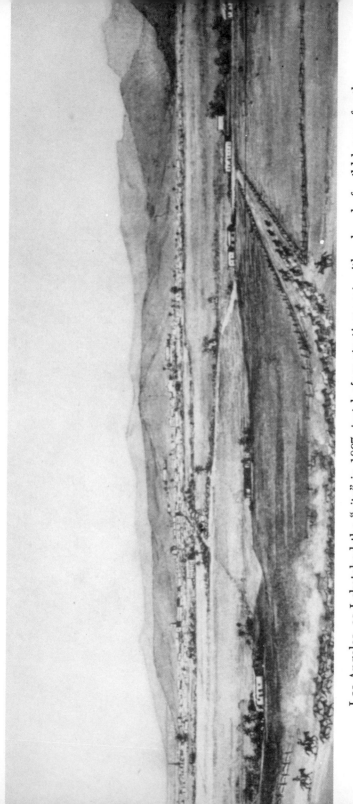

Los Angeles, as I sketched the "city" in 1867, just before starting east with a band of wild horses for the Omaha market. At the time of my first visit Los Angeles was a sleepy settlement with less than 5,000 inhabitants. This drawing is now in the Southwestern Museum of California,

story extension roofed entirely with glass; artificial light-
ing for portraiture was unknown, and a photographer
without skylights would have been helpless. The furnish-
ings consisted of a few elaborately fashioned chairs,
several screens and back-drops, headclamps, cameras, and
sundry photographic props. Walled off on one side were
the finishing room and the dark room.

The photographs on display were as catholic a group of
personages, personalities, and mere persons as could be
found in any studio at any time. Included, of course, was
an imposing portrait of President Lincoln, along with ap-
propriately scaled likenesses of Grant, Sherman, Sheridan,
Meade, Custer, and other Northern generals. Less con-
spicuous, but still prominent, were such dignitaries as the
Governor, the Mayor, and the head of the university. And,
like as not, right among them was your own Aunt Prunella,
or your wife's second cousin from Winooski. Their pres-
ence practically guaranteed that you yourself would soon
be suspended in illustrious companionship.

Styles, whose younger brother was chief "operator," em-
ployed six assistants, and we were occupied almost con-
stantly. Not only was Styles the top practitioner of his art
in that part of Vermont, but his reputation had spread well
beyond. The presence of the State university had a lot
to do with that. Sooner or later every undergraduate would
come in for his portrait, and sooner or later his father,
mother, sisters, and brothers would come to town to visit
him—and have their pictures taken, too. In this present
day of magnificent equipment which makes every amateur
a competent photographer (if there are any brains behind
his eyes) it is hard for many people to comprehend the
universal importance of the professional during the dec-
ades preceding the '90's. But remember that the Leica and
even the simplest Kodak were still undreamed miracles. If
you wanted a picture, you sat in a chair, put your head in

a vise, watched the birdie, and laid your cash on the barrelhead. There wasn't any other way.

Within a modest front window a few hand-colored enlargements, all richly framed, were suspended on tasseled cords, and on the glass was gilded the legend, VERMONT GALLERY OF ART. It was the sort of establishment that a young man could be proud to work for, and I set to it with a will.

While I was still adjusting myself to the new plan of things the War ended. For some weeks Lee's surrender had been expected; yet, when it came, nobody was really quite prepared, for the struggle had gone on so long that it seemed to be a permanent part of our existence. Then suddenly, on April 9, 1865, the bells began to ring. It was Palm Sunday, all the sextons were at their posts, and all the bells of Burlington sounded together. But it was no ordinary Sunday pealing that we heard: it was the wild clamor of good news. When the churches grew quiet, other bells still clanged out the story—the firemen were lustier than the sextons, and the students were lustiest of all. Bulletins were posted at the telegraph office. Grant was the hero of the hour, and Lincoln was spoken of almost with reverence. But their old rival General Custer still pressed them for honors. It was this tireless cavalry leader whose unremitting pressure had brought the final battle to a head, and it was to him that the Rebel flag of truce, a white crash towel, had been delivered.

So ended the war between North and South. Today people have a habit of saying that war can settle no question. They may be right—but the war of 1861-65 surely settled the question of secession in the United States of America.

Six days later, on the eve of Easter, the church bells rang again.

About midnight on Friday the news of Booth's attack on Lincoln had flashed through, and by daylight a low-voiced throng was gathered downtown to await the announcement that so clearly must come. By eight o'clock on Saturday morning we all knew that the President had died without speaking again. All day the dead march tolled.

The next weeks, as I look back, seem to have been entirely a funeral period. Burlington was far from the route of the train that carried Abraham Lincoln back to Springfield, but the town took full part in the national mourning. I recall one clear detail, an unaffected touch in the studio an hour after the President had died: when Mr. Styles came in for the day's work, he paused for a moment before the Lincoln portrait, then draped it with a heavy black band that was not to be removed during my time.

While Lincoln was lying in state, preparations were going forward for a happier event—the Grand Review. And on May 23, the first of two great armies marched past the White House to salute President Johnson. I was not present to watch the Army of the Potomac swing down Pennsylvania Avenue, with General Meade at the head; but my father went down from Troy, and a little later I heard all about it from him and from my brother Ed, who was one of the marchers.

On May 24, General Sherman led the Army of the West over the same route, and not only Washington but all the loyal States of the Union watched the procession, bursting with patriotism and well-founded pride. All of us passionately echoed Sherman's words that this was "the most magnificent army in existence—sixty-five thousand men, in magnificent physique, who had just completed a march of nearly two thousand miles in a hostile country. . . . The steadiness and firmness of the tread, the careful dress of the guides, the uniform intervals . . . the tattered and bullet-riven flags, festooned with flowers, all attracted universal notice. Many good people, up to that time, had

looked upon our western army as a sort of mob; but the world then saw, and recognized the fact, that it was an army in the proper sense. . . ." Von Moltke, the Prussian, had remarked in 1861, "I am not interested in the movements of armed mobs," yet this same sarcastic soldier profited in 1870 from what his observers had learned in 1861-65.

About the same time that Andrew Johnson moved into the White House I was moving out of temporary hotel quarters into a large, comfortable room on the floor above the studio that Mr. Styles had fixed up for his brother and me. Practically free of rent, and with my truly unusual salary of twenty-five dollars a week, I was in a position to save a lot of money.

But for some reason or other, I didn't seem to save any more than I had at $6 back in 1860, or at $10 or so only a short while before. I never was able to pin down the exact cause, but I suspect that I just had an uncommon talent for living right up to my income. Most of my meals were eaten at the American or the Van Ness. I developed a feeling for rich ties and brocaded waistcoats. And, of course, a rising young man couldn't afford to be seen in public places in anything but a plug hat and a well-cut coat.

I acquired a taste for, though by no means a talent in, the music of the flute, and promptly bought myself a handsome silver-mounted instrument. I discovered a new yearning for athletic prowess, and soon my room was equipped with weights, pulleys, dumbbells, and Indian clubs. I found, in short, a remarkable aptitude for desiring everything that took money out of my pocket. And not the least of my expenses was a weekly journey to Rutland to visit my fiancée. Although I took an early train down on Sunday morning and returned by a late one the same night (thereby avoiding hotel bills), I still spent far too much money.

Monday through Saturday my social diversions were very much the sort we had enjoyed in Rutland, suppers, picnics, home dancing (the waltz was still quite shocking), and the like. And there was one new departure that was very important to me—membership in a literary society. Our little club had no pretensions, not even a name. The young ladies and gentlemen who comprised it were very serious in wishing to improve their minds. Few of us had enjoyed the advantages of a higher education, and I can think of no better way for the group to have set about remedying the condition.

What did we read? Well, there was always Shakespeare as a cornerstone—*Hamlet* and *King Lear, Romeo and Juliet, As You Like It, The Merchant of Venice*, and *The Tempest*. Dickens was popular, and I remember that his novels were coming out regularly in serial form, just as they had been doing for several decades. But it is not *David Copperfield* that I remember reading at that time, nor *A Tale of Two Cities;* the title that comes to mind is *A White Hand and a Black Thumb*. Charles Reade, the great reformer, pressed Dickens closely. *Very Hard Cash,* which came out in the middle '60's, was an involved and alarming tale having to do with a retired sea captain and his £20,000. This unfortunate gentleman and the young hero (who seemed to be in love with the captain's daughter) spent most of their time trying to escape from an insane asylum, where they had been wrongfully cast by the wicked banker, one Mr. Hardie. Then there was that fine shocker, by an unnamed author, entitled *The Silver Ship, or The Bloodhound of the Caribbean*.

We read Emerson and Holmes and Thoreau, and Bancroft, the historian. Our poets were chiefly the Americans, Whittier, Longfellow, Felicia Hemans, and the revered Bryant. But the one who gave me more pleasure than any other was John Godfrey Saxe, of Vermont. In later years,

when I passed so much time on trains in the West, I took particular delight in his *Rhyme of the Rail:*

> Singing through the forests,
> Rattling over ridges,
> Shooting under arches,
> Rumbling over bridges,
> Whizzing through the mountains,
> Buzzing o'er the vale—
> Bless me! this is pleasant,
> Riding on the rail!

A later stanza of this happy jingle runs:

> Gentleman quite old,
> Asking for the news;
> Gentleman in black,
> In a fit of blues;
> Gentleman in claret,
> Sober as a vicar;
> Gentleman in tweed,
> Dreadfully in liquor!

Saxe also wrote the good-humored diatribe against early rising, which begins:

> God bless the man who first invented sleep!
> So Sancho Panza said, and so say I.

I do not profess any critical knowledge; but I will continue to hold that Saxe is a very *satisfactory* poet.

Current reading matter, apart from the newspapers, was supplied by a few magazines. Directed to the gentle female eye were the perennial *Godey's Lady's Book* and a new publication called *The Lady's Friend.* The *Atlantic Monthly* was going strong. *Frank Leslie's Weekly* was well known. *Harper's Weekly* flourished mightily; it was *Time, Life, New Yorker,* and the *Saturday Evening Post* combined.

It was in *Harper's* that one saw the war pictures (all hand-engraved or lithographed, of course, for the art of photo-engraving was still unknown) and read editorials—not too serious—about the dreadful profanity in the Army.

It was in *Harper's* that one read about Dr. Draper's six-teen-inch telescope—"the largest in the world"—and saw reproductions of lunar photography; or learned that hare-brained inventors were continuing to build machines with which they fondly hoped "to sail through the air." And it was in *Harper's* advertising columns that a young man could keep abreast of those little significant facts that made life worth living: Tiffany & Co., of 550-552 Broadway, New York City, offered the pocket-size Deringer pistol; a public-spirited chemist named Hostetter was ready to supply Stomach Bitters to the Debilitated and the De-crepit; American Metallic Collars permanently solved the problem of neckwear—turn-down $1, choker 75 cents; the Tennessee Swamp Shrub Balsam Co. guaranteed (if one were eighteen) to grow a full beard and mustaches.

Life was by no means simple; but it moved at a slower tempo then. Hard work and sobriety were just as impor-tant as they are today; but they carried with them an almost automatic promise of material success. Even in war existence was decent; your very enemies were dependable gentlemen. And the future, if unknown, could be plotted from given lines. I liked things as they were in 1866.

Suddenly my snug little structure crashed at my feet. On the second Sunday in April, I had, as usual, gone to Rutland to spend the day with Miss Eastman and her fam-ily. Some time during the afternoon we had a difference, a difference so slight that I haven't the remotest idea now of its origin. She had spirit, I was bull-headed, and the quarrel grew. When I started for the depot after supper Miss Caddie said coldly, "Good night, *Mr. Jackson*." With equal formality I responded, "Good night, Miss Eastman," and bowed from the hips. All the next week I was upset. I arranged to take Saturday off, and late Friday afternoon I went to Rutland, hoping that I could mend the breach. If I had possessed the wit of a squirrel, I would have

acknowledged my fault—whatever it was—and been for-given. But at twenty-three I knew hardly more about the feminine mind than I do today, and I failed miserably. I was, so to speak, discharged. And since I found it im-possible in my shame to face the world, I renounced it.

CHAPTER VII

"O PIONEERS!"

IN the meaty phrase current today, I couldn't take it. All my friends knew of my engagement, and I lacked the moral fiber to tell them it was broken. There was only one course visible to me: I must leave Vermont forever.

Within twenty-four hours I was on my way; direction New York City, destination unknown. After expressing to Miss Eastman a little packet containing her letters and memorabilia, I boarded a sleeping car at the Burlington depot. The time of departure was 10.30 P.M., Saturday, April 14, 1866. I know because I wrote it down; I was methodical in my misery.

Early Sunday morning the train arrived in Troy. There I had some three hours to brood on the station platform. Home and family were only a few blocks away; but it never occurred to me to visit my people. I was running away from them, as well as from my job and my friends. Caesar at the Rubicon had nothing on me. *Alea iacta est,* I thought rather magnificently as I waited for the New York train.

As the cars slowly pulled away, I took from the pocket over my heart a small picture of Caddie and enjoyed a few moments of exquisite sadness. Then with a sigh precisely modeled on the dying suspiration of Hamlet I wrapped the photograph in a handkerchief and put it back in my breast pocket. I was intensely gratified to note that several persons turned around as I did so.

During the rest of the trip I divided my time between

83

the scenery of the Hudson and the faces of my fellow pas-
sengers. It was my first journey along the river since my
boat ride to Albany in 1853; as for the people in the car,
they were so many models for me to sketch. Beginning in
boyhood, whenever I found a man or woman in repose,
I almost automatically got out my pencil—and there are
few places better designed for informal portraiture than a
passenger coach. Occupied as I was, I found the ride to
New York almost too short.

Although I had never before come into the metropolis
by rail, I counted myself an old hand at the geography of
the big city. It was only a step, I knew, from the Chambers
Street station to City Hall Park, the center of town, and
with brisk confidence I picked up my bundle and headed
in that direction. After fifteen minutes my bag was begin-
ning to be heavy, and I still saw nothing that I recognized.
It so happened that the rail terminus had been moved up
town to Thirty-fourth Street some time before; but, since
street signs were conspicuously absent—and since I also
disdained to ask questions—I walked a good three miles
before finding my hotel.

Lovejoy's on Park Row—which I chose because I saw
its sign first—was a typical medium-sized, medium-priced
hostelry, no better and no worse than a score of others
I might have chosen from. Brick-fronted and, as I re-
member, five stories high, it accommodated perhaps sixty
or seventy guests. The main lobby was up a flight of iron
steps that had filigreed railings on either side. In the base-
ment was the restaurant and a shop of some sort. If I were
to compare Lovejoy's with a place that might be familiar
to men somewhat younger than myself, I would pick the
old Lafayette, still flourishing down on University Place.
But the comparison would have to be general and cover
only physical appearances; for Lovejoy's at its best was
never quite in the Lafayette's class.

On Monday I was up early. I had left Vermont with

vague intentions; now it was time to build ideas into plans, and, in turn, to translate those plans into action. Since I had very little cash—not more than $25 or $30—I *had* to take action.

After reading the morning papers I went for a walk, going as far south as the Battery, which I had last seen as a soldier returning from war in 1863. At noon, still without a glimmer of an idea, I suddenly encountered Ruel Rounds, another veteran of Company K, who was then about thirty. Since I regarded myself as a social outcast, my first impulse was to duck away; but Rock—so-called, perhaps, because he was by trade a marble cutter—saw me at the same time I spotted him. After a moment I realized that the world at large was still unacquainted with my humiliation, and we determined to have dinner together.

During the meal I learned that Rock was quite as footloose as I was. At the end he informed me that he had recently lost the job he had come to New York to take and that he was flat broke. As I paid for both of us, it occurred to me that Rounds was just the man I was looking for to share my new adventure, whatever it might prove to be. I thereupon told him that I was thinking about heading for the great open spaces to start life anew.

Rock was full of enthusiasm. Anything would suit him better than poverty in New York. Why not, he suggested, try for a berth with one of the silver-mining companies in Montana Territory? He understood that there was great demand for husky young men; not only were they paid handsome salaries, but transportation was furnished. He knew a man named King who had already signed up for such a job. We decided to find Mr. King and have him introduce us to the right people.

Tuesday and Wednesday we went the rounds of the silver-mining companies; but, although we covered every office in their bailiwick, which centered about the inter-

section of Pine and William Streets, we found no encouragement. On Thursday we ran into Harry King, who disclaimed knowledge of the rumor which had tied him up with the silver interests. The new partnership of Rounds & Jackson was discouraged.

We next discussed the chances of paying our own way—somehow—and landing work upon arriving in the West. Once we had got ourselves as far as the Missouri River the rest would be easy. That we knew with certainty. Didn't everybody say so? Billy Crowl, a young friend of Rock's, was so sure of it that he decided to chuck his job with H. B. Claflin's and go with us. We would leave on the coming Saturday, just as soon as Crowl had drawn his week's pay.

On Friday morning Rock took the ferry to Hoboken to look up a man who owed him some money. I went with him—but not just for the ride. The previous day I had lost nearly all my remaining money, probably to a pickpocket, and my errand in New Jersey was to convert my watch and chain into cash. I thought I could get a better price across the river than in New York. Both of us failed. Upon our return I went up Broadway to the shop of a pawnbroker I had previously noted. Somewhat to my surprise the Israelitish brother in charge offered me $66 without muttering any of the traditional phrases about "poor quality." Although the watch and chain had cost me $150 in Burlington less than a year before, I was glad to accept the quick-sale price. With Crowl's small contribution it would be enough to get all three of us to Detroit, where Billy had a married sister who would immediately supply the $150 needed to carry us the rest of the way.

We left New York on Saturday, just one week after Caddie Eastman had blighted my life. Already that portion of the past had begun to dim.

Early Sunday afternoon found us at Suspension Bridge, and we at once set out to visit Niagara Falls. It was an

exciting experience, particularly at that season when great ice blocks were tumbling into the gorge. After enjoying the view from Terrapin Tower on Goat Island, and the inevitable drenching which accompanies every tour through the Cave of the Winds, we had a good supper and an early bed. Our train was scheduled to leave at 7:15 next morning.

The Great Western to Detroit gave us a taste of something new. Our second-class tickets as far as the Falls had furnished practically the same accommodations that first-class passengers enjoyed; but west of Suspension Bridge second class meant what it said—and a good deal worse. Billy and Rock and I found ourselves riding "immigrant cars," or, in more precise language, common box cars fitted with hard benches. It brought back the troop trains of the war—except that these cars were filled with the blended stench of garlic, bad whisky, and bodies that had never been bathed. The only boon was the odor of tobacco, and although I still didn't like to smoke myself, I was grateful for Rock and Billy's cigars.

The presence of several first-class passengers (who lacked smoking compartments in their own cars) gave us an idea. We were presentably dressed. Our hair was trimmed. Our faces were clean. Why ride with the cattle? Soon we sauntered into a first-class coach, where we rode with great aplomb all the rest of the way to Detroit. I am sure the conductor detected us, but he was a decent man and made no move to run us out.

Upon our arrival in Detroit late Monday afternoon Rock and I registered at the Franklin House and, according to the entry in my journal, "deposited our baggage consisting of one shirt & a pair of socks with as much importance as though it was a trunk filled with a complete wardrobe." Crowl, after cleaning up, left us to call upon the sister and brother-in-law from whom he was to get the $150 we needed so badly to take us to Montana. Soon he was

back to tell us that he would pass the night with his family and would meet us again the following day. That night, secure in the knowledge that we would have comfortable funds within twenty-four hours, Rock and I enjoyed a good meal and later dropped in for a turn at the Varieties Theater—which turned out to be one of Detroit's less savory music halls.

At noon on Tuesday Billy showed up with his tail between his legs. His trip to the West was no go so far as his sister was concerned, and he had failed utterly to "raise any stamps." Her best offer was to take Billy to Cleveland to see whether their father cared to finance the trip.

On Wednesday, Crowl and his sister, Mrs. Knight, took the boat for Cleveland, promising to be back no later than Saturday. Then Rock and I took a tally of our resources. We had just enough money to settle our hotel bill to date, and that we decided to do before they dunned us. It also seemed the best way to assure credit until the end of the week.

The next three days were an uneasy period for Rounds and myself. Yet, even without money, we had an interesting time exploring the sprawling, untidy city of Detroit, which was then hardly more than an overgrown crossroads town, with Michigan and Grand River Avenues no more than dusty thoroughfares leading to the romantic West. Detroit was still more of a trading post than anything else; but the signs of industrial greatness were visible, even though the principal articles of manufacture were stoves and boxcars. My future friend, Mr. Henry Ford, was still just a toddling infant down on the Dearborn farm where he had been born three years before.

On Saturday, as promised, Crowl met us at the hotel. Everything was rosy, he assured us with an easy smile; his father was most enthusiastic about our Montana proj-

ect and had given Billy an order upon Mr. Knight for
$150. Billy then departed to pick up the cash.

For some curious reason, however, Mrs. Knight had
written her husband precisely the opposite instructions.
Her father had issued a flat veto, and any funds Mr.
Knight might pay over to Mr. Crowl's son must be en-
tirely at his own risk. Furthermore, Mr. Knight was to
detain William if possible. Billy always had a flair for
fiction.

When he came back to the hotel a second time, there
was hardly any need for him to tell us the bad news—
his face showed that. All his brother-in-law would do for
him was to promise him $20, payable the following week.
That was small comfort to Rock and me. Our hotel bill
was already $12, and we both had a strong prejudice
against going without food. We decided to jump the bill
temporarily and head for the country, where we were sure
we could find work on a farm; while Billy would return
to his sister's house and wait until he got his $20.

Off we started, and we had actually reached the Four
Mile House out Woodward Avenue before either of us
recognized the absurdity of our plan—one look at our soft
hands, city clothes, and stovepipe hats, and any farmer
we asked for a job would burst out laughing. But the re-
alization of folly brought with it a compensating idea. I
was wearing a new and well-tailored coat for which I
had paid $40 only a month or so before. Perhaps I could
make a swap somewhere back in town and get a little
cash to boot.

It was after dark before we had trudged in from the
outskirts to the center of Detroit, and Rock and I had
long since begun to suffer a deep, gnawing hunger. Our
first attempt to do business was at a second-hand shop,
where, according to my journal, "an oleaginous female
was in attendance, giving suck to an obstreperous infant.
Couldn't make a trade with her, though Rock spoke in

his blandest and most insinuating tone. She 'didn't buy no goods by gas light—been cheated too many times.'"

But at the next place I found the proprietor willing to give me, in exchange for my own handsome garment, a faded yellow coat several sizes too small and $5. That greenback engraved with a "V" was almost the biggest sum of money in the world.

Restaurants were too expensive, even though we were ravening, and we bought a huge bagful of pastries instead. After satisfying our appetites in part we picked out the Milwaukee Exchange, a shabby dive on Atwater Street, for our night's lodging. Most of all we hoped to avoid any encounter with the Franklin House, where we still owed money.

At noon on Sunday we waited by arrangement outside St. John's Church to meet Billy Crowl. When he failed to show up, we became thoroughly annoyed. It was not primarily the fact that he owed me a small sum of money— Rock owed me even more. It was his promises, unkept, and the wasted time. Had we faced things four days earlier, we might have taken immediate steps to get employment of some kind. As it was, we had relied on Billy; and now we were in a much deeper hole. And, of course, Rock and I lacked the detached outlook needed to blame the whole mess on ourselves alone.

On Monday, after a second night at the Atwater Street place, we set out to find a cheap meal. That was difficult in Detroit, for there were no such inexpensive restaurants as abounded in New York. At last we bought a loaf of brown bread for a dime and a quart of milk for eight cents. About noon we went back hopefully to St. John's; but no Crowl appeared. We then sent a note to him at his sister's house and returned to the Milwaukee Exchange hungry and very angry. There Rock dug up a dirty shirt of mine that I had thrown away and went out in the absurd hope of realizing a spot of cash; I was amazed

when he came back with fifty cents, which we promptly spent for a meal. At seven o'clock Billy came in, and without a penny for us. When he told us he would have "some stamps in a day or two," we merely grunted. Rock and I then went out on Michigan Avenue, where we found an "uncle" who let us have $1.50 for our waistcoats. A little pathetic and wholly ridiculous, we headed back for the Milwaukee through the chilly evening, hands thrust deep in our breeches pockets and plug hats pulled low on our foreheads.

Things went from bad to worse, and on to worst. Rounds had written back to his people in Vermont for some money that was due—but meanwhile we were literally on the town. Tuesday night we spent in a police station. It was cold, and we finally screwed up our courage to the point of overcoming shame. The sergeant was surprisingly hospitable; not only did he find us some blankets and an old mattress but he and several officers off duty gave us seventy-five cents for a meal. After we had rolled up in a corner, we heard ourselves being discussed: "two New York chaps strapped" was the explanation given to everyone who inquired about our presence.

Next morning we were required to give our full pedigree for the blotter; but, in a strange country, that bothered us very little. Shortly after noon we met Billy, and to our amazement his brother-in-law had at last coughed up $20 in hard money. In addition Mr. Knight had secured one pass to Chicago over the Michigan Central. We decided that all three of us would leave at once—a notion which we abandoned as soon as we had inquired the price of two regular tickets. Instead we had supper together, and later all three of us returned to the Milwaukee Exchange and spent the night in the only bed our room contained.

On Thursday, May 3, exactly ten days after our arrival in Detroit, we held a council of war. Since I was a "pro-

fessional" man, my chances of landing a job were held brightest. Accordingly I was given the pass to Chicago and $3 and was speeded on my way. Rock and Billy would stay in Detroit to await the arrival of Rock's hoped-for funds from the East, and as soon as some money appeared they would follow me.

A few years before, when I was still working for Mowrey in Rutland, an old friend of his named Rawson had visited the studio on a tour of New England. Rawson, an academic painter of middle age, lived in Chicago, I remembered now; and, as soon as I reached my destination, I started out to find him. After visiting a gallery or two, I tracked down Rawson, who remembered me at once and received me with cordiality. He occupied rooms in the Opera House, which was not only the thing its name implied but an office building as well. Robert Lincoln, the late President's son, was a tenant there too, with quarters on the same floor as Rawson's. I saw him in the hall on several occasions.

Saturday morning after breakfast Rawson took me around to the photographic studio of Gillett & Paxon to see what they could do about finding me some work. I had a long conversation with the two gentlemen; but business at the moment wasn't promising enough to warrant their taking me on. Several other calls were equally unproductive. Finally one photographer told me to come in on Monday ready to work. In consequence I passed a relaxed and agreeable Sunday with Rawson.

On Monday I had a sharp awakening from my pleasant dream: my expected employer had "found somebody else." I started the rounds again, and to my great relief quickly found work with a sign painter named Swift. Mr. Swift was not only the slowest of mortals but an old sourpuss besides. Yet I was happy to stick with him until something better should turn up. Mr. Swift had at least

the virtue of paying his help punctually, and on Saturday I collected $18.

Late that same evening, when I returned to my temporary quarters under Rawson's roof, I learned that "a young fellow had been there inquiring for me," and that I could find him at the Sherman House.

The "young fellow" was, of course, Billy Crowl, and with him was Rock. Two such starved and bedraggled soldiers I had never seen before. They had waited vainly for Rock's money to come in; and then, when only a dollar or two remained of their scrawny capital, they had started toward Chicago. Part of the distance they had covered on foot, but most of it was accomplished by deadheading. I fed them and took them around to the establishment where I had previously engaged room and board for three, at $6.50 a week apiece.

When we had exchanged information, including the good news that I had work and was earning enough money to feed, if not quite to lodge, three hungry men, Rock silently produced a clipping from the *Detroit Daily Tribune*. Dated more than a week earlier, it read:

"STRAPPED." Yesterday two young men from New York, named Ruel Rounds and William Jackson, called at the Police Station and told a story of want, curious in parties of their appearance yet apparently truthful. They were "strapped" and a long way from home. They stated that in company with W. H. Crow who resides in this city, they started from New York to go to Montana Territory. They paid Crow's fare to this city upon representations that he had friends here who might supply them with the "needful" so that they could reach their destination. Crow's friends, however objected to his going West and the New Yorkers were thus left destitute, they originally having only funds enough to bring them to Detroit.

I had always had an itching to appear in print, and here, at last, Fame stood up to greet me! Even at the time I laughed heartily, though I must confess that I hoped

the papers in Troy, Rutland, and Burlington would not copy.

Some little time after I had gone to work on Monday the boys arrived with a problem. Mrs. Robe, our landlady, had informed them that she required her money in advance. Since they had not enough to pay for even the two nights they had spent in her house, they thought I had better be informed at once—because I was more or less in the same predicament. Rawson, whom we consulted, advised telling Mrs. Robe calmly that we couldn't pay up entirely until I had earned another week's wages. "Fall back on your dignity, boys," was Rawson's amiable suggestion, "and you can tell the old hatchet face she can call on me if you default."

Rock and Billy set out to look for work, but meanwhile we were in for another uneasy time. Even with my $18 on Saturday we should still be short the amount already due. By this time, however, we were all accustomed to living on hope and a shoestring, and certainly our collective condition was better than it had been one week before—there could be no question about that.

Gamblers have a superstition about good cards running with what they refer to as "clean living." I can't say that I know much about the matter; but the three of us were certainly gamblers, and, with or without clean living, a change of luck came at the end of the week. I got my pay, and $25 came for Rock, who had left for Marengo, some miles northwest of Chicago, the day before to look for work.

The ensuing orgy rivaled the wildest doings of the Emperor Heliogabalus. After settling our bill at Mrs. Robe's, Billy and I plunged into a feast of strawberries and ice cream—and then went off to have a bath! Small wonder that we found the door locked against us when we returned to our boarding house half an hour after midnight.

On Sunday I had a conversation with a Mr. St. Clair, a prosperous young man of thirty or so who had been studying painting under Rawson. Since he was dissatisfied with his progress and intended to leave Rawson in any case, I could see no ethical obstruction in the way of a little sales talk. To my delight St. Clair engaged me as his instructor for the coming two weeks, at $20 a week. I cannot now recall whether the two-week period was designated because Mr. St. Clair never made longer commitments in any field or for the reason that he regarded a fortnight as sufficient time in which to become a finished artist.

Next day I bade Sign-painter Swift a tearless farewell and, accompanied by St. Clair, purchased the supplies needed for my pupil's instruction. We then set to work, and in the course of the day two small pictures were completed.

Life was looking up. On Tuesday a letter from Rock informed Billy and me that he had found work as a marble cutter at $3.50 a day. Since board in Marengo could be had for only $4 a week, I suggested that Billy join him there. We had already agreed to pursue the future on a sort of Three Musketeers basis. Everything would go into a common fund; and, as soon as we had saved enough for our transportation, we would start for the frontier town of St. Joseph, Missouri.

St. Clair and I painted together during the daytime and in the evening enjoyed such diversions as were available only to men with money in their pockets. Twice in one week we attended the theater—a new high record for me—seeing, at Crosbie's, the renowned trouper James E. Murdoch in *Wild Oats;* and, at McVicker's, the beguiling Kate Reignolds in a farce entitled *Richelieu at Sixteen.* Another evening, since St. Clair was a Mason like myself, we visited Blaney Lodge No. 271.

On Saturday, St. Clair decided that we should make a sortie into the country, and preparations were made to leave early the following week. I got my first pay, which turned out to be $5 more than I had been promised. That was so gratifying that I immediately spent twice the extra amount. Perhaps I could justify the expenditure of $8 for a box containing twenty-four Winsor and Newton water-colors; but I shall never be able to explain, even to myself, what prompted me to hand out another three dollars for a flageolet and instruction book. Less than a month before I had been all but starving in a Detroit station house. Now I was going in for music lessons!

At 9 A.M., Monday, May 28, we took the train for La Salle, Illinois. From the beginning of our association St. Clair's underlying motive had been to open a studio somewhere, and we were now on our way to explore one of the towns he had in mind. In La Salle, where we arrived shortly after noon, all we found was dirt and decay. If St. Clair was not completely convinced by our supper at the Harrison House, our night's lodging made up his mind. We pulled ourselves unrested from a hard, lumpy bed at four the following morning and felt, rather than saw, our way through a chilly rain to the depot, where we boarded a train for Davenport, Iowa.

About eight o'clock I had my first sight of the Mississippi, and I was grievously disappointed. This was not the Father of Waters I had read and dreamed about—it was just an ordinary river with a railroad bridge across it. But, as the train cautiously proceeded over the trestle, which was then undergoing some repairs, I experienced a thrill of anticipation. The great prairies of the West lay just beyond.

An hour later we set our hand luggage down in the Penn House and went out to investigate Davenport boarding houses. We found a satisfactory place with a private family at $5.50 a week. St. Clair thought we could use

these quarters as a temporary studio; but, since the appearance of the town had been immediately favorable, I was determined that any shop we might set up should have a little more dignity than a bedroom afforded. And so we found a tiny room in the business section at a monthly rental of $4.

We spent three weeks in Davenport. I never found out just what St. Clair had in mind; nevertheless, I painted industriously and continued to give him such instruction as he seemed able to comprehend. We had endless petty bickerings. The longer we stayed together the more unpleasant became our relations. I have often wondered why he put up with me, when all he was really doing was to pay me wages to quarrel with him.

If St. Clair was a dim lamp, I was a dimmer one. Instead of saving every penny above my bare living expenses I dribbled my money away. And I was homesick. I wrote letters back to Vermont, mooned about, and started to do a color portrait from the photograph of Caddie Eastman. On the sixth of June I had a whole day of dismal introspection; this was to have been our wedding day.

I determined to strike for the real West just as soon as I had scraped up enough money to pay my fare to St. Joseph. The boys in Marengo expected to be able to buy their own tickets by the middle of the month, and all I had to do was set a time and place for our reunion.

St. Clair and I wound up our vague affairs—which meant that I turned over to him all the pictures I had painted—on Saturday, June 16. After taking care of my board bill and a few trifling debts besides, I had exactly $22.75 to my name. The fare down the river as far as Quincy, Illinois, and thence by rail to St. Joseph set me back $18.25. Even then I couldn't leave Davenport; for the final letter from Billy and Rock, which was to determine the time of our rendezvous, had not arrived.

Nor did the expected letter come on Monday, nor on Tuesday. In desperation I started off, knowing neither how nor whether we should find each other. I had no choice. My capital was reduced to $1.75.

But I had my tickets, and I let no forebodings interfere with my enjoyment of the ride down the Mississippi. It was an experience I had been looking forward to for a long while.

The steamer *Savannah*, which left at 4:30 P.M., only four and a half hours late, was itself the most remarkable feature of the trip to Quincy. Instead of being built to cut proudly through the waves, like any proper ship, it was constructed on the lines of a turtle—and I soon discovered why. With a draft of only twenty-six inches, the *Savannah* still scraped bottom at frequent intervals, and we were really crawling along the river bed until we passed below the rapids some miles south of Davenport. At that season the water over the rapids was so excessively low that most of the cargo had to be unloaded and transferred to freight cars.

The scenery was pleasant, and, for the most part, the country was green and inviting. But I thought then, and I still think today, that it couldn't compare with the Hudson. And I believe I am not expressing mere local pride in holding to that opinion. No river of the four continents I have visited has ever shown me the beauty I have seen along the Hudson.

At 8:30 the second evening we docked in Quincy. And in the twilight, to my delight, I saw Rock and Billy standing on the levee! The boys had arrived the day before; and, in full confidence that I should soon be along, they had simply watched every boat that came down the river.

A meeting of the finance committee was called as soon

as we had withdrawn from the crowd, and a rapid sum-
ming up revealed that our liquid resources totaled exactly
$3.50. Since the night was warm, we voted against spend-
ing anything for a bed. When it was quite dark we made
our way to the railway station and curled up for the rest
of the night on a baggage truck.

On the morning of Thursday, June 21, the first day of
summer, we crossed from Illinois into Missouri, and at
7:30 departed westward on the Hannibal & St. Joseph
Railroad. Just as we were about to leave, a lively thunder-
storm came up; and the early drenching of the fine coun-
try between Hannibal and Palmyra gave it all an ad-
ditional richness and, as I recorded in my journal, "an
extremely Western out-in-the-woods look.... Some por-
tions quite picturesque. Tall trees draped in clinging vines
and soft moss and the luxuriant vegetation common to
swampy lands." And then I added in a fit of caution: "But
there was a disagreeable suspicion of fever and ague con-
nected with all this." Or perhaps my breakfast of crackers
and rat cheese was beginning to back up on me at that
point.

When we came into Macon at noon, we decided to get
off and lay over until evening. In that way we could
spend the night on the seat of our coach—which could
certainly be no harder than the baggage truck we had
used the night before—and also arrive in St. Joseph early
in the day, when time would be most valuable to us.
Having thus carefully adjusted our economy, we found
a circus in town. Unanticipated, but an obvious necessity,
it took a major portion of our remaining capital. We could
feed the monkeys, if not ourselves.

Just before dawn, and less than an hour before we
reached our goal, a most terrible thunderstorm struck
us. Never have I seen such a rain, and never have I known
such a succession of flashes. Noses pressed against the
water-smoothed panes, we had our first sight of the

prairies that stretched to the edge of the lightning-streaked sky. The storm ended as the train pulled in, and in the dim morning light we stepped out into a city of mud.

This was the gate that opened upon the West. This was the shining frontier. This was St. Joe.

BULLWHACKING TO GREAT SALT LAKE

IN 1866, the Union Pacific had only reached a point some hundred miles west of Omaha, while the Atchison had proceeded no farther than the town of Topeka. All overland traffic still moved in covered wagons. And since geography had determined a starting point, the settlement on the left bank of the "Great Muddy" had flourished.

Through nearly a full generation wagon trains had made up in St. Joe for their treks to the Oregon country, to Dakota and the Great Salt Lake, and to California. From here, or, to be precise, from a point immediately across the yellow, churning Missouri River, the Pony Express had departed, back in 1860-61, to carry the mails to Sacramento. And here most of the great forwarding companies had, at one time or another, maintained offices —like the firm of Russell, Majors & Waddell, founded at Leavenworth in the middle '50's, which at its peak employed 4,000 men and 40,000 oxen.

William Russell, known up to 1861 as "The Napoleon of the West," had, late in that year, been ruined by the sensational yet hopelessly unprofitable Pony Express; but his old partner, Alexander Majors, was still in business transporting freight over the prairies. This active and pious gentleman, who required all his men to sign a pledge not to swear, get drunk, or be abusive to animals, was the sort of employer Rock, Billy, and I were looking for. We were still clinging to the original notion of strik-

ing into the Montana mining country; but by this time we were ready to take any job in any direction—so long as that direction was west.

We were three insignificant adventurers; but we were part of our times, and part of a popular movement that was not only immense but unique. Adventure and opportunity in the West had been a familiar idea to the American-born since the earliest settlement of the country. When times were hard in the East—when there were too many children to share the New England farm—when you left the Army after serving through a war, and were restless and footloose—when you had a broken heart, or too much ambition for your own good—there was always the West. Horace Greeley's advice was far too obvious to be startling. Go west? Of course go west. Where else?

But that taken-for-granted opportunity, the wide continent quite reasonably bestowed on the citizens of the Republic, was something entirely different to the new people thronging in from Europe. It was sheer miracle. Free land? There had been no such thing in the old countries for so many centuries that the very idea was fantastic—there was not even land that you could buy, except by accident or the very slow turnover of estates as family situations changed. And here in America were illimitable acres, and the kindly Homestead Act of 1862, which *gave* land to anyone who would take the trouble to farm it and live on it. The tide of European immigration gathered force and swept west with the restless Americans. You met every language and every racial type on the plains in the '60's and '70's.

The normal influx of settlers had been somewhat slowed by the War; though it was on the increase again, following the Government's offer to count service in the Army as part of the five years' residence required by the Homestead Act for permanent possession of land. The building of the railroad was also bringing in many men who had

been in the Army. But in 1866, many of the travelers were people like Billy and Rock and myself, young men bound for fabulous fortune—it mattered not where.

It was a good half mile from the depot to the center of St. Joe, and by the time we had waded through the mud to the City Hotel we were not only begrimed but ravenous. After cleaning up we decided to spend the last of our microscopic hoard on a breakfast. Then we began reading the help-wanted columns of the *St. Joseph Herald*.

We found our meat at the very first glance:

100 TEAMSTERS WANTED—One hundred teamsters for the Plains. Apply at Intelligence Office on Francis St. between 2d and 3d

We were so sure of landing jobs at the Francis Street place that we voted to look elsewhere before signing up. Who knows, we thought, but that the frontier is crying for workmen? Why should we take the first offer? Wouldn't it be wiser to look the town over?

Billy had a letter of introduction to Tootle, Farleigh & Co., a dry-goods house, who also conducted a forwarding business; he would get the lay of the land from their angle. I had a profession of my own; I would get the lay of the land as the photographers saw it. Rock, who could hardly expect to find work cutting marble here, would just get the lay of the land. Somehow one of us would find a well-paying job that would enable us to eat and then appraise our futures on a full stomach.

Billy made his try first, while Rock and I hung around outside. In a little while he rejoined us. He informed us that information had been given him concerning the imminent departure of one Mr. Myers, with a wagon train, for Montana. We could meet Myers at 2 P.M. and see whether he had anything for us.

Punctually at two o'clock we presented ourselves at

the appointed place—only to find that Mr. Myers had departed with his wagon train some hours before. We gave Billy the fisheye; but he refused to accept responsibility for our failure.

Close at hand was the wagon depot of Woolworth & Barton, where a lot of teamsters were lounging about. We thought it could do no harm to have a talk with them. Up to this time none of us had noted the manifest truth that we were three of the strangest fellows ever seen west of Broadway. As we approached the bearded and booted teamsters the direct contrast suddenly opened our eyes to our own condition. Those teamsters were decent enough, I suppose. But we got no encouragement from them. What was the West coming to, they must have thought, when soft-handed, white-skinned dandies from the city wanted to take over the bulls and the mules?

That experience served one purpose, however; it hastened our visit to the intelligence office whose advertisement we had read just after breakfast. If we were such odd candidates, it might be well to get around there now and do a little talking before the roster had been filled.

At the office on Francis Street we had no trouble getting ourselves accepted. A number of trains were leaving from Nebraska City, up the river, early in the following week. The pay was twenty dollars a month, and found. The destination was Montana, the very place our hearts desired. Here was luck indeed.

But was it luck? At the end we learned that the fee for getting the job was $1.50 each, and payable in advance. We found no present comfort in the assurance that fees would be refunded by the employer; yet on the whole we were heartened. The boat wasn't scheduled to leave until early Sunday morning, and somehow we would raise the essential funds within the thirty-six hours that separated us from sailing time.

I still had the paintbox for which I had paid eight dollars in Chicago. Certainly in this busy town of nearly twenty thousand there must be at least one photographer who knew that my paints would be a bargain at five dollars. Off I went with the little black box in my pocket. But no one would buy. (If my luck at the time was miserably bad, I now consider it a happy failure. I still have that little paintbox. The paints have been renewed, of course, but the box I continue to use almost every day.)

The boys had nothing to report when I rejoined them, and at dusk there seemed only one course open to me: I must use my fraternal affiliation and solicit funds of some brother Mason. I had heard tales of lodge members who made a fair living traveling from town to town prostituting the pass-word, and of all impositions that one seemed the cheapest. Probably I hadn't become desperate enough; but, whatever the deterring factor, I simply could not bring myself to that point. When I told the boys I couldn't do it we all turned our pockets inside out. With the few coppers thus raised we bought another meal of cheese and crackers.

After a night in the railroad station—where we explained to a prowling watchman that we were "taking the next train"—we raised the stamps for some bread and coffee by selling my one spare shirt.

Again I took to the road with my paintbox, this time calling on the architects as well as on the photographers I had not visited the day before. Still there were no buyers. Shortly before noon, weary and wholly discouraged, I rejoined the boys. As I approached the meeting place Rock held up one arm and waved a piece of paper.

It was a five-dollar bill!

Back at the intelligence office Rock and Billy had spent the morning swapping yarns with other embryonic teamsters. None of them had owned to the possession of a

spare dime. Yet Rock's story must have been impressive;
for soon one of the men motioned him to one side. A
quiet, rather soft-spoken young fellow, this unknown
named Smith had fished into his pocket and given Rock
the five-spot. It was an act of spontaneous generosity that
has been equaled only once in my experience—an hour
later, when we had paid over the $4.50 to cover our fees,
this same Smith, without the slightest solicitation, gave us
another five dollars to buy provisions with!

When we boarded the steamboat *Denver* Saturday
night we found it loaded to the guards with Mormons
on their way to Salt Lake City. We teamsters were herded

together upon the hurricane deck, with strict orders not
to go below. That was all very pleasant and comfortable
during the night and in the cool hours after dawn. But
the climate of the Missouri Valley is not really agreeable
in late June. By noon we were soaked with sweat and be-
ginning to be sunburned. The boys started to slip below
for ice water. Soon all of us were circulating about the
main deck—and by no means confining our attentions to
the water cooler.

As all the world knows, the Mormons at that time
were a sect in whose religion and economy a surplus of
women had become an extremely important factor. Even
on the good ship *Denver* they had—or at least seemed to
have—their customary surplus. And soon most of the boys
in our party were trying for the attention of the extra
ladies. What is more, they were accomplishing their pur-
pose with no objection at all—except from certain male

members of the group who seemed to be running the party.

On Monday, after a night's partial sleep, with my boots as a pillow, I found my face and neck and hands fiery red. Rock and Billy, as well as many other paleskins of the day before, were equally burned. But we all believed it would be an advantage to have a little color from the sun when we applied for our places in Nebraska City.

In the afternoon the boat stopped briefly at Brownsville. But we were there long enough to enable Rock and me to "run up town where we eat a pie and drank any quantity of the clear, fresh water from the wells." Addicted as I was to the cheese and crackers we had eaten exclusively since boarding the boat, there never was a time when I couldn't slip in a pie or two.

At 2:30 A.M., Tuesday, June 26, we landed at Nebraska City. After disembarking we napped on steps and in doorways until daylight. Then an agent rounded us up and took us in a body to the Cincinnati House for breakfast.

After breakfast we were checked off—all very informal. Apart from knowing, in a vague sort of way, that the wagon train belonged to a man named Matt Ryan, we never found out anything about our employer; and the office, if any, never knew anything about us except our names and the date of our signing. But as soon as our sketchy pedigrees had been recorded we were led off to the company store to be outfitted for the plains.

We received according to our needs, some more, some less; but every new teamster started away from Nebraska City with a pair of blankets, a white rubber coat, shoes, stockings, pants, shirts, and an old-fashioned carpetbag— plus a Colt .44 revolver with a supply of cartridges. Our store bills averaged about $40 and were charged against our still unearned pay. At $20 a month we had a long stretch ahead before we could catch up. But if Matt Ryan didn't care, why should we?

After our equipment had been issued we went on foot, bags in hand, to the wagon camp, which was located in rolling prairie land some four miles from town. Arrived there, our first act was to prepare dinner: bread freshly baked in Dutch ovens, fried bacon, and coffee which I can only describe as hard-boiled. That was all; but it made up in quantity what it lacked in variety. After the meal the experienced hands inducted us into the mysteries of their craft, in hope, largely futile though it proved, that we would be able to make a little sense with the yokes, chains, and whips when the westward journey began at dawn next day.

The rules of wagon-train organization were the product of experience that had ripened long before our batch of greenhorns arrived on the scene. Always very elastic in practice, the standard prescription called for twenty-five wagons to an outfit. Just how that number had been determined upon is something I do not presume to know; however, I have some small opinions on the matter. Twenty-five wagons formed a compact unit, a "round number" convenient as a basis of calculation. That number was also just about right to be supervised by a single wagonmaster and his assistant. And very much to the point was the fact that twenty-five wagons required about the maximum number of oxen that could find enough grass and water within close range of a suitable camp site. This was so vital that custom forbade the joint encampment of two or more trains which might chance to meet at the close of a day's drive. (In the dangerous Indian country in Montana and upper Wyoming very large trains were not uncommon. But trains of two or even three hundred wagons were really eight or ten separate trains traveling close enough together to discourage attack; yet far enough apart to assure sufficient grass.)

The second major rule had to do with power, and experience had elevated the ox to the honor and duty of haul-

ing man's heavy goods many centuries before the great plains were discovered. An ox—within limits—is a docile beast. An ox can fend for himself wherever grass grows and water, however stagnant, collects in pools. An ox is less of a temptation to Indians than a horse or mule. An ox has strength and stamina. Twelve oxen can pull a wagon-load of seven or eight thousand pounds almost anywhere—and twelve oxen to the wagon became the rule. That meant three hundred oxen in active use with each "standard" train, plus about thirty substitutes to take the places of lame and otherwise ailing animals. For herding, horses or mules were used, at the ratio of one to every forty to fifty oxen. Thus a normal train consisted of 25 wagons, 330 oxen, and 8 or 10 saddle animals. (Ours had only horses.)

Boss of all this was the wagonmaster. Ours turned out to be a handsome gentleman named Ed Owens, with wavy, shoulder-length hair. But Owens, for all his tumbling hair and the leather leggings he rode in, was not only sound but one of the most patient men I have ever known. In a vocation resounding with profanity and explosions of bad temper he almost never raised his voice in anger; nor did I ever hear him berate even his slowest teamsters. He was truly a gentleman. His assistant, a man whom I can recall only as "Frank," was a figure from a smaller mold; but Frank, under the command of Owens, was at least endurable.

A wagonmaster was a very important man. First, he was responsible for valuable equipment and a still more valuable cargo; second, he was responsible for the safety of twenty-five to thirty men. On the road he was, of course, responsible for everything: time of starting each daily drive and its length, choice of camp site, selection of route (when an option existed), and all the innumerable, unpredictable daily troubles, which might range from a teamster with a jumping tooth to a dried-up water

hole. Usually he rode at the head of his train, either on a mule or his own horse, while the assistant wagonmaster supervised the progress of the train and trotted back and forth with instructions to the drivers.

So far I have written about "oxen" and "teamsters." From now on I shall refer to these creatures by their

stable names instead of their more formal stud-book titles. On the plains an ox was never anything but a "bull"; a teamster never anything but a "bullwhacker"—and in all the language there is no word that so exactly expresses a meaning.

We bullwhackers were a curious, mixed crew. Mostly quite young, several of us ex-soldiers, we had among us four or five middle-aged "professionals," men who dearly loved the hard life. But of the dozen or so lads who

came up with us from St. Joe not more than two or three
had ever seen an ox-drawn wagon before. Several of
the boys were of good address and obviously of some
education; a few had been farmers in Pennsylvania, Ohio,
Indiana and Illinois; four or five had been clerks in the
cities, like Billy; three of them were graduate roustabouts
from the Missouri River school; one was a French-
Canadian; and one, I carefully noted in my journal, was
"a genuine jack-of-all-trades from Boston." We were a
Foreign Legion in miniature.

Altogether there were twenty-five of us, one man for
each wagon. And besides Ed Owens and Frank, the
wagonmasters, there was the very necessary night-herder,
who took his ease while the rest of us drove, and the
equally indispensable clerk, who did most of his work
at the beginning and end of the haul—a total personnel
of twenty-nine men.

My practical education began at dawn on Wednesday
with the booming cry, "Roll out! Roll out!! The bulls are
coming!!!" In an instant the whole camp was alive with
swollen-eyed men stumbling over each other in light
which was just bright enough to distinguish features at
close range.

By that time the herder, helped by the bosses, had
rounded up the bulls, and ten minutes later the herd thun-
dered into the corral—that is, into the circular enclosure
formed by our wagons, tongues out, like this:

At once the work of yoking up began, and any green-
horn observer would have noted nothing more than a
score and a half of men each in indiscriminate pursuit of

enough steers to pull his own wagon. But, even though most of us were utterly inexperienced, we had already been told how exact the process was: Each driver had his own twelve bulls to identify, beginning with the "wheelers," then the "pointers," the "swing cattle" (three yokes) and the "leaders," six pairs in all, each of which had to be yoked and bowed and chained in proper position.

The late Alexander Majors has written that he once timed the procedure, from the corralling of the herd until the first wagon got under way for the morning drive, and that it took exactly sixteen minutes. The veracity of Majors is beyond question; but I am certain that the sixteen-minute record must have been hung up by a crew of expert bullwhackers coached to beat all previous times. Even after many weeks our outfit never did better than thirty-five or forty minutes—and we considered that an excellent job. It was no less than miraculous in comparison with our first try on the morning of June 27, 1866, when we required nearly eight hours and found ourselves weary almost unto death before we swung into line at high noon.

On that first day, and for the three or four days following, we made only one drive of nine or ten miles. Usual practice, however, was two drives, totaling perhaps fifteen miles. The camp would be brought to life as soon as it was light enough to recognize one bull from another, and with luck we would be on the road around 5 A.M. The first scheduled stop came about 10 A.M.—breakfast time for the bullwhackers and grazing time for the bulls. As soon as the animals had been turned loose preparations for cooking began. Four, five, or six men formed a mess, and in a moment half a dozen fires would be blazing, half a dozen coffee pots bubbling, and half a dozen skillets sizzling with bacon.

While a volunteer handled the cooking the other four or five in his mess fetched water and fuel. Supplies of both

these necessities were somewhat problematical. Often the available water would be satisfactory for the cattle but hardly suitable for the men; when that happened we either drank the warm, brackish water left over in kegs from the previous decent source, or faced the situation with the strongest coffee ever brewed. Fuel was equally uncertain. Now and then, if we happened to be following a stream, we could count on cottonwood for our fires; but there was little wood of any description to be found on the Nebraska prairies. Throughout our whole journey we relied almost entirely on "bull chips," that is, sun-dried ox and buffalo dung. When sufficiently dry and aged it was a truly excellent fuel; when wet it was terrible. We soon learned the trick of hanging gunny sacks outside the wagons and gathering chips as we walked alongside. When, as usually happened, we hadn't found enough en route a tumultuous demand for fuel arose the instant our oxen were unbowed. "Bull chips! Bull chips! Bull chips!" smote the sky in mighty chorus—and if our version on the plains was a touch more robustly Anglo-Saxon than I have indicated, we were uttering more than a mere vulgar expletive. We were voicing a real and immediate need: after food, water, and grass, the prime essential was fuel.

After breakfast we had our wagons to grease—every hub needed a liberal smearing every day. Then we could relax for an hour or two. That is, most of us could. The grazing cattle were never left without at least two guards, day as well as night. It was necessary, first, to see that they did not scatter in all directions; second, to be on watch for marauding Indians.

At two or a little later the herders would bring in the bulls for the second drive of the day, and then the dawn procedure of finding your own dozen and yoking, bowing, and chaining them into place would be repeated. Under way once more, we would continue, usually, until just

before sunset. Then camp would be made as before, the animals turned out for grazing, and the fires lighted against the preparation of supper—or perhaps I should call it dinner. That meal was a duplicate of breakfast: bread, bacon, and coffee (roasted in Dutch ovens, and freshly ground for each meal), with perhaps the addition of beans or dried apples. But, except when someone shot an antelope, a sage hen, or a jackrabbit, the endless sequence was bread, bacon, coffee; bread, bacon, coffee; bread, bacon, coffee. A modern dietician would go through the roof at the thought of such fare, and in late years I have sometimes wondered about it myself. But scurvy on the plains, while not uncommon, was seldom severe. And as for myself, I positively thrived on this unbalanced diet of heavy bread (often baked with saleratus instead of baking soda), bacon that was likely to be rancid, and black coffee for which we never had enough sugar. Yes, I sometimes wonder.

Matt Ryan's train carrying groceries, sugar, oil, whisky, and sundries was as trim an outfit as ever crossed the plains. In line with accepted practice, it consisted of exactly twenty-five wagons—but not the traditional prairie schooners, those immense, unwieldy conveyances which still typify the covered-wagon days to most people. Instead, we used Studebakers, Bains-Murphys, and Schutler's along with the latest Jackson "back-action" wagons (made in Jackson, Michigan)—two light, strong sections designed to be hooked together as a rolling unit. Such a wagon as the Jackson was far easier to control on grades and curves, and it had the additional advantage of packing a bigger pay load without increasing the gross burden of its 12-bull-power motor. (Its modern counterpart may be seen on the highways today: the tandem auto truck.)

More than thirteen hundred miles westward and north lay the enchanted land of Montana, where our cargo

and the hearts of at least three young men were consigned. Thirteen hundred miles! As we whipped our slow-footed beasts along the dusty trail, that distance might have been thirteen hundred light years. At the start Fort Kearny, a small fraction of the way, was the limit of our imagination.

During the first few days out of Nebraska City we made, as I have already stated, only one drive a day. And it was an utterly exhausting drive. Hours were needed for the operation of fitting three hundred oxen to the twenty-five wagons, and many hours more were needed

to cover the few miles to the next camp. Bullwhacking is an art not to be learned in a week or a month, and the animals knew our deficiencies even better than we did those first days. Only the voice of a master can make twelve bulls gee or haw with a single word. Only a cunning hand can make an 18-foot whip crack out like a rifle shot—or cut a notch in a lagging bull's hind quarter.

As if ignorance of the bulls and incompetence in pushing them along were not enough, we had an additional plague at the very start. A hot, dry wind blew continuously, choking us with dust and burning our faces and lips with powdered alkali. The older men had told us not to wash, and we followed their instructions. But no admonition was strong enough to keep us from moistening our lips unconsciously as we plodded on toward the

Valley of the Platte, and by the end of the second day every new man had a cracked and bleeding mouth.

Then there was the hazard of the whips. When a bullwhacker detects an off-pointer or a near-leader soldiering he snakes out his whip, and the buckskin popper at the tip whacks the loafing animal almost into the next county. But such a whip has a ferocious back-lash. A green driver can easily chop a piece out of his own person!

All in all, the first two weeks of this "adventure" on the plains was the severest physical hardship I have ever known, and every day I cursed the folly that had prompted me to throw up my well-shaped career in Vermont. There I had worked at most ten hours a day, doing something I enjoyed, at the princely salary of $25 a week. Here, stinking and sweating, I choked through fifteen, sixteen, seventeen hours a day at a task that maddened me—and they were going to pay me $20 a month!

The torture did not end with darkness. At the end of the day, my whole body aching, I would crawl to bed on top of the packing cases. As I lay wrapped in my blanket and far too weary to be kept awake by anything, the quantities of strong coffee I had just drunk nevertheless caused me to live through the day a second time by the nightmare route. And my dreams invariably centered upon the exasperating animals I had just loosed from their yokes. I don't know how the late Dr. Freud would interpret it; but, for twenty-four hours a day, seven days a week, my life was bulls, bulls, bulls.

But pain is seldom without compensation. After the high winds that baked us at the start had died down we were blessed with many days of clear, bright weather. It was good just to be alive in that glorious atmosphere. Cracked lips, swollen feet, and lame backs were all forgotten while we gulped in the clean morning air.

And there were things to think about as we whacked

our bulls up grade. We were seeing Indians now. Soon we would be in country where they were known to be on the warpath. Almost every day brought reports of fresh killings and scalpings west of Kearny. There is nothing like fear to take one's mind off petty physical discomforts.

Our first Indians were Otoes, a handful here and there. Just a day or two before reaching the fort, Billy had the honor of engaging in a personal "encounter" with an Otoe brave. As we were halting for the midday rest, half a dozen redskins galloped up and began their usual begging for "tobac." Billy accommodated one of the half-naked gentlemen by tossing him his chewing plug— whereupon the ingrate wheeled his horse and would have gone off with the entire pound had not Billy caught the bridle. Whipping out his Colt, Billy called the Otoe every name he had learned from the professional bull-whackers, plus several more he had brought with him from New York. He got back his property.

At the time we were all so engrossed in the humor of that little situation that we failed to observe a much more significant item of behavior. While Billy and his tobacco devotee were putting on their act another Otoe was rapidly circling the camp. After all of them had gone away the boss called us together. Owens looked at us for a long moment before he spoke.

"Indians don't drop by in this country for a cup of tea, gentlemen," he drawled. "Nor just for tobacco, *Mister* Crowl. But they sometimes do count up the men in a wagon train. That's one reason why you carry Colts. That's one reason why we've got a stand of carbines with us. Never forget it, *never forget it!*"

Owens didn't tell us that the Otoes were a weak tribe devoted to peace. But he never had to remind us again that warlike Indians were not necessarily confined to newspaper columns.

On July 11, after exactly two weeks on the road, we reached Fort Kearny, about halfway between Nebraska City and Julesburg, Colorado, our next great landmark. We had come 197 miles, at an average speed of fourteen miles a day.

When we pulled up for the night the military post was in clear sight, and I was eager to inspect the famous fort. But regulations forbade any encampment within a three-mile radius. Consequently it wasn't until the next morning that I got a close view of the barracks. Then we had only a moment to glance at things while arrangements were being made for us to continue westward in company with ten more wagons that belonged to the firm of Doolittle Brothers—the post commander's orders were that no train of less than thirty wagons should be permitted to face the dangers beyond Fort Kearny.

The road up the Platte to Julesburg was by far the pleasantest part of the whole journey. On a trail so smooth and level that the bulls seldom had to be driven hard we were often able to make seventeen or eighteen miles a day, and without tiring ourselves. Ordinarily we had to herd the animals along; but here—at least, when the boss was out of sight—we could ride the tongues much of the way. And when we halted at the end of a day's drive we had the river to bathe in. The shallowness of the Platte is notorious—"half a mile wide and six inches deep" —but even in late July it was cold, and who cared if it was muddy? As soon as we had unyoked the oxen all of us but the guards on duty would peel off our clothes and splash in.

But such outrageous ease was not to last long. When we came to the little settlement of Cottonwood a number of hands, lured by offers to cut ties for the railroad that was soon to come through, decamped without ceremony. With fewer than twenty drivers for our twenty-five wagons, there appeared to be at least a few days' rest in

the offing. But the appearance was a delusion born of optimism. Within five hours Ed Owens had picked up six or seven new hands at a near-by ranch—and the following morning we were on our way an hour earlier than usual.

The basic reason for those desertions (aside from fear of the Indians) was low wages, and there were constant murmurings and mutterings among all of us about striking for fifty dollars a month. Another source of dissatisfaction was the general laziness of certain individuals. The two most consistent loafers were Billy Crowl and our French-Canadian, whose name was Eugene. Frenchy got under my skin to such an extent that I consigned him to the everlasting hell of my journal: "He is without exception the most lazy, unaccommodating, hoggish, bullheaded person I ever saw."

But everybody was too busy during the day and too tired at night for any organized front to take shape. And on July 23, twelve days out of Fort Kearny, we were encamped just three miles from Julesburg, where we were to ford the South Platte. Then we were to swing up into Nebraska again, cut through Wyoming (still part of Dakota Territory), and finally reach Virginia City, Montana. Why strike? We were practically there!

That same evening, as if to reward us for our virtue in sticking by him, Owens promised to boost our pay from twenty to forty dollars a month. But it was not pure altruism that prompted the wagon boss; Ed saw that we would soon find out that his newer hands were getting forty. Bullwhackers weren't as plentiful up the Platte as they had been on the banks of the Missouri.

On Tuesday, July 24, we were up and away almost before dawn, and by eight we were passing through Julesburg (just rebuilt after its destruction by the Indians a year before) on our way to "California Crossing" three miles beyond. The village itself was a settlement of no more than a dozen buildings, half of them saloons and

dance halls; but it was a cheerful hamlet, after our weeks of dreary Nebraska ranch structures. There everything had been low sod houses, with flat mud-plastered roofs. Here we found almost a bit of New England—a few of the houses were actually shingled!

About ten o'clock we reached the fording place three or four miles past town. It was a great picture. The South Platte was about half a mile wide at this point, and on both sides were wagon trains preparing to cross, while the river itself was the scene of the heaviest traffic we had yet witnessed. Oxen bellowed, men shouted and swore, and the air resounded with an incessant cracking of whips. (I sketched what I could on the spot and, several years later, painted from those drawings the picture which is now owned by Mr. Guthrie Barber of New York.)

After spending an hour shifting our loads—all perishable goods had to be placed on top, just under the canvas—we prepared to plunge in. At best it was a difficult undertaking. The water was never more than three to four feet deep; but the current was swift and the sandy, gravelly bottom became quickly undercut if a wagon stopped for more than a few seconds anywhere between the banks.

Twelve yokes of oxen, instead of the customary six, were chained to each wagon; and, instead of one driver, ten or twelve of us were needed to start the reluctant beasts through the water. Then followed two hours of whipping, shouting, and heaving to negotiate a distance of eight or nine hundred yards.

The best I can say for it is that we were dressed for our task—or, rather, undressed. Some of the men crossed the river completely unclothed. But most of us were ludicrously costumed in hat and shirt, and nothing else. I don't know why anybody troubled about even that concession to modesty. Halfway across we passed a band of fifty-odd Indians, either Sioux or Cheyennes, heading

south. The braves, except for breech-clouts, rode their horses in a state of majestic nudity; the squaws, leading the pack animals, plodded or swam without benefit of any excessive drapery; and the children, from four to fourteen, splashed through the current in unconcerned nakedness.

By late afternoon we had taken most of our wagons across. Then, almost in a moment, the sky filled with black clouds and a strong east wind blew upon us. We were about to have one of the terrific thunderstorms characteristic of that country.

All of us were so tired that any kind of interruption was welcome. Then I suddenly thought of something: here I was on the north bank of the Platte, while every possession of mine except the clinging wet shirt on my back and the hat on my head was on the other side of the river. Pants were the immediate need of both flesh and soul; but, apart from revolver and boots—which some Indian or paleface would surely steal before morning—there were also my journal and sketchbook. Even if nobody removed them, they would be in grave danger from the elements.

I debated the folly of taking my chances over night against the even greater folly of attempting to cross and then recross the Platte in the darkness of a thunderstorm. Soon I compromised by finding myself some food; I had eaten nothing since early morning, for there had been no time to prepare a dinner.

After I had filled myself with fried sow-belly, bread, and coffee there was no need to decide what I would do: the storm was already upon us, with hail to punctuate the more conventional thunder, lightning, and rain. Since I couldn't return for my clothes and other belongings, I gratefully accepted the invitation of a man named McLain to bunk with him.

The storm grew more furious. Our wagon rocked in the gale, and it seemed that we must surely be turned over;

only the tons of goods under the cover kept us upright, and, at that, we were blown some little distance in our tracks. The rain beat down so hard that it came through the canvas roof as if it had been a sieve, and McLain and I took refuge under a great buffalo robe. There we were shielded from the water; but by morning we were as wet as if there had been no protection. A buffalo robe weighs a good thirty pounds, as I remember, and sleeping under it in July proved to be very much like taking a vapor bath.

Wednesday dawned clear. The rest of our train was with us well before noon, with the loss, from exhaustion, of a single bull—the first to die so far. To my great relief, I found nothing missing from among my belongings.

Inspection showed that a few of the wagons had broken tongues, and all of them, of course, required a thorough greasing. After we had made the necessary repairs Owens decided that both bulls and bullwhackers could profit from a rest. Accordingly, we camped where we were for the remainder of the day.

On Thursday we struck up Pole Creek and crossed it some five miles upstream. While we were preparing our dinner on the other side my old favorite Eugene, or Frenchy, provided all of us with a happy interlude. From the very beginning of our trip, this Gallic gentleman had been the camp bore, boasting continually of his prowess with the ladies. With the arrival in our midst of a Sioux family, looking for a handout of grub, we seized the opportunity to quiet him permanently—at least, on the topic of gallantry.

"Here's your chance, Frenchy," one of the boys whispered. "See that good-looking squaw over there? Well, all you have to do is smile at her. They can't resist Frenchmen, you lucky devil."

Frenchy, who was about five feet six with his boots on, and on the corpulent side, grinned lecherously and started to make eyes at the Indian woman. She, with or

without understanding his intentions, grinned back. Then she made a guttural noise. At that the lean and stalwart buck who was her husband seized Frenchy's fat arm, and the poor wretch turned the color of cheese long exposed in the sun.

"No, no, no, no!" he exclaimed wildly. "No want to. No want to. Not me. No, no, no!" Then he broke away and stayed on the far side of the corral until the Indians, well fed, had gone away. It was the only time Frenchy ever missed a meal.

For the next three days we did some steady climbing, and by Sunday, when we reached a small cattle outfit known as Louie's Ranch, our animals were suffering acutely. Not only was the pulling harder, but both grass and water were scarce.

The twenty-eight miles that lay between the ranch and Mud Springs in the North Platte basin were practically arid, and the only way to get the bulls over the intervening ridge alive was to drive them mercilessly. We succeeded—but only at the cost of going the whole route in a little more than twenty-four hours. When we came to the springs at 9 A.M., Monday, the agonized beasts were mad with thirst. We were fortunate not to lose a single animal. Perhaps the purity of the water saved them: despite its name, Mud Springs bubbled as clear and sweet as the Bandusian Fountain of antiquity.

We were now in a new and exciting country. The rolling plains and rounded ridges had given way to high

bluffs and sharply chiseled buttes. The yellows were turning into reds and saffrons, while the blues were becoming deep purples. And the air was so clear that the highlands to the west seemed almost within grasp. What deception!

On Tuesday we came to the banks of the North Platte and camped not far from the massive, square pile named Court House Rock. There I had time, my first opportunity in more than a week, to do some sketching. I completed two pictures of the rock. The following day, August 1, I was able to bring out my drawing book again, and this time my subject was the aptly labeled Chimney Rock. I also sketched my impression of another fierce thunderstorm that overtook us through here; and, a year or so later, I completed an oil painting showing how we shielded our campfire with a blanket while the rain beat down.

The western highlands were just as close as they had been two days before—and just as remote. Or so it seemed to the casual eye. But mine was not casual. If the heights were no nearer, they had surely become higher, and it was possible now to separate one detail from another. At thirty miles the bluffs began to take on the aspect of some fabulous city out of the Arabian Nights. At twenty miles I saw turrets and minarets. And at ten I could almost discern bearded Persian lords and their veiled ladies peering from the balconies! But I kept my visions of Scotts Bluff closely to myself.

On the way from the bluffs to Fort Mitchell I had no time for such walking reveries. The road was narrow and precipitous, and at one point I missed probable death by a hair. Going down a slight grade my miserable bulls suddenly swung into a tearing gallop, and in an instant the second part, or "back-action," of my wagon was halfway over the edge of the road, skidding on its axles, and threatening to drag with it the front half, all the bulls, and myself (since I was between them and the canyon

below). For once I could use my whip at full strength without a qualm. Frantically all of us fought to stay on top; and then, with a mighty heave, the frightened animals hauled the back-action up on to the trail once more.

When we camped a little while later the boss gave me permission to do some sketching for the rest of the afternoon. It was the last chance I got for some days.

At Cooley's Ranch, three days past Scotts Bluff and some five miles east of Fort Laramie, Wyoming, we were met by one of the owners of the train, a man named Everhardy. He made a complete inspection and culled out about one-third of our cattle, replacing the more emaciated beasts with frisky young steers fresh from Texas. It was a sound move, of course, with the most rugged country still before us; but the immediate result was almost a repetition of our first days out of Nebraska City. We were now fairly well seasoned teamsters, yet the labor of capturing, yoking, and bowing the green bulls was nearly as overwhelming as it had been six weeks before. On August 7, we got up at dawn, as usual; but it was almost noon before we could begin our drive.

I had been looking forward to Laramie, perhaps the most famous of all forts in the Indian country. When we arrived there, however, I found a number of letters from Troy, Rutland, and Burlington, and became so absorbed in them—my first mail since leaving the Middle West—that I hardly noticed the fort.

That same afternoon we began a steep and arduous ascent that kept us sweating, with double and even triple power, until five o'clock next morning. Perhaps my weariness, as well as the fascination of my letters, limited me to this remarkably banal comment in my journal: "Fort Laramie appears to be the best built fort we have seen so far."

In the Black Hills (now known as the Laramie Range) we ran across the Myers mule train, with which we had

tried to land jobs back in St. Joe. A day or two later, along the Big Bitter Cottonwood, a very large Mormon train passed us while we were repairing a broken wagon —and that naturally brought back the memory of our voyage up the river to Nebraska City. Billy, Rock, and I decided that the world was a very small place after all, even in the West.

We were driving on into ever higher ground. The road was rocky, and often steep. Trees were scarce; cedars and a few hardy pines were all we saw. But the hard country was not without its compensations. Sage hens and jack-rabbits abounded, and our skillets profited. After weeks of bacon, bacon, bacon, even the most venerable grandfather rabbit was a treat.

On August 10 we came to a critical junction. To our right lay the "Powder River Road," a new and very short route to Virginia City. To the left was the old road, across Horseshoe Creek, then almost due west past the ruins of old Fort La Bonté. It was 425 miles against more than eight hundred. It was also grave danger against comparative safety. The new way cut straight through the worst Indian country—so bad it was, indeed, that no train smaller than three hundred wagons was supposed to try it. Ed Owens decided—very sensibly we all thought, though few admitted it—to follow the safer, longer trail that would eventually take us up the Sweetwater Valley. Just a few days earlier I quite honestly would have welcomed the extra hazard—the death of a hero was still a charming thought to a young man firm in his renunciation of the world. Now I was not so sure that I would end my days in the wilderness, a cast-off lover. The stop at Fort Laramie had jolted some of the nonsense out of me, as the following little confidence in my journal will testify: "Since I received those letters I am beginning to think of getting around back home again."

Our route decided, we had ten solid days of hard trav-

eling before setting foot on the banks of the Sweetwater River. And much of the way required "double teaming" —twelve yokes instead of six—with all the extra hitching and unhitching and back-tracking that went with it. If it was hard on the men, it was literally killing to the oxen. Nearly every day we lost one or two from exhaustion. On top of this difficulty we now experienced the real distress of running out of sugar. This was doubly exasperating, with tons of the stuff on our wheels. But all of it was under specific consignment.

Some of the boys, Rock among them, met the shortage by raiding the earmarked bags. A few others, notably Bill Maddern, whose sister was the famous actress Minnie Maddern (mother of the even more famous Minnie Maddern Fiske), bought sugar of their own as soon as we came to Deer Creek Station on August 17. An index of the profits to be made in the business of overland transportation in the year 1866 is found in the price of sugar at this Platte River trading post: 75 cents a pound.

We camped perhaps two miles beyond Deer Creek Station, which was one of the few telegraph offices operating along the old stage line. On the morning of the eighteenth, just as we were rolling out, flames suddenly shot up behind us. A few minutes later the telegraph operators and a mail rider galloped by, shouting "Indians!"— a band of braves had swooped down on the station at daybreak and set the place on fire. At least three men were killed and scalped. The survivors were on their way to sound the alarm at the military post which lay just ahead.

For the first time since leaving Nebraska City all our Spencer carbines were brought out, ready for action. But we saw no redskins. Very soon, however, three six-mule-team army wagons thundered past us filled with soldiers. With them was a repair wagon driven by a couple of linesmen. It all seemed very matter-of-fact and well ordered: 1) Indians burn your telegraph office; 2)

you go for help; 3) help comes to destroy Indians; 4) repairmen right the damage. But it was a grim cycle— one that would be repeated many times and in many places for twelve or fifteen years to come.

At nightfall we came to Platte Bridge, site of the present city of Casper, and not many miles south of Teapot Dome, destined to be famous in a later day. We crossed at once, over the very finest—if only because it was the first—bridge we had yet encountered, a sturdy and workmanlike structure of logs. This was a noted spot, the scene of countless Indian fights. Near here Lieutenant Caspar Collins lost his life—and won the curious distinction of having his Christian name permanently misspelled. Several companies of cavalry were stationed here now, and many of these soldiers, I noted in my journal, "were very anxious to trade a little whiskey out of us."

On Sunday, August 18, we made the long, dusty descent to the foot of Red Buttes. The clouds kicked up by the bulls were so heavy as to render the first yoke or two actually invisible from the point where I ran alongside. Here the only course was to lock the wheels and pray that your wagon wouldn't crash into others that had already reached the bottom. But Owens had taken the precaution of stationing several men there to shout directions, and the only casualty was sustained by an Irishman named Ed, who had his foot trampled and painfully hurt. But since Ed, in a fit of magnificent Hibernian rage only two or three days before, had bitten through the ear of one of his bulls, we all rather enjoyed the spectacle of justice in poetic enactment.

Early in the following week, as we were approaching the Sweetwater River, a dramatic crisis arose. We were, as I have mentioned, out of sugar. Now the molasses petered out, and many of us were making no bones about digging into the supplies of sweets in our wagons. So far Owens had made no direct comment; but when we

camped on Tuesday he announced that all shortages would be charged against wages. That was manifestly unfair, since none of us had any way of checking against our original loads, and it would be a simple matter, at the end of the trip, to pay us all off with charge slips. Rock and a man named Gray, who had been the most open offenders, stood up and bluntly told Owens they would accept no such arbitrary ruling; that they had taken only as much as they had needed for their own use; that they were entitled to that much; and that Owens could like it or be damned. Then, before Owens could fire them, Rock and Gray walked out of camp, taking with them the outfits that had been charged against their wages at the store in Nebraska City. Owens tried to object. But Rock was no boy to be trifled with; he was an ex-soldier and he wore his two pistols with authority. So departed the first of the Three Musketeers.

On Wednesday morning some sixty or seventy cattle had strayed, and it was noon before we found them hidden up a coulee. By sunset, when we reached Sweetwater Station, Rock and Gray, who had gone on ahead with the Doolittle wagons, were already at work on a new job. Laughingly they told us they were now "telegraphers." But actually they were cutting and carrying hay for the telegraph company's horses, at $1.50 a day and their board. I genuinely envied them their new lot; but I had determined to let nothing block my way to Montana.

That night at the ranch house I enjoyed the enormous luxury of reading a newspaper—several back numbers of the *Salt Lake Vedette*. If only half the news printed about the Mormon capital were true, I thought, Salt Lake City would surely be a place worth visiting.

While I was musing, one of the ranchers slipped into a chair beside me, apparently, I reasoned a moment later, because I looked very young and green. In brief, he

offered me fifty dollars to "drop" a side or two of bacon
and a sack of sugar as we drove out of camp the follow-
ing morning. But Ed and Frank had already sized up the
place, like the old hands that they were, and decided to
stand guard that night at the corral. Otherwise I imagine
that the rancher would simply have helped himself, in-
stead of attempting bribery.

Early Thursday morning I said good-by to Rock. We
did not meet again, nor did I ever hear from him. Some
ten years ago, however, I learned that he had died in
Boise, Idaho, about 1890.

Our progress up the Sweetwater was not an easy one.
We had been losing cattle steadily. Not only were our
reserves gone, but no wagon was without at least one
limping bull. A few, indeed, were down to five sound
yokes.

On Thursday afternoon our underpowered wagons
passed through the shadow of Independence Rock, a great
landmark since the first Oregon train went by in 1830.
We camped not far beyond the rock, and almost as soon
as we had unyoked the worn-out beasts another of those
fierce thunderstorms struck. One of Doolittle's men was
hit by lightning and killed instantly. Next morning our
crew stood by while his comrades buried him and
marked the grave with a shingle found in one of the
wagons. I never knew the victim's name.

Through all this country the going was very hard.
Double teaming was the rule, rather than the exception,
and that cut our daily distances to a half or a third the
usual mileage. But we knew that the Continental Divide
was close at hand and whipped the panting bulls along.
And on Monday, August 27, a great shout went up as the
snow-capped Rockies suddenly loomed in the distance
beyond a little ridge. We hauled on till midnight.

Crossing and recrossing the Sweetwater, we saw many
antelope, and whenever we camped a few of us tried

to stalk one of the graceful creatures. But through here none of us ever succeeded in getting so much as a shot.

It was a great relief on Tuesday when we came to a steep hill that was actually going *down*. But the descent was not only steep; it was narrow, so narrow that we bullwhackers had to run along between the wheels to avoid the danger of being crushed against the high sides of the cut. After that it was a relief to be plodding safely upward again.

In this always rising land we were experiencing, even in August, a wide swing of the thermometer. From mid-morning until close to sunset we sweated almost as we had on the plains in July; but after dusk and all through the night and early morning the air was biting cold. When on the night of August 30 there was sleet and a brushing of snow I knew what the veterans had meant by their tagline: "In this country you'll find only three seasons—July, August, and winter." We were very fortunate to have gathered, at the recently abandoned St. Mary's Station, a large supply of neatly stacked pine logs. Bull chips at their best never sent up a blaze to compare with the fire we had that night.

Just at this time I was troubled by a most painfully sore mouth. The combination of long working hours, short, uncertain sleep, raw weather, and our abominable diet was undoubtedly the cause. But I didn't even hear the phrase "vitamin deficiency" until fifty or sixty years later, so I blamed my ailment on alkali water and too much soda and saleratus. Also, I found myself with a mad desire for sweets. My course was simple and direct: I changed from bread to flapjacks made of flour and ground oats (intended for the horses) and I cut into a hundred-pound sack of consigned sugar. If Ed Owens, or even Matt Ryan, chanced not to like it, they could go climb a tree—I wanted something that tasted good. I can

now report to the medical profession that oats and sugar cured my sore mouth within a week.

At South Pass Station, near the top of the watershed, we laid over most of the day to fix a broken wagon tongue and to build several yokes to replace hopelessly wrecked ones. Ed Owens bought a couple of telegraph poles for the job, and I have to confess that it was a pleasure to hang the rough yokes we chopped out of them upon the necks of a few bad-tempered bulls that had been troubling all of us. At South Pass, also, we encountered a company of soldiers bound for the East. All of them had goods that would have to be sold, exchanged, or abandoned, and for several hours there was a sort of Bagdad bazaar on top of the Rocky Mountains. The thing that puzzled me at the time was the universal desire for pistols among those well-armed men. I swapped my good one for a damaged one and $5. Billy Crowl got $7.50 for his, and an Army overcoat to boot—he also got "minkey" drunk.

It was either late on August 31 or early in the morning of September 1 that we crossed the Great Divide. With us at the time was the big Mormon train, which had again caught up with us at South Pass, and it was an agreeable trek we made together. The road was good and on the down grade now. The air at eight thousand feet was exhilarating. The Wind River Mountains, blue-purple and topped with snow, were a splendid sight. And the Mormon ladies were charming—at least, the two who rode in my wagon were. Those good people had been much more unfortunate with their cattle than we: so reduced were they that the women, after riding most of the way, had been compelled to walk. Unsuitably dressed and poorly shod for such rough hiking, they quickly accepted our invitations to travel in our better-drawn wagons. Possibly the presence of fair passengers on the wagon tongues slowed the progress of the train somewhat. If so, the quickening of pulses made up for it.

On the night of September 1 we all camped together at Pacific Springs, the first trading post on the western side of the watershed, and next day we reached the Little Sandy. There Owens reported buffalo—but after a hunt lasting several hours we found only a broken-down Mormon bull!

In camp on the third, Ed hired a couple of the Mormons to drive as far as Bridger. That set me thinking. It had been announced that our train was not going by way of Great Salt Lake, and the old fort was about as close as we would come to the place. In a flash—and for no assignable reason, except that I thought it would be easier to return to the East from there, by way of San Francisco!—I decided to go to Salt Lake. Montana, goal of my dreams these many months, dissolved into thin air.

When on the fifth the Mormon train took a short cut for Bridger I was still firm in my resolve. But I would wait until our outfit came to Ham's Fork before leaving— there was always the chance that Ed would change his mind again and drive to Salt Lake.

Before going to bed on September 6, I talked over the matter with Billy and Maddern and five others. It was now certain that the train would skip Salt Lake, and we were equally certain that we wouldn't. It was one of those things that no sensible person could ever explain—but then none of us was an intellectual mastodon.

I won an uncontested election as party spokesman, and on the morning of the seventh I stepped up to tell Ed we were leaving. At that our normally mild wagonmaster exploded in all directions. When he had goddamned us all to the deepest hell I waited for the other seven to take their places beside me. But I stood alone, except for Bill Maddern.

When Ed found that he had cowed all but two of us he really put on the pressure. First, he threatened to turn

Bill and me over to the military authorities. When that rather empty menace failed to move us Ed swore that such renegades as Maddern and Jackson would never be allowed to get through into Salt Lake City alive.

I can hardly blame him. We had no sufficient justification for deserting. Yet Bill Maddern and I continued to stand our ground, and the train went on without us. It was the last time I ever saw Billy Crowl. It was also the last time I saw "Samaritan" Smith, whose generosity in St. Joe had enabled me to land the job I was now quitting. (I had already paid him back the money he had advanced.)

After a few minutes Maddern and I picked up his trunk (my belongings were in the carpetbag that had been bought for me in Nebraska City) and hoofed it back a little way to a ranch house. Johnson, the proprietor, gave us directions to a stage station (along the old mail route) "about half a mile from here." As always, the half mile was on the conservative side. Maddern and I forded Ham's Fork three times and almost broke our backs under the trunk before reaching the station some three miles from Johnson's. There we instantly picked up a job putting up hay at a dollar a day. In addition, Collwell, the contractor, guaranteed our transportation to Salt Lake when we had finished the haying. After a really magnificent dinner of boiled beef, pork, potatoes, and coffee we felt pretty well pleased with ourselves.

Driving a hayrack was about the same as handling a wagon—bulls are bulls under all circumstances. But the work of loading the hay was as tough as any I've ever done. Between the daily grind and sleeping out of doors I got as hard as a blacksmith.

The work was tedious, however, after the constant variations of bullwhacking, and the three weeks Maddern and I put in around South Bend Station were notable chiefly for long hours and the unceasing complaints of

Collwell. When the time came for us to quit, this bad-tempered ignorant old Mormon welshed on our wages. We put no stock in his promises to pay us off "when I come to the city and get my hands on my money there"; however, we had been tided over and well fed.

On Thursday, September 27, Bill Maddern and I signed up, at a dollar a day, to drive with a fourteen-wagon train headed for Salt Lake. All in all, I enjoyed the twenty-two-day trip from South Bend into the Mormon capital. Ed Perry, the boss, was an easy-going wagonmaster, and that helped. I was approaching a goal of sorts, and that helped too. Most important, perhaps, to my well-being was the improvement in food. We still ate bread, bacon and coffee, of course; but as we began to edge into civilization, with it came fruit and vegetables and milk and eggs. Not cheap—apples, seventy-five cents a dozen. Not often. Not much. But, God, how good!

After two weeks on the road we believed we must be almost at Salt Lake, for James Byers, owner of the train, came out to meet us. But what might ordinarily have been a three-day drive stretched out into a week. Mid-October suddenly became mid-winter.

On Sunday the fourteenth, after two days of cold rain, snow began to fall. Next morning the storm increased, and the haul through Silver Creek Canyon became a terrible ordeal. Looking back now, it seems impossible that we should have got through at all.

Beneath two or three inches of snow lay mud; frozen in the morning when we started, soon it was beaten by hoofs and wheels into a stiff mush of hub-deep clay. One wagon after another would crush sickeningly down into this stuff and stick there. We coaxed and cudgeled the struggling oxen. We shouted and swore. When all else failed, four or five of us put shoulders and legs and backs to work, and we got the wagons through by pounding and yelling and heaving with all our united strength. Six

yokes were hopelessly inadequate. We were regularly yoking twenty-four oxen, at times as many as thirty-six, to each wagon, and the labor of unyoking, back-tracking, and yoking up again was of itself no small thing in the wind and cutting snow. My own wagon, an immense Studebaker, carrying almost five tons, was the most heavily burdened in the train, and early in the afternoon it stalled completely. We tried to dig it free, and to pry it up with makeshift levers; but it only sank deeper and deeper, and at last we abandoned it and went on. The last fifty rods of the drive took us up a steep grade slippery with mud; yet one by one the wagons crept through —all but mine and one other, which by now were not only bogged down but frozen in.

That evening we were all a desperate sight. Plastered with mud from head to foot, soaking wet, and shaking with exhaustion, we made camp at last, just before dark.

My moccasins (I had lost my boots) had lasted for about half the day. One thin layer of leather was not much protection in a knee-deep mixture of mud, snow, and ice, or for running over a crusted snowdrift, and by noon not even that one layer remained. Where there was no snow, I was stumbling over rough ground and stubbing my toes on rocks and pieces of wood, and when I examined my feet in camp I was astonished to find that, though they were badly bruised and completely numb, they weren't actually bleeding.

That was not the end of the day. The cattle had to be taken a good three miles down to the bottom of the hill, where they could find feed and shelter, and I had to help take them. There was absolutely no sensation in my feet; I felt no pain even on frozen ground and in scrubby underbrush half covered with snow. But when I got back to camp at ten o'clock, I was "completely used up for once in my life." I ate a little bacon, drank some leftover coffee, and turned in at once, still cold to the mar-

row, for the fire had gone out before I returned. I believe, though, that the lack of fire saved my feet. I have no doubt they were frozen, and had I been able to thaw them rapidly, I might well have lost them.

Next day, I was unable to move out of my wagon, and for two more days, through Parley's Canyon, my feet were so swollen and sore that I couldn't drive. But we were almost in, and on down grade my incapacity made little difference.

On the evening of October 18, as the storm died away, we corralled within three or four miles of Great Salt Lake. Darkness hid the city from view; but when morning came it was almost as if we had been magically transported while we slept. The air was clear and still. The early sun shone warmly. And beyond us lay the white houses and green trees of Brigham Young and the Latter Day Saints.

I felt well again, and I drove my oxen into the city.

ON TO CALIFORNIA

WHEN we reached the edge of town I noted to my amazement that the trees were still loaded with fruit. One of the other teamsters told some children that we were driving a "church train," and in an instant they were off filling their hats and aprons with delicious peaches for us. Still munching contentedly, we reached Main Street, where we unloaded our wagons at a small store. Then we drove down to the public corral and made camp for the last time.

We all slept late, and next afternoon Byers, the owner, came down to pay us off. There was a good deal of haggling about "extras" and "deductions" all around; but I think the low point of the bargaining came when Byers docked my wages two dollars to make up for time lost after I had frozen my feet in his service. In my whole life I can recall no single mean act quite the equal of that one.

Bill Maddern and I had already decided that we would operate on a straight partnership basis. Since he owned a decent suit of clothes, he undertook to do some preliminary scouting for jobs and to look into the matter of living quarters. It was just common sense for me to keep out of sight until I could make myself more presentable. My coat was the same yellow-black hand-me-down I had got in Detroit; my trousers were so patched and torn that I wore two pairs to avoid arrest for indecent exposure; my second-hand boots were squashed down and without

heels; and my hat was recognizable as a head covering only when I had it on. To complete the picture of a classic ragamuffin I now owned a curling tawny beard.

Room rents were very high. But after a two-day search, during which time we slept in our wagon (although the canvas cover had already been stored away for the winter), Bill found two rooms at thirty dollars a month. Since they were not available separately, we took them both—and hoped we could find a tenant for one of them

among our companions. Our furniture consisted of a small table, lent to us by the landlady; two blocks of wood for chairs; a sheet-iron stove that cost ten dollars, second hand; and such pots and pans and other utensils as we had been able to snag from the wagon or buy for a song. Our bed was the floor, with two blankets and one rubber cover.

I can't remember the address; but it was one of the East South Temple streets. And for ten days or so we lived quite contentedly there, Maddern and I, and, after a day or two, another ex-bullwhacker named Wilson. All the food we could eat came to less than a dollar a day for three, and after the dreadful monotony of wagon fare we felt we were living on the fat of the land, with beef, mutton, pork, potatoes and bread. Instead of butter we bought "valley tan" molasses (sorghum) at fifty cents a quart. Flour cost six dollars the hundred pounds and potatoes were one dollar a bushel. But beefsteak was really cheap—fifteen cents a pound—and after months of greasy bacon we gorged ourselves on good red meat.

Wilson soon found a job, but Maddern and I had no luck. After getting a haircut and shave I felt a little less diffident about looking for work; however, no paint-shop or photographic studio needed any help, and at the start I didn't try any other fields.

We wondered whether Salt Lake City was the place for us. Now that we were in Utah, California suddenly took our fancy. Both of us wrote letters home asking for money to take us there.

In the meantime what little we had was going fast. By the end of October we were down to flour and potatoes. Then on the thirtieth Bill found a job on a farm, at the usual dollar a day. He would try to get me in with him.

On Sunday, November 4, Bill came up from the country to inform me that I could start work the following

Thursday. He left me a dollar to eat on. Rich again, I went out in the afternoon to watch a sham battle between two regiments of Mormon militia, about two thousand soldiers in all. It wasn't so sham, to judge by the numbers wounded; but everybody had a beautiful time, including all the wives and children.

A couple of days later I had a double stroke of luck: first, I rented the rooms to four miners down from Montana; next, I sold our stove for ten dollars (just what it had cost) to the new tenants. After that fine piece of business I bought a good dinner and then took in a play, two in fact—*Plot and Passion* and *Sketches in India*—at the commodious Salt Lake Theater that had been built in 1859. Mr. and Mrs. Irwin were the stars, supported by an all-Mormon company. But seated in twenty-five-cent nigger heaven I saw rather less of the stage than I did of the theater itself, a well decorated auditorium with three circles above the parquet, and two richly carved and gilded stage boxes. One of the boxes, usually occupied, I was informed, by Heber C. Kimball, was empty. In the other I recognized the bushy beard and solid features of Brigham Young himself. Inordinately fond of the theater, the patriarch was attending the play practically alone: only three of his twenty-odd wives sat behind him.

On Thursday, as arranged, I went down to Birch's farm, about four miles south of the city in Mill Creek Ward. Birch was a stooped and wrinkled Englishman, industrious, amiable, and totally illiterate, who perfectly exemplified the sturdy peasants imported by the Elders to develop the land without questioning their authority or the doctrines of the church-state they ruled. He had one wife about his own age and two others young enough to be his granddaughters. Three very young children and a maidservant completed his household.

Birch was engaged in building a new barn of adobe.

Bill and I spent our days tearing down an old structure, carting the sun-baked bricks to the new site, and helping the old man lay them. Our evenings were passed in the kitchen with the family, all members of which were impressed with our vast learning. Bill read aloud with considerable effect, and after supper he would give what amounted to a command performance from one newspaper or another. I remember in particular his impressive rendition, from the *New York Ledger*, of a lurid piece entitled "Britomarte the Man Hater" (based, I believe, on Book III, *The Faerie Queene*). My contribution to the inner life of our employer's family was a group of portrait sketches.

Within a few days of my arrival Bill and I met several other Mormon families. Elder Ephraim Scott, a near neighbor of Birch's, had a waterwheel to be erected; and, as at a New England or York State barn-raising, the whole countryside rallied round. After a score of able-bodied men had heaved and strained for half a day the new wheel was in place, and then all of us, with a great mass of wives and offspring, swarmed indoors to partake of the feast prepared and served by the four Mesdames Scott in their adobe-walled, earthen-floored kitchen. I was much impressed by the attitudes of reverence while the blessing was being invoked. The Mormons present were a rough and matter-of-fact lot; but all heads were bowed and all tongues stilled during grace.

After a few days we saw Elder Scott again. Brother Birch's little boy Francis was desperately ill of a fever, and the elder's assistance was required for the ceremonial

"laying on of hands." While Mary Ann, the sick child's mother, stood close to the bed, with the rest of us well in the background, Scott and Birch approached. First they poured a few drops of oil on the boy's head; then, with their hands touching it lightly, they rebuked the illness and sternly commanded all disease to be gone. After a long prayer everybody withdrew but the mother; then the elder informed Bill and me that, by virtue of Brigham Young's direct communion with God, young Francis would be well again by morning. And in the morning young Francis was as bright as a new dollar. Bill and I were astounded; but the Birch family accepted the phenomenon as a commonplace.

A few weeks later Elder Scott spent a long evening in the Birch kitchen, and I am sure the purpose of his visit was to convert Bill and me to Mormonism. After a general discussion about livestock and produce and prices— Mormon faith and Mormon economy were always inseparable—Elder Scott opened his Bible and read us, from the Apocrypha, the eleventh and twelfth chapters of Esdras. Most of the details of that prophecy have long since slipped from my memory; but I recall very positively that things didn't look any too rosy for the world at large. According to Mormon teachings, those two chapters had to do with the United States: another great sectional strife would come, and after mutual extermination the Mormons would take over the management of the whole country. All this was scheduled to happen during the administration of the twentieth President. Then the "Lion"—Brigham Young, of course—would rule; the Millennium would come to pass; and God's Chosen People, the Mormons alone, would be present to enjoy it.

But Bill and I were much more impressed by the conversation of Mr. Brown, one of Birch's three fathers-in-law. This gentleman had been in California, and from his descriptions that state sounded immeasurably more agree-

able than all the Lion's kingdom. And it cost next to
nothing to make the trip: empty mule trains left for Los
Angeles every two or three days, and passage could be
arranged for as little as $10.

Early in December my clothes arrived by express from
Troy, and Bill and I received, almost at the same mo-
ment, $100 apiece from our families. Even the prospect
of employment by Savage & Ottinger, Salt Lake pho-
tographers, wasn't enough to hold me back from the land
of perpetual summer.

Now that we possessed the wherewithal, we found our-
selves in no hurry to depart. Farmer Birch's barn was
finished—but he had urged us to stay on as his guests as
long as we wished. He liked our company. I entertained
him with my painting, and Bill Maddern more than paid
for his keep with his daily readings aloud. We could
come and go as we pleased, and it gave us a wonderful
opportunity to see the great city that the Mormons were
building.

We took baths at Hot Sulphur Springs. We visited the
Tabernacle and the Temple, both of which were far from
finished. We attended services in the "Bowery," an open-
air enclosure, and heard the "kire" rehearse its Christmas
Eve songs, while one Brother Bailey exhorted the ladies
to work without stint to "make a party." We bought a
rifle. We made sweet music, Bill on a cornet, I on my
flageolet. We had our pictures taken at Sutterly's—$4 a
half dozen. We played euchre and draw poker. And every
once in a while we dropped in at Wimmer's Exchange for
a snort of red-eye.

Shortly before we started on our way to Southern Cali-
fornia I took a walk by myself and encircled "Brigham's
Wall." Here sentries were always on duty, guarding the
government offices, schools, and workshops within; the
Mormon "White House," the all-important Tithing Office,
and the printing house which published *Deseret News*,

said to be edited by the patriarch himself. Everywhere the beehive coat-of-arms was visible—but over the door of the leader's "seraglio" there was a huge lion, and nothing more.

This sort of thing was all very pleasant, and no doubt very instructive; but within a few days Maddern and I noticed that our immense capital of $200 was melting like snow on a hot stove. On the impending trip we were not only paying to ride, but feeding ourselves en route. The fare from Salt Lake to Los Angeles was a staggering blow. Mr. Brown's guess of $10 had been absurdly optimistic. The best we could do was $30 apiece, with a man named Ed Webb—all wagonmasters in my life were Ed. Blankets, cooking utensils, coffee, sugar, a seventeen-pound side of bacon, a hundred-pound bag of flour, and sundries took almost $50 more. Our rifle and ammunition came to $25. Living expenses meanwhile had eaten up practically all the rest. When the last bill was paid we had $8 in cash between us—$8 to start life in California, and that much only if we spent none of it during the six weeks it would probably take to get there. Heigh-ho! we thought, and I suppose it was as sound an attitude as any.

The Webb train was scheduled to leave on December 20, and old man Birch saw us on our way from his farm with an immense bundle of food prepared by his wives; upon opening it later we found molasses, preserves, beans, onions, potatoes, cooked meats, and enough bread to last us a week. Bill and I hated to leave that kind family, and I know they all felt a real affection for us. When Birch awkwardly bade us good-by he said: "Don't thank me for nothin', boys; there's only one thing I wish ye'd leave with me, and that's yer larnin'."

When we reached the wagon depot in the city we found that our departure had been postponed twenty-four hours. Next day another delay held us up, and it was not until noon on December 23 that the train hauled out.

Once under way, however, we made good time. Seventy-four years ago there was no freight going out of the Rocky Mountains, and our wagons were empty except for personal effects and the straw provided as bedding for the passengers. The mules moved out briskly, and when we camped for the first night we were more than twenty miles south of Salt Lake.

One of the things I had been looking forward to on this trip was sketching. While crossing the plains I had seized every opportunity; but most of those drawings were done hurriedly, in the form of notes, really, and had to be completed during my stay at the Birch farm. Now I could arrange to keep the "models" before me and do more finished work on the spot. Accordingly, I started off on foot early on Christmas Eve, walked several miles, selected a pleasing view of Utah Lake and set to work. When the train passed me, I kept right on, stopping only in midafternoon when I calculated that a stiff hike would bring me up with the wagons about the time camp was being made. This system worked so well that I followed it almost every fair day thereafter, and by the time we reached Los Angeles at the end of January, I had a sizable portfolio to record my trip down through Utah, across the northwestern tip of Arizona, the lower end of Nevada, and Southern California.

On Christmas Day I sketched some more; but I knocked off early to get ready for the festive dinner we had planned. Bill and I had already made some agreeable acquaintances, and we had decided to form a permanent mess with three of them. The oldest of the trio was a jolly ex-sailor of fifty-odd, known to all as Uncle Billy, who was overflowing with tales of the seven seas and ready to do a nimble hornpipe at the pop of a cork. One of his cronies was Fred Gibbons, a Fenian, who had worked as a miner from Canada to Mexico. The other had spent fifteen years in the Regular Army; he was simply "Ser-

geant" to everybody. His hair was sprinkled with gray, and in my journal I set him down as "a hale and hearty old fellow of about forty." Maddern and I had liked all three from the first moment, and after we had seen their behavior in adversity we knew they would stand up as traveling companions. Soon after leaving Salt Lake the wagon boss told them the horse with which they had paid their fare was dead. Except for some $7 they were penniless; but, without any complaint, they turned that over, plus an English bull's-eye watch owned by Sergeant. Our association, beginning with Christmas dinner of warmed-over steak, fried potatoes, bread, preserves, and coffee, remained firm and friendly to the end.

There were half a dozen other paying guests, a crew of twelve or fifteen drivers, Webb, boss and part owner, and his wife, the lone female in the train. Mrs. Webb was an amazing woman. Within a few weeks of child-birth, she still walked most of the way by choice, cooked for her husband's mess, attended to many little chores, and then sat up half the night singing and playing euchre or cribbage—a true pioneer woman, I suppose. Her husband was good-humored and easy-going (traits that seemed to be the earmarks of a successful wagonmaster), a man who loved his bottle and who loved to share it. As we drove south, native wines became plentiful, and there was seldom a stop where Webb failed to stand a round of drinks. Most of the men were willing winebibbers, while two of our companions, Ed Towns and a man called only Lousy Al, managed to get falling-down drunk almost every night. (If anyone should think it strange that the Mormon country should have been so flowing in wine and ardent spirits, I can clear up the matter: the Mormons, in theory, at least, frowned upon drinking; but they had no objection to liquor, especially when the gentiles within their gates were drinking it and paying them for it.)

All this country, new as it was—it had been settled for only some eighteen years—was prosperous and thrifty. Brigham Young's economy was planned for general comfort rather than the enrichment of the individual settler. No real poverty was allowed to exist (all the travelers of the time noticed and commented on this), and no one was encouraged to build up a large estate. The system seemed to work, judging from the attractive settlements and well-cultivated lands through which we passed.

The end of the first week found us in the town of Fillmore, about halfway down the state. Here some of the early arrivals wished to set up their temporal capital, and they had gone so far as to erect a state house. But Brigham Young had vetoed the idea of separating church from state, and the unfinished structure of red stone was being used partly as a school and partly as a telegraph office when I first saw it. Chancing to arrive on a Sunday, some of us attended a Mormon meeting that evening. After prayers business was discussed, and the business had to do largely with a dance to be held the next night, New Year's Eve. One brother pointed out that it would have to be a "bull dance," that is, one without instrumental music, for the sufficient reason that there wasn't a fiddle in town. To this a second brother objected strenuously—not because he could dispute the fact, but because the term "bull dance" outraged his sense of propriety. The first brother thereupon responded with magnificent scorn that he could talk of a bull fence in meeting and saw no reason to be delicate about a bull dance.

The festivities in Central Utah that saw out the old year and ushered in 1867 were perhaps less sophisticated than those which attended 1940's arrival in the Rainbow Room. Yet they served. And they were still in progress three days later, if my journal entry, written some months afterward from scattered notes, may be offered in evidence:

JOURNAL

Thursday, January 3, 1867. No hurry getting off. Webb, who had remained behind to attend a ball at Fillmore, came in before we started. Drove only to Beaver, some six miles, and camped on a vacant space in the village. Blustering and stormy afternoon, with an occasional spat of snow. Very vexatious time baking. Good many of the boys drunk and quarrelsome. Felt ugly myself and suppose the rest did. (Mustn't infer from this that I was drunk.) In the evening there was a dance at the dedication of a new brick church—free, so most of us went. Many of the boys remained until the small hours of morning and had a huge time. Reuben, a comical Yorkshire lad, still retaining his broad accent, particularly distinguished himself. Males and females were obliged to keep to their own side of the house, as in a Shaker meeting. An introduction was an unthought-of thing. Shook hands vigorously to salute partners. All kinds and conditions and customs of people were there—mothers with extremely infantile progeny; homespun in all its varieties; cowhide boots with pants inserted; and language very far from polite ...

Two days after our whirl in Beaver we camped in Red Creek, a stopover that was distinguished by perhaps the most offensive pun of my career—but one which gave me inordinate satisfaction and which I wrote to most of my friends in the East:

JOURNAL

Saturday, January 5, 1867 ... The settlement and creek are well named. Everything is red—the earth, the rocks and the water. The adobes that the houses are built of are red. Red cedar is used for wood work and fences. But I am sorry to say that the natives are not (well) read.

Next day we reached Cedar, near Zion Park and Bryce Canyon (as yet unknown to travelers); on the seventh we passed through Kanarra (rather slowly, since Webb, Towns, and Lousy Al carefully investigated the grape vines they saw growing over many doorways); and on

January 8 we crossed The Rim. We were now in cactus country, in the "Dixie" of the Mormons. Here, we had been told, snow never fell; but the first thing we found below The Rim was a band of Pah-Utes tracking rabbits over a fresh white blanket.

Five days later we crossed the Rio Virgin, near the Arizona line, and now we were edging upon real desert land. On the seventeenth we entered the Valley of the Vegas, not many miles from the great Boulder Dam of today. Then came the Mojave Desert, land of hot red sand, land of the "Joshuas," those twenty- and thirty-foot cactuses which are the most distinctive features of that entire landscape.

On January 28, after the descent through Cajon Pass, we had a distant view of San Bernardino. That evening we camped at Cocomunga Ranch, again in green country, back in civilization where a man could get drunk sitting in a chair. The wine was excellent, and we played cards for it. At $1.50 a gallon much was won and lost— but all was put where it would do the most good.

Early next morning I dreamed I was back in Virginia along the Bull Run. If the fumes of wine are given part credit for the phenomenon, I am in no position to argue the matter. But it is still my belief that a bugle announcing the arrival of the stage for Los Angeles had more to do with it. I sprang up instantly and drank in the fresh, cool air, while the birds sang in the beauty of the dawn.

We were off ourselves not much after the stage had pulled out, and by dark we were only a day's journey from the city. On the thirtieth we camped within two miles of our destination, and early on January 31, I walked across the Los Angeles River on a narrow log footbridge.

Los Angeles, a town of less than 5,000, had in 1867 all the charm it lacks today. Single-storied Mexican houses were almost universal—the genuine article, not a professional booster's Spanish nightmare. Orange and lime

trees lined the streets, and traffic was sparse and slow-moving. Los Angeles was honestly quaint, rather than merely blatant.

After a visit to the post office, where I was depressed upon finding no letters, I looked up the Café Français in time to join Webb and most of the boys. Next I bought a newspaper—for two bits—and found that greenbacks were accepted only at a discount of 25 per cent. I also found, when I sold my rifle a little later, that the discount was inoperative in *my* direction. But I was nearly flat, and I made no objection when a gunsmith handed me $18 in folding money—which meant that I was getting, in purchasing power, $13.50 for a gun that had cost me $20 in Salt Lake City. I used part of it to pay my way into Lee & Ryland's Great Cosmopolitan Circus in the evening.

Bill Maddern, still my partner, tried for a job in the band after the performance; but there were no vacancies, even for such a trumpeter as Bill. As for myself, I feel that the following line from my journal will come as no surprise: "Made no effort to get work myself, as I want to get up to Frisco as soon as possible."

The best way to San Francisco was by sea, and the nearest port was Wilmington, some fifteen miles to the south of Los Angeles. Webb was obliged, by the terms of our arrangement with him, to take us to the very edge of the coast, and we set off on the morning of February 2. I remember one circumstance of our drive very clearly: as we approached the marshes the sky suddenly grew black with birds—tens of thousands of geese—and the air whirred as I have never heard it since.

We passed through Wilmington's single street a little after noon, and I noted a substantial government building, with several squads of soldiers standing around; the Wells-Fargo office; a hotel called the Wilmington Exchange; and "a couple of quite respectable saloons." But

no ship was in sight at the long wharf which reached out into the bay.

Back in town at one of those saloons, we learned that coastwise vessels rarely put in at Wilmington. When everybody told us to try for passage at San Pedro, we hoofed it to that port, a couple of miles beyond. There the news was bad for us: the only ship in the harbor, a schooner, had no room for passengers—how we would have paid the fare never mattered—and wanted no seamen. We returned to Wilmington, determined to strike north on foot.

After riding back to the city by stage (which took my last dollar) I loafed around under Webb's hospitable, if ramshackle, roof for the best part of a week. On February 11, after leaving a small surplus of chattels in my host's keeping, I started off on foot for Clear Creek Mines, with Maddern and a lad named McClellan. Our combined capital was $1.57.

The first night out we slept under the stars, in what is now the Hollywood Bowl, and for forty-eight hours we lived on my old familiar delicacy, cheese and crackers. The third evening found us at a ranch belonging to one Major Gordon, eighty miles above Los Angeles. Here we built up our nerve to ask for a handout—I didn't learn until much later that in the ranch country any wayfarer is always welcome to hang up his hat at mealtime. We were received hospitably and given a solid meal, and then they told us that a bull train up the road was short one driver. Before dawn we were on our way to find a berth for one of us. When we caught up with the outfit Bill and I told McClellan the job was his if he could make the grade—which he did without any trouble.

Bill and I pushed on, carrying our bundles on our shoulders. Crossing a broad valley grown over with sagebrush and cactus, we saw a sizable herd of cattle off to our right. Then we noted that the animals were moving

toward us. Soon the thudding of their hoofs had increased to an ominous rumble, and we realized that the longhorns were preparing to stampede. With no mounted herdsmen in sight to cut them off, Bill and I would have to stop them—or else.

We shouted and waved our hats and jumped into the air. On came the herd. We yelled and whirled our coats and jumped even higher. Still they came on, until not more than a hundred feet lay between the animals and ourselves. Then the herd leader, a black bull, slowed. At fifty feet he was dubious about continuing—but the pres-

sure behind forced him to within fifteen or twenty feet of us before we felt even moderately safe. Taking no chances, we continued our dancing and shouting until we had turned the whole herd to one side. (Some years later I read with peculiar understanding an account of General Stephen W. Kearny's march from Santa Fe to San Diego during the Mexican War. On one occasion his column was attacked by wild cattle, and it was necessary to slaughter them indiscriminately to save horses and men from being gored to death.)

At Twenty Mile Ranch, a few miles beyond, Bill and I were welcomed to another free meal. After dinner and an exchange of ideas with our hosts, old Mr. and Mrs. Ward

and their son Nels and his wife, we offered to go to work. Ward said he could use one of us, and Maddern at once withdrew in my favor, insisting that he would rather take his chances on getting work at the mines. When he left next morning, I gave him a cheap watch I had managed to hang on to since Salt Lake—if he got hard up, he could sell it; if not, he could return it some day. Bill and I exchanged letters for a while; but we never met again.

The Wards were pleasant people, who had come to California from New York; that common starting point helped to make our association a little easier at the outset. But the life at their place was one of unbroken toil, and the six weeks I spent with them would have made almost any other job a rest cure by comparison. Twenty Mile Ranch was a stage station and roadhouse, and that meant an unpredictable number of guests arriving at the most unpredictable hours. Somebody was always hungry. Somebody was always wanting to go to bed—or to get up. Usually the house was filled to the rafters, with never less than two persons to a bed. Often an overflow slept in the barroom, or in the barn. It was all a pretty mad sort of existence, both for hosts and guests. But on the edge of the Tehachipi Hills, with a good stretch of desert to the south, the guests had no choice but to take things as they were. The four Wards had none either—they owned the place. As for myself, I was very happy to be eating regularly and to be building up a little capital against the future.

I cut wood (cactus and sagebrush only), made the fires, hitched and unhitched the mules and the horses, fetched water, loaded and unloaded baggage, milked the cow, dug ditches, built fences, shod horses, plowed the scrawny garden, and helped to set out row upon row of grape vines. I also became the staff artist; both Nels and Mrs. Nels wanted pictures of themselves and a full set of drawings of their little domain. I even found time, now

and then, to practice with the bow and arrows I had bought from a visiting Indian. If I ever had an idle moment, there was always John Bright to look for. John Bright was a boar, and despite his size, he managed to get lost nearly every day.

Meanwhile I had decided against going on to the mining country. All reports were so unfavorable that I was soon thinking about a quick return to the East. Troy and Burlington, and perhaps even Rutland, would look pretty good again.

When at the end of March a man named Ned Carl came through driving an empty wagon to Los Angeles I quickly arranged to ride down with him. Ward had known about my intentions, of course, and without any haggling he paid me the $33.50 due me. Two days later, on March 30, I was back in the city having supper with Ned Carl and his pretty wife. And that night, like any man of substance, I registered with great assurance at the United States Hotel. "Think I shall stay at the hotel as long as my money lasts," I observed in my journal next day. "One feels perfectly independent as long as he can run his fingers through a few gold and silver coins in his pocket."

The following day I went out to call on Webb and his wife, whose baby had meanwhile been born. We three took a drink or two of wine from a gallon jug, and then Webb told me such gossip as concerned the boys who had come with us from Salt Lake. When I heard that Jim Begole, an agreeable lad from Michigan, was about to start east with a drove of horses I pricked up my ears. That sounded like something for me.

I located Jim on the range a few miles south of Los Angeles and asked him whether he could give me a job. Jim said he was willing enough, but that Sam McGannigan was the man to see. For the next two weeks, during which time I spent the rest of my silver and gold, I went

daily to visit Jim at his wagon camp. I thought it could do no harm to learn something about horses while waiting for Mr. McGannigan to appear, and, naturally, I picked up a bit of lore. These animals were tough little broncos and mustangs, descended from the Spanish stock that had been accidentally introduced 300 years before. A wild lot, most of them could be bought for from $6 to $12; exceptional horses were worth $15 to $20. With a little capital, a man could pick up a string, drive them to the Missouri River country, and make from 100 to 300 per cent on his investment.

But I nursed no ambitions to be an entrepreneur. All I wanted was three squares a day and transportation in the right direction. The lofty ranges of the West were very fine indeed; but at the moment I longed for the restfulness of the long, low ridges in Vermont called the Green Mountains. I noted in my journal that "a band of bell-ringers played several old familiar airs in front of the hotel, making me feel quite homesick." And the next day, Sunday, April 14, just ten days past my twenty-fourth birthday, I dolefully observed the first anniversary of my departure from Burlington. Optimistic as I was, I couldn't help but wonder whether the year had done much to build my "career."

Two or three days earlier I had met Sam McGannigan, a bony, loose-jawed individual of thirty-five or forty. With no enthusiasm he had told me that there might be a place for me when he was ready to start. But nothing happened until April 15. Then, without committing himself beyond the moment, McGannigan announced that there was a little work to be done at camp:

JOURNAL

Monday, April 15, 1867. Went down to corral about seven. Sam came a little later and made propositions to brand some mules he had sold. Lassoed them quickly and soon had them

branded. They were wild devils and gave me a great tumbling over the ground—busting my breeches and skinning my knees. Took the whole bunch out again on the hillside and kept them there all day. Had a great time with a wild stallion that ran into our herd making trouble and we had to corral the whole bunch and catch him. Brought them all in early. Sam is out gathering another band so as to make one camp for all.

Little jobs like this kept coming along for two weeks more. They knocked the knees out of my trousers and the toes out of my boots. They took pieces out of my hide. And they paid me nothing at all—except the $5 Sam advanced to get me out of hock at the United States Hotel. But they got me a place. On April 30, we loaded up McGannigan's wagon with our belongings and camp supplies and prepared to leave for the market in Omaha 2,000 miles away. Our party, besides the 150-odd horses we were driving, consisted of Sam, Jim Begole, Johnnie, the young wagon driver, and myself—and myself only by the grace of God:

JOURNAL

Thursday, May 2, 1867. All hands up early and began packing for a final getaway. Kellar, the party who wanted to go with us, came out early and we all went off together. Had some fun with Johnnie in his experiences with a bucking horse. I rode a wild bald-face bay. Got along all right until within a mile of Mud Springs. I noticed the cinch had slipped back too far under the horse's belly, and I dismounted to tighten up. Had hardly touched the ground when he gave a snort and a sideways jump, jerking the rope from my hand and snapping off the bridle rein. And away he went out into the sage brush, the saddle turning under his belly the first thing and then dragging out behind his heels until it was pretty well demolished. Two or three of the boys rode after him . . . Picked up all the pieces and then rode into camp on Sam's horse. Felt sore over the mishap and saw that Sam was much displeased.

In the evening after supper he brought up the subject by saying that he thought it would be very unsafe for me to go through on this drive, as all the horses were Spanish broncos and had more or less of the devil in them—and there was no telling what accidents might happen to me, my neck or something else broken, and it would be bad for all of us; and he thought it would be for my interest as well as his own that I should go no farther...All of which I silently accepted without protest and began at once to think out some plan by, which I could reach San Francisco.

Friday, May 3. As we were hitching up in the morning Sam came to me and said that he disliked to put me to any inconvenience and if I would do my best to learn how to handle the stock safely I might go along—all of which I was ready to promise, of course. But this action was undoubtedly influenced by the fact that it was hard to find anyone to take my place...

I was beginning to learn about men. During the next three months I was to pick up a few more facts that would help me cope with life.

WILD HORSES

THE McGannigan-Kellar party, which left Los Angeles on May 3, 1867, consisted of nine persons. Besides Sam, Johnnie, the assistant wagon man, Jim Begole, and me, there was Jim Kellar, a grizzled and profane veteran of the plains, his three helpers, Dan, John, and Dilly—and Mrs. Jim Kellar, who was very young and barely intelligent enough to distinguish bright objects. We had two wagons and, in round numbers, 200 horses, 50 of which were Kellar's. Of the entire lot fully half had never been even partly broken to saddle, while nearly every one of the rest could be counted upon to shy, buck, and go into a frenzy with or without provocation. I think the description "ornery critters" might well have been invented to cover those horses of ours.

The first ten days of the trip were lively enough. We were all bucked off our horses, more or less in rotation. Sam and Jim were so unsuccessful at roping that one member of the party was reduced to Shank's mare for a day. Jim and Dan, on herd the night of May 7, managed to lose *all* the stock—and they appeared in camp next morning without the faintest idea of the creatures' whereabouts. Once the horses stampeded, and once a lot of them had to be thrown and shod—that was a morning of "lively work," according to my journal. At dawn on the eleventh Sam came into camp with a raging toothache, and I turned dentist and pulled the molar, using a rusty bullet mold for forceps. On the thirteenth we had to aban-

don a mule with "the trembles," and the next day the very devil got into the stock. To cap it all, Kellar's horses stampeded that evening and smashed his wagon so badly that he had to leave it and go back late that night to repair it and bring it up.

Otherwise things were pretty humdrum. But on May 15 we began to have a little excitement. I quote from my journal of that day:

Found camp seething with suppressed excitement over a scandal that has been developing ever since we left California in company with the Kellars. Old man K. had taken to himself a very young unsophisticated girl as a wife and had her along with him in his outfit. From the first our Sam had cast lecherous eyes upon her and it was not long before he had dominated her to such an extent that he usurped the old man's place and prerogatives whenever occasion permitted, which frequently occurred on account of the night herding.

Kellar hadn't found out that his wife was being "dominated." But sooner or later, no matter how oblivious the old man seemed to be, the thing was bound to blow open. And Kellar was supposed to be a very dangerous man with a gun.

I doubt if any illicit affair was ever so acutely and intimately scrutinized by the group in which it was flowering. When Sam persuaded Kellar to let Mrs. Kellar ride in his wagon, a day or two later, there was no lack of ribald comment. I find that I referred to this incident, with some dignity, as "ridiculous."

We followed substantially the same route that I had taken to California just a few months before. By the end of May we were back in Mormon territory again, and that meant a chance to do a little trading. After some enjoyable swapping-talk with the "Yahoos" (as the Mormons were called by the gentiles), John made an exchange, "without sight or seeing," of a lame colt for a

cow and a calf. We were more than pleased at the prospect of fresh milk in camp, but alas! the deal fell through.

Santa Clara was a pretty village of a dozen or so houses, with many peach orchards. Five miles beyond was St. George, the capital of southern Mormondom, which I remember chiefly because there I got a new pair of brogan shoes. My boots were completely gone, and Sam grumblingly supplied the new footgear. Another five miles, and we came to the older settlement of Washington, which had a large stone grist mill and a cotton factory. Everything here was saturated with alkali—ground, water, and rocks. The soil and rocks were red, and in many places coated thickly over with the white alkali. Some of it must have got into Sam, for in a fit of irritation, he hit Jim over the back with his whip. Jim controlled himself, but later he said darkly that "there might be some hanging done soon."

On June 6 we reached Summit by way of Cedar, and camped in the midst of a snow and sleet storm. Kellar and I were on night herd. Just before we went out Sam asked me to fire two pistol shots if Kellar started back to camp before morning. But nothing happened.

Monday, June 10, was notable for a general cleaning up. We cut each other's hair in a sort of round robin; Sam cut John's and gave him what I have noted as "a regular 'Dead Rabbit'" trim. I believe the name came from the old New York gang known as the Dead Rabbits —many of whom, sooner or later, had their hair cropped short in the penitentiary. In any case, a "dead rabbit" was the crew cut of the '60's.

Corn Creek, Meadow Creek, Fillmore, Pioneer Creek, Buttermilk Fort, and Round Valley came next—and then, on the thirteenth, a difficult crossing of the Sevier. The river was so high that it overflowed the road; everything was mud and mire, and some of the stock nearly bogged down for good. I had a close call myself.

On June 15, we reached Nephi and took the road along the eastern side of Utah Lake. The weather was extraordinary. There was a very cold wind, and it rained, and at the same time we were almost blinded by clouds of dust. The adobe soil of the road got very soft and slippery, and we had to ride carefully. The next morning my little bronco seemed to be soldiering on the job, and I spurred him hard—there came "a big hoist from behind and a stiff buck in front, and I was lying flat on my back in the middle of the road." I was not the only victim that day; Jim, Dan, and Sam raced into camp whooping that afternoon, and Jim's horse slipped and threw a complete somersault.

After passing through Summit and Payson on the eighteenth we reached Spanish Fork. The stream turned out to be only twenty feet wide, but much too deep and swift for fording with the wagon, which had to be driven downstream and taken over a toll bridge. But we did swim the horses across, though it took the united efforts of ourselves and a crowd of natives—it was Sunday, and the whole town turned out to help. We would get the horses to the edge, and then they would stampede back through the crowd; we would repeat our activity, and so would they. After a time we herded up a dozen of the tamer animals, pushed them into the water by main strength, and drove the rest in after them.

We had another hellish crossing the next day, at Dry Creek, but finally we got the stock safely around the Point of the Mountain, and on the twentieth we camped at Doc Dunyon's Warm Springs bath house. The afternoon of the twenty-first found us luxuriously swimming in Doc's big swimming pool.

On June 22, we drove around Salt Lake City. We passed near the Birch farm, where I had worked not so many months ago, so I went to call on them. I must have

looked pretty disreputable, because they didn't know me
at first. When they recognized me there was a whoop,
and we all ate some strawberries together.

For the next day or so we loafed—except when the
horses got into some loco weed and we had to change
camp. I caught some trout. I wrote letters for Dan, who
was "a mite short on my schoolin'." I even found time to
practice braiding rawhide in elaborate patterns. Before
we set off again John left the party—he lived in Egan,
Nevada, and had signed up only for the trip to Salt Lake.

He was a good fellow, and I gave him a wholehearted
send-off in my journal:

... Left him solitary and alone to start for Egan. Long may
he live to enjoy the increase from his ranch, the tailings of his
quartz mill, and his stud colt.

On the way over Parley's Pass we began to meet wagon
trains bound for "the States," and considered joining
forces with some of them. But there were objections. One
of the men from the other trains rode with me for a while,
and said that we should not be very welcome companions
unless we had more men—our band of horses would in-
vite Indian attention. I can realize now our foolhardiness:
seven men and a woman, with 200 horses as tempting
prizes, about to face the wildest and most hostile country
between the two oceans!

Kellar and I were on herd the night of the twenty-sixth, when, abruptly, the old man announced that he was going back to camp and "get a decent night's rest." Here was the crisis at last. Would I fire my pistol and give Sam his warning? I compromised. I fired twice, as arranged, but "in the ground so they could not be heard very far."

In the morning, when I returned to camp, there was no Sam, and Kellar was cutting out his horses from the rest of the band. So something *had* happened!

The boys delightedly informed me that Sam had not heard my muffled pistol shots, and that he was caught by Kellar *flagrante delicto*. But all the looked-for gun play did not materialize—only an exchange of geneological references. Then Sam had left camp, and Kellar had gone on ahead.

What would happen next? I drove the wagon on ahead and caught up with Kellar just as Sam appeared. Here, surely, was the bloody climax:

... Sam got out his pistol and began loading it ostentatiously. Kellar, observing this, spoke up to the effect that he had as good a pistol and horse and could shoot as straight as any other man. Nothing more was said or done; however, Sam went on with the band while I went down to the mill and put some flour on board and followed after ...

That was about the saddest end to weeks of suspense that anyone could imagine. All the boys felt cheated, and I have wondered ever since about the wild, wild West where men were said to shoot each other at the drop of a hat.

We came to Fort Bridger on Monday, July 1, after more messy river crossings (during one of which Sam nearly drowned the stock rather than pay toll for them to cross the bridge). There we found many Indians—Utes and Shoshones—and they were as picturesque a gathering as I have ever seen:

...I noticed the trappings of one of the horses: buckskin almost covering the whole animal, and solidly embroidered all over with beads in fanciful designs, the edges being fringed with rows of tiny bells. In the afternoon a chief's daughter, a young and pretty girl in a calico gown, came into camp thus caparisoned. Around the horse's breast was a narrow embroidered band hung with several brass bells; below it was a wider one ornamented with beads, and pendant from it more than a hundred silver thimbles and as many big bright glass beads. She made a merry jingling.

With the Fourth at hand, all were in gala attire, painted and powdered to the limit, with many white and scarlet blankets and leggins. Met a couple of Utes that I shook hands with and had a little "confab." Said they were going down into the San Pete valley to give the Mormons hell.

There was some lively swapping. Jim traded the lame colt (for keeps, this time) for three buffalo robes, and Sam got five robes and a pistol for a white colt and three robes for a mule colt. By then we had plenty of buffalo robes, but we had some trouble in getting away from the hosts of Indians who were anxious to trade more robes for horses. The Indians were nearly as much of a nuisance as the mosquitoes, which were swarming by millions and tens of millions. We tried smudges, but "they could stand more of it than we could." Those mosquitoes actually stampeded the herd several times, and I saw horses so thickly covered that you couldn't tell what color they were!

After Kellar's "withdrawal" Sam had taken on a couple of boys from one of the bull outfits. We didn't know much about them, and during the week of the Fourth of July it became clear that some sort of skullduggery was going on. First we would lose a mule and a couple of horses; then they would mysteriously reappear; then other animals would disappear. After a couple of days one of the new men decided to leave our outfit and make for Green River. In the middle of the night of July 7, Sam woke us

all up by shouting the terrifying news that all Dan's stock had been stampeded and that we were "surrounded by rascals." Just as he was about to send to the fort for assistance, Charley, the man who had quit, turned up again and told Dan where the missing animals were.

Next day Charley laid bare a plot: some villains were organizing to run off all our stock at Green River or up Bitter Creek. He had been with them and knew all their plans. None of us believed him, but we gave up trying to straighten things out and set off on the day's drive. Apparently there *were* rustlers about, for the Johnson outfit came up to us with a prisoner, one English Bill, whom they had caught. There was a great deal of palaver, which brought out very little except the fact that Charley was certainly a liar. It seemed like a good idea to send both men back to the fort, and Sam whipped out his pistol and commanded that they should be tied up.

This ferocious gesture had its usual effect—nobody paid any attention to it, and the talking began all over again. Sam, possibly exhausted, said at last that he was willing to let the whole affair drop right there. The remarkable Charley then begged to be allowed to go on with us, and the even more remarkable Sam agreed. So we put the tempest back in the teapot and, with our pet villain, continued on our way. It was not a very good time for internecine strife—we were hearing tales of Indian depredations all along the way, and every train we met reported some trouble.

We lost a sorrel and two mules a night or two later, with Charley on herd, so the storm boiled up again the next morning. Sam, who had bought a bottle of Old Cabin Rye the night before and who may not have been feeling at his best, "commenced swearing and tearing around generally." Charley objected and left us once more.

At noon on July 9 we came to the Green River. Nor-

mally some hundred feet wide, it was now flood high, yellow instead of green, and at least 125 yards across. After sending our wagons over by cable ferry, we tackled the real problem of getting the horses to the other side.

It was no great feat to drive our horses into the churning stream—but there was no power within our command that could keep them from riding the current a short way, then climbing out on the same side of the river they had started from. After several attempts I was "elected" to lead them over by riding one of the more docile animals and hoping the rest would follow. The water was icy; but

I stripped to my shirt, mounted an amiable white-face named Bally, and plunged in.

Before we reached the middle of the river, Bally rolled over (as did I) and swam back. After warming up a bit in the sun, I made a second try—with the same result. Then I shifted to another horse, and on the second attempt Whitey and I made it. But we were quite alone. Not even my inspired leadership could get our horses to swim across the stream. Sam had to admit defeat and, next day, pay full fare on the ferry.

A little later we passed the Continental Divide and went by two stations that had recently been burned by Indians. There were grave mounds beside them. Everywhere we heard of Indian trouble, and we began to corral the stock at night and to keep even more careful watch.

When we reached Fort Sanders on July 21, we found

that all trains were under military inspection, and no party of less than forty men was permitted to travel the Pole Creek region. These precautions were not without justification; beyond Cheyenne Pass at the head of Pole Creek we found ruined buildings, and freshly made graves with the usual legend, "Killed by Indians."

Despite the hazards, Sam and one Lobeck got up a series of horse races during this part of the trip. Sam had great faith in his big sorrel, and Lobeck was equally confident about a gray mare. Both horses were rubbed, curried, and blanketed as if they were $5,000 animals, and two races were run off. Sam lost the first for ten dollars and the second for twenty-five. I don't remember that any tears were shed in our party.

On the evening of the twenty-fifth, at Pine Bluffs, we came upon the first signs of advancing civilization. Groups of workmen, guarded by soldiers, were building and grading for the railroad, and we saw great piles of ties. There was a big demand for labor—at $2 a day, or $40 a month and board. On July 28 we met several hundred men going out to work. They were a pretty sad and seedy-looking lot. Except for a few regular laboring men, most of them seemed to have come down a long way in the world. Nearly all of them carried muskets or pistols.

Just above Julesburg we met the railroad actually in operation. We were really getting out of the wilderness, and I found myself whooping for very joy. Only one year before, when I was plodding west, there had been no sign of railroad building. How the frontier was changing!

At Julesburg—already beginning to fold its tents to move on to the new camp at Cheyenne—we ended our long horseback ride. From here to Omaha we were to travel on the cars. Six had been engaged for $700. We had an awful time getting the horses on board. Many of them had to be roped and almost dragged on. But at last

we bade farewell to the lively little town and roared off into the night.

Two uncomfortable nights in a freight car—"there was just enough loose corn scattered over the floor of the car to make it a little bit uncomfortable"—and we were in Omaha unloading. The horses looked thin and weak after their ride, and I felt somewhat the same.

On Saturday, August 3, I tackled Sam on the subject of my pay for the drive. When I think of his response, even after seventy-three years I can still work up a healthy indignation. He was willing to buy me a suit of clothes!

On Monday I cornered Sam in the town and extracted a $20 bill from him. I paid $19.50 for a new suit and blew the rest on a shave and haircut—and "felt like a man again." I looked up the two photographers of the town, Eaton and Hamilton, and decided that Hamilton was the better prospect for employment.

The next day I saw Eaton and Hamilton again and verified my first impression. Eaton didn't want to take any chances. But Hamilton was willing either to hire me by the week, or to give me charge of a branch gallery of his and run it on shares. He wanted another day to make up his mind definitely, so I went out to the camp to spend the night and get my things.

My farewell provided a final endearing memory of Sam McGannigan. In the morning he "ordered me in a domineering way to get breakfast and to hurry about it." I said that I didn't intend to do anything of the sort, and that if he didn't have enough men of his own to get his breakfast *I* certainly didn't care if he ate or not. Sam then announced that he was going to make me do it—"but just about then I had my valise packed and I walked out without waiting to see how the matter would be settled."

I was a free man. And the same day I had a job. Hamilton arranged to pay me $15 for the first week, $18 for the

second, $20 for the third, and then $25 regularly if all went well. I wrote my name on the register at the Douglas House, and my troubles were over. I must quote the last sentence of my journal:

Feel very much elated over the prospects of beginning life over again and just laugh aloud to myself in pure enjoyment.

CHAPTER XI

"RIDING ON THE RAIL"

BACK in Vermont, in the early part of 1866, I had been the artist in a photographer's gallery at $25 a week. A year and a half later any casual acquaintance might have remarked with complete accuracy: "Oh, yes, I know Jackson. He's the artist in a photographer's gallery. Makes twenty-five a week." A *very* casual acquaintance might even have added: "Jackson seems to be a steady sort of fellow."

If I hadn't gone up or down in the world, I had certainly footed over a handsome piece of it by the time I settled down in Omaha with Photographer Hamilton. And, if I wasn't the stable character of the story books, I had done enough knocking around to appreciate (for a while, at least) the luxury of working in the same place every day, sleeping in the same bed every night—and *not* wearing the same clothes until they fell off me.

Somehow or other, during those penniless months on the road, I had made a useful discovery about money— it didn't necessarily rot in the pocket over night, I found. Even small sums could be set aside and accumulated into a solid lump. In the course of time the total might grow large enough to be used as first payment on a business of your own. That was especially true if your employer was middle-aged, comfortably situated, and eager to get back to his fine farm near Sioux City, Iowa.

In the late fall of 1867, convinced that I could make a go of it, I bought out Hamilton, with a mere token down

payment. Hamilton knew from experience that there was plenty of business and that I was able to handle it, and he was content to let me pay him as I could out of earnings.

Meanwhile I had written my family a full account of my prospects in the town that had grown from less than two thousand to more than twelve thousand in seven years. And about the time I was concluding negotiations with Mr. Hamilton my father offered to put up the rest of the money, plus a small operating capital, if I would take my brother Ed in with me.

After the war Ed had worked for a while in father's shop, later as bookkeeper and copyist in a law office. The fact that he knew nothing about photography didn't trouble me. While I took the pictures, Ed could run the office and handle the accounting. It promised to be a happy arrangement all around.

By the middle of 1868 the firm of Jackson Brothers was in full swing at the corner of Douglas and Fifteenth Streets. We were the leading studio in town, without any question; for we had also absorbed the rival gallery owned by Mr. Eaton. As soon as that gentleman had learned about Hamilton's decision to retire he came around to see whether I wouldn't buy him out too; Mr. Eaton also pined for Iowa.

It was a buyers' market, and Jackson Brothers was able to start out with two businesses for the price of one. There were no niggers in the woodpile, either—I suppose there just isn't anything that can keep a man from going off to Iowa, once his mind is made up.

Omaha was a fine location for business. The town was old, as age is reckoned beyond the Mississippi—the first house was built in 1853—and it had at the same time the enormous vitality of a boom town. Omaha was the marketplace for a prosperous farming country. The Union Pacific operations had brought in many workers and traders. By

the time Jackson Brothers got under way Omaha was the unrivaled metropolis west of Chicago and north of St. Louis.

For the first year we stuck pretty closely to the usual work of studio photographers—straight portrait jobs; group pictures of lodges, church societies, and political clubs; and outdoor shots that gratified civic pride. There were many commissions to photograph shop fronts and, occasionally, interiors. Now and then, too, somebody would order pictures of his new house; or of his big barn, and along with it the livestock. We were kept busy.

Ed took care of the front office and did the canvassing. Ira Johnson, a boyhood friend, who had come west with my brother, handled the portrait jobs. I did the outdoor work, and my seventeen-year-old brother Fred (who had also come with Ed) was general studio assistant.

The business paid well enough, but it was hardly exciting. Every once in a while, however, I could increase the tempo by going off for three or four days as "missionary to the Indians." South of Omaha lived the Osages and Otoes; to the west, up the Platte, dwelt the Pawnees; north, along the Missouri, the Winnebagoes, and the tribe for whom the city had been named, the Omahas. They were all friendly—and there was money there, both for the red man and the photographer. Those Indians would pose for me by the hour for small gifts of cash, or just for tobacco or a knife or an old waistcoat. And I in turn was able to sell the pictures through local outlets and by way of dealers in the East. To handle this work I devised a traveling dark room, a frame box on a buggy chassis, completely fitted out with water tank, sink, developing pan, and other gear essential to a wet-plate photographer. Soon my one-horse studio (which at first scared the daylights out of all the livestock) ceased to be considered "bad medicine," and I was welcomed equally before the

tepees of the Poncas and the earthen houses of the Paw-
nees.

But the thing that really got me was the railroad. Here
was something truly earth-shaking, and, whether or not
there had been a dime in it for me, sooner or later I
would have been out on the grade with my cameras.
It is almost impossible to exaggerate the contemporary
influence of the first transcontinental railway. Authorized
by Congress in the midst of the War, its real progress
began only after Appomattox. The tempo increased from
1866 to 1867, and construction reached a dizzy climax
during the summer of 1868, with the Central Pacific push-
ing from the west and the Union Pacific from the east.
Although working toward the identical end, the two
roads were in frantic competition: for every mile of track
the Federal Government made an outright grant of twenty
sections—12,800 acres—of public land, plus cash aid that
ran from $16,000 a mile, across the plains, to $48,000 a
mile, over the Rockies and the Sierra Nevada. This contest
captured the mind of every literate American, as well as
the fancy of thousands more who, if unable to write so
much as their own names, could at least cut ties, drive
spikes, and shovel ballast.
In July of 1866 the Union Pacific had reached only the
present site of Columbus, 100 miles west of Omaha. One
year later in Julesburg, when I came through on my way
back from California, the rails were already there to
amaze me. And a year after that, although engineers,
laborers, barkeepers, gamblers, and "dance-hall" girls
were all at the point of exhaustion, the Union Pacific had
crossed the Continental Divide.
During the last months, the rival directors called a truce
and agreed upon Promontory Point, Utah, as the meeting
place for their respective lines. But in the popular mind
the race continued, and people came from all over to

My first "shingle," Omaha, 1868. ("When Pawnee Meets
Sioux," a painting by F. O. C. Darley, furnished the theme.)

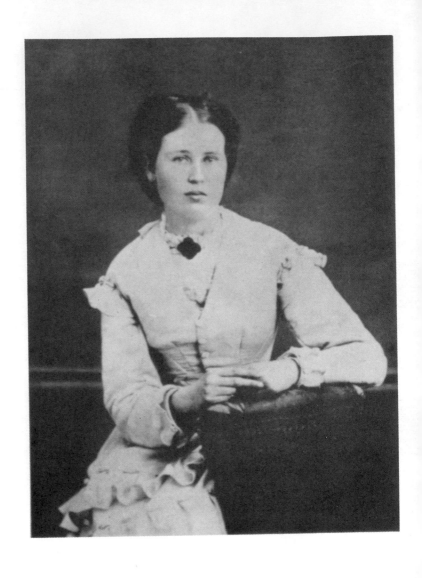

Mollie Greer, who became my wife on May 10, 1869.
She died in 1872.

watch the work. During the final weeks of construction the country about Ogden took on the aspects of a playground. Everybody who was anybody seemed to be hurrying west for the joining of the rails.

There were two very good reasons why I was not present at Promontory Point on May 10, 1869. One was that my business just wasn't big enough to support an expensive junket. The other had to do with Miss Mary Greer of Warren, Ohio, who had chosen that very date as her wedding day—and since she was doing *me* the honor, the joining of the rails became for the moment insignificant.

I had met "Mollie" Greer some months before, while she was making an extended visit with relatives, Mr. and Mrs. John Campbell, of Omaha. Soon we became engaged, and my fiancée very sensibly decided that we should be married where I worked, rather than spend time and money returning to Ohio for the ceremony. Our wedding took place at noon on May 10 in the Campbells' parlor, with Bishop Clarkson of the Episcopal Church as the officiating clergyman, and immediately afterward we departed on our honeymoon, to St. Louis by steamboat.

Just a few days before our wedding I had received an order for enough railroad pictures to justify a trip to Utah. But it was a job that would require several months of hard work, with plenty of rough living, and, clearly, I could not take my wife. Accordingly, Mollie and I agreed that she should visit her family while I went west. But before her departure we had six days together, six idling days, on a boat that moved little faster than the current, a boat that tied up along the bank each night to avoid shifing sand bars. Six wonderful days on a slow boat! No, there is nothing like a Missouri River steamer.

In St. Louis I put my wife on board an eastbound train. Then I started off in the opposite direction. With me,

from Omaha, traveled an assistant named Hull, an experienced camera man and a willing worker.

The new enterprise was launched largely on the strength of one order. The stereoscope—to me still a very wonderful device, with its convincing third-dimensional illusion—was on the threshold of a tremendous and long-enduring popularity, and Jackson Brothers, after some intensive soliciting, got an order for ten thousand stereographs of scenes along the train route. With that as a nucleus, I was sure I could establish myself as a front-rank scenic photographer. It was a great opportunity to start a collection of negatives. And it was also an opportunity to travel upon the railroad I had seen building.

There was, of course, very little money to finance my venture. But the lack seemed trifling. Undoubtedly we could pick up enough as tramp photographers to pay our living expenses; and since the Union Pacific had been able to discern an advantage to itself in my expedition, we were promised passes.

It really turned out to be quite simple. On June 23, 1869, after nearly twenty-four hours on the cars, Hull and I stepped down into the wild new town of Cheyenne. Just two years before, when I was helping to drive Sam McGannigan's horses down through Cheyenne Pass, the town had not existed. Now it was a noisy, unkempt settlement, rapidly growing into a substantial wooden town. Saloons, gambling halls, and brothels—usually all three enterprises under the same roof—were the *sine qua non* of social existence. And of all these, positively screaming with elegance and refinement, the establishment of Madame Cleveland stood first.

After breakfasting in a place known not inappropriately as the Tin Restaurant, Hull and I began working the streets; that is, making negatives of various shops and business houses. That afternoon John Sumner, an old Salt Lake acquaintance, mentioned that the ladies at

Madame Cleveland's were pretty solvent, what with the railroad, the near-by Fort D. A. Russell, and this and that, and suggested that we look into the matter. My journal covers that situation:

Thursday, June 24, 1869 ... Hull and I thought we would go around and see if we couldn't get a job out of them. Talked it up a while but they seemed indifferent. I called for a bottle of wine, and soon after they began to show considerable interest in having a picture taken. Had another bottle, and then they were hot and heavy for some large pictures to frame and began to count up how many they should want.

We spent nearly a week in Cheyenne, and, counting our successful afternoon at Madame Cleveland's, plus some views I sold McClelland, a local dealer, Hull and I left town with a profit of $60. Ten of it, however, I invested in an "A" tent (like the ones I had lived in along the Potomac), and another $12 or $15 went for supplies and utensils. We were going next into a country where hotels and restaurants were largely non-existent.

On the train I unexpectedly drummed up a neat piece of business. The "news booster" bought all the Indian pictures I had with me and placed an order for a thousand stereos of Weber Canyon, where I was planning to do some extensive photographing. From him, in return, I bought a package of "portable lemonade"—granulated sugar impregnated with citrus extract—which, when mixed with water, provided a drink that seemed very tasty at the time.

I photographed the settlements of Wasatch, Blue Creek, Corinne, and Uintah, with many points of scenic interest that we were conveniently able to reach along the line; much of Echo and Weber Canyons was included. The trainmen were, on the whole, very obliging about letting us off between stops, and equally so about picking us up when we flagged them. Hull and I, on our part, took pictures of the locomotives and their crews, and we gave

away as many prints to the trainmen as we sold them. We spent most of July out on the line, riding in the cars, on the cars, and, not infrequently, right out on the cow-catcher of Number 143.

This was a period of great experimentation for me. The art of timing exposures was still so uncertain that you prayed every time the lens was uncapped, and no picture was a safe bet until the plate had been developed. Working in a fully equipped studio was hazardous enough.

Going at it in the open meant labor, patience, and the moral stamina—or, perhaps, sheer phlegmatism—to keep on day after day, in spite of the overexposed and under-developed negatives, and without regard to the accidents to cameras and chemicals.

Photography was still, of course, in the wet-plate stage, and for this trip I had contrived a portable dark room. It was a wooden box 30 x 15 x 15 inches, fitted with pans and trays, and made so that it could be enlarged with a retractable canopy. This case was cumbersome enough to lug around; but it was extremely compact in comparison with my buggy studio that had seemed such an advance barely one year before. Hull and I carried two cameras. The first was a standard 8 x 10. The other was a stereo: with its pair of brass-barreled Willard lenses,

it looked like a young cannon. Then, besides the bulky plates, we had a mass of collodions, silver baths and developers. We may have looked as if we were ready for a picnic—but it wasn't one.

Late in July, Hull and I arrived in Salt Lake City, as usual, in my experience, just one jump ahead of the sheriff. At one time, shortly before coming in, we had been held up for two or three days because we lacked the seven dollars necessary to get a package of indispensable chemicals out of the express office. There we sat, with enough exposed negatives to pay for a dozen boxes of chemicals; but we couldn't turn the prints into cash because we lacked ingredients to do our printing. Finally I borrowed the money from Baggage-master McCoy of the Union Pacific, who had known me in Omaha.

Eastern Utah was the seat of our operations from the end of July on. I photographed the "last rail" at Promontory Point; for, although a stretch of empty rail is in itself a dull subject, this particular one had instantly established itself as a popular choice. From many angles I took the spectacular bridge just completed at Devil's Gate. I recorded Thousand Mile Tree (exactly one thousand Union Pacific miles west of Omaha). And, of course, Hull and I made expeditions to all the striking natural views of the surrounding country. Devil's Slide, Pulpit Rock, Death Rock, Monument Rock, Hanging Rock, Castle Rocks, and Needle Rocks are only a few of the wonders we visited and bagged for our collection.

Through all that summer triumph and failure mingled freely; but, on the whole, our expedition was a decided success. We barely managed to meet our expenses on the road—but I returned to Omaha late in September with just about the finest assortment of negatives that had yet come out of the West.

My journal in entirety would make repetitious reading. But here and there a day stands out, and I have selected

a dozen or so such days as more or less representative of
the summer of 1869:

JOURNAL

Friday, July 9, 1869 [*Corinne*] As Crissman [*a fellow pho-
tographer, whom I was to meet again in the Yellowstone*]
was urgent in his invitation to occupy his quarters in carry-
ing on our work, we did so, moving in all our traps and
doing our developing in his dark room. Don't think we could
have done anything at all in our tent.

The weather was hot and sultry. Fine dust sifted over
everything; the sage brush that abounded everywhere caught
it up to be showered upon each and every passer by. The
light was a yellowish haze and, combined with the heat, was
detrimental to successful photography. During the week we
made but few good negatives. Our best were made early in
the morning; but as the day advanced it was impossible to
get density. Financially we did quite well, making about one
hundred dollars and getting away with seventy-five [*for a
week's work*].

The stifling heat created great thirst. Bear River water
was almost worse than nothing at all. Used a good deal of
"portable lemonade" and also visited the numerous saloon
tents for a cool punch or cobbler.

We usually went to bed as soon as it became dark, for
we were up early every morning. If the days were hot, the
nights were invariably cool and pleasant. We made our beds
on the rough ground with but one blanket beneath, but slept
well. Dust sifted in everywhere and was a great inconvenience.
Cockroaches and ants were rather too numerous for com-
fort, sometimes crawling into mouth and ears while we slept.

For meals we had a good square each day at the Uinta [1]
House; for supper and breakfast we had canned peaches,
sardines, bread and cheese, washed down with water sweet-
ened with lemon sugar.

Hull has done all the running about, as I prefer doing
the dark-room work of coating and developing plates. He is
a good canvasser and drummed up quite a number of orders.
Hull did some work for a friend of his in Creighton and

[1] According to modern usage the town is now spelled "Uintah," but,
on the other hand, there are the "Uinta" Mountains.

Munroe's store and got a gallon of good corn whisky for it.

Looked around with the intention of getting a team and wagon to travel with. Horses and mules were being auctioned off very cheap—but our means are yet too small for the undertaking.

Intending to leave Wednesday, we got left. The difference of half an hour between R.R. and town time [*this was years before the establishment of standard-time zones*] made us that much late. Finally got off the next day, Thursday, all right and arrived in Uinta at half-past six. Pitched our tent at once in the rear of the station and then went down to the Weber and washed up.

The scenery about here is magnificent, and this little town of not more than a score of tents and houses lies at the very base of the mountains. The water is good and the air far more agreeable than in Corinne. This morning were up quite early; but the wind blew so hard we did not attempt to make negatives. Spent the day in cleaning plates, fixing up chemicals and a general renovation.

Loitering about the streets we saw a crowd going to a tent outside the town; so we followed and found it was a police trial—the first cases up for the newly elected town officers. A young gambler arrested for fighting and disturbing the peace was fined fifteen dollars. A fair but frail aid also paid fifteen dollars, and court adjourned, all done in five minutes.

Monday, July 26. [*Salt Lake City.*] Went to Savage and Ottinger's and got just what I wanted [*cardboard, for mounting*] by paying a pretty stiff price for it. Met C. R. Savage himself, the veteran Mormon landscape photographer, and had a few minutes' talk with him.

Too late to take the three-dollar opposition line, so had to wait for the five-dollar Wells, Fargo coach. Spent a dollar buying apricots at twenty-five cents a dozen—a great treat. Off at nine-thirty and got back to Uinta at 3.30 P.M. Mounted all our 8 by 10's that afternoon, and Tuesday began deliveries. Sent Hull up to the bridge builders' camp, and I took the ones for about town. I was dead broke on my return from Salt Lake City, but at the close of day found we had something more than thirty dollars.

Decided to make another visit to the city, so we started off Wednesday morning by the three-dollar opposition line and reached the city by 4 P.M., putting up at the Salt Lake House.

In the evening went to the theater, where we saw Annie Ward, looking very familiar.

Thursday we spent in sight-seeing and in visiting the photographers. The afternoon so warm we did nothing but sit under the cool porch of the hotel and feast on apricots, while reading the papers. Thayer from Omaha came in by the afternoon coach, and after supper all of us went up to the Warm Springs for bathing. Went to bed early.

Settled bill and found we had just two dollars left—just enough for breakfast.

Sunday, August 1. [Beyond Weber City.] We packed up early and began to move our outfit up by hand; but the bridge builders at work above came along with their hand car bound for a visit to Echo and invited us to put our traps aboard, so in a few minutes we were landed at the west entrance to the tunnel, a good place to work from.

Monday made a number of views of the tunnels, bridges, etc., moving our things along gradually by hand until we were above the second tunnel. In the evening Hull rode down to Weber with the returning bridge builders and got bread, coffee and eggs, and walked back five miles. Had quite a time getting the coffee roasted. With no suitable pan, we melted apart an old tin can. The next thing was to grind the coffee, which was done by pounding it in a buckskin bag with a stone.

A storm during the night nearly demolished our tent, and we had a hard time in the morning getting breakfast. Made two or three negatives of the east end of Tunnel 3 and then packed up to move on. Got the section men to take us aboard their hand car, and were put down at the Thousand Mile Tree. Could find no spot level enough to put our tent on, so we borrowed a shovel and scraped out a place on the hillside and, spreading the tent, slept on it instead of under it.

Next morning we packed up just enough stock to work with and carried the box a mile or two down to the Devil's Slide. Considered our work completed in Weber up to Echo and began to cast about for some way to move up there. What seemed to be the easiest way was to get everything together in one place, jump the freight train as it passed the quarries, for it usually passed there very slowly, see the conductor and ask him to stop where we had left our traps and take everything on board. Train men all along had been

so accommodating that we thought this would work—but when the train did come by it was two hours late and went by as if sent for. Went back to where Hull was waiting, and from there we shouldered our packs and went on. In the morning, Thursday, the fifth, got an early breakfast, packed up and carried our bundles into Weber. Reached Echo about eleven that night. Looked for some place to sleep and found it under a pile of bridge timbers.

Friday, August 13. Immediately after breakfast the bridge builders broke camp and, moving up to Mountain Green, made a new one. With our work done, we walked up there and arranged for all of them to go down to the bridge again and be taken on it. As 117 (engine) wanted to be in the picture, the gravel train was run up to the new camp, and we all piled onto it.

Tuesday, August 24. Walked up the Castle Rocks, and climbed up into the two caves, leaving my cards in each.

Decided to board at the section house rather than cook ourselves. Found the food very plain and the company rather mixed, to say the least; but, judging by external appearances, we could not esteem ourselves any better than they— for, to tell the truth, we were two pretty seedy looking customers.

Thursday, September 2. [*Wasatch.*] After breakfast, which took about all of our stock of provisions, we moved our working box up to town and after the trains went out made an 8 by 10 of the eating house. Looked well on glass [*as I composed it under the cloth*] but nearly worthless as a negative. Had both dinner and supper there.

No other negative work in afternoon, as bath was about played out. Silvis, photographer [*for the Union Pacific*], is here with tent doing portrait work. Spent some time with him helping to get his bath and collodion in better condition.

Rain, with hail as big as walnuts.

Wednesday, September 8. In accordance with plans previously arranged we had everything in readiness early this morning for a return to Salt Lake City. Put up at the Salt Lake House. Had a good wash-up, bought shirt, collars and necktie and had a clean shave, except chin. Sunk three dollars on a commonplace play.

Friday, September 10. After filtering and testing bath we carried our box to the Tabernacle. Found gates open and no one about, so we entered and set up our outfit. When we had a plate sensitized and were about to expose it the caretaker, escorting a party of sightseers, spotted us. I met him half way, however, to have the first word—said I supposed there would be no objection. "Yes," said he, "I do object. I have no authority to give you permission. The President is the only one who can do so, and he is in Ogden." And so he left us and went on with his party.

As soon as his back was turned I told Hull that as the camera was focussed and a plate ready to go ahead. The man came back; but I told Hull to go ahead with the development while I held him in conversation. It worked all right . . . Our cash was run down . . .

Monday, September 20. Parks [*lunch-room proprietor*] suggested that I go up into the Uintas with Ruth and Dawson, who talk of starting off in the morning on a trading expedition for furs.

Tuesday, September 21. Dawson has decided to give up the Uinta trip. However, there is a fisherman here who holds out over on the Bear River somewhere. Parks thinks about making the return trip with him and has invited me to go along. Lingo goes also, making a party of four, including Bill the fisherman.

Wednesday, September 22. Bill has two horses, and I was to ride one of them; got three more horses from Dawson, one for blankets and my photographic kit.

Worked last night until twelve making a batch of dry plates [*a new experiment for me*]—coffee process. Used the coffee as prepared for restaurant and washing water from the condenser in the machine shop [*since anything but distilled water would probably have contained deleterious chemicals*]. All very much of a makeshift, and not any too sure of the final result.

Got off about half-past eight. We rode on down the valley, following a blind Indian trail, to the fisherman's camp, arriving there at sunset. A picturesque location in a bend of the river and under a high mountain that towers over the surrounding region. Found a man named Chapman there, an

old New England fisherman, who is chief of the concern, and Bill his assistant. "Indian Bill" is the third member of the party. Chapman and Bill No. 1 have a wall tent and Indian Bill, with his squaw, a Bannock woman, live in a tepee on the bank of the river behind a thick clump of willows. These men have built a dam and trap for fish as they run up the river. Of course fish was the largest part of supper.

Sunday, September 26. Packed up for the return—had two horses packed with fish. Stopped several times on the way to shoot ducks and sage hens that were very numerous. Lost our bearings for some time in going over the last hills, but made it all right about half-past eight.

Back in Wasatch I found a letter from Ed. Business in Omaha seemed to need my attention at once; so, leaving Hull to finish up, I boarded the first eastbound train, and by October 1 was back on the job in my studio. It had been a magnificent summer's outing for me and, as continuing sales of those western photographs demonstrated, a profitable venture for Jackson Brothers.

EXPLORING THE MYTHICAL YELLOWSTONE

THE two administrations of President Grant (for whom I twice voted) were not an unmixed blessing for his country. In the North as well as the South a vindictive Reconstruction exacted its price. The "robber barons," as exemplified by Jay Gould, the cantankerous "Uncle Dan'l" Drew, and the absurd and unprincipled "Colonel" Jim Fisk, levied their tolls; Black Friday, the disastrous corner of gold, occurred less than a week before I returned to Omaha, and the scandals of the Erie Railroad were a perennial shame. Federal finances were shaky. The currency fluctuated. A stifling economic depression settled over the land.

But this hurly-burly era of thievery and abuse was for me the most rewarding time of my whole life. While everybody else stewed and sweated I lived mostly in the open country, weeks removed from any news, good or bad. I was exploring the Yellowstone (whose very existence was still doubted in some quarters); or wandering over the unmapped Rockies of Colorado; or helping to uncover the cliff dwellings of Mesa Verde. And if any work that I have done should have value beyond my own lifetime, I believe it will be the happy labors of the decade 1869-1878.

In Wyoming during my summer along the line of the Union Pacific I had first met Dr. Hayden. Ferdinand Vandiveer Hayden—what a name for a pioneer!—was then some weeks less than forty years old. A graduate of

Oberlin and a doctor of medicine, he had never practiced his profession (except as a Union surgeon); instead, he had elected to be a geologist. As early as 1853 he had gone into the West. And until his death in 1887 this unexcelled leader and gentleman never rested from his efforts to inform Americans about America. Even the Indians, some of whom regarded him as insane, were awed by Hayden's industry. They named him Man-Who-Picks-Up-Stones-Running.

Immediately after the War Dr. Hayden became Professor of Geology at the University of Pennsylvania. With his summers free for field work, he was also able to lead annual government parties to explore and survey the vast unmapped regions of the West.

The United States Geological Survey had been set up under the Land Office in 1867. While Hayden, whose title was simply "Geologist," headed this stepchild of the Department of the Interior other groups of geologists and cartographers—all more or less rivals—were out, some under the aegis of the War Office, others representing the Interior. But Hayden was too big a man to be aware of any competition. "To strive, to seek, to find, and not to yield," was the principle that guided him always.

On July 23, 1870, Dr. Hayden, on his way to Wyoming, called at my place of business in Omaha. He spent a long time studying my Union Pacific pictures and the Indian groups I had photographed near Omaha. Then, with a sigh, he remarked, "This is what I need. I wish I could offer you enough to make it worth your while to spend the summer with me."

"What *could* you offer?" I asked quickly.

Dr. Hayden smiled and shook his head.

"Only a summer of hard work—and the satisfaction I think you would find in contributing your art to science. Of course, all your expenses would be paid, but..."

At that moment my wife walked into the reception

room. Our living quarters were on the floor above the gallery, and she often came in to lend a hand.

"Dr. Hayden has just been outlining his plans for Wyoming," I explained, after introducing him.

"And telling your husband how much I would like to take him with me, Mrs. Jackson," he added emphatically.

Mollie looked at Dr. Hayden for a moment, then at me. Then she laughed—and I knew that everything, so far as she was concerned, was arranged.

Two days later Dr. Hayden telegraphed me from Cheyenne to join him as soon as possible. Quickly I straightened out the affairs of my shop and left my wife in charge, for my brother Ed had withdrawn shortly before, to take over the management of his father-in-law's farm at Blair, Nebraska. She had the able assistance of my operator; but I doubt whether Susan B. Anthony herself was ever feminist enough to be willing to take over the management of a Nebraska photographic gallery.

On Sunday, July 31, we dined with my wife's relatives, the Campbells, and then I took the omnibus to the station. Next morning I was in Cheyenne.

Camp Carlin, quartermaster's depot for Fort D. A. Russell, was situated a couple of miles above the town, and there I was soon introducing myself to James Stevenson, executive manager for Dr. Hayden, who was in charge during his chief's temporary absence in Denver. Stevenson, in turn, introduced me to the other members of the party—Lester A. Bartlett; John H. Beaman, meteorologist; Campbell P. Carrington; Henry W. Elliot, an artist; Arthur L. Ford; Henry D. Schmidt; Cyrus Thomas, the distinguished ethnologist and entomologist; and Charles Turnbull. Several days later, when Hayden came up from Denver, he brought with him his friend Sanford Robinson Gifford, whose splendid canvases now hang in many museums. With the eight teamsters and helpers, there were an even twenty of us. And, with the under-

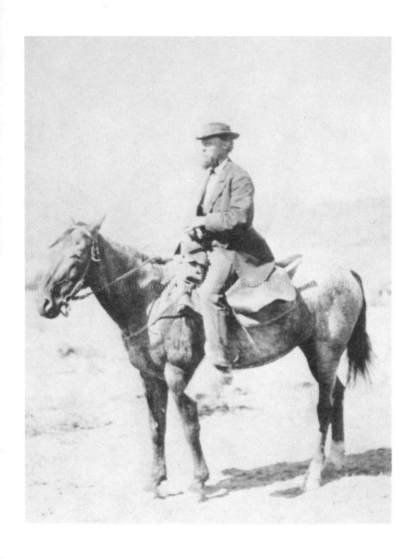

Ferdinand V. Hayden, first United States Geologist. I took
this picture of Dr. Hayden on his favorite horse,
Patsy, in Wyoming in 1870.

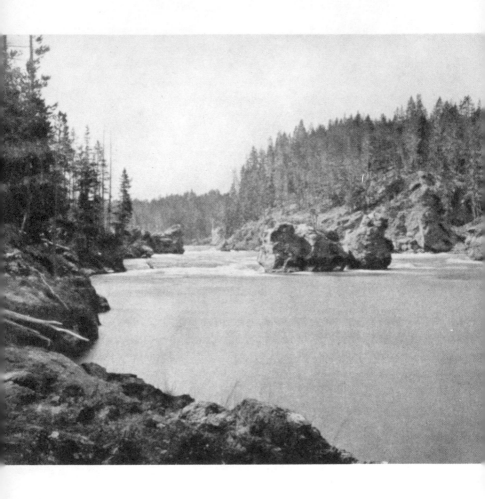

The Yellowstone River in 1871, one of my first photographs of that country. The water in the foreground is actually a surging wave; but a fifteen-second exposure smoothed it out on the negative.

standable exception of Dr. Hayden, quite the most important person of all was John Raymond. He was our cook. (Later he earned the sobriquet "Potato John," in consequence of a passionate but futile attempt to boil some spuds soft enough to eat at an altitude of 12,000 feet.)

We got under way not quite a week after my arrival at Camp Carlin, and, as I recorded at the time, "I will venture to assert that no expedition ever started on the plains with a better mess outfit." There were four heavy wagons to carry food supplies, tents, blankets, and working paraphernalia; and two army ambulances, light and fast, for side trips. All six were drawn by mules, while horses carried the men. And stylish horses they were. Listed as "condemned cavalry mounts," they may not sound so fine. But take all your Arabs, your blue-grass beauties, and your fifteen-thousand-dollar polo ponies—for superbly schooled mounts, I'll stick to army seconds.

The Hayden party of 1870 was out nearly two months. Up the Lodge Pole, down the Chugwater, up the Platte and the Sweetwater, then across through South Pass and into the mountains, the route was, in the main, through country I have described before. But to me, nevertheless, most of it was actually new territory—for the reason that in 1870 I was constantly departing from the high road. For every mile on the map we covered between two and three on the ground—up mountainside, down stream bed, across country—to gather rock specimens, to survey and map, and to paint and photograph.

My equipment, plus extras and refinements, was the same I had carried the previous summer: the double-barreled stereo, and the 6½ x 8½ (also adaptable to stereoscopic work); the portable dark room, completely rebuilt and improved; a full stock of chemicals; and enough glass for 400 plates. The whole must have weighed not less than 300 pounds; but since I had one of the two ambulances at my disposal, neither weight nor bulk mat-

tered much. I had also Hypo. A fat little mule with cropped ears, Hypo was almost as indispensable to me as his namesake, hyposulphite of soda, was to dark-room chemistry. Carrying my cameras, tripod, dark box, chemicals, water keg, and a day's supply of plates, all loaded in big, brightly painted rawhide containers called parfleches, Hypo was good for as many miles as my horse was, and together we covered an enormous amount of ground off the road from the wagon party.

It was those independent excursions, or, rather, the spirit beneath them, that made this expedition and all the ensuing ones under Dr. Hayden so engrossing and satisfying. Every day we had an informal conference around the campfire and then we would set about our work individually, or in groups of two or three. One little division might be assigned to calculate the flow volume of a stream; another would be given the task of sounding a lake; several other men might investigate the geology of the region or hunt fossils; Gifford, Elliot, and I would go off to record our respective impressions of a striking landmark, like Independence Rock or the Red Buttes. We all had work to do, and Dr. Hayden had the rare compound faculty that enabled him not only to select able assistants but to get all of them to pull together. On top of it, and with never a word, he made every man feel that each little individual side trip was vital to the whole —as indeed it was, the way Hayden apportioned the work.

This, my first survey trip, began with our departure from Camp Carlin on August 7. Following the Oregon-Mormon trail as far as Fort Bridger, we then went up into the Uinta Mountains for some two or three weeks and returned by way of the old Overland Trail (the same route I had taken trailing mustangs in 1867). For Dr. Hayden and the veterans it was more or less routine, and

nothing of striking value was unearthed. But for me the expedition was priceless—it gave me a career.

Besides, I had seen new sights and undergone new experiences. A whole wagonload of fossils—crustaceans and bivalves deposited by the ancient inland sea—may have been a commonplace to the geologists; but to me it was novel and exciting. Indians I knew well; but I had never met and talked with the chief of a whole people until I photographed old Washakie, head of all the Shoshones. And I had certainly never experienced the proud satisfaction of having a place named for me. That came after I discovered a little canyon near Casper. (When permanent settlers moved in they gave "my" canyon another name. In 1925, however, the citizens of Casper restored the honor of which I had been unintentionally deprived, and Jackson Canyon is now so marked on the maps.)

If any proof be needed that I had a busy summer, I can point to my journal. I simply hadn't time to make full entries, as the scrambled jottings of September 9, 1870, will show:

[*Granger, Wyoming.*] Drive over rolling hills and Bad Lands. In sight of railroad once more. Stop at station. War news: France no more; Napoleon prisoner, etc., etc. Chinamen. Grave. Fruit from eastern bound train, watermelons, peaches, etc.

Translated, that means to me now that the Franco-Prussian War had just ended; that I saw a crew of Chinese laborers rounded up for some job; that I encountered the head-stone of another Indian victim; and that, without any question, I ate a lot of fruit.

By the time our party had got back as far as Fort Sanders, about which the town of Laramie had sprouted up, Dr. Hayden had asked me to become a permanent—and salaried—member of his staff. It was arranged that I should meet him in Washington a little later, and then,

from Fort Sanders, at the doctor's request, I went off with Jim Stevenson in one of our ambulances to photograph the Pikes Peak region.

That side trip was my introduction to the country below Denver, and, apart from valuable additions to my growing collection of negatives, it was important to me in that it was just about the last chance anyone had to see the "old" Colorado, for the Denver Pacific was just coming in. There was as yet no city at Colorado Springs, but by the following autumn, when I again happened to be there, men were at work plowing the lines for its streets. At Colorado City, just west of the springs, I was able to see the log cabin that had formerly served the territory as its capitol. And the present busy town of Manitou was still plain Soda Springs.

After taking the pictures Dr. Hayden wanted, we sent our ambulance back to Camp Carlin and started east on the Kansas Pacific Railroad. I had already written my wife that I was needed in Washington, and would, therefore, hurry straight to the capital.

But hurry was not on the books for the first part of the journey east. Soon after crossing the line into Kansas the train slowed down. Then it stopped. Buffaloes covered the track ahead.

After a short halt the train was able to proceed, but only at a crawl. All that day, with the cars seldom moving faster than twenty miles an hour, often slowing down so that we could have walked alongside, occasionally stopping dead, we saw buffaloes. I cannot estimate the number we saw making their southern migration that day; but I would *guess* not less than half a million.

If that sounds like the mad vision of a hashish dream, I offer in evidence Martin S. Garretson's authoritative book, *The American Bison*. At this time, sober-minded plainsmen believed that a *billion* buffaloes still roamed the West, while the most conservative calculation placed

the number at 60,000,000—as many as all the cattle in the United States today.

A great buffalo herd was an extraordinary thing to see. A mile-wide valley would be filled from side to side, and as far ahead as the eye could reach, with buffaloes so closely packed together that they looked like a moving carpet. One old plainsman said, "A man might have walked across the valley on their huddled backs as on a floor." A herd crossing the Missouri could, and did, stop steamboat traffic for hours; and passengers on the early railroad trains were quite accustomed to waiting for the buffaloes to pass—and to shooting them from the car windows, just for fun.

The Indian, when he killed a buffalo, used everything: meat, horns, sinews, hides, even intestines. The white man might take the tongue, and leave all the rest of the carcass for the wolves; or perhaps he might chop off the prime cuts of delicious meat from the hump; or possibly he wanted robes and took nothing but the hide. Thousands upon thousands of buffaloes were slaughtered for the tongues alone. Thousands were killed for sport by hunters from Europe. And many thousands more were legitimately killed for meat to feed the men who were building the railways; Buffalo Bill Cody was employed for eighteen months by a railway construction camp, and received $500 a month to supply it with the hind quarters of ten to twelve buffaloes a day.

At this rate the defenseless creatures disappeared rapidly. Soon the plains were so strewn with buffalo bones that it was possible to make a comfortable fortune by selling the bones for fertilizer and buttons. The herds lay where they had grazed, whitening the valleys. Stray skulls were used by surveyors to mark sections of land, and by travelers for written messages to other parties on the trail. But, in less than a generation, the roaming buffalo was gone.

General Phil Sheridan was asked to support a bill placing the American bison under government protection. He refused. "The best way to get rid of the Indian," he said, "is to destroy the buffalo by which he lives. The more buffaloes killed, the better—and what good is a buffalo, anyway, except for slaughter?"

I passed some two months in Washington, finishing up my printing work and cataloguing all the pictures I had so far made of Indians and western scenery, conferring with Dr. Hayden about next year, and making final arrangements to go on the government payroll. Then I returned to Omaha, where I had a busy winter and spring of portrait work. I even managed to set aside a comfortable sum of money; for, in addition to my studio earnings, I was now drawing $150 a month from the Department of the Interior.

My new job made it necessary for the Omaha business to be sold. I should be completely taken up with the work of the Survey. Also, my wife was expecting a child early the following year. If we could dispose of the business, she could spend the summer with her family, while I was off with Hayden. Then in the fall we would move to Washington and enjoy a gold-braided life together until the next expedition took to the mountains. The plan looked fine on paper. But there was no buyer immediately in sight, and, rather than sacrifice a going concern, Mollie undertook to manage the studio once more. She accompanied me as far as Ogden, however, when I left, shortly after June 1, 1871, to join Dr. Hayden in an exploration of the Yellowstone country. It was her first trip into the Rocky Mountain section, and it made a pleasant little holiday for both of us.

When I arrived in camp I found our energetic leader already on the spot. Also present were most of my old friends—all, in fact, save Gifford. In his place had come

Thomas Moran, a painter of the first rank, and the man for whom Mount Moran was later named. In addition, besides Potato John Raymond and most of last year's camp staff, we had with us a dozen or more eager young men, mostly relatives or protégés of important persons in Washington and New York. But although these boys were "legacies," all of them, as soon as they had learned that they were not out on a fishing trip, became useful helpers. George B. Dixon, of Philadelphia, who was studying medicine, showed a keen interest in the camera, and Dr. Hayden assigned him to me.

On June 10, when we broke camp in Ogden, our party numbered thirty-four, as against twenty in 1870. The increase in personnel had been made possible through larger Congressional appropriation, and in part the forty-odd thousand dollars put up in 1871 was a recognition of Dr. Hayden's earlier work. But the real interest in Washington lay not so much in what the survey had already accomplished as in what it might find in the Yellowstone. And in order to appreciate the really enormous public interest, one should first have a view of the background.

John Colter, a member of the Lewis and Clark Expedition, was probably the first white man ever to set foot within the thirty-three-hundred-square-mile area now called Yellowstone Park. When he came back to civilization after a solitary tour of the region in 1807 no one believed his tales of grottoes and geysers, tumbling cataracts and boiling sulphur fountains; "Colter's Hell" sounded so much like one of Marco Polo's yarns in a thirteenth-century Venetian drawing room. In 1829 John Meek had the same experience, and it was not until 1852 that the slightest credence was placed in the Yellowstone legend. Then just a few were willing to believe—and only because the newest report had issued from the mouth of the courageous Jesuit missionary and explorer, Pierre-Jean De Smet. Even Jim Bridger, who had no peer as a guide in

all the Rocky Mountains, had been laughed down when he tried to tell about the wonders of the Yellowstone.

Just before the war Bridger had led Capt. W. F. Raynolds and a small party, including Hayden, into the Lower Yellowstone; but by 1865 their preliminary findings had been forgotten, except by a few explorers and scientists. And it was not until 1870 that the first fully organized and publicized expedition, under Henry D. Washburn and N. P. Langford, made its way into that glorious and nearly impenetrable country. When they came back—even after Langford had published his story in *Scribner's Magazine*—the doubting Thomases demanded still further proof! And it was Hayden, spurred partly by the Langford article, who determined to satisfy them.

If taxpayers and Congressmen alike wanted more evidence, none of them wanted it half so much as Dr. Hayden. He had a double motive. The abstract scientist in him wanted more facts to work with, while the practical planner in the man at once saw how a widespread public interest could keep his Survey alive permanently. Hayden knew that Congress would keep on with its annual appropriations exactly as long as the people were ready to foot the bill, and he was determined to make them keep on wanting to.

That was where I came in. *No photographs had as yet been published,* and Dr. Hayden was determined that the first ones should be good. A series of fine pictures would not only supplement his final report but tell the story to thousands who might never read it. Photo-engraving and ten-cent picture magazines were still unknown; but an astonishing number of people bought finished photographs to hang on their walls, or to view through stereoscopes.

My equipment was substantially the same as I had used during the previous two seasons in the open. For its

day it was a pretty flexible battery that I carried, the
8 x 10, the 6½ x 8½, and the stereo. By this time I had
rigged up my first gadget for "speed" work—a drop
shutter, actuated by a rubber band, that enabled me to
shoot action at high noon with a one-tenth second ex-
posure. But most of my pictures were stills at five seconds
and upward. When speed was no consideration I always
stopped my lens down to get maximum depth and defini-
tion.

We were to enter the Yellowstone from the north, then
the easiest route. On the way through upper Utah and
across Idaho I took a few pictures. Up in Montana I
made a few more pictures. No one could understand
what I found to interest me in Virginia City, by that time
nearly played out as a mining center; but, of course, no
one knew how hard I had worked to go most of the way
there five summers before.

From Virginia City and its tired-looking Chinamen
patiently reworking old gravel we moved over through
Fort Ellis and established our base camp at Botelers'
Ranch on the Yellowstone River. The three brothers for
whom the place was named were Dutchmen, laughing,
hearty fellows who kept bachelor hall in a big log house.
They set a good table and, to augment their income from
a cattle and fur business, they obligingly took in occa-
sional guests like ourselves.

There we spent three days shifting our supplies from
the wagons to mule packs. Then, escorted by a small
detachment of the Second United States Cavalry, we
started south into the Yellowstone proper. The nearest
Indians were a tribe of Crows at the agency down the
river; but though they were not warlike, the government
was taking no chances. Our cavalry escort was shared by
the Barlow-Heap party, representing the Engineer Corps.

In camp the first night away from the Boteler place we

all sat up until after midnight discussing what lay before us. One of our two hunters and several of the packers, who claimed to have been in the Yellowstone before, described its marvels. While they gave their imaginations free rein, Dr. Hayden, whose nerves were usually keyed to the limit, relaxed against one of the packs and said nothing. He was satisfied to let the wonderland tell its own story—to himself as well as to the rest of us, for most of it had not yet been seen by the eyes of white men.

Late the next afternoon we had our first close view of the enchanted land, when our party came upon the Mammoth Hot Springs. We were, so far as records show, the first white men ever to see those bubbling caldrons of nature, and I found myself excited by the knowledge that next day I was to photograph them for the first time.

I was peculiarly fortunate that first day. The subject matter close at hand was so rich and abundant that it was necessary to move my dark box only three or four times. My invariable practice was to keep it in the shade, then, after carefully focussing my camera, return to the box, sensitize a plate, hurry back to the camera while it was still moist, slip the plate into position, and make the exposure. Next step was to return to the dark box and immediately develop the plate. Then I would go through the entire process once more from a new position. Under average conditions a "round trip" might use up three-quarters of an hour. At Mammoth Springs, however, there was so little shifting to do that I was able to cut the average time to less than fifteen minutes. Another thing that helped was the hot water at our finger tips. By washing the plates in water that issued from the springs at 160° Fahrenheit, we were able to cut the drying time more than half.

But soon the inevitable compensation occurred. After going up the Yellowstone as far as Baronet's Bridge, we

proceeded to Tower Creek. At the point where that stream drops into the gorge the view is magnificent—but recording it on a glass plate from the bed beneath turned out to be my biggest photographic problem of the year. Clambering down, and even up, the steep sides of the canyon was not an insuperable task. Neither was moving the camera over the same precipitous route. But getting the heavy dark box within working distance was a stickler. In fact, in the absence of mechanical aid, it couldn't be done.

Since the mountain could not be brought to Mohammed, another method had to be worked out, and finally I solved the situation. After setting up and focussing my camera at the bottom of the gorge, I would prepare a plate, back the holder with wet blotting paper, then slip and slide and tumble down to my camera and make the exposure. After taking my picture, I had to climb to the top carrying the exposed plate wrapped up in a moist towel. With Dixon to help, cleaning and washing the plates, I succeeded in repeating the procedure four or five times. The end of the day found us exhausted but very proud; and we had reason to be pleased with ourselves, for not a single one of our plates had dried out before being developed.

Pictorially the climax of the expedition came with our week's stay at the Falls and Grand Canyon of the Yellowstone. There were four of our party making pictures, the two painters, Elliot and Moran, and two photographers. The other photographer was J. Crissman, then of Bozeman, Montana, whom I had met in Utah two summers earlier. Crissman had been taken along as a guest, and since he was a good companion in every sense, he had made himself fully welcome. A little later I was able to return the courtesies he had shown me in Corinne, where he let me use his dark room. When his own camera was

blown over into a canyon and destroyed I turned over my old 6½ x 8½ to him for the rest of the trip.

So far as I am concerned, the great picture of the 1871 expedition was no photograph, but a painting by Moran of Yellowstone Falls, which hangs, or used to hang, in the Capitol in Washington. It captured, more than any other painting I know, the color and the atmosphere of spectacular nature. Unfortunately that particular canvas was so badly neglected—and later, so badly restored—as to lose its original character. But a fine copy, which Moran made some years afterward, may still be seen in the National Gallery.

Neither picture, however, could hold a candle to the man himself. Thomas Moran, by birth an Englishman, was six years older than I, and he lived to be eighty-nine. For fifty-five years we were friends, but at no time were we ever closer to each other than during those first weeks after our meeting. That ability instantly to make people like him was, I am convinced, one key to his genius. He had so much to give and he gave so unstintingly that even a mountain or a waterfall must have responded to his charm. Prior to 1871 Moran had never known a true wilderness, and he was as poorly equipped for rough life as anyone I have ever known. But it made no difference— he had a solution for every problem. Never had he mounted a horse before we left the Botelers'. And then he did so with a pillow tucked in over the cantle of his saddle! Frail, almost cadaverous, he seemed incapable of surviving the rigors of camp life and camp food. Yet within forty-eight hours he was writing to a friend: "You should see me bolt the bacon." He astonished every member of the party, including Dr. Hayden, with the extent of his knowledge. It reached into every field. One day, after a string of trout had been brought in, Moran modestly showed us a way of cooking that was new even to the experienced woodsmen among us. He dug a shallow

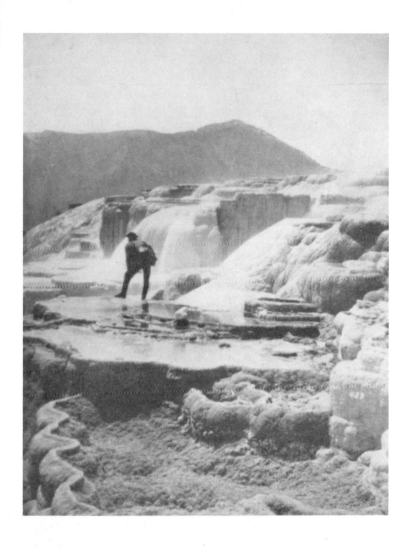

This is perhaps the oldest existing photograph of Mammoth
Hot Springs; I took it in the morning of July 21, 1871, our
first day in what is now Yellowstone Park. The man examining
the formation is Thomas Moran—to me, always the
foremost painter of the Yellowstone.

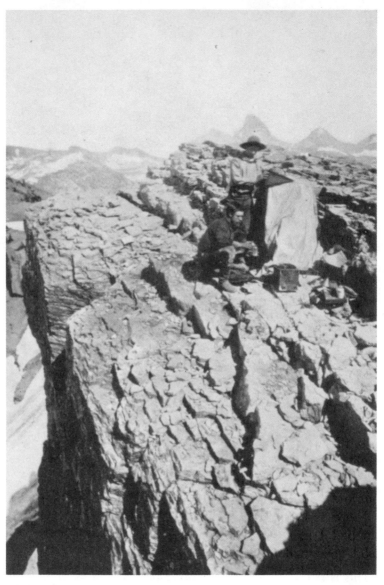

Young Charley Campbell and myself beside my dark tent
on a high ledge commanding a view of the Three Tetons.
After arranging the group, I joined Charley, while
my packer made the exposure.

hole in the ground beneath the fire, wrapped several fish in wet paper, placed the package in the hole, covered it with dirt, and raked some coals over the spot. Half an hour later we were dining on delicious baked trout. Moran became greatly interested in photography, and it was my good fortune to have him at my side during all that season to help me solve many problems of composition. While learning a little from me, he was constantly putting in far more than he took out.

Meanwhile, of course, Hayden and the others were out doing their work. Pictures were essential to the fulfillment of the doctor's plan for publicizing this Survey; but the basic purpose was always exploration. I cannot be too careful in emphasizing the fact that in this and all the following expeditions I was seldom more than a sideshow in a great circus.

After finishing up (as well as anyone could!) around the Falls we broke camp on Cascade Creek and pushed up the river to Yellowstone Lake. That had been one of our main objectives, and we had prepared for its exploration by bringing along a collapsible boat. Primarily that skiff had been intended—and was so used—for mapping the shore line, locating the islands, and sounding the lake. But I was able to "borrow" it on several occasions, and I thus had the means for reaching many vantage points otherwise inaccessible to me. It was a tiny, frail craft, and how it survived the loads I put in it has always been something of a mystery to me. Any slight squall would have swamped us. But the squall never came while I was on board. I have not been without my full share of luck in this world.

From the far end or "thumb" of the lake we visited all the near-by hot springs and mud puffs, and all my daylight hours were filled with picture-taking. But one day my turn came to do some exploring on my own account, into the Firehole country to the west of our camp. Some-

where beyond rose the Madison River, and we wanted
general information about the country thereabout. I was
rewarded by the discovery of a new basin of geyser cones
and caught one of them in eruption.

We were now prepared to return to our base, and we
left the lake by way of Pelican Creek and crossed over
to the East Fork of the Yellowstone. At Soda Butte we
laid over one day, while I completed my first series of
hot-spring pictures, and then the party made its way

back to Botelers' Ranch by the same route we had fol-
lowed on our ascent. We had spent exactly forty days in
the Yellowstone.

At the ranch we picked up our wagons and swung over
to the Three Forks of the Missouri. Then we struck up
the Jefferson as far as its Beaver Head branch, and thence
in a southerly direction across the divide and on to the
Snake River plains, finally coming out at Fort Hall, Idaho.
From the Snake River we worked east to Evanston on the
Union Pacific, where the main expedition disbanded for
the year.

Within the next few months I was to begin to taste that
little fame which comes to every man who succeeds in
doing a thing before someone else. Besides myself there
had been two other photographers in the Yellowstone that
season. One of them was Crissman, whose pictures never
passed the confines of a purely local market. The second
man was the expert T. J. Hine of Chicago, who had been

attached to the Barlow-Heap party. Hine got back to Chicago just in time to have every single negative destroyed in the terrible fire of 1871. And so the fact that my pictures were the only ones to be published that year is something for which I have to thank Mrs. O'Leary's cow.

CHAPTER XIII

MOUNTAIN OF THE HOLY CROSS

W HEN I returned to Omaha in the fall of 1871, after
another short picture excursion into central Colo-
rado, I found my wife well but very tired. Supervising
the studio and preparing for motherhood had been a
heavy drain on her strength. I decided to settle up my
affairs as soon as possible, and then to see that Mollie had
a vacation. She had certainly earned one.

Now that I was to remain with the Survey, I prepared
at once to sell my studio and standing equipment. A pho-
tographer named Silver made me an offer, which, although
it entailed a sacrifice, I accepted. I retained my cameras,
of course, and all my Indian and Survey negatives. Then
my wife and I packed all our possessions and started
east. My father had just retired from business, and he
and my mother were living in Nyack on the Hudson.
They were eager to see us both, and we planned to pay
them a real visit before going on to Washington.

But I found, after only a few days in Nyack, that I was
urgently needed in the capital. A bill to establish the
Yellowstone as a national park was under consideration,
and more prints from my negatives were required at once.
Accordingly I went on alone, leaving my wife with
Mother and Father, who were already much attached to
her. It was planned that Mollie would await her confine-
ment in Nyack, and, as soon as she was equal to the
trip, join me in Washington.

She was not ever to join me again. In February, when

her baby was born, Mollie died. Our child, a daughter, survived but a short while.

These are matters about which, even now, I can write no more.

By the end of February I was back in Washington. The photographs which I had prepared, with the assistance of my brother Fred, now a government employee, and two other young men, had helped do a fine piece of work: without a dissenting vote, Congress established the Yellowstone as a national park, to be forever set aside for the people. And on March 1, 1872, with the signature of President Grant, the bill became law.

Congress also made a liberal appropriation for a second expedition, to explore Yellowstone Park more fully and to take in the Teton Range south of it. The Survey was divided into two sections, the larger under Hayden to go directly to Fort Ellis and rework the territory covered the previous year, the other, headed by Stevenson, to explore the Tetons and then swing into the Park through Tahgee Pass (now known more prosaically as the West Entrance). Since the Stevenson division was preparing to go into country hitherto unphotographed, it was natural that I should be assigned to work with it. N. P. Langford, first superintendent of the park, also accompanied the Stevenson party.

I now added to my other equipment an 11 x 14 camera. The demand, as well as real need, for big pictures compelled that course, since satisfactory enlargements from small negatives could not be made.

Since it was impossible to prepare and develop the bigger plates in my portable dark box, I now had to set up a dark tent every time I wanted to make a picture. This little tent had a conventional cover of gray-white canvas; but inside it was lined with orange calico to cut out the actinic rays.

From Ogden, to which point our wagons and camp out-fits had been sent from Cheyenne by rail, Jim Stevenson led his section as directly as possible to the Three Tetons. A permanent camp was set up in the upper end of Teton Basin, then still a favored shelter for trappers; in the early days it had been called Pierre's Hole, for an old *voyageur* who had first come into that country for the Hudson's Bay Company.

While Stevenson led the main party out of the basin,

I started off on a side trip with my photographic section. With me, besides Charley Campbell (my late wife's eight-een-year-old cousin), were two young men, J. M. Coulter and P. J. Beveridge, and a packer named Aleck. We had two mules to carry our supplies, and, of course, all of us were on horseback. Our primary objective was the high tableland between the branches of the Teton River.

Reaching the main plateau, an altitude of about 11,000 feet, was not difficult; but achieving a photographic van-tage point was another matter. At one place we had to

pass around a narrow, high ledge, an extremely dangerous
undertaking through the deep, sloping snow. But we
made it, and almost immediately we were rewarded with
one of the most stupendous panoramas in all America.
Thousands of feet below us lay the icy gorge of Glacier
Creek, while on the eastern horizon the main range shim-
mered in the mid-morning sun. Above all this towered
the sharp cone of the Grand Teton, nearly 14,000 feet
above sea level.

I quickly set up my cameras and began one of the
busiest picture-making days of my whole career. It was
one of those rare days when everything I wanted could
be had with hardly a shift of the dark tent. Everything,
that is, except water. While Charley and Aleck went off
to fill their rubber water bags from a trickling snow bank,
I crept under the small tent and started to coat a plate.
When I pulled aside the flap a little later I looked up and
saw upon a rock ledge not twenty feet beyond me a moun-
tain sheep in dignified contemplation of the strange scene
before him—a bewhiskered man under an absurd cover-

ing of orange-hued canvas. With a high-speed miniature camera I might have snapped him a dozen times. But after a moment, during which the bighorn never twitched a muscle, I decided to have a shot at him with my rifle. I slowly reached out for it, and I know my eye never left the big ram—but suddenly, without a sound, he was gone.

After ten days the five-man photographic corps rejoined the main Stevenson party, and together we moved straight to the Tetons. At the foot of the Grand Teton, Langford and Stevenson decided without further preparation to attempt its ascent. Since they had no way of knowing that it would later be regarded as one of the truly difficult peaks of North America, they simply went ahead and climbed it. That, in my mind, is the way to climb a mountain. Sometimes there is an awful lot of nonsense about it.

For example, in 1898, when the Rev. Franklin Spencer Spalding (later Episcopal Bishop of Utah) led a small party to the top, he took with him a certain gentleman who later announced that Langford and Stevenson were frauds—since he had found at the top no evidence to prove that anyone had been there twenty-six years earlier! A realist of high order, and with political influence as well, this gentleman still later succeeded in having himself acclaimed—by joint resolution of the Wyoming legislature—as the first man ever to scale the peak.

By the middle of August the entire party, now grown, with additions to the Hayden branch, to sixty, was assembled in the Lower Firehole Basin. (One of the party, I remember, was a man who is still distinguished in the scientific world today—Mr. C. Hart Merriam, a Trustee of the National Geographic Society.) A photograph I prize more highly with each passing year was one I made of the expedition the day we all came together.

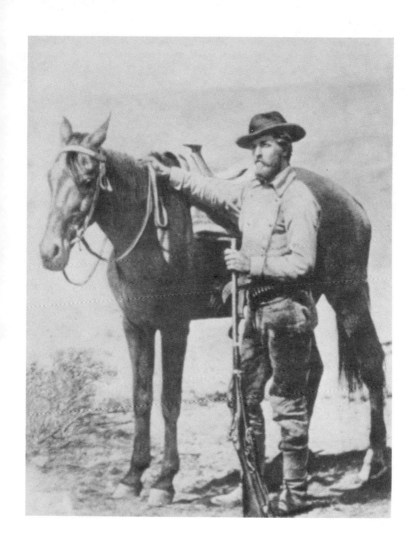

In 1872, while a member of the U. S. Geological Survey
exploring the Teton country, I set up my camera, then stepped
into this picture as an assistant uncapped the lens.

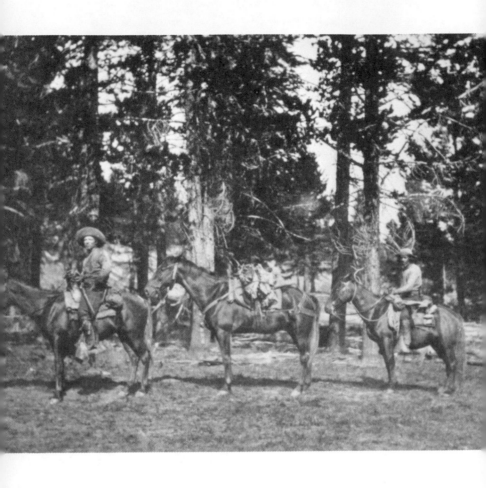

Our hunters, Joe Clark and a Mexican named José, arriving in camp in the Upper Yellowstone, 1872, with the day's supply of elk meat, strapped to the center horse.

The next few weeks were designed to cover one of my most fruitful periods. Subject matter, equipment (I was using my 11 x 14 exclusively), and working conditions, all contrived to give me a series of exceptional photographs. Everywhere I went—from the Gallatin Mountain country, clear to the southern end of Yellowstone Park —everything favored me. Just as this book is being prepared for the press, I find one of my 1872 pictures appearing again in print—the view of Jupiter Terrace at Mammoth Hot Springs, which the *National Geographic* for June, 1940, has seen fit to use as one illustration for the article entitled "Fabulous Yellowstone."

I passed the winter of 1872-73 in Washington. As in the previous year there was much to do on top of the field work—helping to get out the report of the Survey, classifying and cataloguing my pictures, providing friends in and out of Congress with endless copies of them, and laying plans for next season. Dr. Hayden wished to return to the Northwest; but the Indians of Wyoming and Montana were in an ugly frame of mind toward the white man and all his works. Accordingly Hayden prepared to explore the equally wild, but less hostile, Rockies of Colorado. It had been his intention to do so in any case, just as soon as he could get to it.

I had twice before made brief photographic excursions into Colorado for the Survey; but to scientists that great Territory was still a largely unknown wilderness. In order to cover as much of it as possible in a single season we were to work in small corps. James T. Gardner, our new chief topographer, was field leader of the expedition.

I was the photographic chief, and in my little section were the botanist Coulter; Lt. W. L. Carpenter, an amateur in entomology, who had secured leave from his Army post; a lad named Cole, son of the United States Senator from California, who was interested in birds; and

Tom Cooper and Bill Whan, two of the best packers ever to work for the Survey. And I had John Raymond —— though how I happened to be the lucky man to draw Potato John as my cook I never learned.

We took the field much earlier in 1873 than in any of the previous three years of my association with the Survey. When I arrived in Denver on May 14, I found our main camp already established on Clear Creek, two or three miles out of town. In temporary charge of the whole outfit was Gardner, who had prepared my itinerary, as follows: "First to Long's Peak, thence south along the Snowy Range to Gray's Peak, and from there work around by way of Pikes Peak to a rendezvous of all parties at Fairplay in South Park."

Ten days later I started out. Besides the riding horses I had six pack mules, four to carry grub, utensils, and tents, the remaining two to tote my cameras, chemicals, plates, and the same little orange-calico tent I had used in the Yellowstone. Everything was carried on aparejos, the stuffed-leather pack saddles commonly used in that country and farther south. As Potato John led off, riding our bell mare, I felt like a general in command of an army. This was *my* expedition.

There was another reason for me to be in high spirits. Two years before, while taking pictures on the Omaha Indian Reservation, I had been entertained by Dr. Edward Painter, of Baltimore, then the agent in charge, Mrs. Painter, and their daughter Emilie. A little later I sent them copies of the photographs, and an intermittent correspondence between the family and myself thus began. When my wife died, I received a letter that was far more than a perfunctory expression of sympathy, with the result that I called on the Painters the next time I visited Omaha. After that the letters went back and forth with a frequency that would seem remarkable— except for the fact that they were all between Emilie

Painter and myself. Our lively correspondence rapidly became intimate, and shortly before I left for Colorado I asked Emilie to marry me. Even knowing the worst— that I was a traveling man—she accepted my proposal and set the wedding for October.

From Clear Creek my little cavalcade hit a bee line for Long's Peak, and on the third day we were entering the foothills of the Rockies through the St. Vrain Canyon. Next morning we saw Estes Park for the first time, with Long's Peak on the far horizon. In camp that night at the lower end of the park we found ourselves close to a summer cottage. Since it was very early in the season, we were surprised to find it occupied—by a hospitable family who entertained us handsomely at supper and who apparently felt fully repaid by the story of our work with the Survey.

On May 30, I set up my camera on Prospect Mountain for a close-up view of Long's Peak and started the season's harvest. Then we left Estes Park and set out along the Snowy Range. All along the way we encountered deep drifts, and frequently the mules would become so bogged down that we had to unpack them before they could free themselves. Finally we arrived at the shores of a little lake, from which I was able to secure a fine view of the main range from Long's Peak to James.

After several days of busy photographing along Boulder Creek we struck off for James Peak. To our surprise we came upon a road, abandoned, as we could tell by the fallen trees across it, but still good enough to speed our progress greatly. None of us knew of any settlement in that immediate country, and we were startled a little later to see houses ahead. But there was no smoke rising from the chimneys. It was a true deserted village, another ghost town. Prospect holes, ore dumps, and the ruins of three stamp mills bespoke its origin—and its end. But though we searched for an hour we found no trace of

evidence to tell us the dead town's name, or who had lived there, or when. To this day I have met no one who could tell me anything more about it.

The weather was a constant hindrance during those first weeks. Snow fell nearly every day, and two hours' work out of twenty-four was my average. Yet the views, when the sky cleared enough for my camera, were so rich and splendid that a stock of finished plates soon piled up.

In Georgetown, another mining settlement, our mules were so frisky upon finding themselves out of the snow and on a dusty street that they trotted out of line, up the alleys, upon the footwalks, and even into the open doorways of stores. Seldom has so small a pack train produced such confusion.

We crossed Leavenworth Mountain and camped near Argentine Pass. Next morning we continued on up, riding our horses as far as we could and then following our own feet to the summit of McClellan Mountain, a height of about thirteen thousand feet. Next young Cole and I climbed Gray's Peak, 14,274 feet above the sea. From on top Torrey's Peak appeared to be higher, and to make sure that I had hit the ceiling in that section I climbed it also. Cole didn't bother, and later precise measurements proved that I need not (at least for my purpose at the time) have troubled either; for although Torrey has a sharper cone, and therefore looks higher, it is actually ten feet lower. It has always been a source of wonder to me that of 58 fourteen-thousand-footers in the United States, 40 are in Colorado, and that all of these 40 differ from one another in altitude by less than 500 feet. (But even more wonderful is the fact that Mount Whitney, 14,495 feet, the highest point in the country, and Death Valley, 276 feet below sea level, are almost within sight of each other in Inyo County, California.)

For a month I photographed the Rocky Mountains,

zigzagging the route indicated for me by Gardner. My companions were as busy as I was, Carpenter with his bugs, Cole with his birds, and Potato John, as always, with his bacon and biscuits. On the Fourth of July we passed a quiet holiday enjoying the effervescent waters at Manitou, and then we trekked off to keep our appointment with the others, seventy-two miles away at Fairplay.

Twenty-five miles a day—an average eight-hour stint—is just about the limit for a heavily loaded pack train, and in order to end each day's journey by around noon we had to start very early. One of Potato John's duties was to see that we were up on time to hit the trail, and no one ever did a better job of it. The first morning, when he stirred us up by shouting "Grub pile!" it seemed as if we had taken no rest at all. Actually it was three-thirty when he started serving breakfast. Next morning the same thing happened. But by the third day we had become so accustomed to the new regime that we all leaped up at the first sound of his voice. It was not until after breakfast that we realized why it had been so easy: none of us had yet sunk into a deep sleep. In his zeal John had called us at 1 A.M., with the result that we had to loaf around for nearly three hours until dawn gave us enough light for traveling!

When we reached the town of Fairplay, we found letters from Dr. Hayden and Stevenson telling us that they would arrive with the supply train about three days later. Another small division of the Survey was already on hand, and with an unexpected holiday before us we proceeded to use it with enthusiasm, if not to anyone's permanent advantage. Fairplay was not quite as wide open as Cheyenne in 1869. But we found it would serve. Purely as a side issue—a sort of constitutional, really—I climbed Mount Lincoln, twelve miles away, and made a few pic-

tures. Among my best early photographs are the ones of the famous Montezuma silver mine near the top.

After Hayden came in we all spent a week comparing notes, studying our common problems, and mapping our courses for the remaining weeks. My assignment was to cross the Sawatch Range to the Elk Mountain region between the Gunnison River and the Grand (so called until 1921, when it received the name of the great river to which it is a tributary, the Colorado), and then to wind up the season by photographing the Mountain of the Holy Cross.

On July 18, I started from Fairplay with my new instructions, a fresh batch of plates, and Dolly. Dolly was a white mule with cold eyes and a haughty manner. I selected her as a temporary mount in Fairplay after my horse became badly injured; but soon I found her the most docile as well as the most sturdy and surefooted of beasts. For the next five years, as long as I was with the Survey, Dolly was mine, and I rode her in preference to any horse.

Criss-cross and detour was the rule as we struck a northwesterly course toward Holy Cross—there were so many pictures that I *had* to take. Mount Massive—Mount Harvard—Mount Elbert, highest point in Colorado—La Plata—Snowmass—these and many more fell before my camera. But many did not, and I regretted the lost ones deeply. Today favorable atmospheric conditions—clear sky, bright sun, still air, clouds to punctuate the background—are always desired by the photographer. In the '70's bright weather was even more important. We had no fast emulsions to counteract the effects of overcast skies, or to "stop" wind-driven foliage, and we had no filters to define clouds and horizons against the sky. If the weather was good, I could take as fine a picture as can be made today. But on bad days much patient manipulation of the chemicals was needed to produce acceptable negatives.

The several parties were proceeding westward in the general direction of Holy Cross along more or less parallel routes. Periodical notes came to me from Dr. Hayden by messenger from beyond some distant ridge. Always these notes included, among more specific instructions, the urgent plea: "Hurry. You are losing golden opportunities."

Early in August all of us were together once more, on the high divide between East River and Rock Creek. And then catastrophe struck us. An evil mule named Gimlet slipped his pack and broke many of my exposed plates.

The Doctor himself was the first person to notice what had happened. Following directly behind my party, he found plates along the trail and galloped up to learn the cause. By that time Gimlet had scattered most of his load, and it was too late to do anything except right the pack and go back to pick up the pieces. Many plates were unbroken or but slightly nicked; many more, however, all 11 x 14's, were irreparably shattered.

I think I have never been so distressed in my life—my finest negatives lost before anyone had even seen a print. Nothing could be done to repair the damage, nothing. Dr. Hayden, who had started in to be severe, quickly realized that it was the fault of no single person; and, as always under trying circumstances, he dropped his customary nervous attitude and became the calmest man in the world. It was unfortunate, he agreed, but by no means disastrous—I could go back and retake the more important pictures. It really didn't matter at all, he assured me; there was plenty of time for all that, as well as for the other work ahead. And so I went back. What is more, Dr. Hayden was right. There *was* time enough for everything: the new negatives proved to be better than the old ones, and the delay brought me to the Mountain of the Holy Cross at the exact moment when every condition was close to perfection.

In the Middle Ages there was the legend of the Holy Grail. Sixty-seven years ago in Colorado there was the legend of a snowy cross upon a mountain.

No man we talked with had ever seen the Mountain of the Holy Cross. But everyone knew that somewhere in the far reaches of the western highlands such a wonder might exist. Hadn't a certain hunter once caught a glimpse of it—only to have it vanish as he approached? Didn't a wrinkled Indian here and there narrow his eyes and slowly nod his head when questioned? Wasn't this man's grandfather, and that man's uncle, and old so-and-so's brother the first white man ever to lay eyes on the Holy Cross—many, many, many years ago?

It was a beautiful legend, and they nursed it carefully. But anyone who wanted to see Holy Cross could climb Gray's Peak on a clear day and pick it up with field-glasses. As one comes close to the cross it always disappears behind Notch Mountain—and that is how the myth established itself.

After making our way over Tennessee Pass we followed an old Indian trail right to the base of the Holy Cross. At no time en route had we been able to distinguish the snowy cross itself, and I confess that I found myself experiencing all the thrill of the old stories. And, I think, the other fifteen members of the group present felt very much the same way.

On the morning of August 23 we separated into two parties. The larger, headed by Gardner, Hayden, Professor William Dwight Whitney of Yale University, and William H. Holmes, later the distinguished head of the National Gallery, were off to climb Holy Cross, for the purpose of completing a triangulation from the summit. Coulter and Tom Cooper, one of my packers, went with me to try for some photographs from Notch Mountain across the ravine. Tom carried the cameras, Coulter the

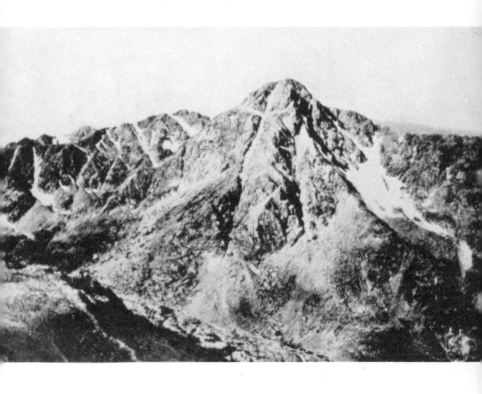

The Mountain of the Holy Cross. This picture is one of
eight which I made in 1873—the first ever taken
of this mountain.

The Mountain of the Holy Cross taken in 1893, with my son waving his hat as I exposed my plate. It was from this exact spot that I had first seen the Cross through swirling clouds.

plate boxes, and I the chemicals and dark tent. Each man's load weighed about forty pounds.

When prospecting for views it was my custom to keep well ahead of my companions, for in that way they could often be spared the meanderings that I had to make. On this day, as usual, I pushed on ahead, and thus it was that I became the first member of the Survey to sight the cross. Near the top of the ridge I emerged above timber line and the clouds, and suddenly, as I clambered over a vast mass of jagged rocks, I discovered the great shining cross dead before me, tilted against the mountainside.

It was worth all the labor of the past three months just to see it for a moment. But as I sat there waiting for Tom and Coulter to catch up, my instincts came to the fore, and I quickly devoured the hefty sandwich I had brought with me. No art was ever any better because the artist was hungry at his work.

By the time all three of us had arrived at the summit, the sky was too overcast for successful photography. While we waited for a break, we could hear faint voices across the gorge. We were that close to the other party.

Had we not been so engrossed in a single objective, our long wait on top would have been delightful. Below us as well as before us the clouds billowed majestically. Then when the mist was heavy in the valley the sun came out— not enough for picture-taking, but enough to create a great circular rainbow at our feet. I have never seen another like it.

But we were too impatient to enjoy such idle pleasures. Seething inwardly, and all to no purpose, we watched the evening approach. We *must* have pictures before going down. And we *would* have pictures. Foodless, without blankets or even coats, we determined to spend the night on the peak. Leaving our equipment at the crest, we walked down to timber line and built a fire. There we rested on the stony ground until morning. Across the way

our friends had a fire of their own, and every time it flared up we hallooed and heard their own halloos in answer.

At dawn we were cold, stiff, hungry—and elated. The day, or at least the morning, promised to be magnificently clear and sunny. In order not to lose a single moment I hurried wearily back to the top and set up my cameras. But I need not have rushed. The sun was still too low, even in midsummer, to have melted any snow, and without water I could do no work.

By the time I had enough to develop and wash a few plates the long flamelike shadows on Holy Cross were rapidly sweeping down into the valley, and, using two cameras, I had made just eight exposures when they were gone. But, with the early sun, those shadows had already helped me to take the finest pictures I have ever made of Holy Cross.

Since 1873 I have been back four or five times. I have used the best cameras and the most sensitive emulsions on the market. I have snapped my shutter morning, noon, and afternoon. And I have never come close to matching those first plates.

FINDING THE LOST CITIES

M Y marriage to Emilie Painter took place on October 8, 1873, before I returned to Washington. Since I was a relatively recent widower, Emilie, her parents, and I had agreed it would be most fitting to omit the traditional trappings. And so we were married with the utmost simplicity, in Cincinnati, at the home of Emilie's brother Samuel.

My wife came of a gifted family of Friends, or "Quakers" (a designation they deplore). Her father, a man of deep religious convictions, had given up a fine medical practice in Baltimore to take charge of the Omaha Reservation. When he arrived in Nebraska, he found that his Indians, although at peace with the whites, were still inclined to take direct measures when dealing with other tribes. Dr. Painter's faith, of course, imposed the absolute command that all differences between men be settled without violence; and not long after he came to the reservation he singly averted a tribal war. Some Kiowas had augmented their herd of horses at the expense of the Omahas, with the result that the Omaha braves, painted and bonneted, assembled to recover their property. But Dr. Painter meanwhile had hitched up his mare to the buggy. Then he told three or four of the chiefs to get on their horses and follow him. "Where?" they asked. "To visit our friends, the Kiowas," he answered serenely. "Leave your guns at home. We are going for your horses." Wonderingly the Omaha chiefs went along. And next

day they were back—with all the missing animals. Neither the Omahas nor the Kiowas ever recovered from their astonishment that one smiling man, simply by talking, could accomplish so great a deed.

William Painter, Emilie's older brother, was another remarkable man. In his teens he patented a mechanical device that improved railway-coach seats, and for the rest of his life he applied himself to engineering problems of all sorts. He was one of those incomprehensible persons who could saunter through a factory in ten minutes, then tell the boss in detail how to speed up his plant, increase production, and cut costs. But he possessed a talent even rarer: he could make money for himself. William Painter invented the "crown seal," with which beer and most other beverage bottles are still capped today.

Emilie's mother, whose maiden name was Louisa Gilpin, was not only a very gracious lady but a thrifty woman of affairs, well qualified to aid her husband in handling the complex problems of the Omaha Reservation. When she approached old age, her Quaker thrift sometimes got the better of her, and in a way that tended to cause real alarm. Mrs. Painter kept a sharp eye on the medicine cabinet; and whenever she found a nearly empty bottle she would heroically drain it, rather than risk having it thrown away. "I tell thee I cannot abide waste," was her invariable answer to my wife's protest.

Her cousin was William Gilpin, first Governor of the Territory of Colorado. When I started business in Denver in 1879 he was still, by courtesy, the First Citizen of Colorado, and it was often our honor and pleasure to entertain him in our house. Governor Gilpin was always especially devoted to Emilie and to our children.

An alumnus of the University of Pennsylvania and West Point, he had received his commission from President Jackson to fight in the Seminole War; he had accompanied

Frémont to the Pacific in 1843; he had fought through the war with Mexico; and he had been, not only Colorado's first governor, but—a distinction he prized even more—one of its very first settlers, a veteran of the "Pikes Peak or Bust" days. I wish I had not always been so completely absorbed in his wonderful stories; they were so good that I could never stop listening long enough to add them to so many less arresting items in my journal. Yet one story did grow tedious: in his late years the Governor became obsessed with the idea of building a railroad to Alaska and across Bering Strait to Siberia. "Here comes Governor Gilpin," my growing children would call out. "Do we *have* to listen while he tells about the train to Alaska again?"

After our marriage Emilie and I went to New York for a few days, staying at the Metropolitan on Broadway not far below Twenty-third Street, then the theater district. Following our brief whirl in the metropolis we went on to Baltimore for another few days, where I had the pleasure of meeting many of Emilie's relatives and friends. Then we proceeded to Washington and a winter of work for me.

We took pleasant rooms at Mrs. Ryan's comfortable boarding house on H Street. The Survey was housed almost around the corner on Seventh Street, and, although I never had to punch a clock, I could be found at work there nearly every day from nine, or earlier, until six, or later.

Quite apart from any lasting value that my classifying and cataloguing might have, there was the immediate need for the Survey as a whole to organize its findings and to prepare them for publication. Whether or not there was an active public demand for such a report, it was imperative that the Survey justify, and keep on justifying year after year, its practical usefulness before Congress. And regularly every year all of us passed through a sea-

son of fits and trembles until the chosen representatives of the people should vote the money we needed to take the field again. Dr. Hayden and his associates were the bone and sinew of the Survey—but Congress had to provide the life blood.

After my day's work, unless some departmental duty interfered, I would spend the evening with my wife, reading or playing cribbage or piquet or chess. Not infrequently, though, we would be asked to dine out, with one of my colleagues, or with some new acquaintance of Emilie's; or we might attend a lecture at the Smithsonian Institution. And on Sundays, if the weather chanced to be fine, we might take the train for Baltimore and there pass the day visiting one or another of Emilie's many girlhood friends. It was a quiet life in Washington, and without any splurges—my top salary with the Interior was $175 a month, and extra income from my photography was neither large nor dependable. But it was the sort of life both of us found gratifying.

The Panic of 1873 threw a staggering burden upon the Congress which convened shortly before Christmas. It was a new order of things which its members faced. And since few of the gentlemen were prepared for it by training, and none by experience, the session of 1873-74 was turbulent and long drawn out. One of the inevitable results was that the Geological Survey should be pushed into the background. The appropriation finally came through so late that we never got out of Washington until July.

We arrived in Denver on the fifteenth, and as in 1873 the Survey was divided into half a dozen small groups. There were seven of us in my photographic division: two expert packers, Bob Mitchell and "Steve" Stevens; two young men of eighteen or nineteen, Frank Smart and Ed Anthony (son of a leading New York photographic-supply dealer), to help with the picture taking; a cook named

Emilie Painter, photographed in Baltimore shortly
before our marriage in 1873.

This photograph of me was made in Washington in 1873, about the time of my marriage to Emilie Painter.

Charlie, formerly a waiter at Charpiot's Restaurant in Denver; and Ernest Ingersoll, "occasional correspondent" of the *New York Tribune*. Ingersoll was a naturalist as well as a journalist, and, although quite young, gifted in both capacities. Our friendship has continued uninterrupted for sixty-six years, and now that both of us live in New York we see each other frequently. When last January my friends of the Explorers Club saw fit to give me a testimonial open house, Ernest Ingersoll was present; and just a few weeks later I attended a dinner in his honor. As we sat at the table together Ernest leaned over and said: "You see, Jack? I told you they thought more of me than they do of you. All you got at the Explorers was open house; but they are making people *pay* to see me."

The lateness of the season had recommended for all divisions a general policy of reconnaissance rather than carefully detailed study in any region, and in order to speed up my end I went back to a smaller camera, a 5 x 8. For its day it was a "miniature"; but it enabled me to discard the developing tent and return to my less cumbersome dark box. And since the plan was primarily to select fields of operation for the next full season, 5 x 8 plates and stereos would serve admirably.

While making final preparations in camp on Clear Creek I studied the route that had been mapped out for me: to Middle Park by way of Berthoud Pass; from there south into San Luis Park; and from that district west up the Rio Grande to its headwaters in the San Juan Mountains. Somewhere in there I was expected to pick up the main party, and then, if conditions and time permitted, we might work down into New Mexico and Arizona. And, of course, I was free to deviate from the schedule if, in my opinion, circumstance should so dictate.

On Tuesday, July 21, after the usual tussle with new mules, our aparejos were given a final adjustment and

we started off. I rode Dolly, the white mule to which I had become so attached the summer before.

The next four weeks were busy and productive, but without striking incident. I had my heart set on getting some fine Indian pictures before the summer was over, and with this in mind even the gorgeous landscapes of the Rockies failed to stir me greatly. And so it was not until we reached the settlement of Saguache in San Luis Valley that I really started to take notice. For not far to the west was Los Pinos Agency, and a large band of Uncompahgre Ute braves, with their squaws and papooses, were scheduled to be encamped there to draw their annual supplies from the Government.

On August 18 we left Saguache and made our way up a canyon of basaltic trachyte into a great grove of quaking aspens. As we continued to go up, the aspens gave way to spruces, and then the spruces thinned out until we arrived at the broad open elevation known as Cochetopa Pass. Passing down the western slope, we came to Cochetopa Creek, and on the broad meadow lands, at its confluence with Los Pinos Creek, we found our Indians. I counted more than seventy large tepees, spread out over a good square mile, and all the grazing land in sight was dotted with ponies belonging to the visiting Utes.

The agency buildings, a dozen or more log houses, were in sight, four or five miles beyond, and we stopped at the creek to make a careful toilet before proceeding any nearer. Such is the vanity of man at the mere prospect of encountering a woman.

The agent, a Unitarian minister named Bond, greeted us when we rode up, and, when I had told him that our first object was photographs, he assured me that we might begin instantly. He seemed quite crestfallen when I ventured to suggest that our prime mission was not to take pictures of himself and his family but of the Indians.

When I tactfully added that it was also my purpose to record the Bond family he brightened again, and I knew we could count on his help.

Next morning the Reverend Mr. Bond took us over to meet Chief Ouray, head man of the Uncompahgre Utes. He lived in an adobe house that the government had built for him, and when we entered this "palace" he was unattended. Rising from a rough board couch that was covered with Navajo blankets, he greeted us with an urbane smile and bade us welcome.

Of all the Indians I have known Ouray was quite the most extraordinary. Some forty years of age, he was, unlike the majority of his fellow tribesmen, short and rather dumpy. His head, while uncommonly large, was well formed; his features were regular and well modeled; his teeth were white and fine. Most striking, his expression was indicative not only of good will but of great intelligence. Ouray was a lover of peace, and his career was unblemished by a single instance of violence against the whites. His personal life was equally blameless. Ouray dwelt austerely with his wife; he used no tobacco, and he hated whisky. Before he died, in fact, Ouray joined the Methodist Church!

We talked together until noon, and our conversation was carried on in English with the greatest ease. Among his other virtues and accomplishments Ouray included the gift of languages. On several occasions he had been taken to Washington to act as interpreter, and it was largely for that service that the Government had built him his house and given him an annual pension of $1,000. Ouray not only dwelt in a house like his paleface brothers but, by preference, wore their clothes—a black broadcloth suit, polished boots, and a derby hat.

After dinner I set up my camera on the porch of the agent's house and started the ball rolling by making a few shots of Mr. and Mrs. Bond. Ouray, now in beaded cere-

monial buckskin, had meanwhile appeared; and he, both alone and with his comely wife, was my next subject. Everything was off to a fine start, when a sudden rain-storm interrupted. That was disappointing—but how disappointing I had no way of knowing until the next day.

It was noon before the sun came out. Meanwhile every preparation had been made for a formal arrival before the tepees of the Utes, and as soon as the weather cleared Ingersoll and I, on horseback, followed the agent in his carriage and presented ourselves to the assembled chiefs. We were received with fitting circumstance and led into a tepee for a ceremonial pipe. Then we were politely informed that there could be no pictures. The Ute medicine men had said, *"No bueno."*

We argued and pleaded and cajoled, but to no purpose. The chiefs Shavano and Guerro were resolutely opposed. "Make Injun heap sick." "Squaw die." "Papoose die." "Pony die." "All die." *"No bueno."*

Chief Tush-a-qui-not, or "Peah," on the other hand, took no strong position. From him, as well as from Ouray, we had bought two or three Navajo blankets.

If Ouray was the most extraordinary Indian of my acquaintance, Peah was certainly (to use a very old as well as a very new word) the most photogenic. He was, in fact, a superb subject—even if his rank and importance were relatively small. After taking a few pictures before the tepee of Peah, his family, and several small groups of his own immediate followers—another thunderstorm came up, and my work was once again abruptly checked for the day. Ingersoll and I were then invited inside, where we spent the next hour in difficult and purposeless conversation carried on in English, Spanish, and Ute, as well as by signs. The thing I remember best was a remark constantly repeated by the old man who was either Peah's uncle or father-in-law. Happily patting his chest, he would announce proudly: "Heap lazy."

My 1874 photographic division, on the way to Los Pinos
and the Mesa Verde. Left to right: Smart, Anthony, Mitchell,
Whan, Ernest Ingersoll, and Charley, our cook. Dolly, my
mule, stands between Charley and Ingersoll.

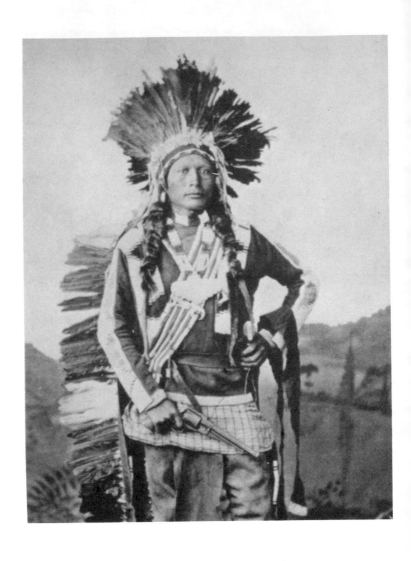

Chief Tush-a-qui-not, more familiarly known as Peah, whom I photographed at Los Pinos Agency, Colorado, in 1874. Peah wears the ceremonial dress of the Uncompahgre Utes.

By the following day even Peah had turned against us. No one would pose. Nor would they permit me to use my camera even from a distance. When I set up my tripod on a commanding elevation to take a panoramic picture of the whole village three or four Indians were detailed to get in my way. As I attempted to focus, one of them would snatch the cloth from my head; or toss a blanket over the camera; or kick out one of the supporting legs. When I retired to the doorway of the agent's kitchen and tried to catch a view from just inside a horseman galloped up and wheeled square in front of me. Then Peah came to demand the surrender of all the finished negatives!

After three or four days of organized opposition I gave up. I had got a few really superb negatives, and I could foresee only mounting trouble if I persisted. And so for the duration of our stay at Los Pinos I roved about and took notes—what I had been forced to omit I might later be able to set down with paint on canvas.

The most interesting occurrence, as it happened, was nothing that I could have photographed with any equipment then in existence. That was the distribution of beef. Live steers were released from a corral, one for every six lodges, and as the gate opened the small group of men whose turn it was filled the air with shrill cries and pursued their animal across the plains. Sooner or later they would succeed in bringing down the hapless steer with a bullet—often the chase would cover a mile, for those Indians were incredibly bad marksmen—and the butchering followed immediately. Everything was taken away to be used, hide, hoofs, and horns, besides the meat.

The evening before we left the agency a chief who rejoiced in the name of Billy visited me. He had come, he informed me with an air of great condescension, to give me friendly warning: this country, regardless of treaties and boundaries, was owned by his people; it would be dangerous for us to proceed farther with my strange box

of bad medicine; hunters who had destroyed their game
had died; other men who dug in the ground and took
away their gold had also died; it would be better for me
and my companions to return at once the way we had
come.

I decided it might be well to answer Chief Billy in the
way he could best understand. Motioning to Bob and
Steve, who were crack shots with both rifle and revolver,
I got them to put on a little exhibition of target shooting,
in which I also joined. After a dozen rounds Billy de-
parted. Neither he nor Peah, who had been audacious
enough to demand the exposed plates, tried any further
interference with us.

The other outstanding event of 1874, and of far greater
importance to the Survey than our visit to Los Pinos, was
the trip to Mesa Verde.

Stopping for few pictures, we covered eighty miles in
less than three days, and on August 27 we stood at the
head of the Rio Grande opposite Cunningham Pass. Be-
yond it, and below, was Baker's Park, our next scheduled
field.

On our way up the Rio Grande we caught up with three
miners driving burros. One of them turned out to be an
old friend from Omaha, E. H. Cooper, whom I had
known in 1868. We all camped together that night, and
when Cooper learned the business that had brought me
to his corner of Colorado he suggested that we might
wish to visit the cliff ruins not so far from their placer
workings on La Plata River. He himself had not seen
them; but the big boss was familiar with their exact loca-
tion and would undoubtedly give us full directions.

Although we had not planned to go beyond Baker
Park, the ruins sounded so exciting that I decided to strike
there directly. Numerous cliff dwellings, remnants of a
civilization that had died long before the first Spaniards

John Moss, Our Guide into Mesa Verde

arrived, had already been found in the Southwest; but
the ones Cooper described promised to be quite the most
magnificent find of all. Even the name of the place was
exciting—Mesa Verde, the green tableland.

At the mining camp Cooper introduced us to a slight,
bearded man with graying shoulder-length hair. He was
John Moss, chief owner and operating head of the claim,
and according to Cooper, "hy-as-ty-ee and high muck-a-
muck of the whole La Plata region." Whatever that may
have meant, John Moss was affable; and soon he expressed
not only a willingness to give directions to the cliff dwell-
ings but to show us the way himself.

On the way Moss interested me very much by his re-
marks on the Indian situation. The Southern Utes had
not been well treated. The boundaries of their reserva-
tion had been altered and their best hunting grounds
taken from them by prospectors. Promised compensation
had not been made, and, in consequence, the Utes were
ordering white men—surveyors in particular—to leave the
reservation. So far no hostilities had been reported. But
Moss was none too sanguine about the future. He him-
self had no fears; for he had made a private treaty with
the regional chiefs. In exchange for some twenty-five
square miles of La Plata land he had agreed to pay an
annual rental in the form of horses, sheep, and a little
cash. It was worth it, he said, to live secure in the friend-
ship of his neighbors. And it was also just and intelligent.
Much good blood might have been saved if John Moss's
course had always been the rule.

It pleases me to point to another manifestation of John
Moss's practical mind. Our host and guide was a candi-
date for some political office in the new and sparsely
settled County of Rio Grande, and since residence require-
ments were on the sketchy side for this first election, it
was an easy matter for my photographic party, including
the boys, to help vote him into office. After our ballots

had been cast Moss closed the polls, and we were off. That night, September 8, we spent at the ranch of a settler named Merritt in the Mancos Valley, who was associated with the miners in an agricultural experiment. His little log house, with immense stone fireplace, was then the only white man's dwelling west of the Animas River in the entire San Juan Basin.

Late on September 9 we arrived within rifle shot of the ruins. As we were riding through the deepest part of Mancos Canyon with the Mesa Verde eight hundred feet above us, Moss suddenly pointed toward the top of the plateau and said, "There it is."

"I see it," was the instant answer of Steve, the packer; and in a moment all of us had managed to pick out something that looked like a house, with spots suggesting windows and a door, sandwiched between two strata of sandstone almost at the top. Abruptly all of us forgot the day's long ride. Only the top would do, and at once.

For the first 600 feet or so we had a stiff climb but not a difficult one. Then we found ourselves facing a flat, vertical wall rising some 200 feet above the ledge on which we were standing. Fifty feet above our heads, in a shallow cave, was a two-story house. But how to reach it?

At that point everybody but Ingersoll and me decided to leave all problems until morning. We two, however, were determined to look for the way up at once. And it was not wholly the zeal of the inexperienced which pushed us on. Ingersoll was a newspaper man, and I was a photographer. Even in those days men of our callings got their stories.

We made it, too. After Moss and the others had gone down we found an old dead tree which we propped up and used to reach some ancient handholds and footholds cut in the rock. Invisible in the twilight, they served our

need, and up we went to the house. It was worth everything I possessed to stand there and to know that, with Ernest Ingersoll, I was surely the first white man who had ever looked down into the canyon from this dwelling in the cliff.

And now I want Ernest Ingersoll to take up the story. When we returned to Denver he sent the full account of our preliminary discoveries to his newspaper, and the *New York Tribune* thus was the first to publish, November 3, 1874, a description of the ruins which subsequent explorations established as the most remarkable in this country:

. . . We came down abundantly satisfied, and next morning carried up our photographic kit and got some superb negatives. There, seven hundred measured feet above the valley, perched on a little ledge only just large enough to hold it, was a two-story house made of finely cut sandstone, each block about 14 by 6 inches, accurately fitted and set in mortar now harder than the stone itself. The floor was the ledge upon which it rested, and the roof the overhanging rock. There were three rooms upon the ground floor, each one 6 by 9 feet, with partition walls of faced stone. Between the stories was originally a wood floor, traces of which still remained, as did also the cedar sticks set in the wall over the windows and door. . . Each of the stories was six feet in height, and all the rooms, upstairs and down, were nicely plastered and painted what now looks a dull brick-red color, with a white band along the floor like a base-board. There was a low doorway from the ledge into the lower story, and another above, showing that the upper chamber was entered from without. The windows were large, square apertures, with no indication of any glazing or shutters. They commanded a view of the whole valley for many miles. Near the house several convenient little niches in the rock were built into better shape, as though they had been used as cupboards or caches; and behind it a semi-circular wall inclosing the angle of the house and cliff formed a water-reservoir holding two and a half hogsheads. . .

INNUMERABLE GROUPS OF DESTROYED EDIFICES

Searching further in this vicinity we found remains of many houses on the same ledge, and some perfect ones above it quite inaccessible. The rocks also bore some inscriptions— unintelligible hieroglyphics for the most part... All these facts were carefully photographed and recorded.

Leaving here we soon came upon traces of houses in the bottom of the valley in the greatest profusion, nearly all of which were entirely destroyed, and broken pottery everywhere abounded. The majority of the buildings were square, but many round, and one sort of ruin always showed two square buildings with very deep cellars under them and a round tower between them, seemingly for watch and defense... Another isolated ruin that attracted our attention particularly consisted of two perfectly circular walls of cut stone, one within the other. The diameter of the inner circle was twenty-two feet and of the outer thirty-three feet. The walls were thick and were perforated apparently by three equidistant doorways. Was this a temple?

... A little cave high up from the ground was found, which had been utilized as a homestead by being built full of low houses communicating with one another, some of which were intact and had been appropriated by wild animals. About these dwellings were more hieroglyphics scratched on the wall, and plenty of pottery, but no implements. Further on were similar but rather ruder structures on a rocky bluff, but so strongly were they put together that the tooth of time had found them hard gnawing; and in one instance, while that portion of the cliff upon which a certain house rested had cracked off and fallen away some distance without rolling, the house itself had remained solid and upright. Traces of the trails to many of these dwellings, and the steps cut in the rock, were still visible, and were useful indications of the proximity of buildings otherwise unnoticed.

A STREET A THOUSAND FEET DEEP

We were now getting fairly away from the mountains and approaching the great, sandy, alkaline plains of the San Juan River. Our Valley of the Mancos was gradually widening, but still on either side rose the perpendicular sides of the mesa,

composed of horizontal strata of red and white sandstone... Imagine East River one thousand or twelve hundred feet deep, the piers and slips on both sides made of red sandstone and extending down to that depth, and yourself at the bottom, gazing up for human habitations far above you...

Keeping close under the mesa on the western side—you never find houses on the eastern cliff of a canyon, where the morning sun, which they adored, could not strike them full with its first beams—one of us espied what he thought to be a house on the face of a particularly high and smooth portion of the precipice... Fired with the hope of finding some valuable relics, the Captain [Moss] and Bob started for the top... After a while an inarticulate sound floated down to us, and looking up we beheld the Captain, diminished to the size of a cricket... He had got where [as it appeared to us below] he could not retreat, and it seemed equally impossible to go ahead.

A TRAGIC INCIDENT

There was a moment of suspense, then came a cry that stopped the beating of our hearts as we watched with bated breath a dark object, no larger than a cricket, whirling, spinning, dropping through the awful space....

The Captain had thrown down his boots.

He was still there, crawling carefully along, clinging to the wall like a lizard, till finally a broader ledge was reached; and, having the nerve of an athlete, he got safely to the house. He found it perfect, almost semicircular in shape, of the finest workmanship yet seen...

Photographs and sketches completed, we pushed on, rode twenty miles or more, and camped just over the Utah line, two miles beyond Aztec Springs...

Our next day's march was westerly... The road was an interesting one intellectually, but not at all physically—dry, hot, dusty, long and wearisome. We passed a number of quite perfect houses, perched high up on rocky bluffs, and many other remains...

This was the end of our season's work. From the eastern edge of Utah we returned through Baker's Park to Denver, and by the beginning of November I was back in Washington.

Those discoveries of ours attracted considerable attention, of course. But no great official notice was taken for some years. In 1888 local ranchers, brothers named Wetherell, found extensive ruins in canyons that Ingersoll and I had not explored, and with report of new canyons rich in prehistoric dwellings interest was reawakened. But it was not until 1906 that Congress set aside Mesa Verde National Park—50,000 acres studded with the best preserved cliff dwellings to be found anywhere in the world.

LAST DAYS WITH THE HAYDEN SURVEY

THOUGH more than thirty years were to pass before the significance of Mesa Verde should be suitably acknowledged, there were some individuals who could at once grasp the implications of those canyon houses. One of them was Dr. Hayden. Before he had glanced at half a dozen photographs, my work for the following season was determined in his mind. I was to go back, take many more pictures, explore further. Hayden was a dynamic, intense man; yet never had I seen him at such a high pitch of enthusiasm.

My 5 x 8 had proved so satisfactory the year before that I decided to rely upon it again, for both single and stereographic views. But I wanted to have a large camera for certain pictures, and I picked a 20 x 24, that is, one taking a plate of 480 square inches—exactly twelve times the area of my 1874 negatives. No such camera was stocked in Washington; but I found one in New York, either at E. & H. T. Anthony's or the Scovill Manufacturing Co., as I remember. By late May of 1875 it was ready for me, and in the first week of June, I was on my way to Colorado with the largest camera I have ever handled outside of a studio. I can add that my 20 x 24— although used only for exceptional shots—was worth all the extra labor it cost.

And so on June 6, after a brief stop in Denver, I made directly for Parrott City, at the head of the Rio La Plata, not far from the New Mexico line. With me, besides Bill

Shaw, the cook, and the two veteran packers, Bob Mitchell, and Bill Whan, were Harry Lee and E. A. Barber. Lee, an experienced guide, took the place of John Moss, who had been forced by business in San Francisco to decline my invitation to join the party; not only was Lee a good guide and interpreter, but he looked a good deal like Buffalo Bill Cody—and all for $25 a week. Barber, in a quite informal way, represented the *New York Times*. But on the rolls of the Survey his name was followed by the word "naturalist." For some reason that never became entirely clear to me all newspaper men, as well as any other persons who had no specific qualifications, were carried as naturalists. They never seemed to mind, and I suppose it gave the Department of the Interior some vague satisfaction—perhaps what the Japanese call "face."

At the start there was a second party, also representing the Geological Survey, in the field with us. My old friend William Holmes was in charge. His chief interest lay in the geology of the San Juan country; but, since Dr. Hayden was concerned with all aspects of the cliff dwellers' old domain, Holmes had also been instructed to devote himself to archaeology. Later Holmes became one of the world's distinguished authorities on the work of ancient man, and it is my pleasure—though perhaps not wholly founded on fact—to think that his great interest had its roots in Mesa Verde.

Our two groups traveled together until about August 1. At that time Holmes, having completed a preliminary investigation of the ruins I had photographed in 1874, headed up Montezuma Canyon to search for other lost cities, while Lee, Barber, and I pushed west into Utah along the San Juan.

Not more than a dozen miles below the Montezuma we found a great circular cave cut by the water in some remote age, and forded the river to inspect it closely.

The rock chamber was a hundred feet deep, and its vaulted ceiling was about twice as high. From almost any point under this enormous natural dome every sound, even a low whisper, echoed back with amazing clarity; and that phenomenon, plus a certain pride in my Spanish, prompted me to name it *Casa del Eco*.

A short way downstream the San Juan plunged into an impassable gorge, thus compelling us to make a trail up on to the plateau. Soon we came to the Chinle Wash. A great river in an earlier geologic age, it was now a thin stream trickling into the San Juan. There we stopped to cool ourselves with a bath—the temperature of the air was 125°, of the water 88°.

In such extreme heat, and with water likely to be scarce, it was imperative that we spare the mules all needless burden. In consequence, before attempting the hundred-mile journey to our immediate destination, the Moqui—now the Hopi—country of Arizona, we dug a hole in the sand and cached such implements and materials as were not absolutely necessary for a fortnight's expedition.

At one point on the way to the pueblos we encountered extensive ruins. In a long shallow cave along the Chinle we discovered a whole little town of sandstone dwellings. Although it had been abandoned centuries before, the accumulated debris was rich in relics. Glazed pottery (mostly fragments), hollowed stone grinding basins, ax heads, arrow tips, and spear points abounded. Only our need to travel light kept us from departing with an immense haul.

Soon after crossing into Arizona Territory we came to the Great White Plateau, so named from its cliffs of white sand stone. Here was the famous "diamond field" which a group of imaginative swindlers had exploited in 1872. After salting the district with a hatful of small but genuine stones and then dropping a few artless hints, these

men had succeeded in promoting a sizable stock-selling scheme. That was before the crash of '73, when people were just as frantic to buy non-existent diamonds in Arizona as they were to invest in Goldman-Sachs common in the spring of 1929, or Kreuger & Toll, or Bank of United States—or name your own.

We met several small bands of Navajos en route to the Moquis and, as paying guests, enjoyed dining with them on sweet corn boiled in the shuck and watermelons. Our hosts invited us to remain for their ritual corn dance soon to be held; but, although I was eager to try for some photographs of that ceremony, we lacked the time to wait over. I think the Navajos were even more disappointed by our departure than I was. Leather was the most sought-after commodity in their country, and any one of those Indians would gladly have traded his right eye for a saddle or an aparejo. For some miles after leaving we could see two horsemen tagging along in the distance, and that night I insisted upon maintaining a watch against possible thieving.

About noon on August 12 we saw through our glasses the first of the mesas on which the Moqui towns were built, and before sunset we had arrived at the Pueblo of Tewa.

Today every child learns about the Southwestern Indian villages before finishing the fifth or sixth grade, and I have nothing to add to the textbook descriptions. But in the '70's and '80's that civilization was not familiar to many people. I was therefore anxious to take all the photographs I could of subject matter that was intensely interesting at the time—even if it produces only yawns in 1940.

One picture of the 1875 trip, though not in itself remarkable, has a certain sentimental value for me. That is the portrait of Num-pa-yu ("Serpent-that-has-no-tooth"), sister of *Capitan* Tom of Tewa, who served us

with bread and corn at our first meal. She was then seventeen or eighteen, and such a remarkably pretty maiden that a dozen years later when in the vicinity I remembered to ask after her; I was told that Num-pa-yu, still very beautiful, had become the most famous pottery maker of the Moquis. Another forty years passed, and once more I was near the home of Num-pa-yu; to my delight I learned that she was still very much alive and that I could see her. We had a long conversation, and then Num-pa-yu sent for several young men and women, her grandchildren, to meet me. That was in 1927, and I have not seen her again. But only a year or two ago my friend John Louw Nelson brought me a copy of his book *Rhythm for Rain*—and in one of the photographs I instantly recognized Num-pa-yu, still smiling after an interval of some sixty years.

On August 15 we started north from Tewa. Apart from the discovery of more ruins and my intense application to detailed sketching (for a reason which I will explain a little later) as well as to my photography, the next two weeks passed without unusual incident. But on the thirty-first we had enough excitement to make up for the preceding lull.

Back in eastern Utah and heading through Montezuma Canyon, we observed an Indian boy half concealed behind some rocks on a distant bluff. As soon as he saw that we had discovered him he jumped on his pony and galloped away. Some little while later a dust cloud ahead of us turned into a band of eighteen or twenty Pah Utes. As they tore down on us swinging their rifles overhead, shrilly crying "Hi-hi! Hi-hi!" we remembered that some renegade Indians were in the vicinity. Apparently these were not disposed to harm us; yet we felt better after Harry Lee had explained in their lingo what we were doing in the Ute country. The fact that their friend John Moss was also our friend established us in their favor, and so did

Lee's assurance that we were none of the surveyors they so detested. (At all times we avoided any mention of the Geological Survey; for even the word "survey" was anathema to all Utes. And I was always especially careful to explain that my camera tripod, despite its telltale legs, was *not* a transit.)

But these men were irresponsible young bucks. Suddenly one of them struck the pack mule with his quirt, others did the same to our horses, and instantly we were in a wild stampede down the canyon, driven by howling savages. All of us were having the time of our lives—but in different ways.

On an open plain at the foot of the canyon we came to a halt. Before us were a score of wikiups, the characteristic rounded wicker-and-canvas shelters of nomadic tribes in the Southwest, and from one of them the Pah Ute chief stepped forth to find out the cause of all the rumpus.

He was an old man, twisted and gnarled like a windswept tree, whose name was Pogonobogwint. We were welcome, he assured us in a quaint mixture of Spanish and English richly punctuated with gesture. He would be honored, he added, to entertain us for the night. But after making him a small present of silver, in exchange for a dozen ears of green corn boiled in the shucks, we explained, through Lee, that we must go on. I felt that we would be far more comfortable in a camp not shared by such impulsive children of nature.

Hardly a week later we learned that another exploring party had not been so fortunate as ourselves. As we rode into Merritt's ranch on the Mancos, Ratcliff, one of the miners, told us that the Gardner-Gannett party, which we had been about to join, had been attacked by renegade Utes near the Sierra Abajo, only a short distance to the northwest. They had held off the attackers for thirty-six hours, then, with several of their mules killed, but with

all men fortunately uninjured, they had cut their way out and escaped.

This incident, on top of our own experience, made me realize once again that there was only one safe rule: when in the Indian country keep your powder dry—and watch out. There was never more than a hair separating our farcical adventure from the near-tragedy of Gardner and the others.

From Montezuma Canyon my section soon worked its way back into familiar territory. After a visit to the Plata camp of John Moss, who had just come home from California, we dropped in at the agency at Los Pinos. But finding the resident Uncompahgres in an unfriendly mood—the attack on Gardner was an ugly symptom of the general dissatisfaction among all the Utes—we pushed on after only a short stop.

I required another month to photograph my way across western Colorado, already snow-blanketed, and it was not until October 13 that I was back in Denver. For once, after more than four months in the field, I welcomed the thought of a winter indoors.

It was not only the comforts of mechanized civilization that appeared so agreeable as I started for Washington. My wife, who had passed the summer at Sandy Springs, Maryland, visiting one of her Gilpin cousins, was an expectant mother, and we had decided to take a house of our own in the capital. We found and rented a suitable small residence on Eighteenth Street, in the vicinity of Du Pont Circle, and there we lived during the three remaining years of my employment with the Geological Survey. There, too, on February 2, 1876, our first child was born—a boy, whom we named Clarence Seymour Jackson.

Besides enjoying the blended satisfaction that comes to him who has a charming wife, a sturdy son, and a

house of his own to return to at the day's end, I had on
my hands for all the next year as absorbing a piece of
work as I ever hope to tackle. That was the Survey's ex-
hibit for the forthcoming Philadelphia fair to commemo-
rate the one-hundredth anniversary of the Declaration of
Independence.

When still in the Southwest I mentioned that, in addi-
tion to taking photographs of the various ruins, I was
doing a lot of sketching. The purpose of making all those
drawings of details that the camera could not catch was
to provide me with the measurements and proportions
needed to reproduce an extensive three-dimensional pano-
rama for the Centennial Exposition. This was considered
so important that I was detailed to this work not only
for the winter of 1875-76 but for the whole summer of
1876.

With Holmes and three or four assistants I spent the
best part of six months shaping clay to exact scale models,
forming the molds, casting the finished objects in plaster,
tinting them to their colors in nature, and assembling the
whole. When the fair opened, this display attracted more
attention than the many photographs and all the rocks
and relics of Dr. Hayden's career. It drew almost as many
visitors as Dr. Alexander Graham Bell's improbable tele-
phone, and, had a Gallup Poll existed at the time, I am
confident that nine persons out of ten would have voted
my models the better chance of enduring. (As a matter
of passing fact, they have not done so badly. A few of
them may still be seen at the American Museum of Natu-
ral History in New York City.)

I was on duty in Philadelphia during the Centennial;
but, when I was not giving informal lectures or answer-
ing questions about the cliff dwellings, the flavor of buf-
falo hump (one meat of which I never got enough), the
geysers of Yellowstone Park, and the domestic habits of
the American Indian, I could study other displays. That

was a wonderful opportunity for me, especially in the photographic field. All the newest gadgets and inventions were there from Europe, and by the end of the summer I believe I knew as much about the practical end of photography as any man then living. One thing, however, was missing from the fair—a panoramic camera that could record the entire horizon continuously.

The lack of such an instrument set me thinking, and I undertook to build one of my own. Mechanically it was no great trick to construct a camera that would rotate at constant speed through an angle of 360°; that was merely a matter of cogs and clockwork. The real snag was a sensitized surface to move at the same speed across the focal plane. A glass plate obviously was impossible. Roll film was hardly past the laboratory stage. Finally, after studying all the data available, I hit upon the idea of coating ordinary paper with a collodion emulsion on a substratum of thin rubber. It worked, and I was (so far as I know) the only photographer in the world capable of making a satisfactory 360° picture.

When the Centennial Exposition shut its doors—world's fairs closed decently after one season in those days—I returned to Washington. The Survey had spent the summer in Colorado again; but, after the Custer massacre on the Little Big Horn, which occurred on June 25, Montana and Wyoming had been pretty thoroughly cleaned up by the Army, and no official objection was raised against Hayden's plan to go back in 1877 and pick up where he had left off at the end of 1872.

Ordinarily I would have gone along again as official photographer. During the winter of 1876-77, however, something happened to alter that idea. In Washington I came to know the Reverend Sheldon Jackson, Superintendent of the Board of Home Missions of the Presbyterian Church, who was about to visit all of his church's

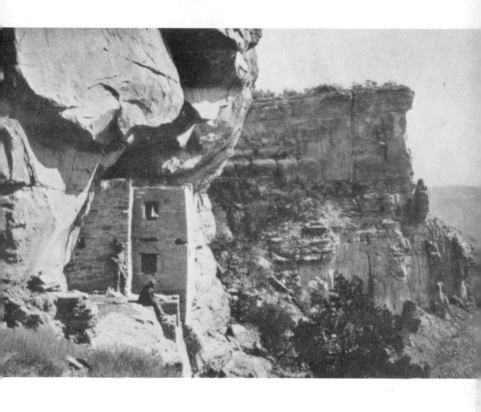

In 1874, Ernest Ingersoll and I, with John Moss, our guide, and several packers, discovered this two-story cliff dwelling of the Mesa Verde. This photograph of it is the first one ever published. John Moss, whom I have sketched on another page, is the standing figure. The other is Cooper.

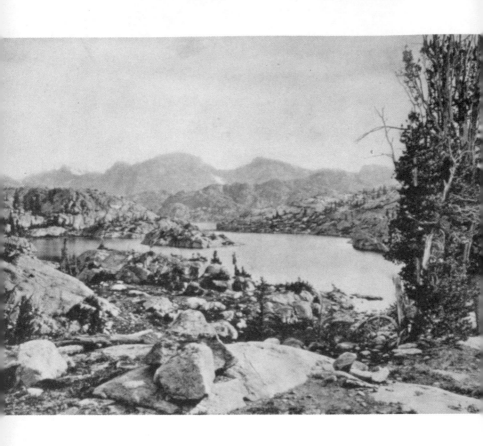

Seneca Lake, at an altitude of about 10,000 feet in the Wind River Mountains; Frémont Peak is the rounded height on the horizon. This photograph, made in 1878, was one of my last as a member of the United States Geological Survey.

outposts between Santa Fe and the Moqui pueblos, and Dr. Hayden arranged to have me accompany the clergyman.

My short visit to the Moquis two years before had been so rich in subject matter that I looked forward to an exceedingly productive trip. In material I was not disappointed. But my 1877 photographs were a total failure. It still makes me feel sick, in a very real, physical sense, whenever I look back on my return to Washington in the fall and the discovery that not a one of my 400 exposures could be developed into a negative. Here is what happened:

Part of the attraction of accompanying Dr. Jackson was the relatively rapid speed at which he planned to travel— I would have the opportunity of covering far more ground than I ever had before in a single season. But speed, coupled with the necessity of keeping the bulk and weight of my equipment within the bounds of a small wagon, was my undoing. Dry film was beginning to come in—I had already successfully experimented with some of my own manufacture—and I decided to depend upon that and to leave all my usual chemicals and paraphernalia at home. From L. Warnerke, a well-known London photographer, I ordered a supply of "sensitive negative tissue, supplied in bands." With my 8 x 10 and all the film, I could, if necessary, have carried the entire load on my back. My heart was as light as my burden when I stepped off the train in Trinidad, Colorado, then the closest rail connection for Santa Fe. But in spite of using great care in handling the film, always changing the rolls in total darkness, packing the exposed film in tight, waterproof cans, with the dry climate of the region as additional safeguard, there was no trace of an image when I developed the rolls in my own laboratory in Washington.

I think it was simply a case of too long an interval between exposure and development. Even now films de-

teriorate with time, and sixty-odd years ago, of course, the science of preparing all light-sensitive emulsions was inexact. At least as late as 1895 dry film was likely to be unreliable: in Calcutta I had an experience identical with the one of eighteen years before; but the second time, fortunately, with comparatively few films.

A by-product of my 1877 misfortune interests me very much now, although at the time I was enraged. After trying every known method to bring out the images I hoped were present, I expressed several rolls of the film to the manufacturer in London. But I never received either an acknowledgment of their receipt or an answer to my long accompanying letter. Perhaps he thought I was another fool American—and he could have been right—but I am inclined to think that I was experiencing the ancient principle of *caveat emptor*. Certainly in the field of practical business ethics the times have changed for the better since that day. If a Government photographer of 1940 had occasion to address a complaint to any maker of photographic supplies, a personal letter from the president and an analysis of the trouble would be the very least of the amends offered.

My experience of 1877 was quite the most costly setback of my career. There was no going back, as I had done in Colorado in 1873, when my mule slipped his pack and broke so many of my plates. I considered the whole summer shot to pieces, and the fact that I had compiled a voluminous first report on the Chaco Canyon ruins— now a National Monument—didn't comfort me much. My feelings were beyond the repair of Dr. Hayden's praise. They still are. I can never replace those lost pictures.

The Geological Survey was destined to be reorganized after the expedition of 1878; but in the spring we knew nothing about that, and our concern was the usual one:

how much money Congress would give us; when we could start.

The turbulence of the early Grant years had been succeeded by the stodginess of the Hayes administration. In 1878 the amiable gentlemen of the House and the Senate just couldn't get going. It was late July before we were in the field.

In respect to the season, our chosen theater of activity, Montana and Wyoming, was rather unfortunate. Before starting out I recalled the old saying about the three seasons of that country—"July, August, and winter"—and by September I should have occasion to think about it again. But, as always, I was so glad to get out in the open once more that I should have gone just as cheerfully through a ten-foot snow.

We left Fort D. A. Russell at Cheyenne on July 24, and from our starting point to South Pass I took no landscape pictures, for I had already done that section pretty thoroughly. But on July 29 I had a new experience with my camera. An eclipse of the sun was due on that day; and, since we were in the belt of totality, Dr. Hayden agreed that we might spend a little time to observe and photograph the phenomenon.

I had no special equipment, and I had no illusions. But the effort was small. I *might* get something. Who knows? —was my attitude.

Ten minutes before "contact" I crept under the dark tent and began to coat my plates. One thing I was sure of—they would be wet enough upon exposure. While I was working I became vaguely aware that it was rather darker than usual. But I kept on. Then I heard cries.

Yes, when I stuck my head outside the sun was almost obscured. The eclipse had begun ten minutes early!

Of course, that is not true. Our calculations were wrong. But that didn't help, even though I was not the guilty mathematician. I caught the moon only after it had

started to slip by the sun, and the one thing I learned very positively was that, photographically, there could be no such thing as half an eclipse—at least not with the equipment at my command in July, 1878. All I had to show for the venture was three or four sun-blinded plates.

My first useful pictures were made near the head of the Little Popo-Agie in the Wind River Mountains. Frémont Peak was our major objective; it had not been scaled since Frémont himself had climbed it more than thirty years before.

Since the ascent was impossible for pack mules, I couldn't carry along my cumbersome wet-plate paraphernalia. It was a case of dry plates or nothing; and so, since I had nothing to lose, I decided to try a collodio-bromide emulsion, slow, but otherwise dependable. In camp the night before our final climb I coated some plates and dried them over a shovel. Then, dreaming of New Mexico and Arizona and all those black films of 1877, I slept.

Next day I found perfect working conditions on Frémont Peak, and in the evening I developed my negatives. They were good (even if one or two bore slight marks of the shovel); but the important thing was not so much their quality as my knowledge that I had found a satisfactory dry film. I think I had lost a little of my self-confidence after that overwhelming failure in the Southwest, and I needed a little extra bucking up.

From the Wind River Mountains we crossed to the headwaters of the Green River, and from there we worked down to the beautiful basin that has the distressing name of Jackson's Hole. (The "hole," incidentally, has nothing to do with me. It immortalizes Dave Jackson, a partner of Jim Bridger in the Rocky Mountain Fur Company of early days.) A few days later we were once more within the bounds of Yellowstone Park. And now it was a park

indeed, with rangers and tourists—and a cavalry detachment to guard them from the Indians!

By the end of the first week in September the weather after sundown was uniformly cold. Ice in the mornings was the rule. Snow fell almost daily. We had been out little more than a month; but the Rocky Mountain winter had caught us. By the time we reached Two Ocean Pass, everything was frozen solid; and we had to break a lot of ice before the doctor had proved that the small spring beneath actually emptied, as the trustworthy Bridger had reported, into both the Atlantic and the Pacific. With that last small investigation the labors of the old Survey may be said to have ended.

Before leaving Wyoming, however, I had one last spine-tingling adventure. Riding with Dr. Hayden through a deep forest along the banks of the Upper Yellowstone River, I spotted some fresh bear tracks clearly defined in the snow. The main train was well behind us, and the doctor proposed that we should not chance losing the animal by waiting for the others to catch up. All he cared about was seeing what kind of bear it was.

As we hurried our horses along we could tell by the character of the tracks that we were gaining on the bear. Soon we caught a glimpse of him lumbering ahead through the woods, and a few minutes later we were within fifty yards. Tired, and still largely concealed by the dense, snow-covered shrubbery, he took his stand behind a heavy fallen tree. I unslung my rifle and dismounted, while Hayden, unarmed, remained in his saddle. His horse was violently excited. Mine bolted; but I didn't notice that.

I moved slowly toward the fallen tree. When about thirty yards separated me from it, a shaggy head and shoulders suddenly rose up—the head and shoulders of a

silvertip grizzly. His eyes glared angrily, and the grip of his claws showed that he was preparing to spring.

It was one of those times when a man acts first and thinks—if he is fortunate enough—afterward. Quite mechanically, the Doctor informed me later, I threw back the cape of my heavy coat, dropped to one knee, and fired. Without sound or struggle the grizzly crumpled in **the snow**

I waited two or three minutes before going any nearer. Then softly I moved up and, from my side of the log, took a couple of exploratory pokes with the tip of my gun barrel. Clearly my bullet had gone home, and it was lights out for bruin. Later when the packers skinned him they were puzzled by the absence of any visible wound. So were all of us. Not until the skull was bared did we find that the shot had entered one nostril and crashed through his brain.

I had visions of a grizzly rug lying before my hearth in Washington. But when we got back to the Wind River Valley the warm weather soon rendered the hide unfit for tanning, and all I took home with me was a necklace of claws—in which my very small son showed remarkably little interest.

"EVERY NATION ON THE GLOBE"

SOON after I returned from the West my daughter Louise was born, November 23, 1878, in our house in Washington. And it was her happy arrival that made me sit down and do some heavy thinking.

I had gone through nine wonderful seasons with the Survey (even the pictureless 1877 tour was a success from the point of view of an archaeologist), and I had established myself as one of the foremost landscape photographers in the country. My career was assured. I loved my work. I could ask nothing more.

But life just isn't as simple as that. I was thirty-five years old. I was the head of a family—a growing family. Soon there would be schools to consider. And there was my wife. Emilie, always loyal and comprehending, surely deserved something better of marriage than a husband who was away five, six, seven months every year.

Most of all, it was a matter of money. I have stated that my top salary with the Survey was $175 a month. With occasional private commissions, my annual income ranged between $2,500 and $3,000. It was not a very high scale of living for a man who had reached the front rank in his field. Nor was there any likelihood that it would be much higher so long as I continued to be a public servant— which I was, with all my freedom, just as surely as any department clerk.

All during the winter months in Washington, while preparing for another season under Hayden, I weighed

the future. And I pretty well decided that after another summer or two with the Survey I would return to the field of commercial photography. I also made up my mind about something else at that time: whatever I might find for myself, it must be in some great open country, where I could do a good part of my work under the sky.

But I need not have troubled so much. Before the spring of 1879, Congress "reformed" the Survey, and the old easy-going days were at an end. Since no specific provision was made at that time for either photography or a photographer, I no longer had to think about the most favorable time for resigning. I was just another man out of a job.

Of course, it wasn't as violent as that. I was in no sense dismissed. And I had my salary until June 30, when the fiscal year ended.

Once the decision had been made for me, I no longer thought about where I might open up shop. I knew. Denver was the place. I liked it there, the climate, the splendid mountains. I liked the people, and many of them were my friends. I liked the way the place had grown, from a raw town of 5,000, when I first saw it in 1870, to a flourishing city seven times that size. I was sure it would keep on growing and that I should be prosperous there. And I was right on both my guesses. Denver's population tripled between 1880 and 1890, and so did my income.

Before transplanting myself and my household I took a trip to New York. I wanted to look over the newest photographic improvements; and I wanted to talk with some men—not only manufacturers in my field, but business men in general. In particular I wanted to get a line on my chances of doing some extensive work for the western railroads. It seemed to me that they were missing a great opportunity to publicize and popularize their scenic routes.

Jim Stevenson, Dr. Hayden's right-hand man, was of great help to me in that direction. He knew all the rail crowd. He had been a friend of Commodore Vanderbilt, who had died just a short while before, and he knew Jay Gould almost as well. Jim was kind enough to take me around to meet him, and of all the powers in the country there was none whose word carried more weight among the western roads than Jay Gould's. Gould had recently lost control of the Union Pacific; but otherwise he commanded practically all traffic beyond the Mississippi. Around 1880, in his own person, he *was* the Missouri Pacific, the Kansas Pacific, and the Central Pacific. And both the Denver Pacific and the Denver & Rio Grande, wherein lay my immediate interest, were almost his private property. Gould's name reeked; but he was king.

Along with other railway magnates Mr. Gould occupied offices in the Opera House—that gaudy palace where sightseers were still reminded, if incorrectly, that Ed Stokes had killed Colonel Jim Fisk for love of Josie Mansfield—at the corner of Sixth Avenue and Twenty-third Street. There, one day in June, Mr. Stevenson and Mr. Jackson were announced to Mr. Gould. He was alone in the room when we entered; and, as I walked toward his desk, I felt as if I were being X-rayed by the blackest, most piercing eyes in the world.

I have never got over the impression that Mr. Gould belonged to some elder generation, although actually he was less than seven years my senior. He was small and rather shrunken, of dark complexion, and with black hair and a full black beard. He spoke quietly and he listened with politeness both to Jim and me. But I felt sure I should get nothing from him. I knew no way to reach a man who could be attentive and at the same time "unapproachable on his bad eminence."

But I was lucky. As soon as photography was mentioned Gould's alert boredom changed to interest.

"Tell me, Mr. Jackson," he began, "are you the man who took those Union Pacific pictures a few years ago?"

I told him I had taken quite a number. Then he really talked. He amazed me with his knowledge of the route and with all the minute questions that followed. He also pleased me by referring to my work in Colorado and the Yellowstone. Finally he embarrassed me—with questions about flowers! Gould was an expert gardener and knew immeasurably more about western flora than I ever would.

No doubt he was a cold and unscrupulous man. But he was extraordinarily intelligent, and I have always found it hard to dislike any person gracious enough to show interest in the things which concern me. When we left, after nearly an hour's talk, he promised to write letters to a number of railroad officials in Denver. And he did so. I am grateful for that kindness, too.

A few weeks later I was on my way west again, accompanied only by Frank Smart. Frank, the son of a Washington photographer, had been with me on and off since 1874, and he was delighted at the prospect of a full-time job in the up-and-coming Colorado capital. By this time he was a thoroughly competent camera man, and I was as pleased to have him in my employ as he was to work for me. Our association continued until his father took him into his firm as a partner.

My wife and children were to spend the summer at Sandy Springs, with her relatives. It was understood, of course, that Emilie would join me as soon as I could get my business going and find a suitable place to live. But no one had given me a written guarantee of success, and I wanted to be on firm ground before uprooting her.

When I arrived in Denver, the first thing I did was to look for a studio. I was still firm in my resolve never to coop myself up indoors again; but I also knew that portrait work was the bread and butter of every photographer. In the summers, when such business was dull, I

could work for the railroads and the big picture jobbers—
and for my own pleasure. In the winters I would stick to
my bench and make money.

Right at the start I found exactly the place. At 413
Larimer Street a two-story building was under construc-
tion. It was within the business center, the rent was
reasonable, and, most important, I could specify altera-
tions at no extra cost. I signed a lease for the second floor,
drew plans for the skylight, indicated the partitions, paid
a deposit, and made a bee line for the mountains. My
new studio wouldn't be ready until September, and there
certainly was no sense in sticking around town.

I was now the owner of all the equipment that I had
used with the Survey; for, through the kind offices of Jim
Stevenson, I had been permitted to buy it for a song.
Cameras like my four, with their various lenses, would
have cost me at least $1,000; but at government knock-
down prices they stood me less than $200, and so I was
not pinched for capital when I set up in Denver.

For about $150 I purchased a team of stout horses and
a light two-seater of the "democrat" type, and off we
started in the direction of Leadville, the "sky city." More
than 10,000 feet above sea level, this celebrated mining
town near the headwaters of the Arkansas River was in
1879 at the peak of its glory.

Founded by gold prospectors around 1860, it had first
been called Oro City. But the surface gold was soon
extracted, and then its importance dwindled. In 1874,
however, a metallurgist recognized in the black sand that
cluttered the sluice boxes an extraordinarily rich lead-
silver deposit—and Leadville began to boom again.

In that same year I had done a little trading with a
storekeeper named Horace A. W. Tabor. Five years later
"Haw" Tabor, grown rich as the result of grubstaking two
prospectors, was Mayor of Leadville. Prodigal with his
seemingly unlimited wealth from the Little Pittsburgh

Mine (and vastly increased by lucky deals elsewhere), the former Vermont stonecutter, now known far and wide as the Bonanza King, occupied a niche halfway between fame and notoriety. He was to go on. A few months later Tabor became Lieutenant Governor of Colorado. In 1883 his money bought him a seat—to fill an unexpired term—in the United States Senate; and just a little while afterward a President, the accommodating Chester A. Arthur, was guest of honor at his wedding—although many people were shocked by the Chief Executive's implied blessing on the union of two divorced persons.

It was in an atmosphere charged with the presence of this lusty spendthrift that I set up my camera in the summer of 1879. Scattered over the hill at the foot of Mosquito Pass were miners' shacks, derricks, ore dumps, and a few stunted pine trees. I photographed them all. At the end of each day the treasure seekers slopped through the mud of Harrison Avenue, to the Clarendon, or the Texas, and to half a hundred other saloons, brothels, and gambling dives, in search of such pleasures as they could pay for. I photographed them, too.

Haw Tabor was an important man in the growth of Colorado, and his investments helped to change Denver from a raw-edged town to a city. After his venture into politics Tabor settled down—so far as he was able—as a sort of latter-day Maecenas. He built the Windsor Hotel in Denver. He built the Tabor Block. And he built the Tabor Grand Opera House (my wife and I attended its gala opening, with Emma Abbott as prima donna). Then slowly Haw Tabor's sun began to set. He bought mines in Mexico and the Argentine. He staked prospectors from Colorado to Chile. He financed nonexistent railroads. No one was refused. In 1893 the repeal of the Sherman Act (which required the Government to buy silver at a fixed price), completed his ruin. A broken man, Tabor died in Denver in 1899, just a year after some old friends had

secured for him the office of Postmaster. His wife survived until 1935, when, at the end of winter, she was found frozen to death in a weatherbeaten cabin on the edge of the Matchless Mine outside of Leadville.

During that summer on the road, Frank and I usually camped at night. We liked to sleep under the stars. We liked the taste of our own food. We also liked to save money.

Occasionally we would put up at a hotel, and I warmly remember our visit to the Cliff House in Manitou, built in 1871. The founder and proprietor was Mr. Edward E. Nichols, who was a good deal like a ship's captain: he made his "passengers" feel safe; he made them comfortable; and he made each one the guest, not of the house, but of himself. It must have been a sound formula, for the Cliff House is still managed by a Nichols.

I have another reason to remember the Nichols family. Son William was among my earliest customers at the Larimer Street studio. He was then preparing to enter Yale, and I believe he was one of the first students to matriculate from Colorado. A graduate of 1884, he spent a number of years on the engineering faculty of his alma mater before entering business. Now an officer of a large manufacturing company, he often entertains me in New York—and the point of this particular reminiscence is that young Bill Nichols is just as good a host as his father was sixty years ago in Colorado.

My first summer as a commercial landscape photographer in ten years was instructive and not unprofitable. By the time I got back to Denver in the fall I knew a lot more people; and, with many orders on the books, I prepared to open the newly completed studio with a full personnel. I hired, in addition to Frank Smart, an experienced camera operator named Hosier, a printer, a

mounter, and a reception girl. And all of us were kept busy from the start.

I still delayed about bringing my wife and children to Denver. It had been all right for Emilie's parents to go to Nebraska when she was a young girl—all of them knew it was only for a term of years. But it was quite a different matter for Emilie, no longer a girl, to move to Colorado "permanently." And so I waited until the spring of 1880, after my business had really begun to roll, to set up my household.

The next dozen years brought solid material success, although, with a growing family, I always felt hard up. About the early part of 1881 I formed a partnership with Albert E. Rinehart, a Denver photographer whose specialty was portraits, and as Jackson & Rinehart we built up a substantial business. When, several years later, Rinehart decided to go into business for himself, I made an arrangement with Chain & Hardy, the leading booksellers of the city, whereunder they agreed to finance a number of photographic projects that required more capital than I could afford to risk alone. And in 1892, Walter F. Crosby, a wealthy amateur photographer, put $10,000 into the business in exchange for a one-third "silent" interest, and we incorporated as W. H. Jackson Photograph and Publishing Co.

During those years I traveled as much as ever—but, in the large, with far greater comfort. In 1881, I got my first railroad job, with the Denver & Rio Grande (whether Jay Gould's letters were partly responsible I never knew), and I not only traveled over all the main route but I did so often in the president's car. Thereafter I spent part of every summer on the rails, for one road or another, and usually with a private car, all beautifully equipped from dark room to darky. Not infrequently I found it possible to take my family with me, and on one occasion my mother came on from the East to spend a month with us.

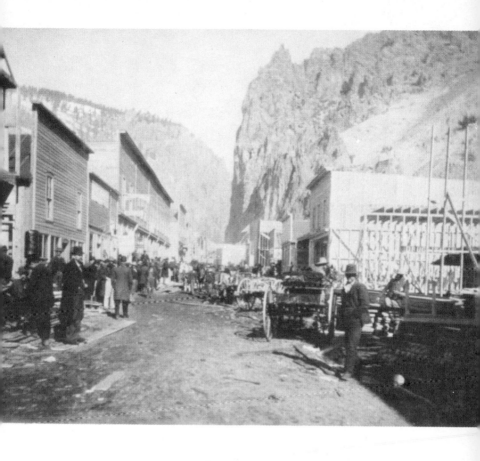

The main street of Creede, Colorado, as I found it in the
early '80's. Creede was then the same sort of booming silver
town that Leadville had been two or three years before.

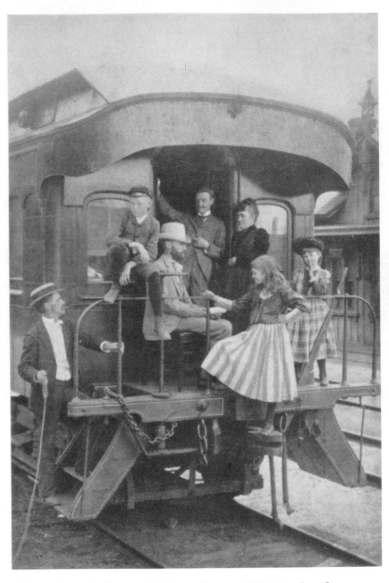

My wife and three children, about 1888. In the doorway
stands my brother-in-law, Orrin Painter. Seated is a friend
named Johnson, of the Southern Pacific Railroad. The tubing
(with bulb) in my hand gives me "remote
control" of my camera.

She was then past seventy; but she stuck to the observation platform, cinders and all, as zestfully as her grandchildren.

In 1883, after photographing the Grand Canyon of the Colorado, I made my first trip over the border, primarily to do some work for the Mexican Central Railway. The next year I returned, chiefly to photograph and, incidentally, to climb Popocatepetl, which was thus far my highest peak. But it is not the snowy mountain of the Aztecs that stands out now. Instead, it is the gift I brought back for my little boy, a Chihuahua, or "Mexican hairless." But Clarence was not happy about the bald dog I carried home in my pocket. He wanted a normal, shaggy animal; and to remedy my defective choice he traded the tiny dog for a full-grown donkey. Clarence was no more than seven or eight at the time; but from that moment I never worried much about the day when he would have to face the cold world on his own.

As time went on, I found my pictures for the Denver & Rio Grande paying big dividends. Other roads asked me to photograph their routes, and I could now take my pick from year to year. Hotels were also beginning to understand the value of advertising their scenic attractions; and between 1885 and 1892 I carried my camera into every corner of the land, as well as through Canada. In the summers I covered such sections as the Gaspé, the Yellowstone, Colorado, upper New York, and the White Mountains. After cold weather set in I found myself busy in Mexico or California or Louisiana or Florida. And since I enjoyed traveling even more, if possible, as I grew older, it was a thoroughly satisfactory life.

If it wasn't always as satisfactory for my wife as it was for me, Emilie fully understood and agreed that it was, under the circumstances, the best one possible for all of us. It gave us the income to live well and to entertain our friends. It gave us the money to build a house of our own

on Capitol Hill. It permitted us, without undue sacrifice, to educate our children; there were three after 1882, Harriet, the youngest (who has always been known as Hallie), having been born June 7 of that year. And it gave us the leisure, now and then, to enjoy long holidays together. All in all, the Jacksons were a contented family.

In 1892, in my fiftieth year, two important things happened. On June 15, my parents celebrated their golden wedding; and they, with my four brothers and two sisters, came to Denver to observe the anniversary under my roof; it was the first time since the weeks just after Gettysburg that all nine of us had been united. The other event took place in Baltimore several months later. It was the renewal of an earlier slight acquaintance with Major Pangborn, "special representative" of the Baltimore & Ohio Railroad Co.

Joseph Gladding Pangborn, just a year younger than I, handled advertising and publicity for the B. & O., and he was a go-getter without peer in his day. But the brashness of the old school of checked-suit promoters was totally absent. Pangborn was adroit and polished. He prided himself on his ability to get what he wanted from the men at the top—and then to be asked to dine with them, in a day when press agents were generally grouped with patent-medicine salesmen. An ex-journalist, Pangborn was able to boast one experience that must surely be unique: in the early '70's, as city editor of the *Kansas City Times,* he felt called upon to write a blistering editorial demanding that the Governor of the State smash Jesse James and his gang of train robbers. It happened that the *Times* was controlled by several gentlemen named James, and the night after Pangborn's editorial appeared the young editor was stopped on the street by a masked man, who said: "We own an interest in this paper and we don't want any more editorials like the one you printed this morning"—

here he tapped his pistol significantly—"and if such a thing happens again, it may check off your time on earth." In the late summer of 1892 Pangborn engaged me to photograph certain sections of the B. & O. route—all 18 x 22's, at $10 a picture—in preparation for his road's display at the approaching World's Columbian Exposition, and during the several weeks along the line together I came to know him rather well. I even adjusted myself somewhat to his grand manner and his habit of sweeping gesture. Yet one day Pangborn tossed out an idea that was a little too big for me to handle.

We were on a private car somewhere in central New Jersey—I remember because my son, then a student at Harned Academy, a Friends school in Plainfield, was spending the day with me—when Pangborn said: "Jack, I've decided to take you around the world with me." Then he lighted a large cigar and watched me from behind his smoke screen. Since I had no cigar to defend myself with, I just had to let the announcement strike and bounce off. Tobacco undoubtedly has its uses.

"You don't appear to be greatly interested, Jack," remarked the Major after an empty moment. Then he chuckled. "Perhaps the thought of traveling doesn't appeal to you."

"I think it sounds very interesting indeed," I responded, rather insincerely, I suspect. Pangborn had so many gaudy notions that I found myself answering most of them with packaged phrases.

"Well, you'll be *sure* of it in just about five minutes," he retorted. Then Major Pangborn sketched a world tour of fabulous proportions. He had conceived the idea of a transportation commission (with himself as head, of course) to visit foreign countries and study their railroad systems. Everything was to be conducted on a vast scale of gold braid and plumes, and it would require not less than three years of travel.

"Where will all the money come from?" I asked, some-what weakened by a half-hour's torrent of enthusiasm.

"Ah," replied the Major, "ah, that is something I am working on now." He smiled mysteriously.

"When do we start?"

"Ah, that's going to take a little time, of course, a little time." Pangborn waved his hand. "You can't work up any-thing as big as this over night, you know. But I would say things ought to start shaping up as soon as the fair is out of the way." Then he gracefully switched to a dis-cussion of his plans for the Chicago exposition, and I was sure I had heard the end of his round-the-world nonsense. In any case, I quickly forgot it except as an after-dinner anecdote for my friends.

Back in Denver there was a great deal to be done. My negotiations with Walter Crosby, begun the year before, came to a satisfactory head, and we now incorporated our business. From Arapahoe Street, where I had moved in 1885, when the original studio on Larimer Street became too cramped, we took a big jump to the Industrial Build-ing at Thirteenth and Colfax. There we leased the top two stories, more than doubling our floor space and nearly doubling our rent. We could hardly have picked a worse time to expand; but Crosby and I were merely a couple of photographers, without the angular vision needed to see a severe depression just around the corner. When it hit us, along in 1893, I was able to take up much of the impact through an unexpected piece of business of the kind which bankers and accountants are pleased to list under the heading of Nonrecurring Profits:

As the World's Columbian Exposition—most beautiful of all fairs—drew toward its close, I was in Chicago, partly to study the various railroad exhibits, partly to examine the newest photographic developments, and very largely for the fun of it. For once I was not using a camera, and

I must say that I enjoyed it hugely—somewhat like the author who always took a vacation simply by *not* writing a book. And then I was called in to do an emergency job. The fair's "official" photographer had been too busy with side issues, and the commissioners needed a complete set of pictures before they could submit their final report. I agreed to provide one hundred 11 x 14 negatives for my usual fee of $10 apiece. But it was not those prints alone which kept the W. H. Jackson Photograph & Printing Co. out of the red in 1893: when I returned home I sold a duplicate set of negatives to Harry Tammen, proprietor of a curio shop, for another $1,000, thus netting nearly $2,000 out of a ten days' job. Tammen, who later achieved a certain fame as the partner of Frederick G. Bonfils on the *Denver Post*, made considerably more than that from the profits of *The White City*, as the collection of pictures was labeled when published; but I was perfectly satisfied with my share.

While in Chicago I quite naturally spent a good deal of time around the B. & O. exhibit, which included a hundred or more of my pictures, one of them a thirty-foot panorama. One day Major Pangborn came into the enclosure beaming like a man who has just inherited a million dollars.

"Well, Jack," he greeted me, shaking hands as heartily as if we hadn't seen each other for many months, "I hope you have no important engagements for the next three years. And if you have, you'd better find a pinch-hitter"—Pangborn was an old baseball reporter—"because I want you to be ready to join my World's Transportation Commission." He paused. "We shall visit every continent and every nation on the globe!"

It happened that things had not yet developed quite to the point of certainty. But about the time the fair closed, President Mayer of the B. & O. announced that his directors had presented to the Field Columbian Museum the

entire B. & O. fair display, consisting of 56 model loco-
motives and some 1700 pictures. It was also announced
that the merchant prince Mr. Marshall Field had ac-
knowledged this generous gift with a token of apprecia-
tion—$25,000, for a study of foreign railroads.

For a man of Joe Pangborn's ambitions the Field check
was only seed corn. Joe set to work, and almost at once
such public-minded Americans as George Mortimer Pull-
man, Joseph Leiter, George Westinghouse, Andrew Car-
negie, and the younger Cornelius Vanderbilt came
forward with additional contributions and swelled the
bag to nearly $100,000. Everything seemed to be set.

"As regards the departure of the commission," Major
Pangborn was quoted in the press, "it will probably be in
the spring or early summer. The commission will consist
of Lieut. A. C. Baker, of the United States Navy, who was
for nearly two years detached for active duty in connec-
tion with the exposition. The lieutenant is a linguist of
distinguished ability, was formerly a professor of modern
languages at the United States Naval Academy, and his
duties in connection with the commission will be of a
very important nature. W. H. Jackson, of Denver, the
great photographer, will be the official photographer of
the commission, and Mr. Edward E. Winchell the official
draughtsman and artist. . . . Mr. Harry F. Stevenson, who
has been my secretary so long, will occupy a like position
on the commission. The work I fully recognize will be
far from mere pleasure or play . . . and I go at the head of
it thoroughly appreciating this fact." Another newspaper
altered the personnel slightly, substituting Lieutenant
George Wood Logan, U.S.N., for Lieutenant Baker and
John A. Barnes for Stevenson, and adding Lieutenant
Hugh T. Reed, U.S.A., Clement F. Street, "mechanical
expert," and Edward Hill, "colored, its messenger."

Quite naturally I was excited. When I asked the Major
whether there was any provision for paying me a salary

he answered: "To be sure, Jack, to be sure. Whatever you need—within reason, of course, within reason." I told him that $5,000 a year would provide for my family while I was abroad, and he waved his hand in easy acquiescence. "You are indispensable," he assured me. "Think no more about it." And so I went back to Denver, engaged W. H. Rhoads, a capable photographer from Philadelphia, to serve as general manager, and worked myself into a lather of preparation.

By January of 1894 it was clear that our tour could not begin as early as planned. Mid-summer secmed more like it. To mc the extra months appeared as a welcome opportunity to squeeze in extra work.

June arrived, and with it the information that our departure had been delayed until September. A little later I learned that our naval and military aides were to be left at home; also Edward Hill, "colored." It seemed too bad about Edward.

Early in September the Major wrote me that everything was in readiness. We were to sail in a few wecks. Apparently as an afterthought he mentioned that his revised calculations seemed to allow no funds for my salary. But he was counting on me, and, of course, all my traveling expenses would bc paid, etc., etc.

I was greatly disturbed. It would be impossible for me to go without a salary. Business in Denver was still far from good, and I could never expect to draw an income from my studio sufficient for my family's needs during my absence. But by this time, with my departure so long advertised, I couldn't afford not to go. I should have been ruined. People could never have understood the true reason.

After stewing in my own juice for twenty-four hours, with Emilie's comforting words unheard, I suddenly thought of something: I had planned while abroad to send unusual pictures to various magazines. Instead of

doing so on speculation, why couldn't I land a contract
before leaving? They frequently published photographs
of mine. Why shouldn't one of them be interested in tak-
ing my pictures regularly while I was away?

I rushed to New York; and the answer to all my ques-
tions was that Mr. Payne, art editor of *Harper's Weekly,*
quickly arranged to use not less than one page a week, at
$100 a page. I was happy beyond possible expression.
My problem was solved. In addition, my pictures and my
name would be seen regularly every week by thousands.
It meant free advertising, and being paid to boot.

As finally constituted, the World's Transportation Com-
mission of the Field Columbian Museum consisted of five
members. "President" Pangborn, accompanied by his
secretary, Harry Stevenson, and Winchell the artist, left
New York for London late in September. And on Wednes-
day, October 3, with Street, our engineer, I sailed on the
6,000-ton liner *Bremen.*

Even without military aides and flunkies, the commis-
sion got off to an imposing start. The papers were filled
with our itinerary, with laudatory comments on our aims,
and with personal eulogies. A blessing came from the
Secretary of State himself, in the form of official letters
to ambassadors, ministers, and consuls everywhere. From
the Hon. Walter Q. Gresham down, everybody looked for
another American victory.

The tour lasted exactly seventeen months. We visited
Europe, brushed northern Africa, almost encircled Aus-
tralia, and penetrated deeply into many parts of Asia.
Altogether we traveled close to a hundred thousand miles.
And though we never went round the world by directional
circumnavigation, we very literally went *around* it.

CHAPTER XVII

HALFWAY ROUND

REASSEMBLED in London, the World's Transportation Commission passed some three weeks in final preparations. Since the rail systems of Great Britain and the Continent were comparatively familiar to Americans, it was decided to proceed at once to the Mediterranean and thence to the Orient. I strongly suspect, too, though naturally nothing was said, that our leader was saving the capitals of Europe for the end—when he could visit them as a world expert on transportation.

We left Folkestone on November 8, 1894, spent only two hours in Paris, and sailed from Marseille the following afternoon. Our ship, the *Kléber*, took us to Tunis, where we stayed for several days. A side trip to inspect the ruins of Carthage—where, of course, I used my camera —gave me considerable enjoyment. In my mind I reconstructed the departure of Hannibal's soldiers and elephants to begin their incredible journey across the water to Spain, up through the Iberian Peninsula, and over the Alps, to threaten the might of the ancient Roman republic.

After a train ride to Algiers, where we spent another few days, a second steamer took us westward again to Morocco, across to Gibraltar and Málaga, then to Naples, and finally to Port Said. From there we left by rail for Cairo and a trip up the Nile as far as Memphis; then, after a few days of picture taking around Suez, we sailed through the canal bound for the island of Ceylon. We

celebrated Christmas at sea, with a gay dinner party given by Captain Hansard of the *Rewa*.

At Colombo, capital of Ceylon, where we landed on December 29, we established ourselves as thorough "Colonials" with the purchase of white duck suits and solar topees. Our introductions brought us innumerable invitations, and between duty to my camera and obligation to my hosts I found myself on the go eighteen hours a day. And I loved every hour of those ten days on the island.

In Tuticorin, India, where we disembarked early on the morning of January 9, 1895, we found a handsome private car, the "Rajah," at our command. Furthermore, our solicitous hosts of the South Indian Railway had provided us with passes good between "any station" and "any station." I had time to do very little photographing before our train departed for Madura. Next morning in that city, I took pictures of the Great Temple, and at noon we went on to Trichinopoly.

After three days in Trichinopoly we proceeded to Madras, where a deputation of government railway officials greeted us. Then followed a series of conferences, from which, as "official photographer," I was happily in a position to excuse myself. Our visit ended the second evening, with a fine dinner in our honor at the Madras Club.

At noon on January 16 we arrived at Wadi Junction and transferred to a branch line. Apparently the management wished to reassure its patrons, for it was named His Highness the Nizam's Guaranteed State Railway. We reached Hyderabad that evening and put up at the Hotel Cosmopolitan, a former palace. Next day I spent photographing the Nizam's elephants and had my first real ride on one of the massive beasts.

Back at Wadi Junction on the eighteenth our party was met by a representative of the Great Indian Peninsular

Railway, and we traveled all day toward Bombay, first through flat, monotonous country, later over mountains that had posed some real problems in railway engineering. En route Major Pangborn received a telegram from the secretary of the government railways inviting us to dine the following evening with Lord Harris, Governor of Bombay.

On January 19 at 7 A.M. we stepped off our coach into Victoria Station, then rated as the world's finest rail terminal. At Watson's Esplanade, "the best hotel in the city" —I still pity the wretches who were forced to put up with second best—we found rooms engaged for us, while at stiff attention awaiting our arrival stood a turbaned messenger from Government House bearing a dinner invitation from Lord Harris.

I spent a full day indoors developing negatives, then managed a poor bath before dressing. At seven-thirty two carriages arrived at Watson's, and along the Esplanade toward the Governor's residence I had my first real view of Bombay. On our right was a long succession of fine residences belonging to Europeans and wealthy Parsees. On our left was the great Back Bay, encircled with lights, and known as the "Queen's Necklace," while far down the Esplanade we could pick out the gleaming cluster that marked Government House. Fashionable Bombay after dark was the most enchanting city I had ever seen.

At the porte-cochère we found brilliantly uniformed Sepoy lancers lined up on either side, and within, half a dozen turbaned footmen silently relieved us of our hats. Then a military aide escorted us to a large reception hall, where we were greeted by a gentleman who introduced himself as Colonel Harris. Major Pangborn made a bow that was almost a salaam and began an elaborate speech. But he had hardly got past the phrase "Your Excellency" when the Colonel quietly explained that *Lord* Harris

would be along in a few minutes. He then introduced us to several other guests who had just arrived.

An aide announced that the Governor was about to enter, and the score or so of guests took their places, as directed, to form a rough U along the sides and back of the room. Lord Harris then appeared. A tall, soldierly man, in full-dress uniform, he moved briskly around the line, greeting each one of us by shaking hands and exchanging a few words. Lady Harris was in England, and there were only three women guests. With one of them on his arm, the Governor led the way in to dinner. Pangborn, the guest of honor, followed with one of the other ladies, and was seated next to his host. After the third lady had been led in, the unattached males followed, in no particular order.

I don't know how the other twenty "bachelors" felt about it, but I was never in my life more content in the absence of a female table partner; for I was enjoying the greatest honor that could have been paid me in the whole Indian Empire—I was seated next to General Lord Roberts.

Roberts of Kandahar! Roberts of the Mutiny! Hero of half a hundred battles! The greatest soldier in the world! When "Bobs" died not quite twenty years later, at the age of eighty-two, I was not surprised to learn that his death had come at the front. Too old for active service, he had nevertheless gone to France; and there, a fighter to his last breath, he succumbed to pneumonia.

I wish I could tell some little story about Lord Roberts's conversation that evening. But the general, while a talented conversationalist, was an even readier listener. He excelled in the art of asking questions and letting the other man fill him with information. And so I did much of the talking, answering as many questions as I could—I would much rather have heard *his* stories.

Over cigars and liqueurs, after the ladies had retired, the

conversation all too quickly became a general one, with the topic, since we were the honor guests, the nature and purpose of the Transportation Commission's tour. Soon after we joined the ladies in the drawing room the party broke up. As we bade Lord Harris good night he asked us to take a short brandy with him, "to keep out the night air." Then we rode back down the Esplanade to our hotel and were in bed by midnight.

Two exceedingly busy days followed, with conferences, inspections, more wining and dining, and for me, of course, in addition, a great deal of photographing. My negatives were piling up at a much faster rate than I could develop them, to say nothing about making prints and mailing them off to *Harper's*.

Worn down, we left Bombay on January 22, bound for the port of Karachi, up the west coast. Our little steamer, the *Kola*, was small and the passage rough at the start. Nevertheless, I managed to catch up with my work *en voyage;* and, when we landed at our destination three days later, I was once more in a position to relax and enjoy myself.

Although it was hot in Karachi, the Major had the great foresight to provide us all with quilts and blankets before we started north by rail on the twenty-sixth. Next morning, when we woke up on the train, the air was very cold; and we were astonished to find ourselves in the midst of a desert—which looked hot, even if it wasn't. Periodically we came within sight of the Indus, a lazy river two miles or more in width as it approached the sea. After a long delay at Rux Junction, where we had dinner, we left for Quetta by way of the Sind-Pishin Railway.

On the evening of the twenty-eighth we came into Quetta just in time to dress and go to the club, as the guests of railway officials once more. I was getting to feel like a character in an English novel, what with dressing for dinner every night and conversing exclusively (so it

seemed) with Lord This and Lady That; and I had already reached the point where the Army, in my blurred mind, consisted solely of generals, with just a colonel now and then to break the monotony.

The next night, however, in Chaman, I discovered that there were still a few captains and *lef*tenants in real life. We were entertained at regimental mess by the 24th Baluchistan, and, in accordance with military custom, we did a little drinking that night. A solid appetizer of sherry was followed, naturally, by a series of dishes, which I cannot recall either by taste or name. But I do recall the claret, the champagne, the port, and the brandy. Afterward, while most of the officers played billiards, I found myself at a card table, with a Parsee scholar, Doctor Somebody-or-other, as my partner. I was happy to discover that the doctor's learning did not include any great knowledge of whist.

We put in several active days in the surrounding country and then returned to Rux Junction to begin our journey into Northwest India. At Lahore, where we made a short stop on February 3, the weather was too bad to permit satisfactory photography about town, and I confined my camera activities to the fortified railway station. That, as much as anything I saw, brought close to me the realization that Anglo-India was still a thin cover on top of a volcano.

We dined that evening in Wazirabad and then took the night train for Peshawar.

On February 5, a cold, clear day, we saw the Hindu Kush Mountains, which since the dawn of history had been India's chief safeguard against hostile incursions from the wild Afghan country to the northwest. Somewhere just ahead the famous Khyber Pass twisted through the Hills.

A little after 9 A.M. we reached Jamrud Fort and were furnished with tum-tums—little two-wheeled carts—to take

us through the pass, whose entrance lay some five miles ahead of us. On the way up the gorge we overtook a two-mile caravan of camels bearing great boxes and bags of rock salt to Kabul. If it had been ordered for our pleasure, it could have been no more picturesque. And, I was sure, if the caravan had passed 500 years before, it would have differed in no important detail—except that archers would have guarded it, instead of Khyber Rifles.

There was something very real about those soldiers, and there was something even more impressive about the blockhouses that studded the winding road. Khyber Pass was still a working frontier, as well as a favorite subject for blood-and-thunder romancers.

We returned to Peshawar and stayed in the vicinity long enough for me to get some pictures. At Campbellpur I made what was to me the most unusual shot of the trip that far—a battery of six forty-pound guns, each drawn by two elephants. There were bullock caissons as well; but they seemed a little tame in comparison. Besides, I knew about bulls—I had lived with them once.

The northernmost district of India is the Province of Kashmir, and thither, on the morning of February 8, we departed from Wazirabad to visit the Maharajah in his

winter capital at Jammu. A reception to the Lieutenant Governor of the Punjab was scheduled, with a grand review of the troops, and a state banquet. Ever since our arrival in India, Pangborn had been pointing toward this great affair, and it was his eager desire to have the Transportation Commission figure prominently.

As our train, which was largely occupied by other visitors, both military and civilian, pulled into the station at Jammu, the Major repeated his instructions for the tenth time. We were to remember, above all, that we were ambassadors representing a great nation, and every item of diplomatic punctilio must be observed. In consequence, when the gay excursionists stepped onto the platform, we remained seated in our car at the end of the train until the Maharajah's emissary should come to greet us. It was all in accordance with court usage, our leader informed us.

The morning was cool and agreeable. But after nearly an hour, Pangborn, exasperated, said we should wait no longer. It was well past noon, and none of us had eaten a bite since our early coffee before taking the train.

By that time the station platform was deserted. Nor was there any conveyance, save a single ekka. Into this two-seater all five of us managed to squeeze ourselves, and the little rat of a horse strained to his utmost as he

pulled us over the long, dusty road to the city on the other side of the Tawi River. The natives loudly enjoyed the spectacle of five men in a creaking cart, but Pangborn was furious.

At the *dak,* or inn, we were served a meal in the lunch room at one rupee a person, plus an extra rupee for a cup that Harry Stevenson had broken. As we left the back room where we had eaten, we passed by an open salon guarded by servants and a major domo. We observed within a richly covered table, sparkling with heavy crystal ware—and set for five.

It had been laid for us, of course; but, since the official delegated to meet us had been unable to find any trace of the World's Transportation Commission on the station platform, he had returned to the palace with the two carriages that had been sent down for our use. All in accordance with court usage, I thought to myself. Then and there I made up my mind that I would get off the train immediately, like any sensible man, the next time I came into a station.

At that moment a gentleman of the court arrived at the *dak* to look for us, discovered our presence from the register, and apologized for the inconvenience we had suffered. An audience with the Maharajah was at once arranged, and the carriages we had missed earlier drove us to the palace.

The Maharajah of Jammu and Kashmir was a bearded Hindu of indeterminate age, though, in my opinion, he could have been hardly more than thirty. His Highness received us with an easy cordiality and shook hands, Yankee fashion, all around. He wore an enormous red turban (perhaps to build up his slight stature), a dark coat heavy with gold braid, white cotton jodhpurs—and he was barefooted. A weak, sensual mouth would have been enough to keep him from being handsome; but he

was further afflicted with a cast in his eyes. All in all, he
was something less than a fine figure of a man.

When all of us were seated, the Maharajah on a low
divan, and the rest of us on chairs which had been carried
in for our express use, the conversation turned to the
purpose of our visit to India. After Pangborn had outlined
the operations and itinerary of the Transportation Com-
mission, the Maharajah called for invitation blanks and,

aided by the Pundit Jedal, Chief Justice of Kashmir,
filled in our names bidding us to his banquet four days
later. Then he introduced the subject of watches. For ten
minutes he discoursed on main springs, jeweled bearings,
and escapements, then gravely asked us to show him our
timepieces. Polite praises were the order for all of us.
Next, smiling slightly, the Maharajah inquired whether
we should care to look at his own watch. Naturally we
wished to see it, and I rather expected something carved
with elephants and studded with emeralds or rubies. But
out of the royal pocket came a nickel-plated turnip with
the word "Ingersoll" stamped on its dial!

Back at the *dak* we dined in the room which had been reserved for us at noon. And such service as we enjoyed has never been surpassed in my experience. We were guests of the state, and these servants were literally our personal slaves. The proprietor abjectly returned the six rupees we had paid him for our luncheon, and he did everything but kiss the floor. It all struck me as absurd; but I was greatly interested to observe how tradition and habit could still rule a people whose forefathers' lives and bodies had been owned by their king.

Later in the evening we returned to Lahore, where, comfortably quartered in our car, we had three full days to take in the sights before returning for the festivities in Jammu.

At sunrise on February 12 (Lincoln's birthday, I remembered) we arrived once more in the winter capital of Kashmir. This time there was no nonsense about staying on board until some one came to meet us. Nor was there any coarse native laughter at our expense: a splendid four-horse carriage, with postilions and outriders, was waiting to take us to the Residency.

First, however, we stopped at the *dak* to change into clean clothes. Pangborn insisted that we all wear Prince Albert coats; but I had a lot of photographing to do and rebelled. The Major was peevish about it and avoided speaking to me—except to ask me to take his picture on an elephant—until evening. The joke was on him, too, for all English-speaking guests attended the daylight affairs wearing informal afternoon garb.

At the Residency we were greeted by Mr. Barnes, the Crown representative, who was giving an elaborate breakfast. The grounds were dotted with tents and canopies to shelter his guests, and in the most sumptuously furnished pavilion we were received again by the Maharajah and presented to Sir Dennis Fitzpatrick, Lieutenant Governor of the Punjab and Commander-in-Chief of the Army of

North India. Sir Dennis, I was pleased to note, wore
corduroy breeches and a riding coat; he, like myself, had
work to do, and he was properly dressed to perform his
duty of reviewing the troops.

Between breakfast and our departure for the parade
grounds shortly before three o'clock I was kept busy
photographing various groups and individuals. In this
work I was very ably assisted by the Rajah Ram Singh,
brother of the Maharajah, Prime Minister of Jammu and
Kashmir and Commander-in-Chief of the army, who saw
to it that I had an elephant at my disposal. The Rajah
was an enthusiastic camera amateur, and he was more
interested in watching me on the job than in talking with
state guests.

I can best give my impression of the review by saying
that all the resources of Hollywood in technicolor could
hope to do no more than equal it today: troops on foot,
all splashed with gold and green and white and crimson
—bearded lancers on black horses—red jacketed and white
turbaned artillerymen firing salvo after salvo—charging
elephants—the spires of the temples beyond—and, in the
far northeast, against a cloudless sky, the snow-tipped
Himalayas. I have never seen a sight to match it—except
perhaps the one that night.

We returned to our car with barely enough time to
dress for the banquet. Our toilets hurriedly completed,
we drove to the palace. It was three miles or more from
our inn, and every foot of the way through the winding,
narrow streets was illuminated by tiny lamps, literally
tens of thousands of open oil cups burning with pendant
wicks in the still night air. At the end was the white palace
square brilliantly illuminated, with soldiers standing at
attention on all four sides.

Once more we were presented to the Maharajah, who
was seated upon a dais in the center of the audience
chamber, surrounded by his ministers and military aides.

When the formal words had been spoken our royal host came forward and took each one of us by the hand. Then we retired to one side to watch the end of a nautch dance that had been in progress when we entered.

Hundreds of guests sat down at the table, and the meal itself was quite as ordinary as any chamber-of-commerce banquet at a large hotel today. The wines, however, were of the best.

The feature of the affair, at least so far as I was concerned, was the *absence* of the Maharajah and his entire suite. An orthodox Hindu does not break bread with Christians, and His Highness stayed away until the toasts were drunk. He appeared just in time for the breaking of glasses to "The Queen!" Then, as custom dictated, Mr. Barnes, the Resident, proposed the Governor's health, and, lastly, the Maharajah's.

Immediately afterward all present went out upon the balcony which overlooked the great square and watched a display of fireworks. Our party made its adieus about 1 A.M. and went back to our railway siding and bed.

Next day we went on to Delhi, and from there to Agra, where, like all good tourists, we "oh'ed" and "ah'ed" at the Taj Mahal. (But my real attitude was: "This is *my* opportunity to have a try at the photographers' challenge.") We passed another day in Allahabad, another in Jamalpur, and then proceeded to Calcutta, the capital, which is, after London, the largest city in the British Empire.

We had only a day there, to my regret, and I had little time to do much besides making a visit to the government photolithic works. I was pleased to hear that at the international exhibit just closed my panorama of Ouray, Colorado, had taken a bronze medal.

On February 21 we departed on the East Bengal Railway in *two* special cars assigned to our use, and some four or five hours later we crossed the Ganges on a ferry boat. On the opposite bank we boarded a train on meter-gauge

tracks (seventeen inches narrower than so-called standard gauge) and rode all night to Silliguri.

From that place we departed for Darjeeling on the narrowest road I have ever seen outside of an amusement park—a 24-inch gauge, with the car floors not more than a foot above the road bed. But a small, light train was clearly the only sort that could have made the steep grades before us. We climbed some 7,000 feet in 50 miles of curving, twisting line.

Smoke and haze hid the Himalayas that afternoon, but from Darjeeling next morning we had a clear view of the range, including Mount Kanchanjanga. Much as I love the Rockies, I can say without hesitation that the Himalayas present a vastly more impressive spectacle.

And, of course, we "took in" Everest—no trip to the region would have been complete without that. When we stood on top of Tiger Hill to view the highest peak in the world there was a slight haze, however, and my negatives produced only a faint image. That was a disappointment; but it was nothing in comparison with the experience I had a few weeks later.

My negatives had accumulated so fast that I had several hundred exposures to develop when I arrived in Australia. There I found that a quarter of them were worthless—on the older ones there was no image at all. Prepared films had let me down a second time. Fortunately I lost only a few weeks' work on this occasion, instead of a whole season's, as in the Southwest in 1877. And my most valuable pictures, the ones taken in Jammu, were among the survivors. I was really very lucky on the whole. But I vowed I would never again delay too long between exposing and developing. It is something I am careful about even today when a latent image, almost regardless of climatic conditions, will endure unimpaired for many months.

A JUNKET AND A KING

S O far I have said almost nothing concerning the real work of the World's Transportation Commission. The explanation is of elementary simplicity: the World's Transportation Commission did no real work.

For a time there was considerable pretense about detailed research along the way, and Major Pangborn dictated page after page of stern material to his secretary. But most of that wore off after a couple of months, and our tour became a handsome junket, with good will as our stock in trade.

At times that commodity became excessive. In Bangkok, for example, where we stopped after brief visits to Rangoon, Penang, and Singapore, our party became the butt of some heavy newspaper humor. I quote portions of the lead editorial in the *Siam Free Press* of Thursday, March 28, 1895:

The average American citizen is nothing if not facetious... They appear to love their joke above all things, and rarely lose any opportunity of indulging in little witticisms at the expense of their neighbours and friends. Like true Americans, too, who love to do everything on a gigantic scale, their witticisms are generally of a colossal character... "From what we have seen of Bangkok it is the most progressive town in the East," calmly said President Pangborn, without a quiver of an eyelid or the least suspicion of a twinkle in his observant eye. A president of a distinguished society or museum as the case may be, or even an ordinary American globe-trotter who, after two hours stay in Bangkok, can calmly tell residents that this city is "the

most progressive town in the East" is either indulging in a gigantic joke, or he believes that Bangkok people are the greatest simpletons he has yet met in the course of his travels east of Suez.... Probably the same witty gentleman told the cultured Singaporeans, after a two hours' stay in their midst, that New York was incomparably inferior to the somewhat mixed architectural styles of Singaporean lanes and alleys, and that he, Mr. J. G. Pangborn, had never yet met with so splendid and progressive a place as Singapore. We might supplement the famous remark of this jokist by adding another of his sage conclusions. He had "never seen a town in the East where there are so many substantial two-storeyed buildings." After this we think there can be no possible doubt of the wit and wisdom of the President of the Commission World's Transportation &c. &c. &c. A gentleman who can see more "substantial two-storeyed buildings" in Bangkok after a few hours' stay than in any one town he has yet visited with half the population, must possess at least one of his faculties abnormally and specially developed. Mr. J. G. Pangborn is clearly a gentleman after the heart of the Siamese...

Later on in Australia other editors found something droll about us. Our arrival in Melbourne was headlined "A COLOSSAL COMMISSION" by the *Herald*, while in Victoria the *Age* sarcastically bold-typed our visit with "HINTS ON RAILWAY MANAGEMENT." And I certainly did not miss—or fail to enjoy—the implication in a paragraph about myself which appeared in the Melbourne paper:

The commission arrived in Melbourne yesterday, and is now engaged in collecting information and pictures about railways. It is accompanied by "the greatest photographer in the world, Mr. Jackson." It is very odd that one of the greatest "bruisers" in the world is also a Mr. Jackson [*Peter Jackson, the Negro heavyweight*]. Jackson is evidently a great name.

But just because occasional editors managed to poke good-humored fun at us, it does not mean that we were poorly treated. Everywhere we were given dignified re-

ceptions and received in serious conferences. At one point, indeed, *my* work was taken so seriously that I landed in jail.

On April 4, my fifty-second birthday, while making some final shots overlooking Singapore harbor, I was arrested by two soldiers. Using a camera in a fortified area was a violation of the law, they said, and escorted me to Fort Palmer, which, as part of the panorama, I had unwittingly photographed. After holding me incommunicado until 6 P.M. they turned me over to a civil police sergeant, who detained me until the American consul intervened an hour later.

Next morning the magistrate who heard my case quickly dismissed the charges against me, and if the story had not been given considerable publicity in the local paper, I shouldn't bother to mention it now. But the newspaper correspondent referred to me as an "amateur photographer." I might in time, like Lewis Carroll, when a friend left the "g" out of his real name, Dodgson, succeed in forgetting that insult; but I shall never *forgive* it.

I now come to another place where I can enjoy one of the dubious fruits of autobiography. I can omit when I choose, and I choose to skip the five months we spent in the East Indies, Australia, and New Zealand, the Chinese Empire, and Japan. My motive is wholly practical: I cannot write a whole book about the trip around the world, and I prefer to use the remaining space I have allotted to this part of my career to just two countries. One of them is Korea, where I had an audience with the King just a few days before his wife was assassinated by orders of the Japanese Minister. The other is Siberia, 3,000 miles of which I crossed in an open sledge.

On Sunday, September 22, 1895, our party sailed from China for Korea on a Japanese ship commanded by an

Englishman. There were only four of us by this time; for Street had returned to the United States a few weeks before to look after pressing business.

It was hardly more than a twenty-four-hour run from Chefoo across the Yellow Sea to Chemulpo; yet the voyage was packed with the sort of dramatic stuff that a Vicki Baum or an Edna Ferber might weave into a smash hit. But look at the setting and the cast, and write your own play: a Japanese boat of 2,700 tons, the *Ghazee*, manned by seamen who owed allegiance to the Mikado; a British master on the quarterdeck; a Korean prince in mortal terror for his life, constantly surrounded by a bodyguard; a quartet of American globe-trotters. Add to this the circumstance that the Sino-Japanese War had just ended, and remember that the whole Orient was still under great tension.

Chemulpo harbor has tides that rise as high as thirty feet. Accordingly the *Ghazee* anchored a full three miles from shore, and Japanese sampans took us in to the jetty. The only luggage consisted of my camera, tripod, accessories, and a handbag; for I was going overland to Wönsan on the east coast alone, while Pangborn, Stevenson, and Winchell sailed around the Korean Peninsula. Winchell had hoped to accompany me; but he was still convalescing from an attack of typhoid fever in Australia, and the Major vetoed that plan.

It was a sensible decision. Wönsan was nearly 200 miles away. The country was mountainous. Roads were poor. Ponies were the only transportation. And the *Ghazee* was scheduled to leave Wönsan for Vladivostok exactly five days later.

At dawn on Tuesday the twenty-fourth I left Chemulpo with two native attendants and two tough little ponies. One of the shaggy animals carried my equipment, while the other was for me to ride. The attendants, or *mapous*, jogged along on foot.

This little adventure was one of the more uncertain ones of my life. Japan and China had just fought a war over the "Hermit Kingdom," and Japan had won. With Chinese suzerainty destroyed, Russia was hovering on the edges to dispute too great an extension of Japanese influence. The Koreans feared the Chinese, hated the Japanese, and mistrusted the Russians. Any stranger in a country like this might be suspected of almost any intrigue.

But those considerations seemed very unimportant at the time. To me Korea was just another new country to be explored and photographed. And in that frame of mind I arrived, shortly after noon, before the great West Gate of Seoul, capital of the Kingdom.

At the American Legation I was disappointed to find our minister away. But the chargé, Dr. Horace Newton Allen, who later became U. S. Minister, welcomed me most cordially. He was, although I did not at the time fully realize my good fortune, the best informed man in the world on Korean internal conditions; and he volunteered to provide me with a trustworthy guide across the peninsula. But first Dr. Allen arranged an audience with the King.

Our reception was set for that very afternoon, and with a good deal less trouble than it usually takes to see the ninth vice-president of your bank. We simply rode over to the palace in sedan chairs, waited for fifteen minutes, and were ushered in—and, while we waited, two sedate gentlemen wearing long black robes and fly-trap hats had opened a bottle of champagne for us, which is something that has never happened to me in a bank.

The King received us in what, presumably, was his office, seated behind two small tables that were covered with papers. A boy of eighteen or so stood at one side. A rather stupid-looking cub, I thought, and was a bit startled to learn that he was the Crown Prince. (When

the King, later Emperor, abdicated in 1907, it was this young man who succeeded him and reigned until 1910, when both crown and country were surrendered to the indisputable might of Japan. Thus I saw together the last King and the last Emperor of Korea.)

Attended by two chamberlains wearing broad purple sashes, and an interpreter—who was superfluous with Dr. Allen present—we advanced slowly, as etiquette prescribed, and bowed three times. Then I was introduced; and if the time consumed by Dr. Allen in presenting me is a valid gauge, my importance was greater at that moment than it ever has been since or before.

We conversed for nearly an hour, and I think the King was genuinely interested both in the Transportation Commission's tour and in my own work as a photographer. When we departed from the royal presence, backing down the room and again bowing thrice, it was quite dark; and eight palace servants escorted us back to the Legation with muslin-covered lanterns dangling from long poles. In addition to their lights the servants carried two large bundles, presents from the King to me. Later, when I had time to open them, I found three jade boxes, a number of silken scrolls, and two handsome tiger skins—which, I regret to say, were somewhat moth-eaten.

After an extremely pleasant dinner with the Allen family I had a conference with my Korean guide, Pak-nai-won, who knew a little English. With Dr. Allen's help, his instructions were made precise, and all fees and charges agreed upon, with the important guarantee that I should arrive in Wönsan in time to meet the *Ghazee*.

At 6 A.M. on Wednesday I left Seoul through the North Gate, and there, aided by Pak, who cuffed back any onlookers who crowded in too close, I took a splendid picture. But there were so many wonderful subjects to photograph all along the way that if my guide had not continually urged me along I could never have kept to

schedule. With mountains in every direction, straw-thatched villages, and an endless supply of eager natives to pose, Korea was an artist's paradise.

But there were flies in the ointment, quite literally. The houses commandeered by Pak were flea-infested hovels, and all but insufferable. Every night I spent on the road I silently thanked Dr. Allen for having provided me with a generous supply of insect powder.

Late on the afternoon of the second day we arrived at the village of Chi-ul-won; and here, Pak informed me, I should be the guest of the district magistrate. My passport and other credentials were sent ahead to his palace by a local messenger. When the men returned, with news that the magistrate awaited me, one of the villagers made a remark that was evidently derogatory to my honor— or perhaps he just hated all foreigners—and Pak cuffed him to the ground, threw off his hat, and made him bow prostrate before me. Then we continued to the palace gate followed by a respectful, if intensely curious, throng.

Yi-Ung-Yul, a benign and patriarchal gentleman of sixty-odd, received me sitting cross-legged on the floor. It was clear (apart from any pleasure he might have found in my company) that he regarded me as a very distinguished person, and later I discovered why. Dr. Allen's letter of introduction apparently credited me with the dignity and power of an ambassador. In addition, my passport had been issued and signed by Secretary of State Gresham himself; and it was really a very impressive document. And anything the passport and Dr. Allen's letter omitted was invented by Pak—his own prestige varied in direct ratio with the importance he was able to bestow upon his patrons.

My dinner with Yi-Ung-Yul is one of the most memorable of my experience. We two dined alone, although surrounded by fascinated servants and retainers. First we ate a preparation of honey, meal, and water. Then came

a sort of aspic, with condiments, mushrooms, and dried fish; with it, in porcelain cups, was served a hot wine resembling the sake of Japan. After we had finished that course, a brazier of live coals was brought in, and in a moment eggs and a chicken were cooking before us. Served with rice and accompanied by pickles and relishes, it was a delicious meal. I contributed some vermouth and several bottles of beer. Yi-Ung-Yul sipped them both politely, but without enthusiasm. Then I had a happy inspiration: I mixed a "half-and-half" of honey and whisky. That he relished greatly, and to show his satisfaction he summoned certain favorite retainers to have a taste. We talked, with Pak as interpreter, until late in the evening. At the end the magistrate presented me with an iron tobacco container, I gave him a box of cigars, and everyone retired for the night.

During breakfast early on Friday, Yi-Ung-Yul appeared in my quarters to inquire after my health and comfort. He informed me that he would accompany the "great American ambassador" a distance of ten *li* (about three miles) from Chi-ul-won.

A thick gray fog filled the valley, and to my great sorrow I was unable to take any pictures of our departure. A herald at the top of the stone stairway before the palace announced the orders of the day in long-drawn-out melodious tones; criers in the lower court repeated his orders; messengers raced ahead to inform the populace that His Excellency was going abroad, and commanded them *to stay indoors*. Then the big gates were thrown open; and, headed by four men blowing yard-long copper trumpets and four others carrying long pikes with blue-and-white flags affixed, my host and I departed. Yi-Ung-Yul rode in a sedan chair, while I trotted ahead on my pony. "Ke-hue-chi-roo, ke-hue-chi-ro-o-o-o-o," sang the heralds as we proceeded through the streets, which,

despite contrary orders, were lined with respectful towns-
folk.

At a hamlet ten *li* to the northeast the procession halted,
formal farewells were exchanged, and a stirrup cup of
wine was drunk. Then suddenly the sun broke through
and, aided by Pak, who pressed the bulb, I was able to
take some pictures, with myself included. I also photo-
graphed Yi-Ung-Yul alone, with the scrolls of his office
as background.

I arrived at the port of Wönsan late Sunday afternoon
and found that the *Ghazee* had not come in. Consequently
I went to the house of the collector of the customs, to
whom I had a letter. Mr. Oisen, a Dane, I think, enter-
tained me in his handsome brick-and-stucco house. His
company was delightful, his food excellent, and his wine
perfect; but the thing I enjoyed most under Mr. Oisen's
roof, after nearly a week of Korean fleas, was his bath-
room.

Before leaving Seoul, Dr. Allen had said to me: "Pak
is smart, but an awful rogue." After paying him off—he
even charged me for the use of his saddles!—I was still
in a liberal frame of mind and decided to give away what
was left of my canned and bottled goods. But Pak had
already appropriated everything of that sort, and so I had
nothing left to give him except the two royal tiger skins,
which he had apparently overlooked. It was then that I
discovered how badly moth-eaten the skins were—and I
am sure Pak had before me.

A threatened typhoon delayed the *Ghazee* until
Wednesday, October 2; and it was not until 7:30 P.M.
that she rounded the headland and turned into the harbor.
I found Pangborn, Stevenson, and Winchell, after eight
days on a slow boat, in a state of weary boredom. They
failed to understand how anyone could tolerate Korea and
were impatient to be on their way from such a dull corner
of the globe. (Less than a week later the eyes of the

world turned excitedly toward the Korean Peninsula. Under orders of Viscount Miura, Minister of Japan, Korean troops dominated by Japanese soldiers captured the palace, imprisoned the King, and murdered the Queen, a persistent opponent of Japanese influence. The King escaped to the Russian Legation, where he remained in seclusion for more than a year. These "incidents" were among the underlying causes of the Russo-Japanese War of 1904.)

On October 3, one year to the day after I had sailed from New York, the World's Transportation Commission departed for Vladivostok.

SLEDGE OVER SIBERIA

SHORTLY after midnight on October 5 our ship dropped anchor, and at dawn I was on deck for my first glimpse of the most extensive empire on earth. In the early light, with mountains sloping almost to the shore line, it looked very much like California.

Pangborn joined me at six o'clock, when the *Ghazee* started slowly to make its way into the Golden Horn. On our left was a rocky islet crowned with a lighthouse. Soon we were passing between barren hills, up a channel hardly a mile wide. Then suddenly we found that these natural defenses to Russia's only Pacific harbor were not barren at all—earthworks and great guns sprouted everywhere. A little later we spotted a cluster of low buildings, either a military or a naval base. As the sun rose higher we could pick out more and more structures, and finally the town itself came into view.

A mile or so from shore, abeam of a guard ship, we anchored once more. Everyone on board was speculating about the yellow quarantine flags fluttering from most other ships at anchor, and we awaited the arrival of the health officers with some concern. When they came on board, two young men with pointed mustaches and beards, our captain conferred briefly, then held up three fingers for all of us to see—we had been given the usual three days for ships out of Japan or Korea. Pangborn chafed at the delay; but to me it was another opportunity to catch up on developing and printing.

We landed in Vladivostok on October 8, and by the simple act of stepping down on Russian soil we "gained" twelve days; for the switch from Gregorian to Julian calendar set us back to September 26. (From now until our departure from Russia any dates that I mention will be Old Style.)

Our temporary host was Colonel Petrov, chief of police, and he arranged quarters for us in the city hall. According to the Colonel, there was no decent hotel in Vladivostok; and from what we saw of the Golden Horn and the Moscow, I am sure his contempt for those hostelries was not without foundation.

I spent the first day waiting for a permit to use my camera, and the next in photographing about the city. But most of the first forty-eight hours were given over to entertainment, with hosts pressing us on all sides. Most pressing (at least, by the canons of etiquette) was the Governor, Baron Paul Ounterberguère. We dined at his residence on September 27.

Both the Baron, a big, bearded, hearty man, and his lady spoke English fluently, as did the only other guests, the Governor's secretary, and Captain Kasherinikov, who commanded one of the big ironclads at anchor in the harbor. It was very much of a family dinner, with the four Ounterberguère children also present and sharing not only the food of their elders but the wines as well. With the eldest son, a boy of twelve, I had one of my most enjoyable conversations since leaving home; he wanted to know about Indians, and for once I felt that I was a reasonably competent authority on America.

Next morning we started north by rail, and by evening we were in Spasskaya, 223 versts from Vladivostok. (A verst, slightly longer than a kilometer, is almost exactly two-thirds of a mile.) After a substantial supper, specially prepared for us in the station, we spent the night in our car.

Under way early the following morning, we rode all day, as on Thursday, through level, grassy prairie country, not unlike Nebraska. That night we spent in our car on a siding in another small town. About 9 A.M. we were hooked onto a regular train, and before noon we had reached the Yman River, where we were scheduled to take a boat down the Ussuri to Khabarovsk.

Moored close to the bank was a flat-bottomed stern-wheeler, some eighty feet long and with a beam of twenty-two feet. It had the look of a Missouri River craft, and I was reminded of my honeymoon trip from Omaha to St. Louis in 1869. All the *Skobelev* needed was a new name and a Yankee captain.

Our belongings were carried on board, and our party returned to the railroad station for a bite and a drink. When we embarked an hour later, the vessel at once swung out into the channel and pointed its bow downstream. Everything seemed to me to be going all right; but suddenly a wild bellow of rage issued from the wheel house, and we were treated to as fine a recital of old-fashioned Yankee blankety-blank-blanks as I had heard since I left the Army. The virtuoso completed his damnation of all oriental deck hands and then came out to greet us. His name was Harwood (or Hardman), he came from Maine, he had learned his art on the Mississippi and the Missouri, and he was "god-damned proud to have some folks from home to visit with." To prove it he invited us to share his table (meals were not normally provided for passengers on boats like his), and I can say with some assurance that no host has ever been happier to entertain guests than Captain Harwood was.

We were three days going down the Ussuri; for not only was the channel shallow, which meant periodic poling to get off the bars, but we tied up at night. Yet it was far from being a tedious trip. New passengers boarded the *Skobelev* at every stop, and I had an oppor-

tunity to photograph individuals of several races—Russians, Manchurians, Chinese, and Japanese, mostly—with hardly a shift of my camera. In the evenings we had a sort of international poker game going on; and, in the circumstances prevailing, an emergency deck made from our visiting cards seemed perfectly normal.

About noon on October 3 our boat suddenly leaped ahead. We were coming into deeper water, and in a few minutes we had swept out upon the broad Amur. Before us rose the high bluffs of straggling Khabarovsk, with a green-roofed church and its four beet-shaped spires crowning the city.

At the landing we were greeted by the chief of police, who informed us that the Governor General, now absent in St. Petersburg, had given orders that we should be quartered in his own house. Then the chief escorted us up the hill to a large two-storied brick structure, where servants installed us in our rooms.

Luncheon was prepared for us, and social intercourse was made possible through the presence of M. Prelle, local representative of the large trading firm of Kunst & Albers, to whom we had letters. It was a hurried meal, however, because the Vice-governor was expecting us to call at three o'clock.

When we had paid our respects to General Grodokov, who understood a little English but made no attempt to speak it, we visited Chief Engineer Domiordontov in charge of railway construction. Both he and his assistant knew English, and our call was very instructive. We received an invitation to ride next morning over the line they were building toward Vladivostok. We also received an invitation to dine with them then and there, and I was truly amazed at the lavish table. I had always thought of Siberia solely as a habitation of exiles; and now here we were, four unexpected guests, sitting down to a table

that fairly sagged under the weight of fine porcelain and glassware.

Early breakfasts in Russia were normally a matter of tea (seldom coffee) with a bite of bread; but word had gone round that Americans ate a heavy meal in the morning, and we were served steak and eggs before our inspection trip began next day. Horses were provided by our railroad friends; and off we went, led by Colonel Tashkin, who was in charge of all convicts working on the road.

Construction was in an early stage, no rails having been laid as yet; and the hundreds of laborers we saw were occupied in clearing, grading, and leveling. We stopped for lunch at one of the convict camps, and there Colonel Tashkin lined up the men for me to photograph. Since it was the noon hour, all the convicts were present; and I observed with interest that a number of them took the opportunity of addressing themselves to Tashkin, presumably about small grievances. The conversations were all very businesslike, with no self-abasement. To me it seemed that the relations were those of boss and worker, not of keeper and prisoner.

After a hearty lunch in one of the shacks I got busy with my camera again. Then we returned to Khabarovsk for dinner.

We were scheduled to begin our trans-Siberian journey on October 6, and on Thursday, the day before, Major Pangborn gave a large dinner party at the Governor's house to return, in a measure, at least, the open-handed hospitality we had enjoyed in Khabarovsk. Our chef, an ancient convict, prepared a meal that would have delighted the most exacting gourmet, and afterward, with no exceptions, we paid cheerful heed to the warning lettered (in Russian characters, of course) on the dining-room wall: "He who does not drain his glass is slighting

the lady of the house." I am sure that the lady, had she been present, would have found no cause to complain.

On the morning of the sixth we learned that the boat up the Amur to Blagoveshchensk would be delayed at least twenty-four hours more. Consequently we were able to accept the luncheon invitation of M. Schimkevitch, a government secretary, who had not only traveled into every corner of Eastern Siberia but had made thousands of photographs on his travels. He was a first-rate amateur, and I regretted that I should not be able to spend more time with him.

Another delay stopped us on the seventh, and I cannot say that I was in the least surprised when, on the morning of the eighth, it was announced that the trip up the Amur had been canceled. A smiling official informed us that we could certainly plan on leaving in the spring, after the ice had melted; or, if we really wished to make such an uncomfortable trip, transportation by sledge could no doubt be arranged. That is, as soon as really hard ice covered the whole river. It would not be long, he told us, a month or two at most, certainly not more than three.

We were stuck. Not even Pangborn could do anything about it. And, to my amazement, Pangborn and the others didn't seem to care. I didn't care, either. I could do a lot of photographing and use Schimkevitch's laboratory to complete my work in. I could do a lot of writing— *Harper's* had already printed three or four short pieces of mine, and they were asking for more descriptive material to go with my pictures. I could even study Russian. In brief, I looked upon the enforced delay as a fine chance to get in some extra work.

And so it proved to be. We were held up for nearly two months, during which time we continued to live luxuriously in the Governor General's mansion; and I accomplished much of the work I projected for myself. Nor

was there any lack of gaiety. The Russians I was privileged to know in Siberia were the most hospitable people in the world, and scarcely a day passed without invitations to breakfast, to luncheon, to dinner, and to supper. Best of all, these constant social engagements enabled me to practice my Russian and my French, both of which I was systematically studying. I never became accomplished in either tongue; but I found much pleasure in the little I acquired.

While we were waiting for the ice to form a highway, I had the opportunity to make two very instructive trips. On one I went as Colonel Tashkin's guest to photograph the convict winter quarters north of Khabarovsk. The other was a short journey down the Amur to a village of Goldi fisher folk.

At this late date, nothing could be of less importance, politically, sociologically, or otherwise, than living conditions in a Czarist prison camp. And so I will mention a few things just as I saw them during the two days I spent with Tashkin.

When I arrived in their midst the convicts were completing their winter quarters, dugouts with sunken side walls and low-pitched roofs, all built of heavy timbers, and then covered with earth to insulate against the cold. A typical dugout was fifty feet long and eighteen feet wide, with a door at one end and a shuttered window at the other. Sleeping platforms, inclining gently toward the center aisle, were erected along either side wall, and there was a sheet-iron stove at each end of the room. With the materials at hand no more substantial shelters could have been built; in general, they were superior to the houses occupied by "free" laborers.

The Government supplied its charges with proper winter clothing and an abundance of plain food. Besides, the convicts were paid small wages for overtime labor; and,

since during good behavior they were never locked up,
there was little difference between their lot and that of
their unconvicted brethren who worked side by side with
them. I saw thousands of convicts in Siberia, and, with
few exceptions, they were indistinguishable from the great
mass of the people. Undoubtedly there were cases of
brutality; but none came to my notice.

October literally raced along. On the seventeenth we
attended services of thanksgiving for the preservation
of the young Czar Nicholas II and his family in a train
wreck. The Orthodox Church was packed for the cere-
mony, which was impressively conducted by tall-hatted
priests richly bedecked in purple velvet and white silk.
At the conclusion all true believers filed past the Bishop
to kiss a large gilded cross he held aloft, while we mod-
estly confined our devotions to shaking hands with the
Vice-governor.

About this time a little meeting occurred which, better
than anything else I can think of, displays how remote
Eastern Siberia used to be from Europe for six or seven
months of the year. One of our railroad friends brought
around a colleague who had urgent business in St. Peters-
burg, and Pangborn was asked to supply him with letters
that would help him while crossing the United States—
for the Russian gentleman was taking the fast route to
his Emperor's court, by way of Vladivostok, Yokohama,
San Francisco, New York, Bremen, and Berlin!

It was not until mid-November that the long-planned
excursion to the Goldi village could be arranged by my
friend Schimkevitch. But on the eighteenth, equipped
with fur coats, felt boots, cameras, an ample supply of
cheap vodka, and candies for the children, we started
off for a forty-eight-hour visit with a little group of that
ancient Mongol tribe. A letter I wrote my wife covers the
trip rather completely, and I shall quote a few paragraphs
from it:

... Our course lay down the right bank of the Amur, and the below-zero weather of the last week made good, solid ice... Nineteen and a half versts out we came to Verongeskaya, the first post station from Khabarovsk to Nikolsk, where we rested for a little more than an hour to lunch and feed the horses. We soon had hot soup and tea prepared, which was preceded by an appetizer from a big bottle of vodka Schimkevitch brought along.

A two-and-a-half hours' drive in the afternoon brought us to the Golds' village, nearly all the way over thick, smooth ice, black as ink in some places, that would have made splendid skating. On a slight elevation a half dozen or so of small houses constituted the little fishing village of Sup-chee-kee. We were invited into the house of the head of the village, the largest and best arranged of them all—a framework of willows set on end and thickly plastered with clay, with a thatched roof. The interior is divided into two apartments, the outer one a sort of vestibule and general storeroom, furnished with two furnace-like stoves. The living-and-sleeping room adjoins this; it is about sixteen feet square and nearly all occupied with a low divan running around three sides of the room. Later, during the night, I realized that these are like the Chinese and Korean kangs—flues from the little furnaces in the outer apartment are conducted under these divans to an outer chimney.

We were evidently expected. Schimkevitch has a hearty, free-and-easy way that puts everybody at once into a good humor, so that there was a general air of great friendliness attending our arrival.

Opening the small door, hot air and smoke burst out like a blast from a furnace; but once inside and accustomed to the change, it wasn't so bad. Eight members of the family were present; but soon other villagers came in, and the little room was filled to its utmost capacity.

A small frozen sturgeon was brought in, part of it was put into an iron kettle, and, with some seasoning herbs we had brought along, a savory soup was soon prepared. As a greater treat for his hosts Schimkevitch produced the big, black bottle of vodka, holding nearly a gallon, and with a tin cup passed a liberal portion to the other people present. We shared alike in the contents of the big bottle—it was a cheap variety, the

best being worth about a ruble a quart, while this cost only a third as much. Not bad, at that.

Supper disposed of, Schimkevitch proposed the performance of some of their dances, and had them get out their regalia and drums. The dance was a walk-around in the small space not occupied by the divans. The regalia consisted of a lot of miscellaneous junk and hardware, tin cans, old bells, anything that would make a lot of noise, all attached to the waist and hanging down behind. The main effort was to produce the greatest amount of noise. To accomplish this they wriggled their posteriors in a queer, twisting motion, while prancing around to the rhythmic thumping of the drums. Old and young took part, until all the natives present had participated.

About ten o'clock we were ready to retire, simply lying down on the divans without removing our clothing. The family came in later and disposed of themselves in the same manner. That the atmosphere was disagreeably thick and close goes without saying.

[*November 19*] Everybody was up early, and we had a preliminary light breakfast of tea and bread, followed by a more substantial one about ten o'clock. By this time all the people of the little settlement were gathered about our house. There were only between twenty and thirty, all told, but as many as two hundred make their home here later in the season. Their dogs were a prominent feature of the gathering. Schimkevitch says that lead dogs in some of the teams are worth two hundred rubles, while the ordinary ones are worth ten to fifteen. The Golds have no other animals.

Speaking of domestic animals, I noticed last night that when our ponies were unhitched from the sledges they were steaming with perspiration, but were given neither shelter nor covering, and were left to stand out all night in a very cold wind. The shaggy little animals seem hardy enough to stand anything. [*At another place I was told that in the coldest weather the ponies were doused with water, which, forming an immediate sheath of ice over their fur, saved them from freezing to death. But I am a bit skeptical. It can't get much colder in Siberia than it does at times in Montana and Wyoming, and horses flourish there on the open range without benefit of ice films.*]

We began our photographic operations by taking a number of groups about the houses and then transferred to the frozen

surface of the river—Schimkevitch is an expert photographer. Later in the afternoon a noted shaman [*priest, really a medicine man*] came in to be photographed, all rigged out in a dancing costume. Around his waist and down his back were strings of rude bells; suspended from his neck, front and back, were half a dozen thin brass plates six or seven inches in diameter; on his head was an immense fur cap, with tail-like appendages to which were attached many brass sleigh bells.

About seven o'clock everything was ready for the dancing to begin. The old shaman sat impassively in a corner of the little room, smoking his long-stemmed pipe in a sort of far-away trance. The main performance of the evening was preceded by the little kids, and some others, in a burlesque of what was to follow. As each little tot finished his short round he was given a handful of candies, with which he quickly retreated to the outer apartment.

Now we come to the climax when the shaman—Ivan Ojowie—made ready for his turn. As a preliminary he drank off a full cup of the vodka, then, still seated in his corner, he startled his silently expectant audience by suddenly giving two or three loud thumps on his drum, followed by a shout. Then he began a song, or dirge, in a halting, jerky voice, gradually increasing in strength, and concluding with half a dozen thumps given with great vigor. He went through eight such periods before he got to his feet and began a dancing step, jangling his metallic equipment, and keeping time on his own drum while an assistant accompanied him on another. A few rounds worked him up to such a state of frenzy that recourse was had to the vodka, and a second full cup was given him. Thus revived, he renewed his singing. Two or three more rounds of the jangling steps, a few more loud and vigorous beatings of his drum, and he sat down completely exhausted...

[*November 20*] Schimkevitch now had his final talk with the people and completed the purchase of all kinds of trinkets, furs, dresses, and implements, at the same time laying in a supply of fish, game, and native foods for his own larder. While I was waiting outside for Schimkevitch to get through, two Russians came in from down the river with dog sledges. One big fellow with abundant sandy hair was the local tax collector, and he carried a real, old-fashioned carpet bag.

Everyone in the village came down on the ice for a farewell and gave a parting shout of good-speed as we started off. Leaving at one o'clock, we arrived at Khabarovsk at six...

The continued cold weather promised an early start on our westward journey, and two days after I returned from the Goldi village Pangborn started to look for sledges. A week later, November 28, everything was in readiness. All we needed was the certainty of solid ice up the Amur.

A few days later the Imperial Mail brought word that the way was safe, and we made plans to depart the following Monday, December 4. With so many friends, we required several days just to make our adieus.

On Sunday, after a parting call on General Grodokov (who sat like a stone image for ninety seconds while I made a camera portrait), I attended a farewell banquet to the Transportation Commission. Twenty-one gentlemen sat down to a dinner which began, according to the menu printed in both Russian and French, with *Soupe à la Baltimore* and ended with *Galop d'Adieu*. It is my impression that the final item was an orchestral selection; but, with all the toasts and non-toasts that passed around, I couldn't be sure. I do, however, remember two of the *toasts*, the ones by Pangborn and Colonel Trusov. With an imagination that was rather startling, considering all the difficulties, our chief proposed: "Here's to good old Russia, drink her down." Trusov responded, in essence: "To our American friends—if Bering Strait were wine, we should all soon live upon the same continent."

When Monday came we were dissuaded from starting. According to our friends, it was very bad luck to begin a journey on a Monday. And I think I can understand why: no one in Russia ever felt well enough after his usual Sabbath to go anywhere except to bed.

Early Tuesday morning Karaoulov, a minor post-office official, called for us. A handsome young man in his blue, gold-trimmed uniform, he was to be our courier. A thorough knowledge of the route and a thin working knowledge of English were his main qualifications.

At the outset we had two *pavoskas*, sturdy, low-slung,

narrow sledges with closed tops, each drawn by a troika, that is, three horses hitched abreast. In addition to our party of four and Karaoulov there was a boy of fifteen or so, whom we had agreed to transport as far as Blagoveshchensk, and the two drivers. Winchell, Stevenson, and Karaoulov rode in one *pavoska,* while Pangborn and I took the other; the boy sat up on the narrow driver's seat. With all our luggage and food and the immense fur coats we had to wear, it was a tight squeeze all around. But at exactly 9 A.M. all eight of us were placed, and we were off in the teeth of a howling blizzard.

Three thousand winding miles ahead of us lay the city of Krasnoyarsk, then the eastern terminus of the Trans-Siberian Railway. The trip took us forty days, and fifteen of them were spent in the larger places along the way—Blagoveshchensk, Chita, and Irkutsk. In other words, we covered the 3,000 miles in twenty-five days of actual travel. When on the road we traveled continuously, sleeping in our sledges, and stopping only at government post stations to change horses and to brew tea and heat up a meal. Night and day, the temperature averaged 20° below zero, Fahrenheit.

We followed the route of the Imperial Mail, which was literally a pony express. Post stations, about fifteen miles apart, on the average, were maintained for the government by private individuals, who were required to supply horses not only for the mails but for all travelers. There was one comprehensive rule about those horses: changes *had* to be made at every station; thus overexhaustion was averted, and at the same time the owner of the animals could keep them always within one station of their base in either direction.

The station proprietors were usually small farmers, without much outside work on their hands during the winter season of heavy travel, thus able and eager to comply with their secondary duty of supplying inn accommo-

dations. Wherever we pulled in, regardless of the hour, hot water was ready in a samovar, and by the time our coats were off, tall glasses of tea were being offered. Food quickly followed—meat or a fowl, whenever available, or eggs, or a savory meat-and-vegetable soup. Known as *tschee,* this soup was the staple of the country, and we always carried a goodly supply—frozen in solid blocks— tb insure our appetites against lean larders en route. But, almost without exception, the way stations had ample supplies in the kitchen. Table utensils were less certain. At one little post inn there was only one glass for the four of us, while at another we had to get along with two plates.

During the first five days we passed through 40 villages and covered some 840 versts. To me, at least, it was the most tiresome part of the journey; for I rode with Pang-born, and since he would tolerate no ventilation, the windows were so frost-covered that I could see nothing of the country. Since that was an unbearable deprivation, I bought an open sledge, for the give-away price of twenty rubles, and from that time forward I rode with the wind in my face and loved it.

We reached Ozerki at 3:30 A.M. on December 11, and since it was only a two hours' run into Blagoveshchensk,

we decided to delay our arrival until a more seasonable hour. And it was good that we did so. At the outskirts, where we arrived at 10:30, we were greeted by messengers who had been on the lookout for us since three days before; had we arrived at six, they would certainly have taken us at once to the officials who were expecting us. And 6 A.M. is no time to make a good impression on anybody, let alone a new host.

We were hardly in our rooms at the hotel when, as ever through Siberia, the chief of police called. Our wishes were his wishes, he assured us. The freedom of the city was ours. The Governor looked forward to seeing us next morning.

Our immediate interests happened to be very personal. As soon as we had engaged an interpreter—for Karaoulov's English wasn't quite up to scratch when it came to translating formal sentiments—we had him take us to a bath house for a long steaming. (It is amazing how quickly a good bath can change the whole point of view. In the course of a few hours we went from 25° below zero to 125° above, and, speaking for myself only, my spirits climbed just as high. After five days of unbroken traveling that bath was worth more than anything in the world.)

At ten next morning Sugerlov, a Government secretary and interpreter, took us to the Governor's residence. General Arsenev—all district heads save one among my Russian acquaintances were generals—was much interested in photography; and, after he had seen a few of my pictures, he asked a servant to call in his wife. Madame Arsenev spoke English fluently, and with her assistance I described the whereabouts and circumstances of many views that I had with me. When we left, we had an invitation to dine with our hosts two days later.

During the next thirty-six hours, besides taking a great number of pictures, I attended a formal luncheon given

the Transportation Commission by some local big-wigs, heard a lively "Sicilian" operetta by a traveling company from Moscow, and celebrated Christmas. The ubiquitous house of Kunst & Albers gave us a party on December 13 (December 25 by the Gregorian calendar); but in less than three months we had grown so used to the Russian reckoning that this Christmas party seemed as strange to us as it must have to our hosts.

On December 14 we dined most pleasantly at General Arsenev's. There were ten or twelve men present, but only two women, Madame Arsenev and a sister of the Governor. I noted once more what I had observed before: that in Russia, supposedly the most backward of the "western" nations, the women seemed to be most advanced. I suppose their habit of smoking cigarettes had something to do with that impression; but I also observed that it was usually the women who were better informed, more at ease, and certainly more fluent in their conversation.

Two days later, after a visit across the Amur to a Manchurian town, where I had time to take no more than half a dozen pictures, we departed for Albazin. There our amiable attaché, Sugerlov, left our employ, and he startled us by bringing farewell gifts. Pangborn received a sword, Stevenson a pair of gloves, Winchell a fine fur cap, and I—a Bible! I have never quite figured it out. But I like to believe that it was a tribute to my kindly disposition, and not a solid hint to save my soul before it was too late.

As before, we drove continuously except for stops to change horses and to prepare food. At Kolinova, which we reached at 2 A.M. on December 18, a little experience inflated our ego. Two officers were waiting for a change of horses when we came in; but Karaoulov's orders were that we should have precedence over everything, *even the mail.* Accordingly we went out first, and, as I have just said, we felt pretty important. But now, after mature

reflection, I wonder whether the Government might not have been a little weary of our presence. We had been sponging for three months, and they might have decided that holding up the military and the mails was a small price to pay to get us out of the country.

We arrived in Albazin soon after midnight on the twentieth, and since we had no specific obligation to stop, we decided to take advantage of the brilliant moonlight and press on toward Chita. Near Petrovskaya, a day later, I saw and photographed one of the most extraordinary sights of my whole trip around the world—a caravan of camels drawing sledges. There were a thousand or more shaggy Bactrians in line, and, accustomed as they were to the rigors of the Siberian winter, many of the beasts were nevertheless bleeding at the nostrils from the cold. It was 25° below zero when I took my pictures.

Siberia is said to have lower temperatures even than the poles. Whether or not that is a fact, the weather was consistently frigid. Yet I was never painfully cold, even when my thermometer read − 40, the lowest it registered. While traveling I wore heavy felt boots and an elkskin coat that was built like a blanket. But, although it was impossible for the cold to get through, I several times suffered from a frozen nose.

It had been planned for us to be in the city of Chita in time for the Russian Christmas festival; but horses were so scarce that even our authority to go through ahead of everything couldn't get us there the night before. At midnight we were still 120 versts away, and twelve hours later we were not yet in sight of our destination. It was not until 3 P.M. that we reached the outskirts, where a mounted officer in a long black coat intercepted our drivers with orders to drive us straight to the hotel, which turned out to be a sprawling one-story log building.

Pangborn was so short of money that he insisted upon going at once to the post office for mail. On Christmas

Day and in Russia that was nothing less than fantastic;
but the Major was used to getting things done, and he
went right to the Governor. We all felt uncommonly fool-
ish when a search of the vaults produced not a single
letter. As for Christmas, the only sign was an utter shut-
down of all public facilities. It was about the drabbest
holiday I have ever known.

But we just happened to arrive during a quiet period.
Christmas went on publicly for the rest of the week.
Next night, after dining at the Governor's, we were guests
at a dance. On the twenty-seventh, in company with the
Governor and his suite, we attended an elaborate celebra-
tion by 300 pupils of the public school; the entertainment
consisted largely of singing and dancing around an im-
mense tree, heavily decorated and lighted with candles.
And on the third day after Christmas there was another
festival, this time by pupils of high-school age, in the
town hall. The thing I liked best about all these holiday
doings was the spontaneous enjoyment of adults along
with the young. Right on up to the Governor, who danced
and sang with the rest, everybody had a thoroughly good
time and didn't mind showing it.

Our mail arrived on December 29. But the local bank-
ers could not understand Pangborn's letter-of-credit, and
we were able to secure traveling funds only through the
good offices of the Governor, who pledged personal securi-
ties to help us. We attended his farewell dinner to us that
night with a feeling that the Russians were the kindest
people in the world. It is hard for me to realize the great
changes that have taken place since the October Revolu-
tion of 1917. But, of course, I was never in a position
while there to know what was stirring underneath the
pretty surface—very few Russians knew, either.

We left for Irkutsk on December 30. The ground in
and near Chita had been blown almost clean of snow,
and our departure from in front of the Governor's man-

Wearing this elkskin greatcoat, I crossed Eastern Siberia in
an open sledge while the temperature averaged
20° below zero.

As we sledged up the Amur River on the way to Kras-
noyarsk, we encountered a train of a thousand Bactrian camels
carrying army supplies. This is the head of the train,
with one of the drivers.

sion was made in a four-wheeler, or *tarantas*. But by the time we had come to the first post station there was plenty of snow once more, and we switched to our sledges, which had been hauled over the bare ground behind extra horses.

On New Year's day, 1896, we had another dry pull, and in the course of the day we changed from sledge to *tarantas* and back again no less than four times. Next day, when the temperature rose to zero, the warmest it had been, we were in deep snow once more, with a notable increase in speed and comfort. The poorest snow was always better than the best country road, and winter was certainly the time to travel—if you didn't mind the cold too much.

Early in the evening of January 2, we arrived in the village of Boyarskaya on Lake Baikal. This is the largest body of fresh water in Russia, and it was still too early in the season for it to be completely frozen over. Accordingly, instead of sledging across Baikal, we followed the shore as far as the southeastern tip—a thirty-six-hour ride —and proceeded to Irkutsk by way of Kaltanskaya. On the afternoon of January 4 we entered the "Paris of Siberia."

Perhaps that designation was a slight overstatement. But accustomed as we were to dreary log houses all along our route, we agreed that Irkutsk was indeed a magnificent city. Here were delicate spires, white towers, and stone façades, with blue and green domes and golden crosses against the sky. The Governor lived in a great palace. And we found a hotel, the Siberia, that shamed every public house we had stopped in since leaving Australia.

In the absence of the Governor General of West Siberia we paid our respects to Governor Swetlitsky of the Irkutsk District, a stuffy old gentleman, whose conversation consisted solely of platitudes. Next in line came

the Vice-governor and finally the Mayor, who turned out to be the brightest of the trio. After giving us a delicious luncheon, the city magistrate took us happily through his house to show us the electric lights and telephone, all of which were gleamingly new.

I was unusually busy with my camera while in Irkutsk, and I found much to photograph besides public buildings and public officials. I was much pleased with the views I obtained at the fashionable skating rink—so pleased, indeed, that I ventured out on the ice myself, for the first time since leaving Vermont thirty years before, and skated to the waltz music of a lively brass band for more than an hour.

I also attended a play for the first time in many months. After a dinner by the Mayor we sat in the Governor General's box and saw *King Henry VIII*. The histrionic details have slipped my mind; but the impact of Shakespeare's bluff Englishman done in elegant French by a Russian company still remains.

After the theater we were taken to a *bal masqué* at the Merchants Club, where our younger members, Winchell and Stevenson, danced their heels off with fascinating ladies in dominoes and extreme décolletages. And I, despite my skating excesses of the previous afternoon, found myself out on the floor with the others until the music stopped at 3 A.M.

Our last entertainment in Irkutsk was a dinner by the Vice-governor. Among those present was the Archbishop of Eastern Siberia, who invited us to call at the Monastery of Vosnesenskaya next day on our way out of the city. Far from being a venerable patriarch, Archbishop Nikodim was blond, handsome, and not much more than thirty years of age. He was interested in everything, and his charm was irresistible. When we waited upon him the following afternoon, he received us in a splendid apartment —the Czarevitch had occupied it during his tour of the

Empire in 1891—and served us champagne and chocolates. After a lengthy conversation on the most worldly topics he took us into the monastery church, where, under the great vaulted dome, we were permitted to kiss the tomb of some patron saint. While we performed our part of the ritual, a dozen cassocked priests swung censers of fragrant incense and chanted prayers for our safety in traveling. Then Archbishop Nikodim walked out to the sledges with us, kissed each one of us on both cheeks, and bestowed his parting blessing.

Starting up the Angara River, we traveled continuously for the next five days. On the third day out of Irkutsk, at Biroshinskaya, we saw the first signs of a railroad since our departure from Khabarovsk. A station was already completed, and laborers, both free and convict, were at work grading and driving piles along the right of way.

On the fourth day we came within striking distance of Krasnoyarsk, and by mid-morning of the following day, January 14, we could see the white churches of the city gleaming in the distance. A little more than an hour later, after having been escorted through the streets by two mounted officers, we were relaxing in our hotel. Our long trek through the snows was over.

HOME AGAIN

O UR courier, Karaoulov, had left us in Irkutsk. Thus, the most urgent need of the World's Transportation Commission was for a new interpreter. A fellow guest in the hotel at Krasnoyarsk, a civil engineer named Bootz, offered his services, and he was engaged at once. In addition to his native tongue and English, which he spoke quite well, Bootz knew both German and French. We could hardly have picked a better man.

Governor Tchelkovskaya, who was the only civilian high magistrate we encountered in Siberia, told us that we had come to Krasnoyarsk at a fortunate moment. The Minister of Communications was due to arrive in a few days, he said, and no one in all the Empire could be more helpful to a party of transportation experts. Pangborn coughed slightly and thanked the Governor for so flattering a definition of himself and his associates.

After our formal visit to the Governor, Pangborn and I, with Bootz in tow, dropped in at the Engineers Club. Now that we were back in the railroad country once more, it was necessary to return, however superficially, to our "study." It happened that several of the local railroad officials really wanted to talk shop with us; and Pangborn, as he frankly admitted to me, was beyond his depth. It also happened that I had picked up a good many technical bits during my many photographic trips throughout the United States. When I volunteered to answer certain questions, Pangborn was utterly flabbergasted by my glib

remarks on rail weights, grade percentages, and radii of curvature. Later he thanked me with great sincerity for upholding American prestige.

I spent several days photographing the sights of Krasnoyarsk, which was on the whole a far less attractive city than Irkutsk. Our evenings, however, were thoroughly satisfactory. Governor Tchelkovskaya apparently took quite a liking to us; for he entertained us far beyond the requirements of mere politeness, with two dinners and a luncheon. One of the dinners was strictly a family affair, and Madame Tchelkovskaya, as well as her husband, did everything possible to make us feel at home. Bootz was with us; but most of the conversation was carried on without his aid. We with a few dozen Russian phrases, the Governor's family with about the same amount of English, got along splendidly. If it is true, as some cynic has remarked, that speech was invented by man so that he could conceal his thoughts, then a difference of language should be a positive aid to understanding. Many times I have felt I knew a man or woman better because it was *hard* to exchange ideas. Any intellectual loss always seemed to be more than made up by a gain in emotional values.

Our friends at the Engineers Club were also very kind. But one evening they were honestly shocked by a breach of etiquette. When billiards was suggested after dinner Winchell removed his jacket and prepared to play, like any honest American, in shirt sleeves. Such a thing was not only unspeakable but unknown. The Russians stamped around the table with their trousers tucked untidily inside their muddy boots—but they played billiards with their jackets on.

Prince Khilkov, Imperial Minister of Communications, was scheduled to arrive in Krasnoyarsk on Sunday, January 21. When his train came in, very late, we stood shiv-

ering on the station platform, along with a great crowd. Everybody in town wanted to see the Prince, and Pangborn, alone of our party, was presented.

Next day the Major proudly informed us that the Prince had just sent him an invitation for all of us to ride back to Moscow with him. He was vastly elated, and the rest of us were almost equally pleased—if for no other reason than that such a distinguished host as the Minister of Communications could be counted upon to command the best of everything.

We left Krasnoyarsk at 8 P.M. on Monday the twenty-second, and again everybody from the Governor down milled and pressed for a glimpse of Prince Khilkov. I wish I might have had a fast "minicam" and a pocketful of flash-bulbs—but then I would probably have little to show for it, because the mist of human breath in the biting night air would have obscured most details.

The train consisted of only four cars, a luggage van (as the English have it), a third-class coach for servants and attendants, a first-class coach of six compartments, and the Prince's private car, complete with reception room, office, sleeping sections, and an enclosed observation booth. The four of us had been given the first-class compartment nearest the Prince's car.

An hour after leaving we were invited to join our host at his evening tea, and for the first time since meeting His Excellency I had a chance to utter more than a polite murmur in his presence. He was now relaxed, after two exhausting days of reception and conference, and he clearly relished this informal chat with us.

Prince Khilkov was a perfect Horatio Alger hero: the well-born youth stripped of his inheritance—in this case, it was the liberation of the serfs that had robbed our hero! —but winning out in the end by honesty, industry, and pluck. As I came to know him better, I found that there was an inordinate amount of pluck. Khilkov had left home

in 1858, when he was twenty or so, sailed steerage to the United States, and found a job as a laborer. After a couple of years he had drifted to South America and picked up work in a railway shop. When his wages were raised from $1 to $2 a day he had sent for his fiancée, a princess in her own right, and they began their married life on $12 a week. Returning to Russia with a good grounding in practical rail knowledge, Khilkov went to work in a loco- motive cab. From engineer he rose rapidly through the grades to a general managership. Then he was appointed government inspector, and finally Minister of Communi- cations, with cabinet rank. In 1896 he was receiving the enormous salary (for Russia, at least) of 50,000 rubles a year, and in addition he was the proprietor of a great estate, a further mark of imperial favor.

The six-day trip across Western Siberia and Russia proper was the outstanding railroad experience of my life. The presence of Prince Khilkov was partly responsible, of course; but the journey would have been memorable without him.

Bootz called us at 8 A.M. on Tuesday and said that we were approaching Atchinsk, where we were to cross our first real river, the Chalim. And a great novelty this cross- ing proved to be—our train throttled down to a crawl and proceeded right out over the ice!

There were at this time almost no bridges over the rivers of Russia. In summer, rail passengers left their cars on one bank and ferried across to another train. In winter, as soon as the ice had become thick enough, ties were laid and rails joined. Thus it was only in winter and early spring that fast, through traffic was possible. That was true not only of rail travel, but of all vehicular transpor- tation. Had we attempted the journey from Khabarovsk to Krasnoyarsk in summer or early autumn, we would have spent three months floundering through mud or choking through dust. Far from being an extra trial, cold

and snow have always been a positive blessing to travelers in Russia.

After breakfast with Prince Khilkov, we settled down in our compartment to a monotonous journey through flat, sparsely wooded country, very much like that between Irkutsk and Krasnoyarsk. Our windows were so thickly frosted that little could be seen; however, we crossed two tributaries to the Ob, and we were then able to stand outside and get a view of things. It was well after dark when we reached the second of these rivers, at Marinsk, and a great bonfire had been built on the bank to light our way across the ice.

Wednesday before daylight we crossed the Tom River, and about eleven we arrived on the right bank of the Ob. Here was one of the railway division offices, with train sheds and a long row of little houses for the employees. I took a number of pictures of the railway heads, including the Minister, our host. A little later our train was run out to the middle of the river and halted so that I could stop down my lens, for depth, and make time exposures.

When we woke up on Thursday the train was pushing along through a fierce blizzard. At noon, as we came into the Omsk station, the wind was still howling, while so much snow filled the air that we were unable to see the city itself, scarcely two versts distant. Next morning found the weather only slightly improved, and we sped west under the grayest of skies. The snow fences, I noted, were slight affairs as compared with our Rocky Mountain snow breaks. We lunched that day in Chelyabinsk, the dividing point between Russian and Siberian railway systems. Beyond us, through the thin snow flurries, we could see the Ural Mountains.

Close to the imaginary line which separates Asia from Europe I observed a sight which impressed me deeply. I was riding in the rear of the Prince's car, and, just after

we had passed a crossing gate, the keeper (a woman!) emerged from her little house, stepped to the middle of the track, and stood at attention as long as the train remained visible. That procedure was invariable, I was told. Even the road gangs stopped work as we went through and stood stiffly, chins up, and heels together. Everybody seemed to know that the Minister of Communications was passing their way.

On Saturday evening Prince Khilkov entertained us at dinner, while we rolled along at top speed, and on Sunday morning, shortly before we arrived in Moscow, there was an informal farewell breakfast consisting of sandwiches and wine. As we approached the Sacred City, gray clouds had settled down, and there was little of its greatness to be seen.

We came to a stop in the Kazan Station, where an imposing group of officials had lined up to greet His Excellency. Like a platoon of infantry, they marched down the platform six abreast. Farewells had already been exchanged, and we saw Prince Khilkov no more.

It was a long ride to our hotel, the Continental, in the Place du Théâtre, in the very center of the city, and as we headed toward it we realized that we were indeed returning to civilization. Moscow, with its million of inhabitants, contrasted strikingly with every place we had visited during recent months.

The World's Transportation Commission was close to the end of its tour. For some weeks all of us had understood that we would disband either in Russia or Germany and return home before "studying" the railroads of Europe. South America was completely out of the picture. We had no choice. Our money was used up, and the original sponsors had lost interest.

After two days crowded with sightseeing, photographing, and souvenir buying we started off for St. Petersburg.

Our party now had six members; for the Major's wife and daughter had come on from Dresden, where they had passed the winter.

When we stepped off the train in the capital on the morning of January 31 we were met by a secretary of United States Minister Breckenridge, who had sent down his carriage to take the Pangborn family to the hotel. Stevenson, Winchell, and I followed in a hired conveyance, and all of us put up at the Hôtel d'Angleterre, almost under the dome of the great St. Isaac's Cathedral. As soon as we had eaten breakfast, we called on Mr. Breckenridge, and after that formality I hurried off for a promenade on the Nevsky Prospect. I didn't especially need the exercise; but I was determined that nothing should interfere with my having a stroll on at least one of Europe's famous avenues.

I had hoped to spend the following day photographing about St. Petersburg; but regulations were very strict, and my permit, even with Mr. Breckenridge's personal intervention, was held up twenty-four hours. So instead of photographing I went shopping. Since I had only some $450 left to get home on, I could afford to spend very little. Yet with the assistance of Mrs. Pangborn, who had known my wife years before in Baltimore, I managed to pick out some exquisite hand-made pins and brooches to take home to Emilie and my daughters. As I put the boxes in my pocket, I realized that my little girls would be quite grown up when I saw them again; Louise was now seventeen and Hallie nearly fourteen.

My picture taking in St. Petersburg was almost negligible. On the day after my shopping jaunt Pangborn told us that he and his wife and daughter had decided to stay a few weeks longer in St. Petersburg and then continue their European tour privately. He recommended that Stevenson, Winchell, and I leave immediately for Germany to catch a boat scheduled to sail on February 18

from Bremerhaven. And he had suddenly realized that we would lose twelve days when we returned to the Gregorian calendar. If we left that very night, we could do it comfortably and still have a day or two in Berlin.

Our last day in St. Petersburg was marked by expressions of good feeling. The Major engaged a private dining room and gave us the best dinner the Angleterre could provide. Then, after many toasts, we left for Berlin on the night express.

Next day at the border, after the customs had made a perfunctory inspection of our baggage, we transferred to the German State Railway, and early on Sunday we stepped down in Berlin.

By the reckoning of the Western world it was now February 16, which left us so little time that instead of departing as planned on the steamer *Lahn* we waited another week for the North German Lloyd liner *Spree*. Since it was a small boat and an off-season sailing, our first-class accommodations came to only $37.50 apiece, and the saving fully made up the living expenses of our extra week. And a good thing it was—when we came ashore in New York on March 3 our combined capital wouldn't have carried one of us more than a hundred miles.

After a call at the offices of *Harper's Weekly*, I took the train for Denver. Home was more inviting now than all the kingdoms of the world.

A NEW VENTURE

THE Denver newspapers gave a flattering amount of space to my homecoming, and for the first few weeks it was a case of "home-town boy makes good." This was all very warming, and, had not more pressing matters interfered, I would have enjoyed every moment.

But the W. H. Jackson Photograph and Publishing Company was in a bad state. Rhoads, employed as manager before I went abroad, had held things together pretty well; but there were several circumstances—as much beyond my control as Rhoads's—which had caused us to lose ground. One was the increasing use of photographic illustration in all kinds of publications. As the process of half-tone engraving improved, not only did magazine pictures cut into the old "view" market, but cheap (and increasingly excellent) reproductions, in color as well as in black-and-white, further lowered the demand for photo-prints. The latter had to be made one at a time, while photo-engravings could be turned out by the thousand. In addition, the hard-working photographer lacked adequate copyright protection; his own pictures could be sold right under his nose, without so much as a thank-you.

The other unfavorable circumstance was the general state of business throughout the country, still suffering from the Panic of 1893. Colorado was further feeling the depression; for after repeal of the Silver Purchase Act the mining industry was sharply affected. Under such

adverse conditions even my considerable reputation in Denver couldn't bring in enough work, and it became quickly evident that I would have to find a new outlet. As it happened, I had already begun to investigate the possibilities of another field.

During my few hours in New York I had run into an old acquaintance of mine, E. H. Husher, a well-known photographer of California scenes, who had recently returned from Switzerland, where he had been sent by a group of Detroit men to study a new photo-lithographic process for reproducing pictures in color. He told me that American rights to the process had been bought by his associates and that the Photochrom Company had been organized to exploit it. Most important (at least from my point of view), Husher, as superintendent, had recommended to his superior, William A. Livingstone, that the new company absorb the W. H. Jackson Company in order to acquire a stock of negatives. Furthermore, Husher had urged Mr. Livingstone to offer me a suitable position with the new company.

Soon after my return to Denver I received a letter from Livingstone, and thus began a correspondence which eventually established me in the Photochrom Company. But that change was not to occur for more than a year; and meanwhile I worked harder than ever before, just to keep things in Denver above the surface.

If the year 1896 was a hard one for me, it was for all the people of the country the most critical time since the War. When, in May, a black-maned orator named Bryan cried out in Chicago, "You shall not crucify mankind upon a cross of gold!" the Democratic Party with wild acclaim chose him as its candidate for President. A little later the thirty-six-year-old editor was also nominated by the Populists, and the most important political battle since Lincoln's first campaign was in full progress. "Free

silver" was a popular platform in Colorado, as in many other parts of the land, and for weeks its champion appeared to have the election within his grasp. But in the end the conservative forces won out, and I was among those relieved to learn that the Republican candidate, William McKinley, had "saved the country from revolutionists."

Business sentiment improved. My own affairs, however, were prospering no better, and, while waiting for the Detroit enterprise to come to a head, I set out on a lecture tour. About inauguration time, 1897, I had been induced by the Presbyterian ladies of Denver to give an illustrated talk. The church netted $800 for one evening, and, very shortly thereafter, a professional manager called on me and drew a bright picture of earnings on the road—with the result that I undertook a tour under his auspices.

"Mr. W. H. Jackson, the distinguished photographer, will deliver his new lecture on '100 MINUTES IN STRANGE LANDS,'" read one of our posters. "Illustrated by 125 beautiful pictures projected upon a screen by powerful stereopticons. Many of these negatives made by courtesy of highest foreign governmental influence. Prices: Reserved Seats, 75 Cents; Admission, 50 Cents; Children, 25 Cents."

My circuit of Colorado brought out good-sized and, in the large, appreciative crowds. But my manager had overlooked several important factors. The ladies of the Central Presbyterian Church of Denver had been on the job for weeks before my initial talk, and they had personally sold every seat in the auditorium. They had charged no expenses whatever against the gross, and, naturally, every penny taken in was so much profit. When I took to the road, there were traveling expenses to be considered, hall rentals, printing bills, and a dozen other little costs and commissions. In brief, my lecture trip was very instructive

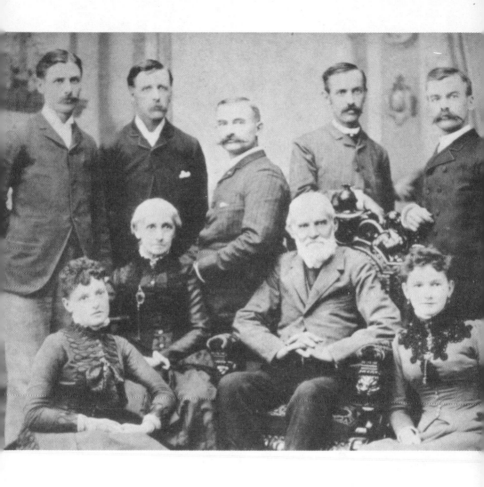

My parents, with all seven of their children, photographed in my Denver home on their golden wedding anniversary. Seated by my mother is my sister Emma, with Mary Elizabeth by my father. Brother Allen stands on the left, next to me; the other three, in order, are Ed, Frank, and Fred.

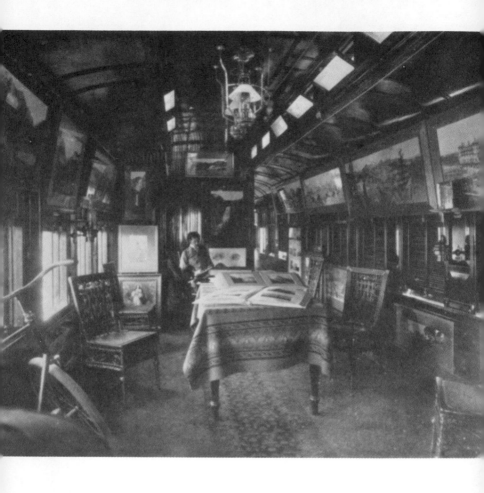

In this car, known as the "California Special," I toured the
Southwest in 1902 with a display of pictures for
the Detroit Publishing Company.

(to myself, if to no one else); but financially it was a failure.

Yet the publicity did me no harm. I had been exchanging long letters with Livingstone, and just about the time I ended my tour he arranged to run out to Denver to talk things over.

He arrived early in the fall of 1897. His company was installed in its new Detroit factory and was ready to turn out the finest color reproductions at prices that could meet all competition. I had two things to contribute: the most complete set of Western negatives yet assembled by one man, and my experience and reputation. After a little beating around the bush, Livingstone and his associates agreed to take over the W. H. Jackson Company at its nominal capitalization of $30,000—some $5,000 was paid in cash (and used almost entirely to cover floating indebtedness), while the rest came in stock of the new company. In addition, I was to become a director, at a comfortable salary.

I moved to Detroit early in 1898, just as Mr. William Randolph Hearst was beginning to reap the fruits of his fiery campaign for war with Spain. "Remember the Maine!" was the watchword, and everybody was singing "There'll Be a Hot Time in the Old Town Tonight."

But by the time the "bullybeef scandal" was being aired, and a young man named Theodore Roosevelt was simultaneously winning official censure and immense popular applause for calling attention to the precarious situation of our troops in Cuba, I was back in the West again with my camera. My new employers had decided that, for the present, at least, I could be most valuable to them operating in the field I knew so well.

There was also the Trans-Mississippi Exposition, in Omaha, to be photographed in the summer of 1898, and a special job which took me into the Black Hills of

Dakota. I remember one sidelight of the Dakota trip with peculiar vividness. My son, who, in partnership with two other young men, had taken over what was left of my Denver business, had landed a railroad scenic order in the Black Hills just a few weeks earlier. When I arrived in Deadwood my presence was noted in the paper with a brief announcement that "W. H. Jackson, father of the well known Denver photographer, C. S. Jackson, is in town. . . ." I had known, ever since Clarence traded his Chihuahua dog for a donkey, when he was seven or eight, that he'd get along all right.

In the fall of 1898 I buckled down to intensive indoor work. The plant of which I was part owner—controlled by the Detroit Publishing Company, another Livingstone enterprise—employed about forty artisans and a dozen commercial travelers. Our business was the production of color prints, by a process hardly improved today, in sizes varying from postal cards to the largest pictures suitable for framing. We specialized in photographic views and world-famous oil paintings, and our annual volume, from the largest to the smallest reproductions, was about 7,000,000 prints. Retail salesrooms were maintained in Detroit, New York, Los Angeles, London, and Zürich. Our 342-page catalogue went to all parts of the world.

But, although I was interested in the manufacturing end, I was still primarily occupied with my camera. Now that I was assured that the pictures I took would be profitably reproduced, I went back to my outdoor career with a zest as great as I had ever known before.

In 1899, I photographed the route of the Chicago & Northwestern Railroad, and I did the same for the Delaware, Lackawanna & Western. I also made a series of pictures in California, coastal views from San Diego to Santa Barbara, and I photographed the points of interest

in and about Boston. Although I was in the field less than five months, I covered more than 20,000 miles.

The following year took me north and south, rather than east and west. After a summer in Canada—the St. Lawrence and the Saguenay; Quebec, Montreal, and the Thousand Islands; then a quick trip through the Adirondacks—I turned to the Lower Mississippi, to photograph life on sugar and cotton plantations. During the winter of 1900-01 I covered the Atlantic Coast, from Virginia to Florida, and then I made my first voyage to the West Indies, principally to get views of Cuba and Nassau.

I spent most of the summer of 1901 in the Colorado Rockies, and my presence in Denver at just the right moment led to one of the most interesting jobs it has ever been my fortune to handle. C. A. Kendrick, an old-time cattleman, now head of the Kendrick-Bellamy Stationery Company, received a call for some cattle-ranch views and commissioned me to run down to the Adair Ranch in the Texas Panhandle to take the pictures. I succeeded in getting some very fine negatives of the great "JA" roundup, one of which—actually a combination of three successive exposures, showing more than 3,000 cattle—is still regarded as perhaps the most representative photograph of an old-time cattle roundup available today.

The year 1902 found the Detroit Publishing Company and its affiliate, Photochrom, at the pinnacle of their prosperity. One result was to send out a traveling display of our work, and it was my agreeable lot to be in charge of the special car which toured the Southwest. Known as the "California Special," this car drew great crowds at every stop. Both Detroit Publishing and the Santa Fe Railroad (which had sponsored the exhibit) enjoyed the most favorable publicity. I, in addition to giving informal talks and answering questions, made good use of the opportunity to take pictures all along the line.

That busy summer, which had its climax in Southern California, was, although I had no way of knowing it at the time, the wind-up of my active career as a landscape photographer. The following spring, just about the time of my sixtieth birthday, my friend Husher sold out his interest in the business and bought a California orange grove. That left us without a plant manager; and, since I was the only member of the firm with enough technical knowledge to take over his job, almost automatically I found myself in charge of production.

On the surface, I had done nothing more than transfer my activities from one sphere to another. But after so many years in the field, it was a real lightening of the load. Anything so simple and well ordered as running out to the factory for seven or eight hours a day was as good as retirement. And I welcomed it.

CHAPTER XXII

I RETIRE

AFTER so many years of work in the open, I turned gladly, even enthusiastically, to a routine career. For one thing, it was a much easier life, going to an office every day, and working with men who knew their craft so thoroughly that all I had to do was to organize their output. For another, there was the almost novel pleasure of living with my own family, of sitting at the table with my wife and daughters, of taking them to the theater, and of going with them on little trips to near-by resorts.

Then there was the engrossing experience of looking on during the growth of one of the great industrial centers of America. In 1866, when I had come through with Rock Rounds and Billy Crowl, Detroit numbered some 60,000. During the next thirty-two years the population quadrupled—but the city was still just a big town that made stoves and carriages and box-cars and marine engines when I moved there in 1898. Yet something new had already begun to stir.

As I remember, I saw my first automobile in Denver. But, wherever it was, I clearly recall my first reaction: What a fine way to get around with a camera!

It was not until I had established my new home that I grew accustomed to the daily sight of those first high-wheeled contraptions, with one-cylinder motors under the seats and with buggy dashboards, chugging and backfiring and stalling along the dusty streets. By 1899, Mr. Robert E. Olds was boldly offering his cars for sale. Two

years later the Cadillac Motor Car Company was incorporated, and in 1903 Packard and Ford entered the field. Horses had begun to stop shying at snorting horseless carriages when, in 1904, a city census showed that more than 2,000 men were employed in the flourishing new industry.

Five years after that nearly 20,000 of the 450,000 residents of Detroit were automotive workers, 45,000 cars reached the market, and the most violent deplorers of a mechanized age were ruefully admitting that the automobile might be here to stay. I had accepted that fact at least three or four years earlier, when I turned in the bicycle that I had enjoyed pedaling to work for a Ford runabout. And I want to say that among the major accomplishments of my life was learning, after the age of sixty, to pilot an early Model T.

It was just about this time, 1908 or 1909, that I joined the Detroit Golf Club and began to play the game with some regularity. (The $50 initiation fee seemed very steep at the time—but, I am told, the cost of membership reached $3,000 a few years ago.) For the next fifteen years or so I played in a foursome nearly every Saturday —and often on Sunday as well—and enjoyed it thoroughly. If we duffers seldom broke a hundred, we always managed to make it up at the "nineteenth hole" afterward.

Meanwhile all three of my children had married, and my wife and I, for the first time since our marriage, had no immediate obligations to anyone except ourselves. I still made occasional photographic trips, and now, when I went off to Georgian Bay, or to the Gaspé, or to the White Mountains, Emilie accompanied me. Those trips, after thirty-five years of married life, were the first really complete holidays we had ever had together.

My father lived until I was sixty-one, and my mother, sturdy and in good health to the very end, survived him

by eight years. A great-grandmother (my first grandchild, William H. Jackson II, was born to my son Clarence in California in 1902), she continued to lead a useful and happy life until 1912. Both my parents now rest in the Friends Cemetery in Sandy Springs, Maryland.

With my mother's death, I found myself the oldest member of the Jackson family. But, although I was sixty-nine, I felt far from old. I continued to put in a full day's work every day. I continued to drive my car daily through the thickening maze of Detroit traffic. I played golf as well—and as badly—as ever before. And I still took occasional trips about the country.

When the World War broke out, with the subsequent entry of the United States, I was glad, especially for my wife's sake, that our son was too old, and our grandson a little too young, to take active part. Our daughter Louise had meanwhile come to live with us, and she and her children brought us great happiness. Those last years that Emilie and I had together were good years.

My wife died just a few weeks before the Armistice, and I buried her in the beautiful Friends Cemetery in Baltimore, beside her father and mother. We had lived together in love and harmony through forty-five years.

Looking ahead without her at the age of seventy-five was no easy task. But three lively grandchildren in the house did much to solve the present, while the future, as it always had before, shaped itself. And I had two occupations—my work, and the recreation of the golf course.

My business demanded unremitting attention. In the flash of almost universal prosperity that came after the World War, our business flourished mightily. Despite the growing competition of cheaper and constantly improving methods of picture production, the Detroit Publishing Company turned out millions of postal cards and thousands of true copies of the Old Masters.

The general business recession of 1920-21, however, was a blow from which we were never able to recover. By 1923 our deficits had reached such a volume that we knew receivership was inescapable, and the following year brought us to the end of our rope. My investment of course disappeared; and, at the age of eighty-one, I found myself without either capital or any certain means of livelihood. It wasn't exactly an encouraging situation.

It happened, however, that I had some $6,000 coming to me for back salary, and that made me a "preferred creditor" of the extinct corporation. When that was paid I felt like a rich man.

In the fall of 1924 I packed up my books, papers, sketches, and other important belongings, and started east. I had a lot of plans—or, rather, a lot of ideas. I wanted to get back to my painting again. I wanted to bring my journals up to date and do some writing. And I wanted to see some of my old friends.

I decided to make Washington my headquarters. A few of my old Survey colleagues lived there. So did my daughter Hallie, the wife of Myron Pattison, a former Denver boy, and their two daughters. With my small capital, plus my War pension of $75 a month, I was sure I could live there very comfortably. And so I started off.

For nearly five years my home was in Washington. At the outset, I lived at my daughter's, and it was a happy year that I spent there. But I found, in time, that it would be more convenient for me to have my headquarters closer to such places as the Library of Congress and the National Museum; and so I took a room at the Hotel Annapolis.

It was the first time in my life that I was able to afford the luxury of concentrating on any work that wasn't closely bound up with my bread and butter. I could spend whole days in the Library and the Museum. I could linger in the Smithsonian. And I could have access to the De-

partment of the Interior for whatever material I required in my writing and painting.

Then there was the Cosmos Club. My old Survey colleague William Holmes, by then Director of the National Gallery, had proposed me; and, a year or so before I moved to the capital, I had been made a member. Founded late in the '70's by members of the Philosophical Society who felt the need for less formal gatherings, the club was one of the pleasantest places in Washington. I spent many hours each week in its comfortable quarters, which, since 1886, have been the old Dolly Madison house at H Street and Madison Place. (Recently the Government has purchased the house, with the announced plan of "improving" the site. I hope they don't.)

While in Washington, I kept fairly close to new developments in photography. As I had planned, I also got back to painting. By combining my personal knowledge of the old West with library research, I found myself gradually attaining to a position of some knowledge and would occasionally be called into consultation by museums, or asked to contribute historical illustrations to magazine articles and books.

None of this added greatly to my income; but every little bit was welcome. And, before so very long, it meant the difference between bare subsistence and reasonable comfort. As I have mentioned, after the wind-up of the Detroit business I found myself with some little cash. Most of this I invested in common stocks (who didn't, in those days?), and, for a time, I found myself with what has so eloquently been called a "paper profit." But suddenly something happened. I don't know quite what it was—although, perhaps, the fact that I had bought some shares on margin was to blame—but, as I say, something happened. In brief, I was a shorn lamb, with very little between me and the cold, cold world save my pension.

During my stay in Washington I had customarily spent

my summers in the West, revisiting such old familiar spots as Yellowstone Park, the Colorado Rockies, and the Valley of the Great Salt Lake. Apart from the immediate pleasure I found in those trips, I was also working on a history of my days with the Geological Survey. Collaborating with me was Dr. Howard R. Driggs, Professor of English in New York University and editor of the "Pioneer Life Series" for high-school readers.

The preparation of our book, which appeared in 1929, entitled *The Pioneer Photographer*, led most unexpectedly to a new enterprise.

When a man is eighty-five, he cannot seriously expect to land a new job. Yet that is exactly what I did. On my frequent trips to New York from Washington to consult with Dr. Driggs, I stopped at the Hotel Latham, a quiet establishment on East 28th Street. There I often encountered Ezra Meeker—the man who had started for the Oregon country by ox-team in 1851, hewed himself a homestead, and, in 1905, when he was seventy-five, dedicated the rest of his life to the marking and perpetuation of the Oregon Trail. A hard-driving, autocratic gentleman in his middle nineties when I first came to know him, "Uncle Ezra," thirteen years my senior, took a fancy to me; or perhaps I should say, simply, that he preferred to deal with a "seasoned" man instead of with the whippersnappers of sixty and seventy who surrounded him. When Meeker died, just prior to his ninety-eighth birthday, Dr. Driggs succeeded him as president of the Oregon Trail Memorial Association and I was named Research Secretary. Early in 1929 I moved to New York to begin work.

Nothing could have pleased me so well. It was work that I was well prepared to do. It enabled me to keep on traveling extensively. And it carried a comfortable little salary.

During the following years I passed my winters in New York and my summers in the West. I addressed meetings

from New York to Oregon. I visited all my old haunts, as well as many places I had never seen before. While on the road I still used my camera—now a "vest-pocket"— and when in town I painted. The first medium contributed to the second, and in those years I turned out hundreds of water-color sketches and at least a score of sizable oil paintings.

At the start, I lived at the Explorers Club, then on West 110th Street. When, in 1932, the depression forced the Explorers to give up its commodious quarters, I moved to the Army and Navy Club, opposite the Harvard Club, on 44th Street. But the next year found that organization without its own building; and then I packed up my belongings once more and took a room at the Latham, where I had first known Ezra Meeker. There I have lived ever since, and there I intend to stay.

CHAPTER XXIII

I GO TO WORK

O N my way back from the West, in August, 1935, I stopped off in Washington to take part in a little ceremony. The seventy-fifth anniversary of the Pony Express had just been marked by 300 Boy Scouts riding in relays over the old route from Sacramento to St. Joe. The message they were carrying to the President was then flown from the Missouri River to Washington, and I was one of the men who rode in the plane. It was my honor to help deliver this message to the White House and, at the same time, to present a commemorative gold medal to President Roosevelt.

The following day, August 23, I dropped in at the Department of the Interior to see some of my old friends. That visit, which began as a purely social call, ended up with my receiving one of the most important commissions of my career. Mr. Arno B. Cammerer, Director of the National Park Service, asked me whether I would undertake the execution of a series of murals to memorialize the early days of the Geological Survey. I assured him that nothing could make me happier, and on the very next day I was "sworn in" as a member of the National Park Service.

I returned at once to New York to begin the work. I was expected to complete four 30 x 60 canvases, intended for permanent display in the museum of the new Interior Building; one year was allowed, and I was to be paid $150 a month, from funds allotted for WPA art projects.

The task presented two basic problems. One was tech-

nical. I had four large compositions to work out; and, in addition, I had to make the separate canvases hold together as a group. The second, and larger, problem was one of research. Prior to the reorganization of the Survey in 1879, each expedition had been known by its leader's name. It was easy enough for me to rely on my own memory, journals, and photographs for a painting to typify the Hayden Survey. But it was quite another matter to do justice to the other three Surveys that had been selected as subjects. It meant reading official reports and studying photographs, and that part alone kept me busy for weeks.

As completed, my four murals represent the Hayden Survey, with Old Faithful Geyser in the background; the King Survey of the Fortieth Parallel, showing an encampment in Carson Valley, with the Sierra Nevada in the distance; the Wheeler Survey of 1873, showing the party before the Pueblo of Zuñi, with Thunder Mountain on the horizon; the Powell Survey of the Colorado River, with the party at work along the canyon floor. They hang today in Washington.

In addition to these major canvases, I painted half a dozen 25 x 30's in oil and more than forty water-colors; most of them have been distributed among national-park museums, Mesa Verde, Rocky Mountain, Grand Canyon, Yellowstone, and others. It was one of the most gratifying tasks of my life. Presumably the Department of the Interior was also pleased; for the original time allowance was extended from one year to nearly eighteen months, when the appropriation was exhausted.

Although in the midst of this work in the summer of 1936, I had made such painting progress that I felt justified in taking my usual trip west. My first stop was Detroit. Ever since the dissolution of the printing business in 1924, my negatives—40,000 glass plates—had been in

storage. Sooner or later, I knew, they would either be destroyed or scattered; and, although I had no financial interest whatever, I wanted those negatives preserved. Mr. Edsel Ford had already been approached, and, with his father's backing, it was arranged to have the entire collection taken over by their Dearborn museum. Known as the W. H. Jackson Historical Collection, my 40,000 negatives are now a permanent part of the Edison Institute.

'My summer continued to be a busy one. From Detroit I went on to Denver and motored down to Santa Fe and back through Mesa Verde. In August I went up to Washington for the Centennial of the Whitman Mission at Walla Walla; then down through Portland to San Francisco, and home to New York by way of the Yellowstone.

After an active winter finishing up my paintings for the Interior, I decided upon another trip to the West. In July I traveled to Boulder, where the University of Colorado presented me with a gold medal. *"De Re Publica Coloradonensis,"* it reads, *"Bene Meritus Est William B. Jackson."* My pleasure in being accorded the distinction of a Latin eulogy far outweighs the discomfort of having my middle initial altered.

That same summer of 1937, in Cheyenne, I had the only severe accident of my life, when, while doing a little window shopping, I tripped over an open cellar door and landed on my back on the concrete floor ten feet below. For a full month I was compelled to keep to my bed with several fractured vertebrae. At my time of life, it was rather a serious injury, and I am thankful to have recovered completely. As it was, I guarded against overdoing things during the following months. I wanted to be in the best possible condition when the seventy-fifth anniversary of the Battle of Gettysburg rolled around.

By the following March, however, I felt as sound as ever, and I went to Washington for a reception when my murals were put on display. Late in May I was again in

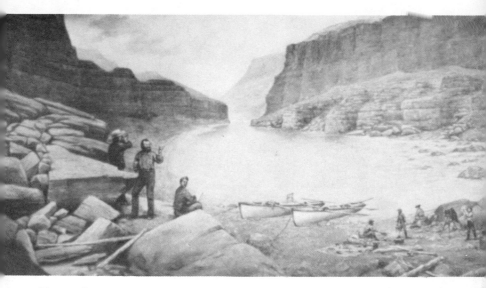

Two of my four murals, painted 1935-36, for permanent display in the Department of the Interior Building, Washington, D. C.

Above, the Powell Survey of the Colorado River. Below, the Hayden Survey of the Yellowstone.

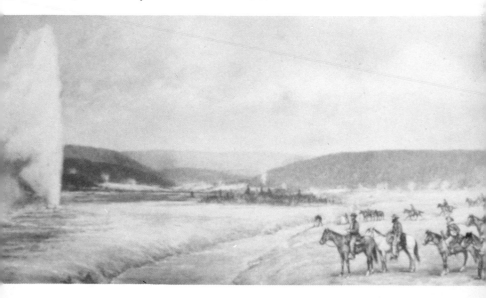

Courtesy of the *New York Daily News*

Memorial Day, 1940

the capital, this time for Memorial Day exercises. I flew from Arlington to Gettysburg, and had the novel experience of broadcasting from the air.

The great reunion of the Blue and the Gray lasted six days, from June 29 to July 4, 1938. There were more than nine thousand veterans present, we all lived together in tents, and I am sure there was more action on the battlefield than at any time since 1863. Again I flew over Gettysburg, this time with another Union soldier and two "Rebels," to strew roses over the cemetery.

That reunion was a wonderful thing to attend. And, since it seemed unlikely that there would ever be another, I took care not to miss any of the important festivities. The climax was the dedication, by President Roosevelt, of the Eternal Light. But a thing that has remained in my mind with equal sharpness was the long queue of veterans that passed through the first-aid tent every day. With a few exceptions, those men hadn't a thing the matter with them. They were just waiting in line, as they had seventy-odd years before, to get their regular issue of rum. They were a sturdy lot, too, those six thousand men in blue, and the three thousand in gray. Every single veteran who came to Gettysburg returned home. Not one fatality among them! That must be a record of some sort.

When I got back to New York, I was, for once, well content to take a complete rest. Consequently, I did not start for the West until the middle of August; and then I limited my trip to the annual meeting of the Oregon Trail Memorial Association, which in 1938 was held at Scotts Bluff, Nebraska. After my return, I had another good rest before starting off on a week's tour of upper New England.

I suppose 1939 will be remembered by many people as "the year of the fairs." I know it will be by me; for I was one of those fortunate persons who found it possible to visit both "Treasure Island" in San Francisco and "The

World of Tomorrow" in New York. I covered the New York fair very completely—at least, from my point of view —for I visited every exhibit I had planned to take in one or more times. In particular, I enjoyed the fine art collections, the various displays of photographic equipment, the motor shows, and the great pageant "Railroads on Parade," I was able at last to see the "joining of the rails," which I had missed at Promontory Point on May 10, 1869, through the circumstance that it had conflicted with my wedding day.

On my way to the Golden Gate, I motored with the Oregon Trail party over the old Pony Express route, from Salt Lake City to Sacramento, where our convention was held. Then, after taking in the fair, I went down the coast to Los Angeles for a fine week's visit with my grandson, William H. Jackson II. It was my first meeting with my great-grandchildren (two then, three as I write), and I was duly impressed.

On the way home, I stopped off for a short visit in Denver; and, altogether, it was as varied and rewarding a summer as I can remember. In addition to other things, I had a new photographic experience. During recent years, I had carried a miniature camera on all my trips, just for the pleasure it gave me. Now, in the summer of 1939, for the first time in my life, I experimented with color film. All I need say is this: if I were at the beginning of my career, I should wish to do everything in color.

Early in October I spent a week in the vicinity of Plattsburg and Keeseville. I had gone up there five years before, for the first time since 1864, to visit the scenes of my birthplace and early boyhood; but I found nothing except an old man who had worked on the family farm after we moved away. This trip, however, was more productive. Although nothing but a vine-covered excavation remained to mark the spot, I nevertheless was able to identify the site of our farm in Peru Township. And in the county

clerk's office I found the deed whereby Peter Keese had, in 1837, conveyed 100 acres of land (presumably with the house) to James Jackson, my grandfather. For some reason which defies explanation, I derived much satisfaction from those little discoveries. And I think they had something to do with my decision, a few weeks later, to get to work in earnest on my autobiography. I had started to do something about it four or five years before; but it was not until the autumn of 1939 that I signed a contract to publish the story of my life.

From that time forward my principal concern has been the preparation of manuscript, the completion of drawings, and the selection of photographs. But I have still found time to do a few other things. I have managed to give occasional illustrated talks before camera clubs and other groups. I have been able to take a few trips—to Washington, in March, for a preliminary showing of my early Survey photographs, just prior to a special month's display by the Department of the Interior; to Detroit, in April, to spend my ninety-seventh birthday with my daughter; then back to Washington, after the Survey exhibition had opened, to appear in a sound reel recording the event. And, as always, I have been able to spend three or four evenings a week with my friends.

From my eightieth birthday on, I have accustomed myself to being described as "the old-time photographer," "the elderly explorer," "the venerable Mr. Jackson," and the like. But this has happened only in the newspapers. My friends and associates know from experience that I am good for any day's activities that I may set for myself. Until I was ninety-four, the summer I cracked my vertebrae, I rode a horse regularly. When I take in a world's fair, I use my own two feet until someone else calls for a wheel chair. And I don't find it too tiring to stand up for

an hour's illustrated lecture if people are interested enough to listen as long as that.

I have been given to understand that my birthdays are of some importance, and since my ninetieth anniversary each year has provided a delightful party. Just how "important" these occasions are I couldn't say. I am inclined to be a little skeptical—but I wouldn't like to do without them.

It has all been very pleasant, this business of growing old. One of its little rewards is the surprise it sometimes gives to people. Just a few months before I reached the age of ninety-six, for example, I received a letter from Mr. J. Dudley Johnston of the Royal Photographic Society of Great Britain. "You may think perhaps that it is a rather long delayed honour," this letter read in part, "but very few in this country were aware of the work you did and the fact that you were still in the land of the living." The letter was sufficient reward in itself; but with it came a diploma conferring upon me an honorary fellowship in the Society. Yes, it has all been very pleasant.

There is a legend that I have found curious. It is that when a man grows old he becomes automatically an authority on longevity, a reliable source of scientific information on diet, exercise, and general behavior. And, of course, I have had my share of such inquiries.

I have usually answered that I didn't know; but perhaps that is not quite accurate. I have reached my age, I think, for two principal reasons. The first is that I inherited a tough constitution. My Uncle Sam lived to be eighty-eight, my father to well over eighty, and my mother reached ninety-one. Two of my brothers are still living; Allen is seventy-seven and Fred is now in his ninetieth year. It is in our blood to live a long time.

The second reason, in my mind, is that I never took out enough time to get run down. There has always been so much to do tomorrow that I haven't ever relaxed to any

great extent. I have been too busy doing interesting things and getting ready to do even more interesting things. Right now, with a presidential election coming up and the situation in Europe most disheartening, no one is looking ahead very far; but I still think I will be in Wyoming in August to help celebrate its fiftieth anniversary as a State in the Union.

Of one thing I am sure: no one ever reached the nineties simply by following a set of rules. In living, as in art, rules are drawn from practice; not the other way round. According to rule, I should have been worn out, through sheer physical exertion, forty years ago; but I am still able to get around pretty comfortably. According to rule, I should have gone bald in the hot plains fifty or sixty years ago; but the barber still uses his shears all over the top when I visit him. According to rule, my stomach must have been ruined by cheese and crackers by the time I was thirty. Yet I still am able to eat whatever I choose; and, dining with friends three or four nights a week, I find myself succumbing to many temptations. As for drink, I am guided by the title of a recent book which, although I have not yet had time to read it, sounds very sensible to me. It is called *Liquor, the Servant of Man.*

As I finish this, the Mexican War is past by ninety-two years, the War of the Secession by seventy-five, and the War with Spain by forty-two; the World War is more than twenty years behind us. Memorial Day has just gone by, and this time the troops paraded up Riverside Drive, past the reviewing stand and the Soldiers and Sailors Monument, before the most silent throngs I have ever known. Today again there is war.

But as I walked up Riverside Drive in the bright morning, one of six old soldiers who marched in our section of the parade, everything still seemed very pleasant. I have been one of the fortunate.